HOW THIS BOOK CAME TO BE

In November 2017, I received a call from Guido Harari, an Italian photographer friend of mine, about doing a Joni Mitchell book. I had never considered publishing a book on a single artist, feeling that too many shots would not represent the quality of imagery that I select from a shoot. I generally publish no more than five to ten images from a single Session, although I shoot hundreds of frames.

I decided to respectfully pass on his offer, explaining that I did not feel that there would be enough images to warrant publishing a book of the scale he was contemplating. Guido subsequently flew to Los Angeles and spent two days in my studio photographing my contact sheets with the colored markings I had made of my choices over the years. Two weeks later back in Italy, he sent me files of hundreds of images that he had selected, and I realized that his instincts were right, there was indeed a book to be made.

The Joni book project is a beautiful example of receiving a gift in an unexpected and magical way. I have learned a lot in the process, discovering a narrative theme in images and text and a deeper appreciation of the wide range of Joni's creative contribution.

A Synergistic Creative Collaboration

I made the decision four decades ago to switch careers from practicing medicine to pursuing a calling for creative expression in the arts. Since then, my creative journey has evolved through multiple disciplines. I began as a graphic designer of album cover art, art director, and public personality photographer. More currently, my work has expanded to documentary filmmaking, focusing on the exploration of the creative process in practice.

Each of these arenas, and my career as a photographer in particular, has provided me with a profound opportunity to work with many of the world's greatest creators and innovators, across all the major disciplines.

In the evolution of my journey as a studio photographer, I was to develop a specific process of working, aiming at creating a relationship of trust for artists to explore creativity in a safe environment. It was also at this time that I began to uncover what seemed to be the underlying dynamics of how the creative process progresses. The exploration of the inner resources and the outer expression of creativity has become the overriding focus of my personal journey.

Working with Joni, the embodiment of an accomplished multidisciplinary artist, provided a rich opportunity for a blending of our individual abilities, as a synergistic creative collaboration. Joni committed herself to exploring and expressing an authentic voice in response to an inner calling. She became, in her own words, "the adjudicator" of her own works, the epitome of the innovator creator, always setting her sights on far horizons, and courageously going there.

NORMAN SEEFF / THE JONI MITCHELL SESSIONS

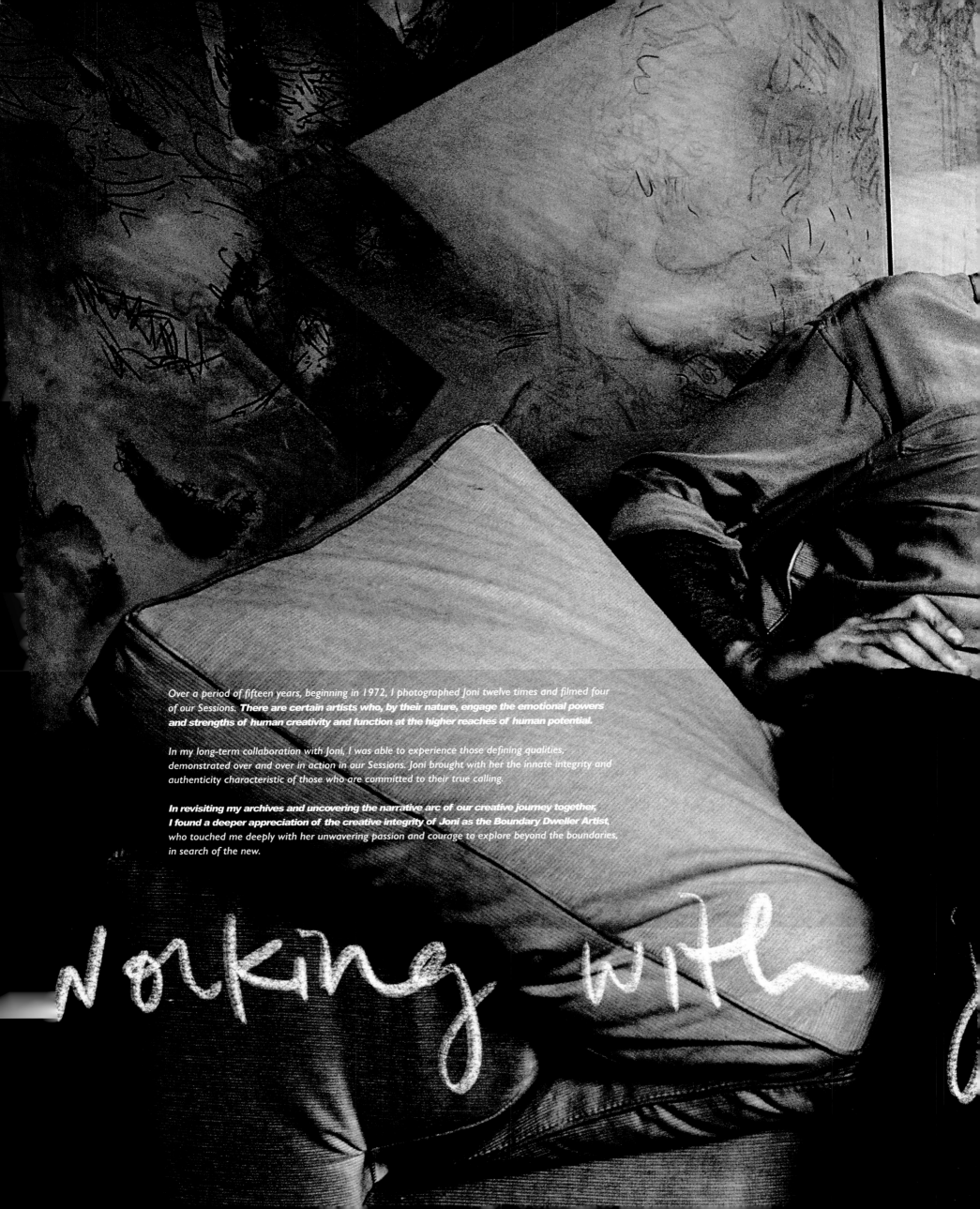

Over a period of fifteen years, beginning in 1972, I photographed Joni twelve times and filmed four of our Sessions. **There are certain artists who, by their nature, engage the emotional powers and strengths of human creativity and function at the higher reaches of human potential.**

In my long-term collaboration with Joni, I was able to experience those defining qualities, demonstrated over and over in action in our Sessions. Joni brought with her the innate integrity and authenticity characteristic of those who are committed to their true calling.

In revisiting my archives and uncovering the narrative arc of our creative journey together, I found a deeper appreciation of the creative integrity of Joni as the Boundary Dweller Artist, who touched me deeply with her unwavering passion and courage to explore beyond the boundaries, in search of the new.

Working with

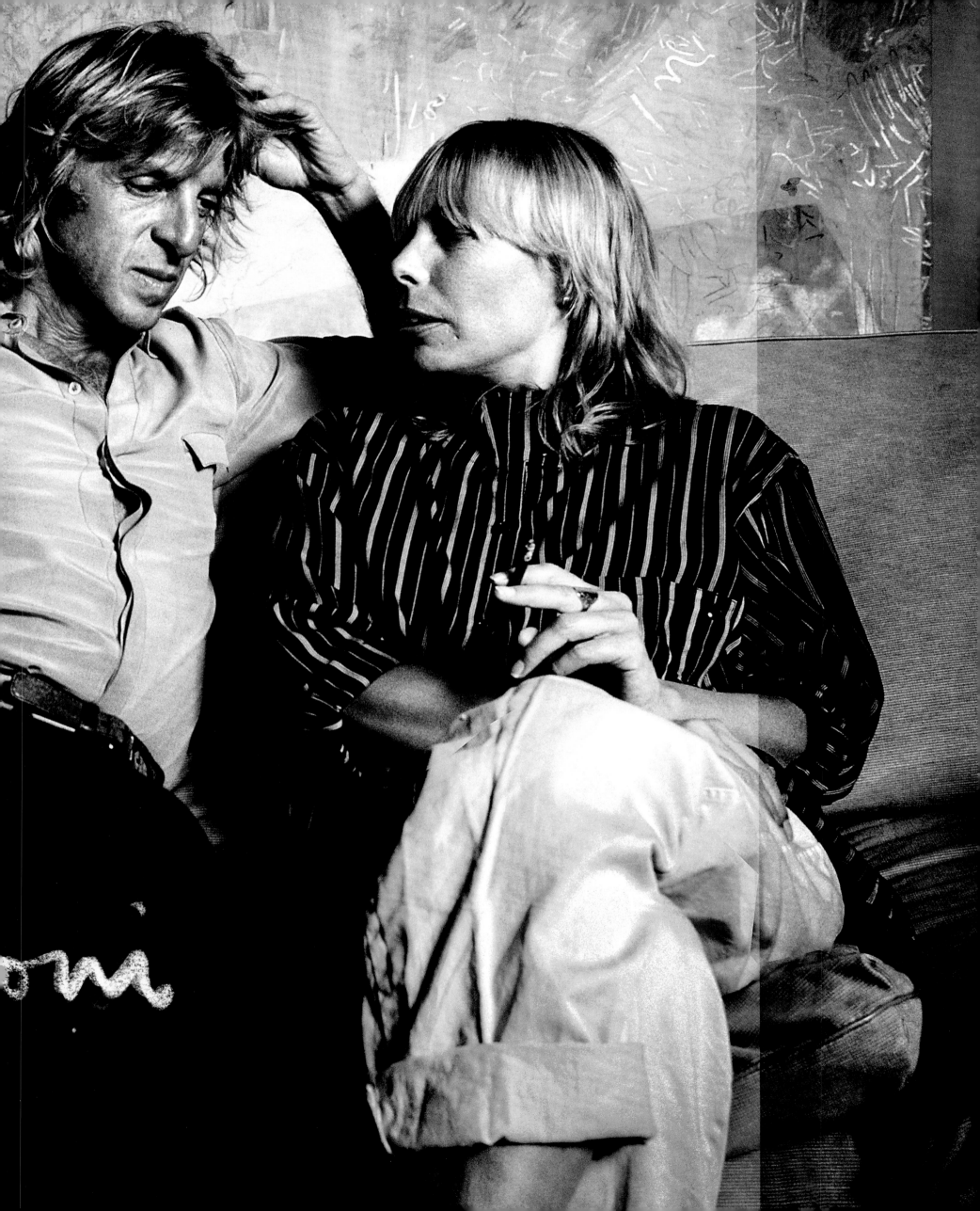

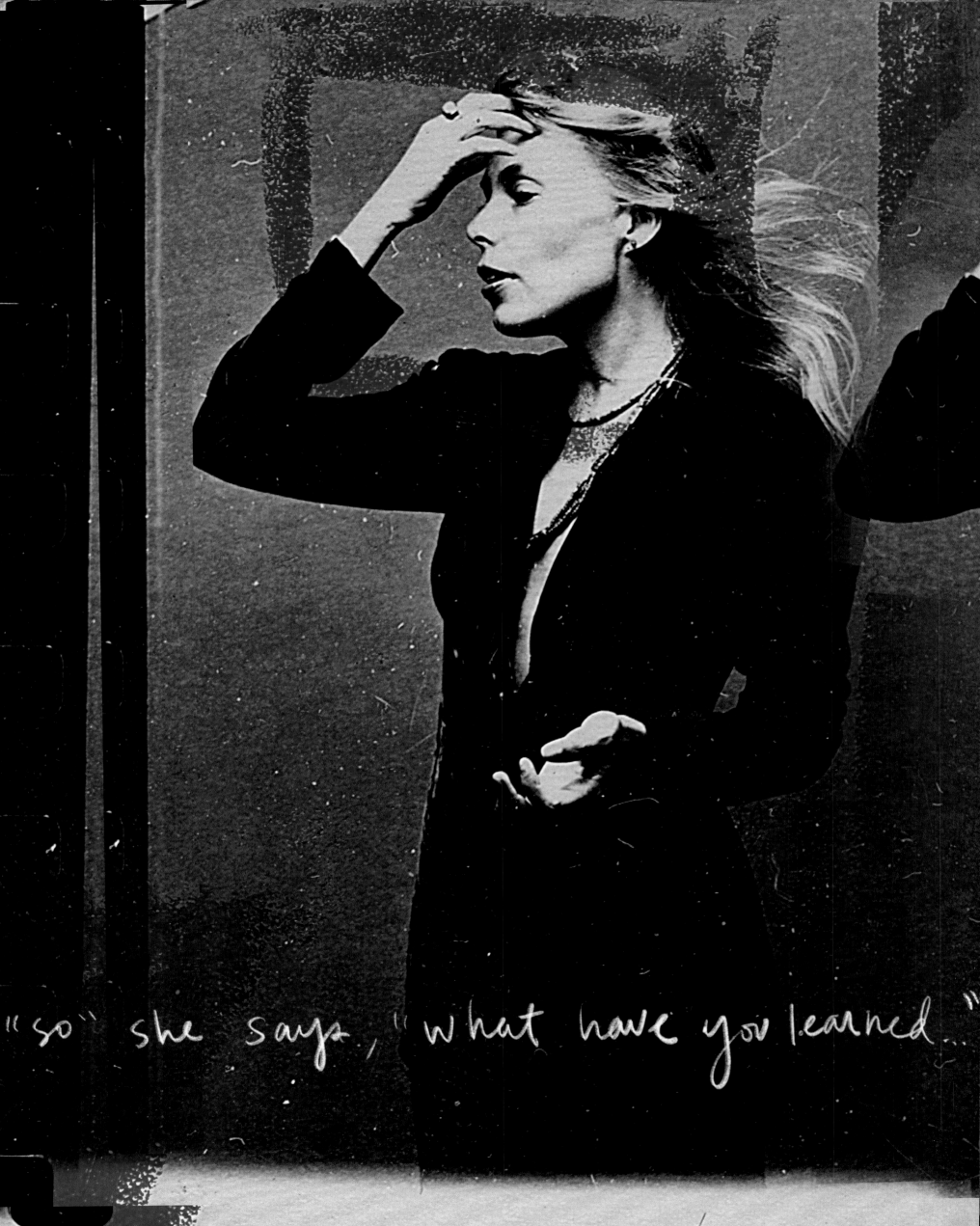

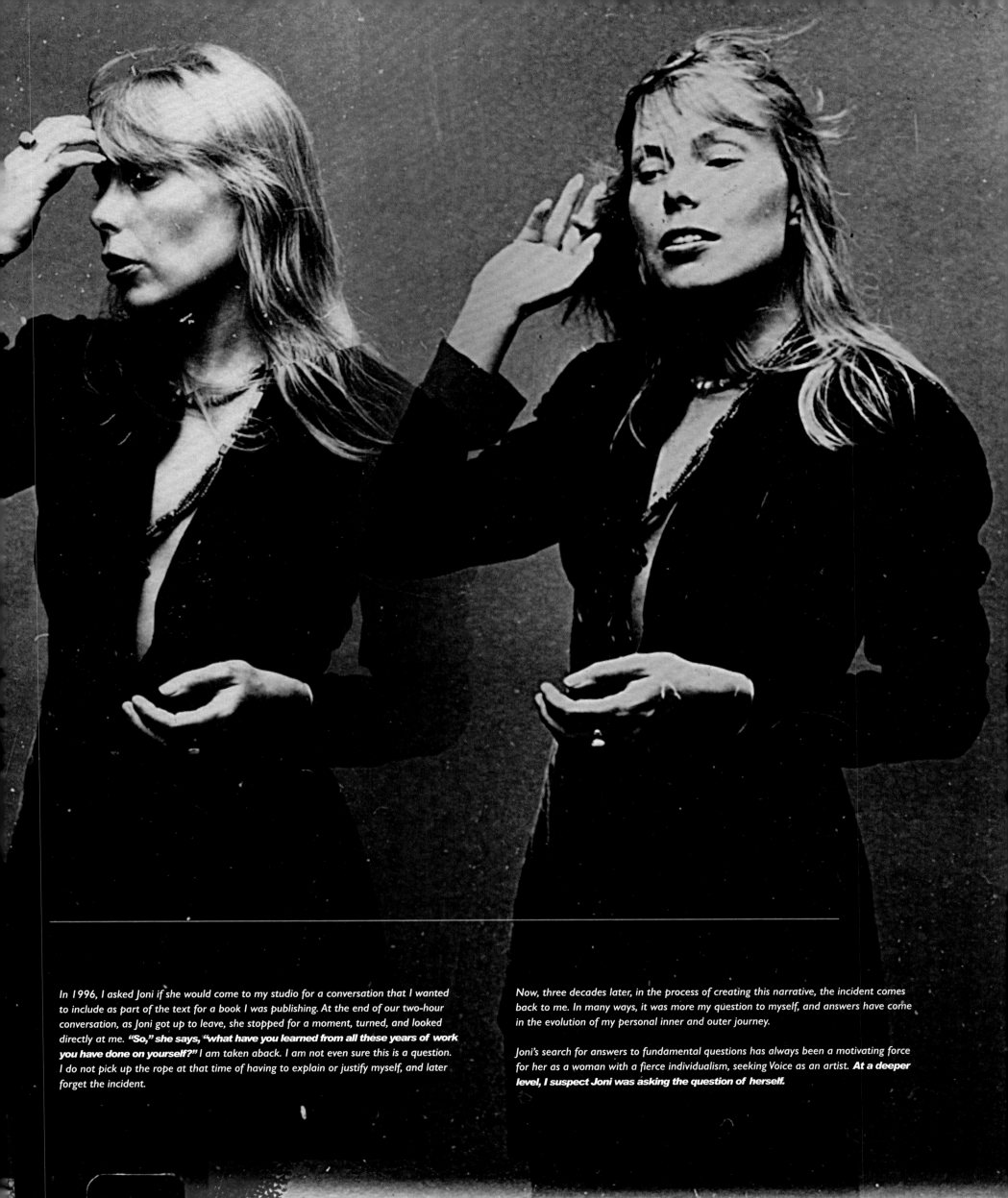

In 1996, I asked Joni if she would come to my studio for a conversation that I wanted to include as part of the text for a book I was publishing. At the end of our two-hour conversation, as Joni got up to leave, she stopped for a moment, turned, and looked directly at me. **"So," she says, "what have you learned from all these years of work you have done on yourself?"** I am taken aback. I am not even sure this is a question. I do not pick up the rope at that time of having to explain or justify myself, and later forget the incident.

Now, three decades later, in the process of creating this narrative, the incident comes back to me. In many ways, it was more my question to myself, and answers have come in the evolution of my personal inner and outer journey.

Joni's search for answers to fundamental questions has always been a motivating force for her as a woman with a fierce individualism, seeking Voice as an artist. **At a deeper level, I suspect Joni was asking the question of herself.**

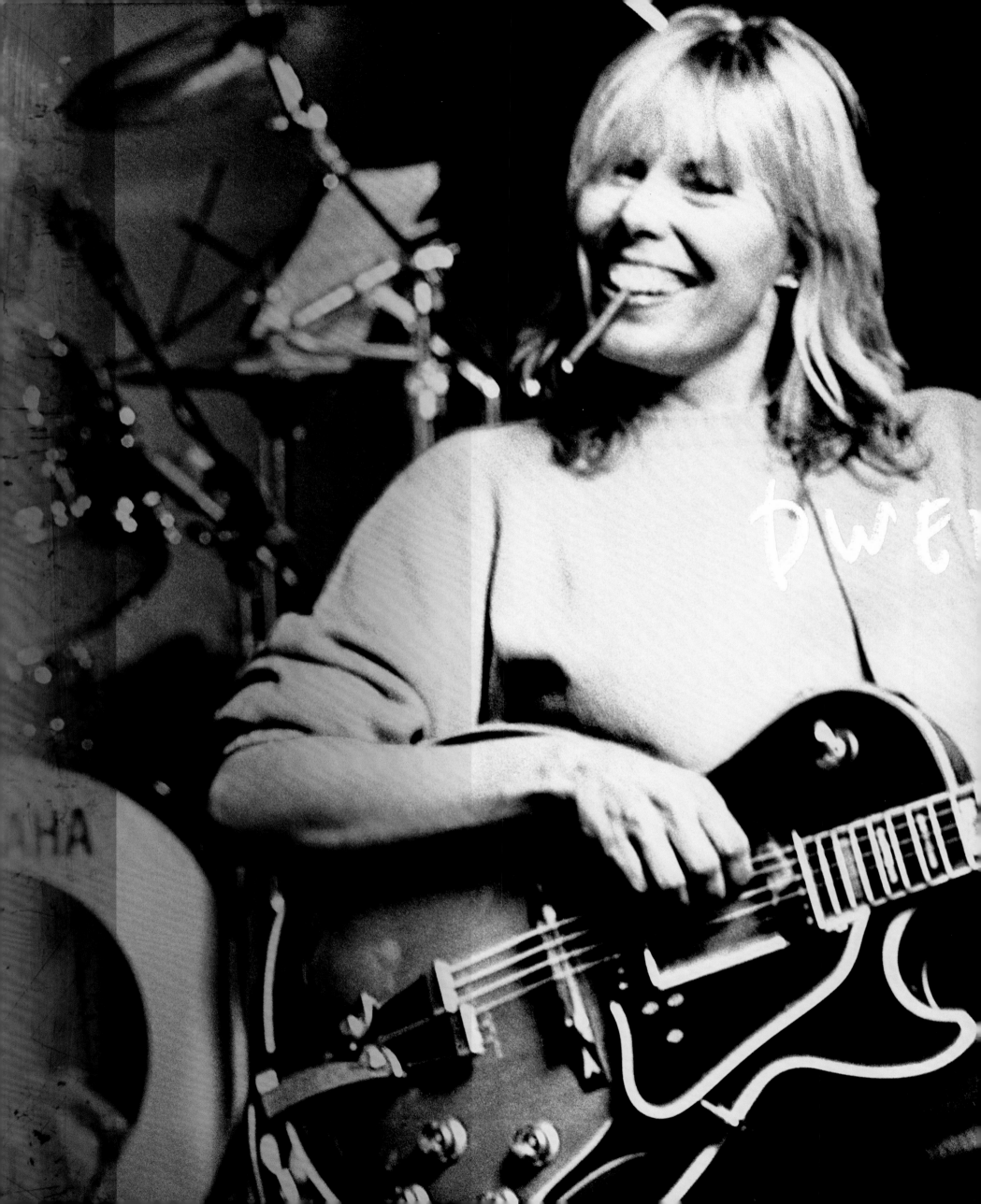

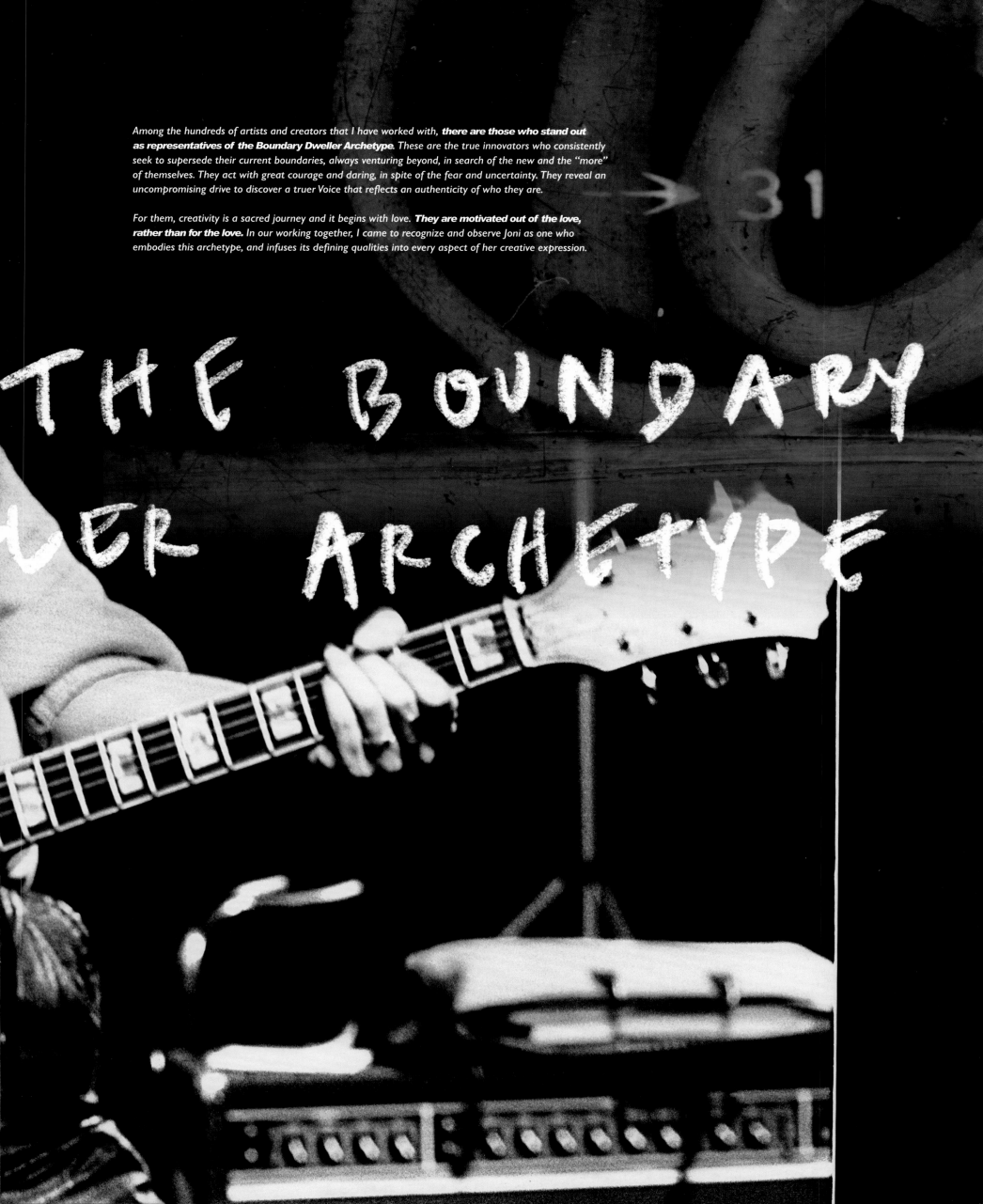

Among the hundreds of artists and creators that I have worked with, **there are those who stand out as representatives of the Boundary Dweller Archetype**. These are the true innovators who consistently seek to supersede their current boundaries, always venturing beyond, in search of the new and the "more" of themselves. They act with great courage and daring, in spite of the fear and uncertainty. They reveal an uncompromising drive to discover a truer Voice that reflects an authenticity of who they are.

For them, creativity is a sacred journey and it begins with love. **They are motivated out of the love, rather than for the love.** In our working together, I came to recognize and observe Joni as one who embodies this archetype, and infuses its defining qualities into every aspect of her creative expression.

THE BOUNDARY
LER ARCHETYPE

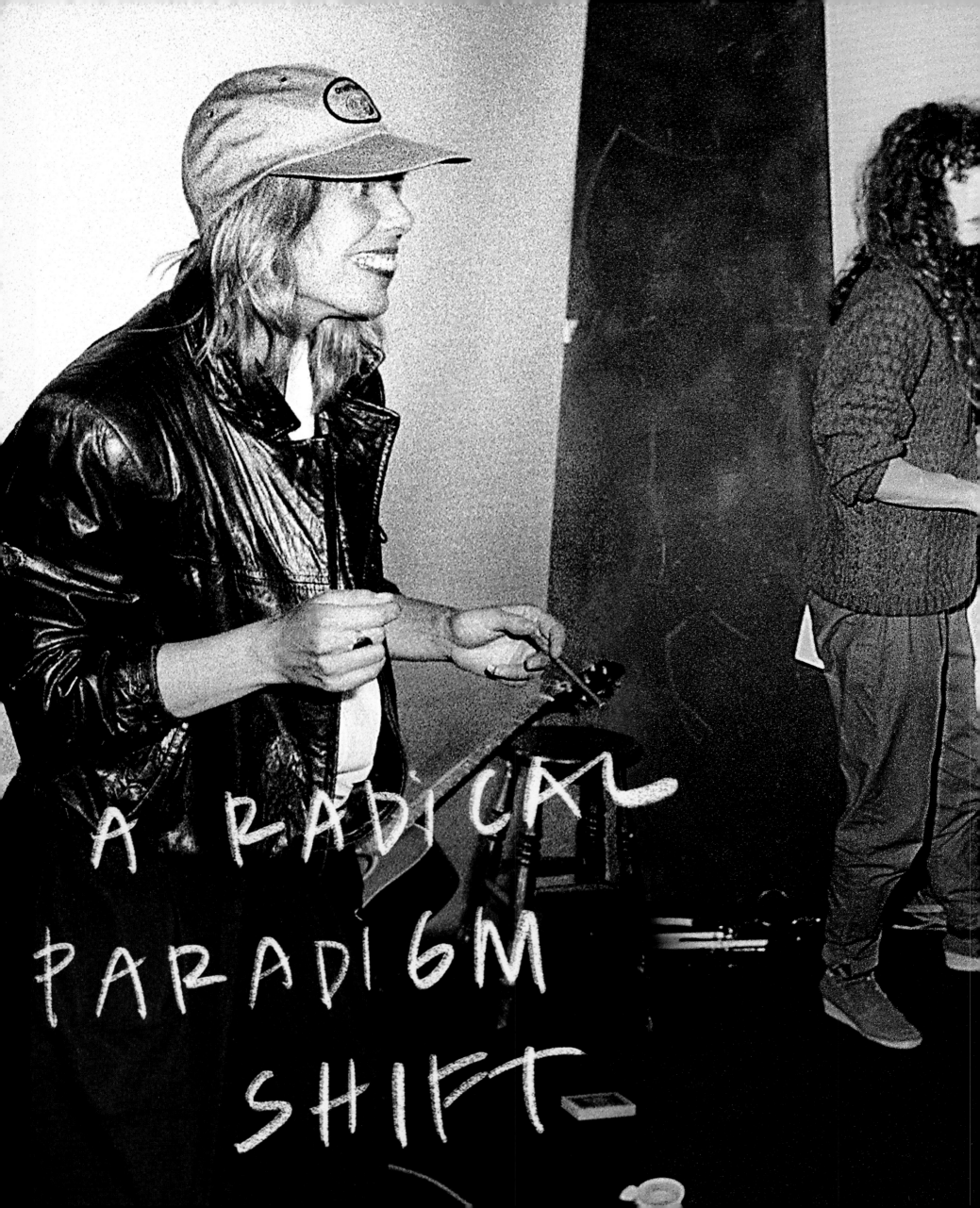

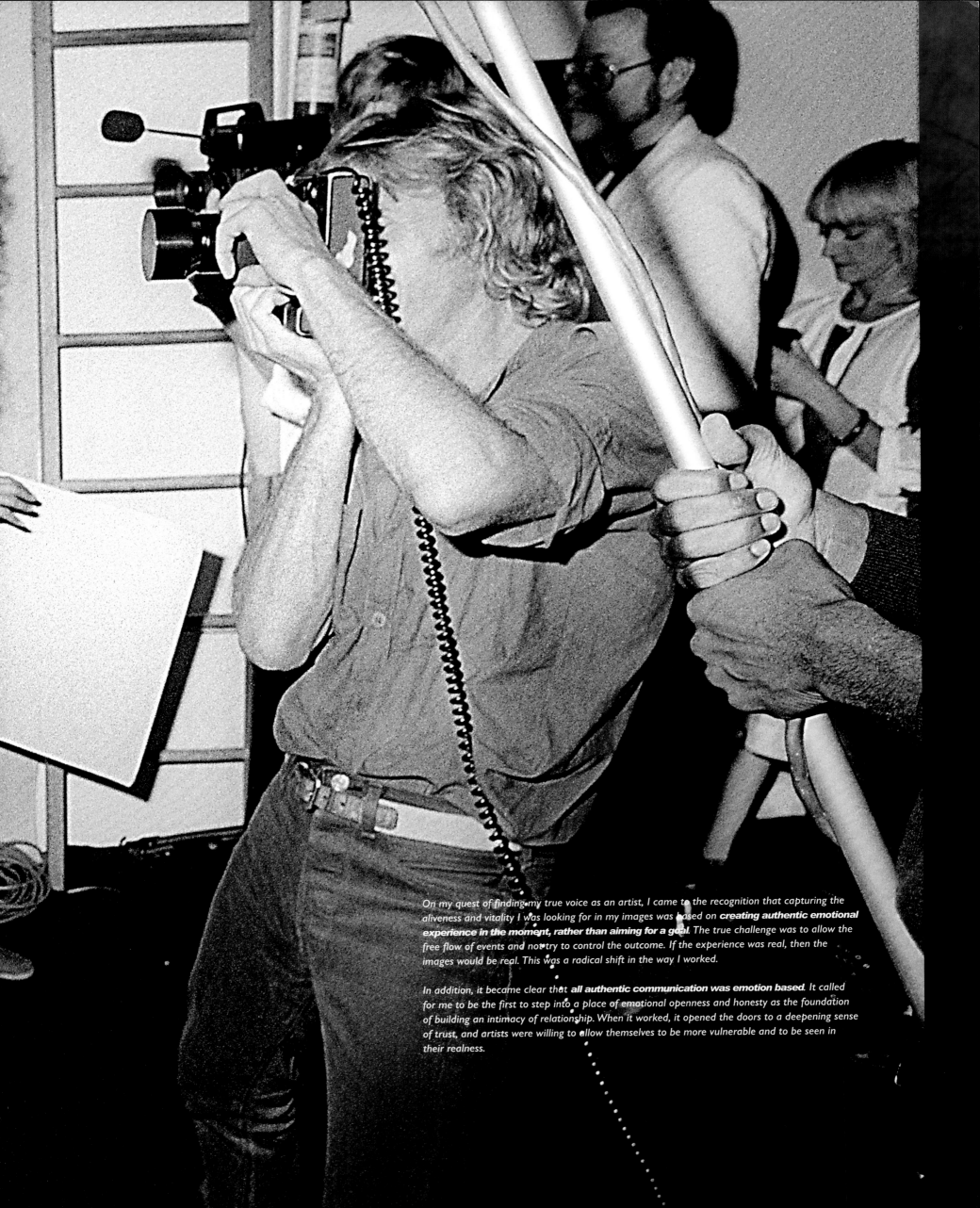

On my quest of finding my true voice as an artist, I came to the recognition that capturing the aliveness and vitality I was looking for in my images was based on ***creating authentic emotional experience in the moment, rather than aiming for a goal.*** The true challenge was to allow the free flow of events and not try to control the outcome. If the experience was real, then the images would be real. This was a radical shift in the way I worked.

In addition, it became clear that ***all authentic communication was emotion based***. It called for me to be the first to step into a place of emotional openness and honesty as the foundation of building an intimacy of relationship. When it worked, it opened the doors to a deepening sense of trust, and artists were willing to allow themselves to be more vulnerable and to be seen in their realness.

Artists most often came for Sessions at some culminating and defining moment of their creative journey. It was a time of creative intensity infused with a heightened state of inspiration and aspiration. **The time was ripe. It was 1975 and I was experiencing this profound and revelatory communication with artists. This inspired me to bring a film crew into one of my Sessions for the first time.** Once I saw the dailies and realized that the depth of the experience could be captured on film, I knew exactly what I wanted to do from now on and I resolved to document my Sessions whenever I could. The Session had evolved into a combination of photo shoot, documentary filmmaking

event, **and dynamic opportunity for exploring the artist's creative experience from the inside out. The Session had now become its own Art Form.**

It was also at that time that I began to recognize that my Sessions had a consistent and recognizable pattern to how they unfolded, **and the same stages seemed to be true for the artists I was working with in their own processes. I was discovering the archetypal map of how creativity progressed.** The beauty and power of knowing where I was along a path of recognizable stages provided an elegant guidance system and a means to accomplish my creative vision with greater focus and ease.

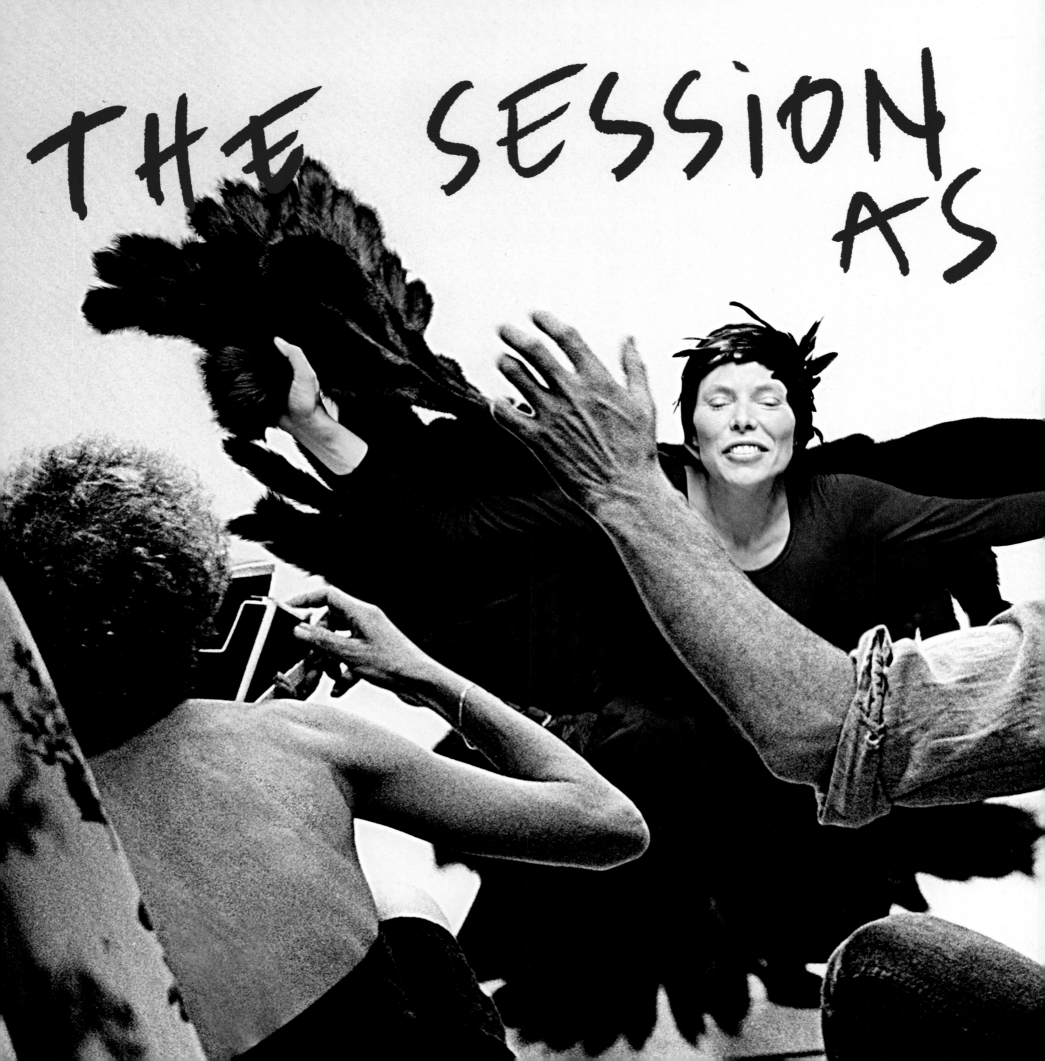

THE SESSION AS

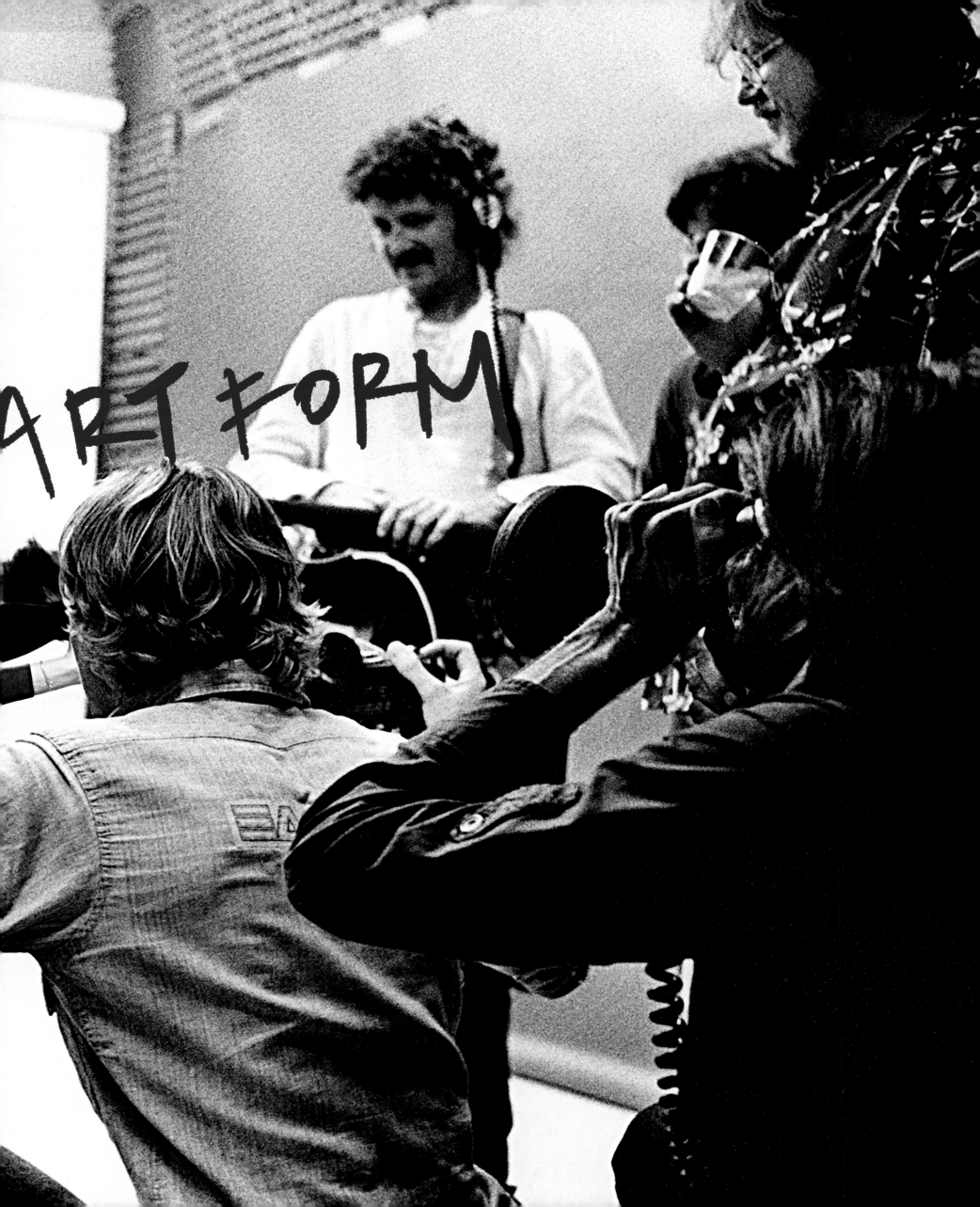

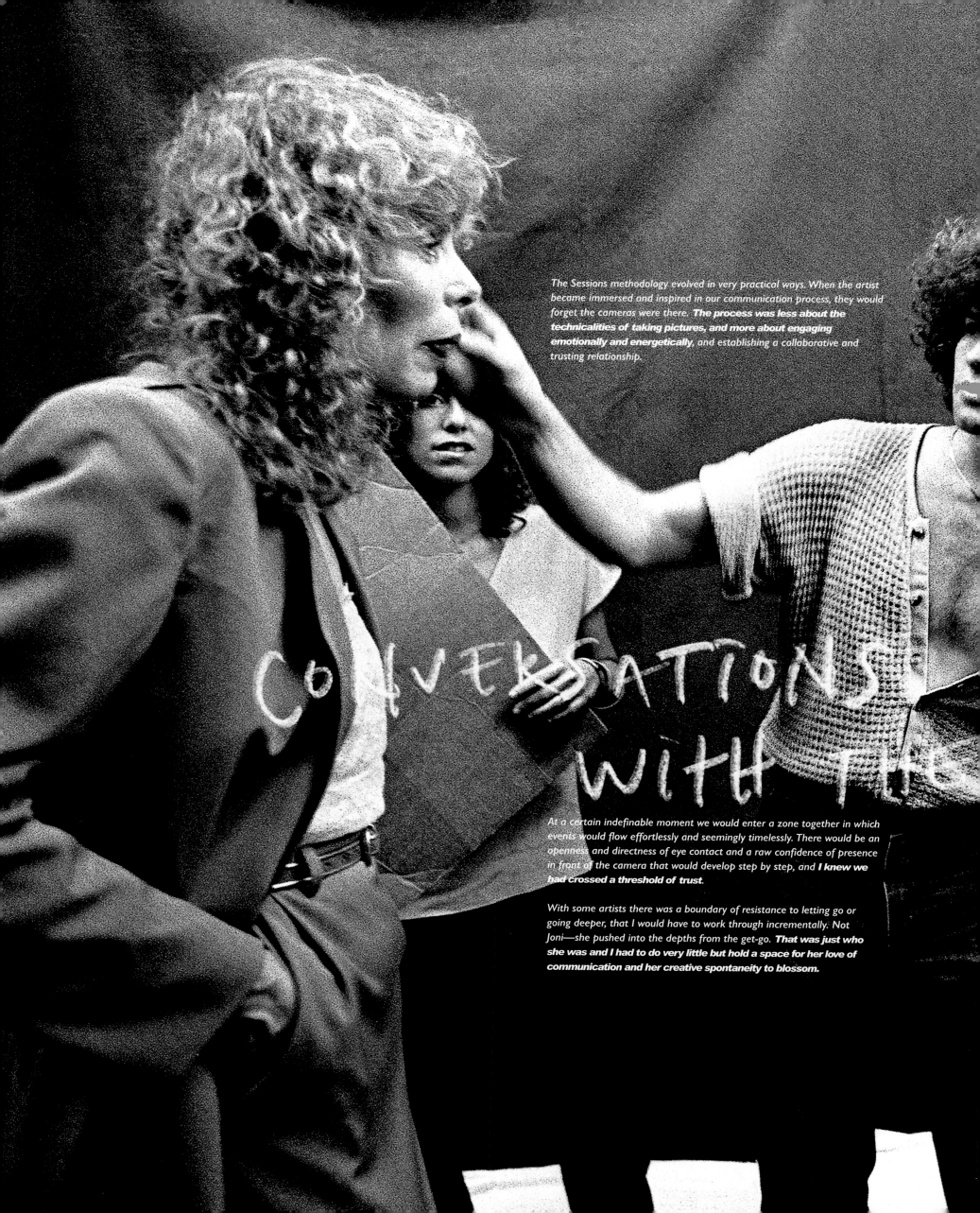

The Sessions methodology evolved in very practical ways. When the artist became immersed and inspired in our communication process, they would forget the cameras were there. **The process was less about the technicalities of taking pictures, and more about engaging emotionally and energetically,** and establishing a collaborative and trusting relationship.

CONVERSATIONS WITH THE

At a certain indefinable moment we would enter a zone together in which events would flow effortlessly and seemingly timelessly. There would be an openness and directness of eye contact and a raw confidence of presence in front of the camera that would develop step by step, and **I knew we had crossed a threshold of trust.**

With some artists there was a boundary of resistance to letting go or going deeper, that I would have to work through incrementally. Not Joni—she pushed into the depths from the get-go. **That was just who she was and I had to do very little but hold a space for her love of communication and her creative spontaneity to blossom.**

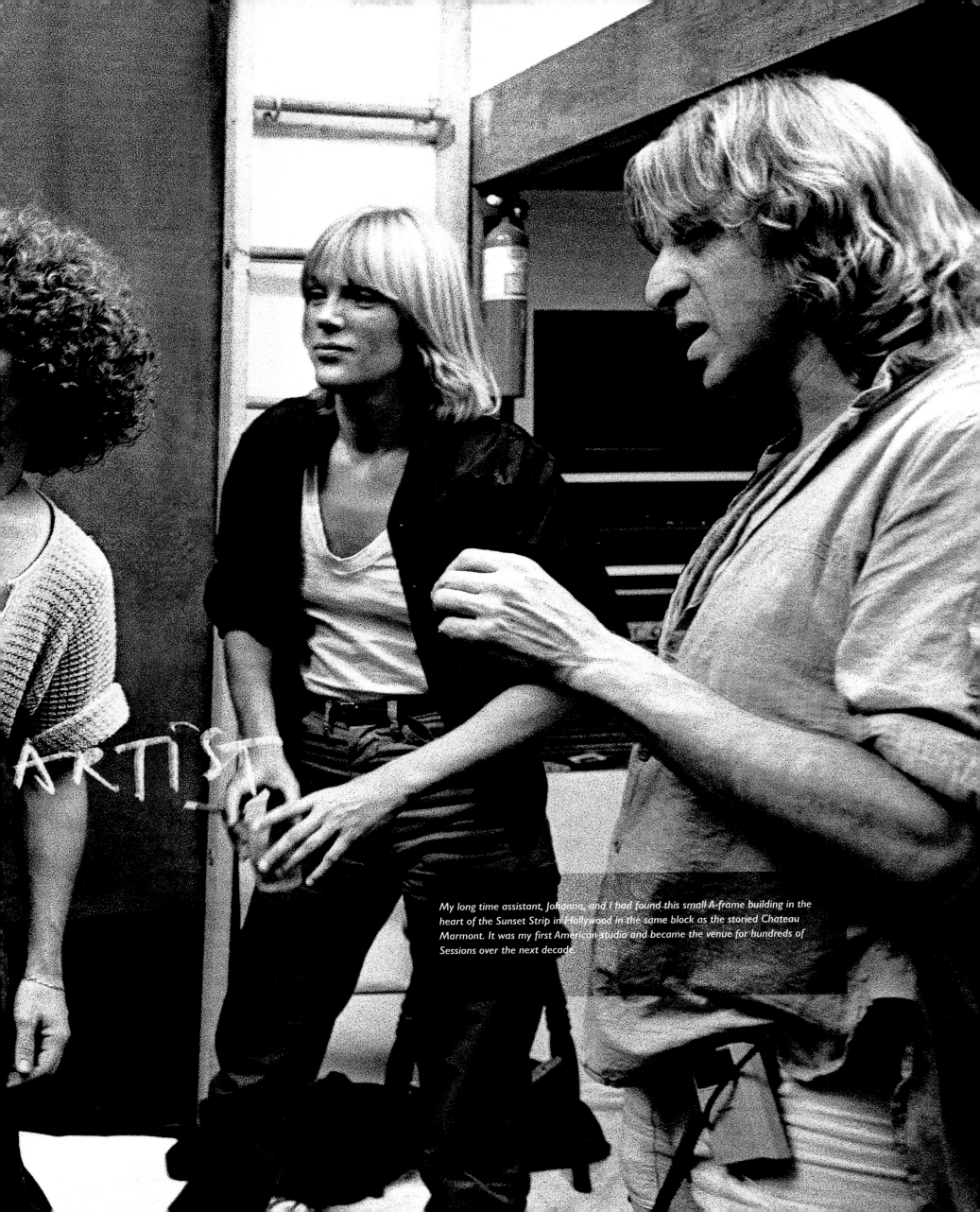

ARTIST

My long time assistant, Johanna, and I had found this small A-frame building in the heart of the Sunset Strip in Hollywood in the same block as the storied Chateau Marmont. It was my first American studio and became the venue for hundreds of Sessions over the next decade.

PROLOGUE

EPILOGUE

NORMAN SEEFF

JONI: THE JONI MITCHELL SESSIONS

SEEFF
PUBLICATIONS

INSIGHT EDITIONS
San Rafael, California

Joni's art director of her Blue album asked me to do a Session with Joni. I did not have a studio yet and I was living in the Hollywood Hills at the time. They came to my house one evening, and we simply set up a backdrop in the living room. It was very informal, and we hung out, drank, played music, and shot very free-form.

This was our first Session. **We were discovering each other for the first time with no preconceptions.** I was thrilled to discover that Joni has a creatively focused presence and at the same time, the ability to flow with the moment, a combination that translated into one radiant image after another. Although I had no way of knowing it at the time, **this was to be the beginning of a productive, collaborative working relationship that was to span decades.**

COURT + SPARK
SESSION

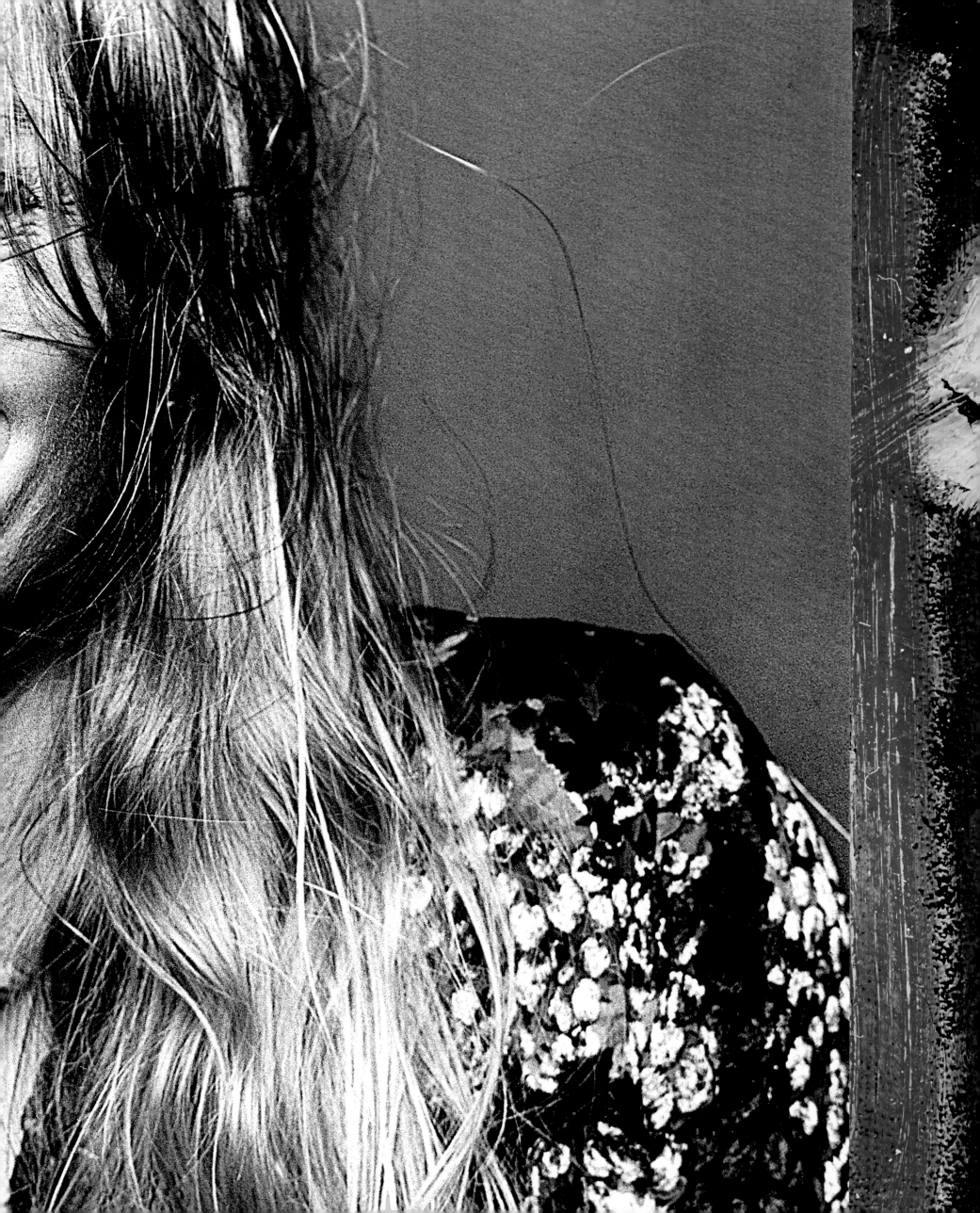

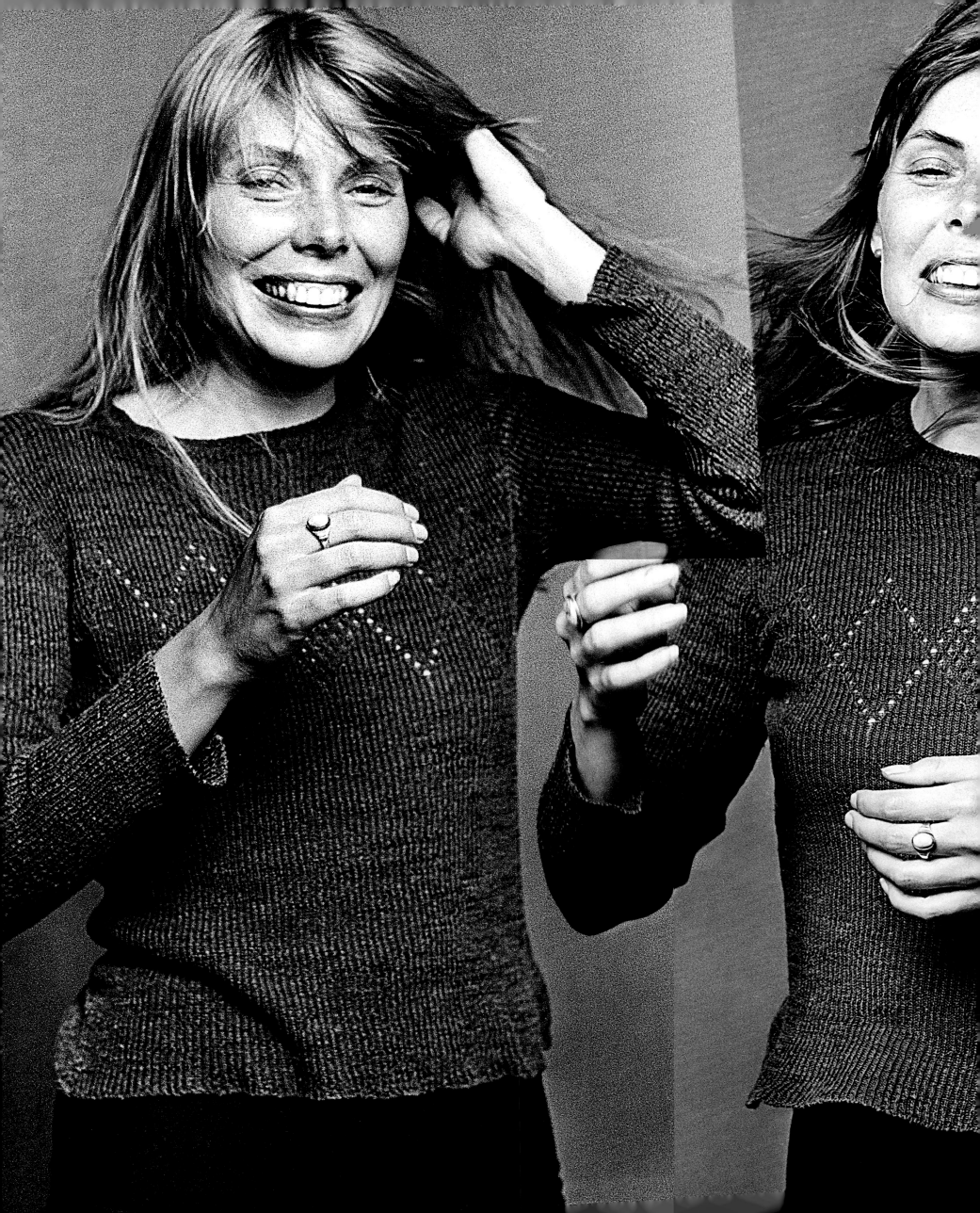

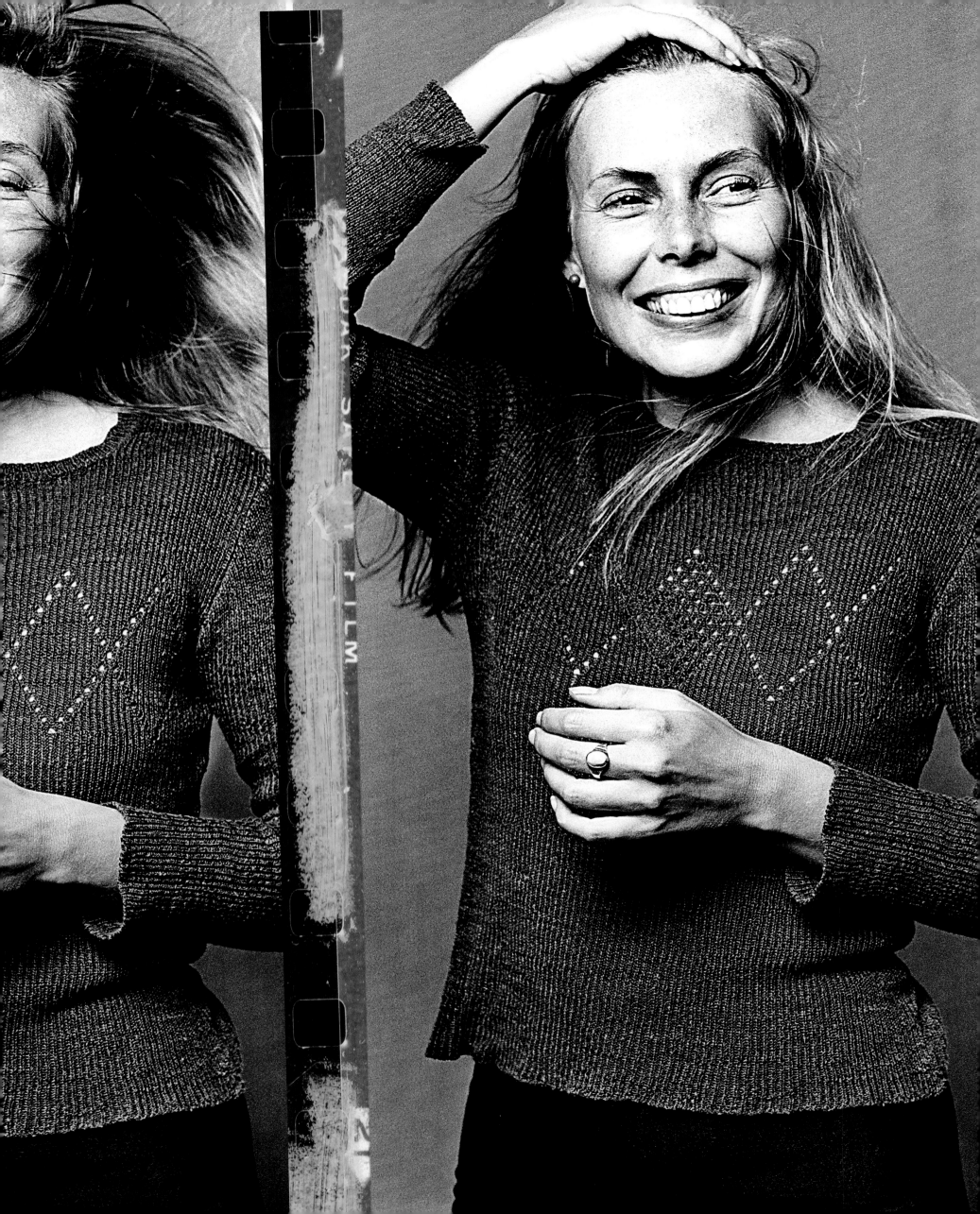

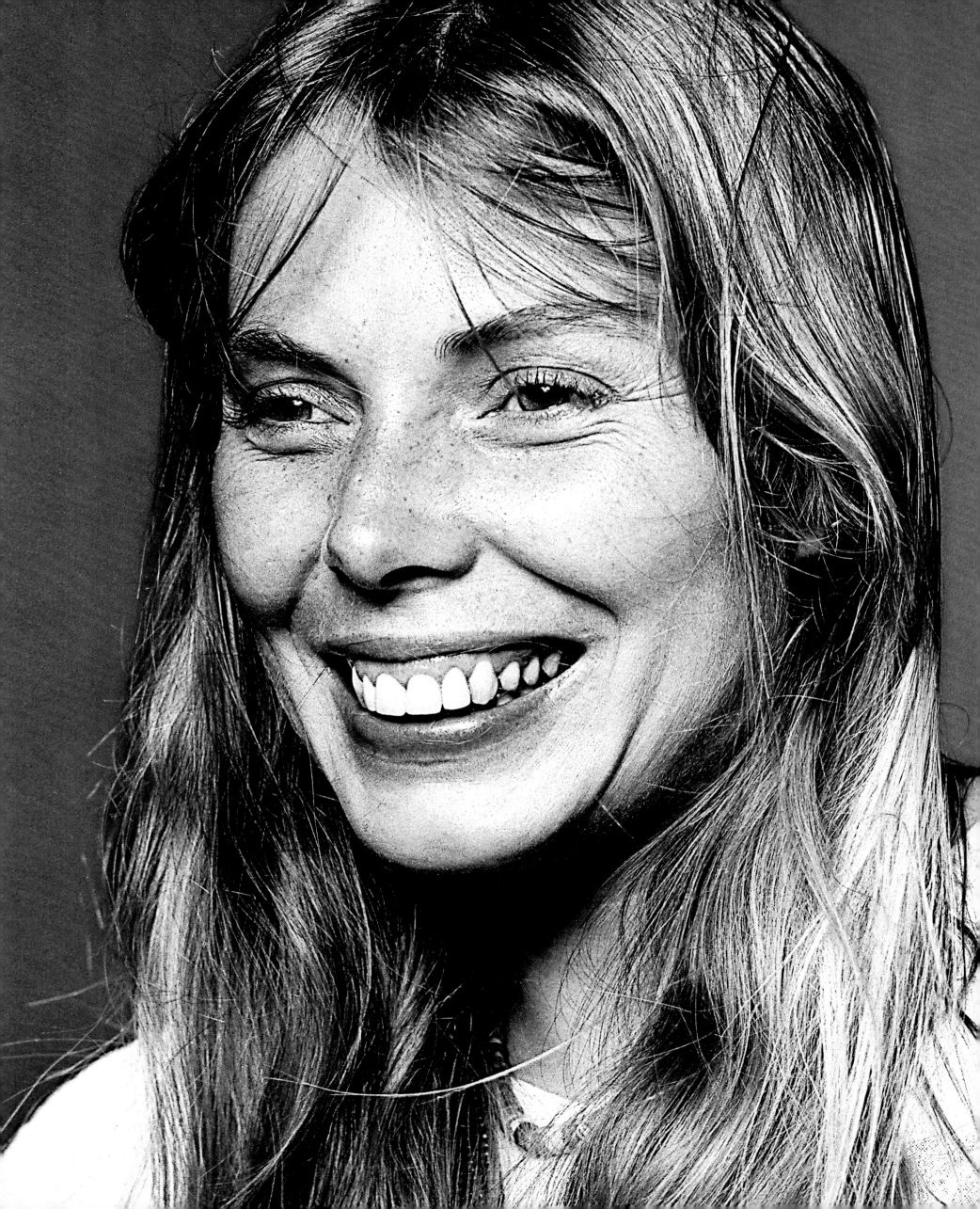

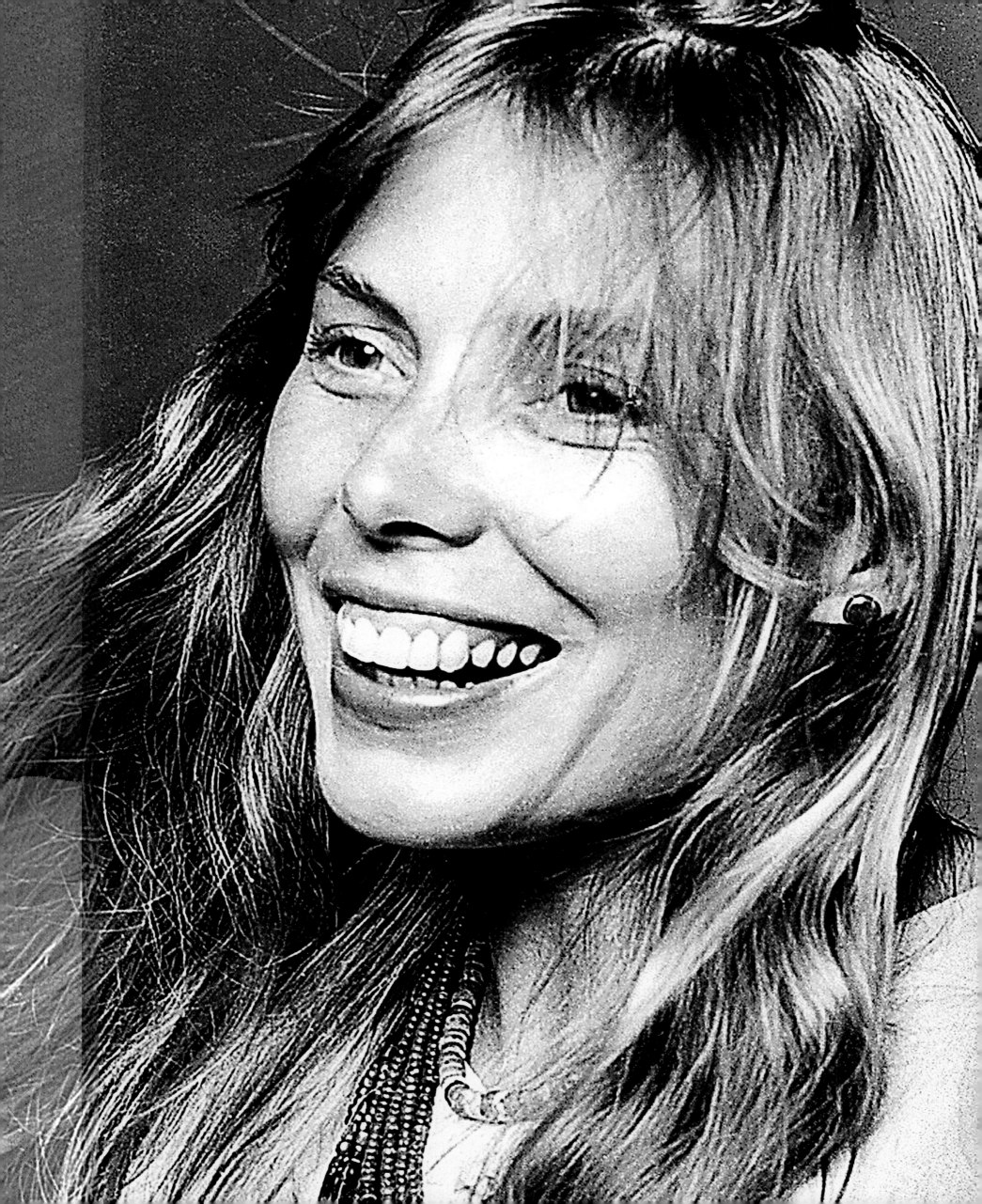

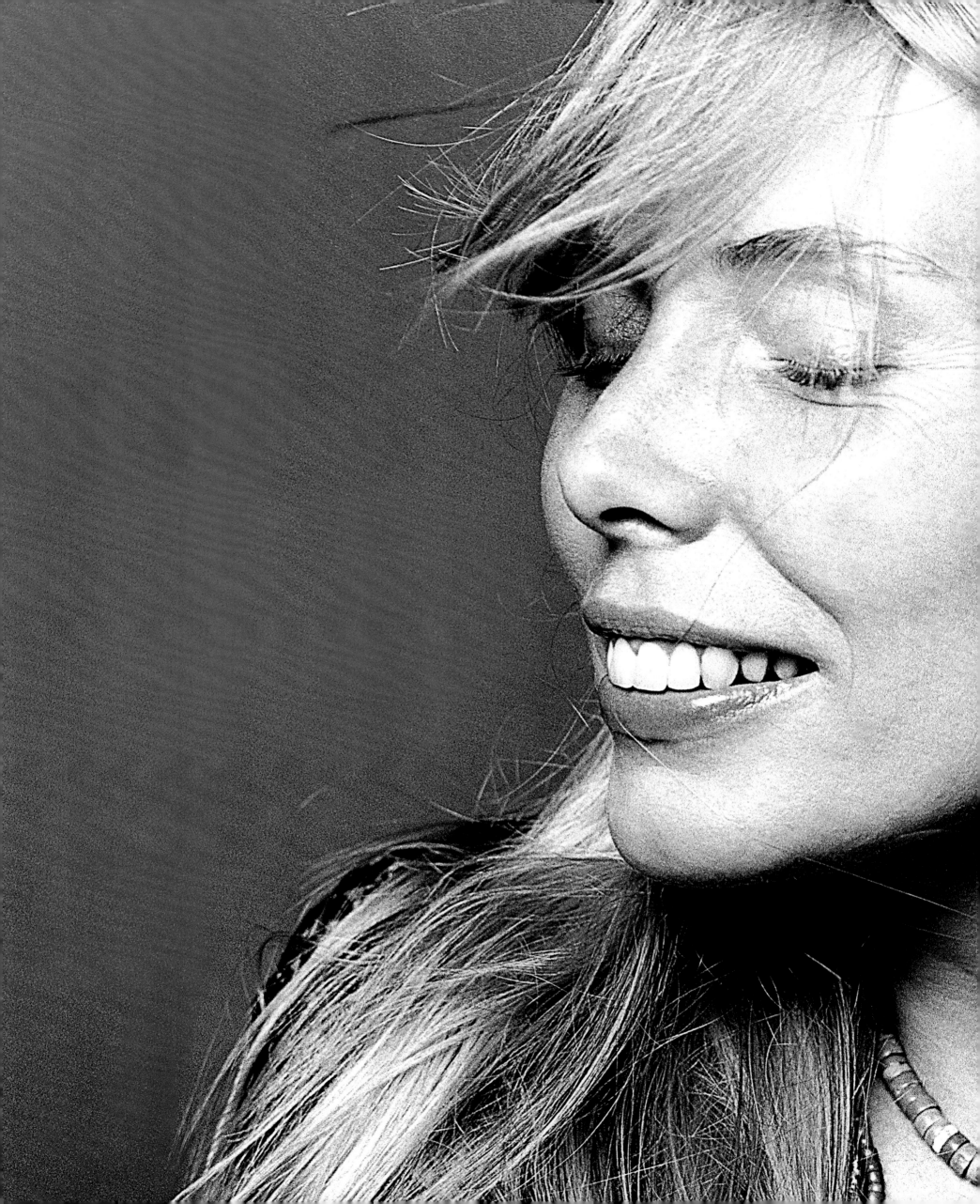

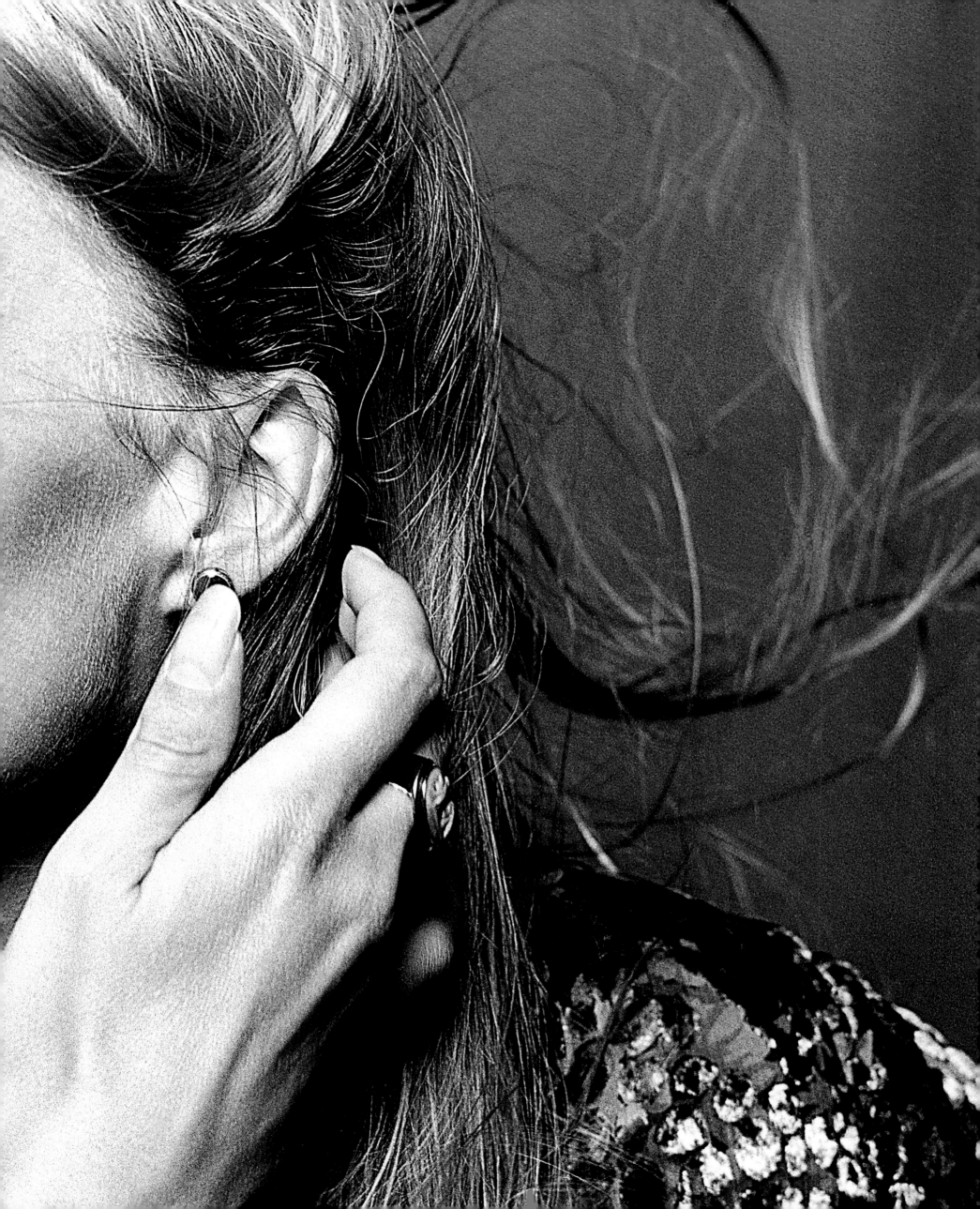

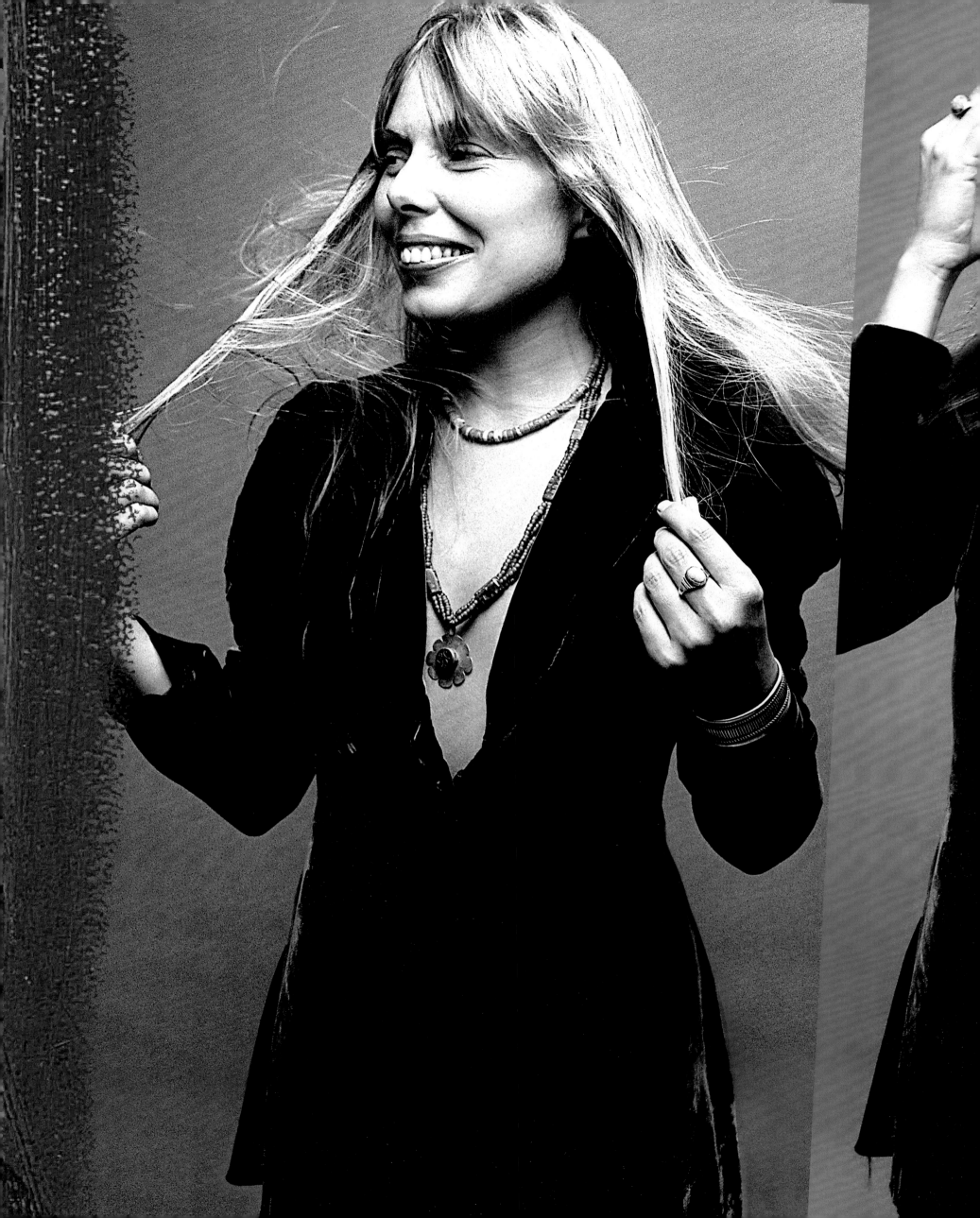

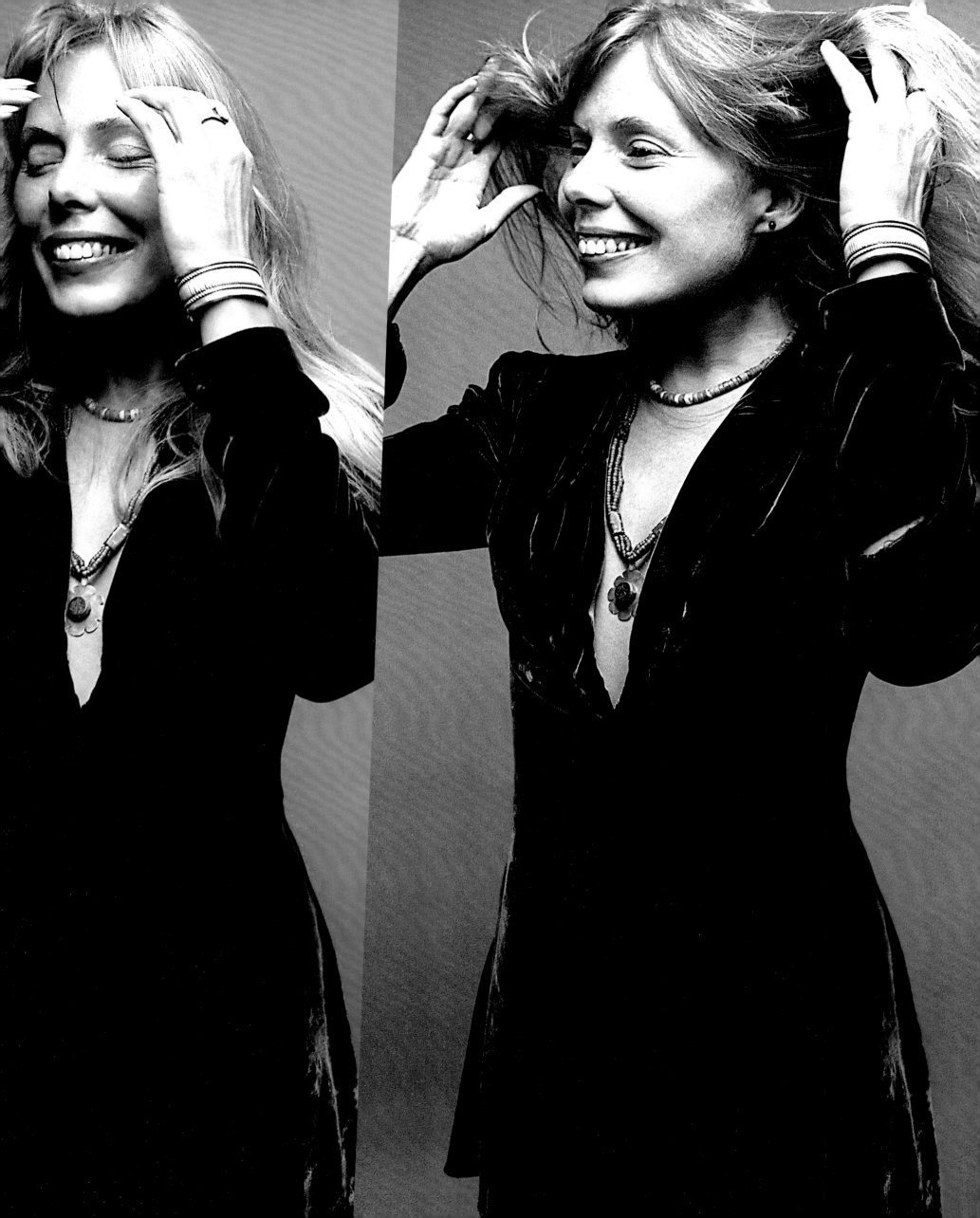

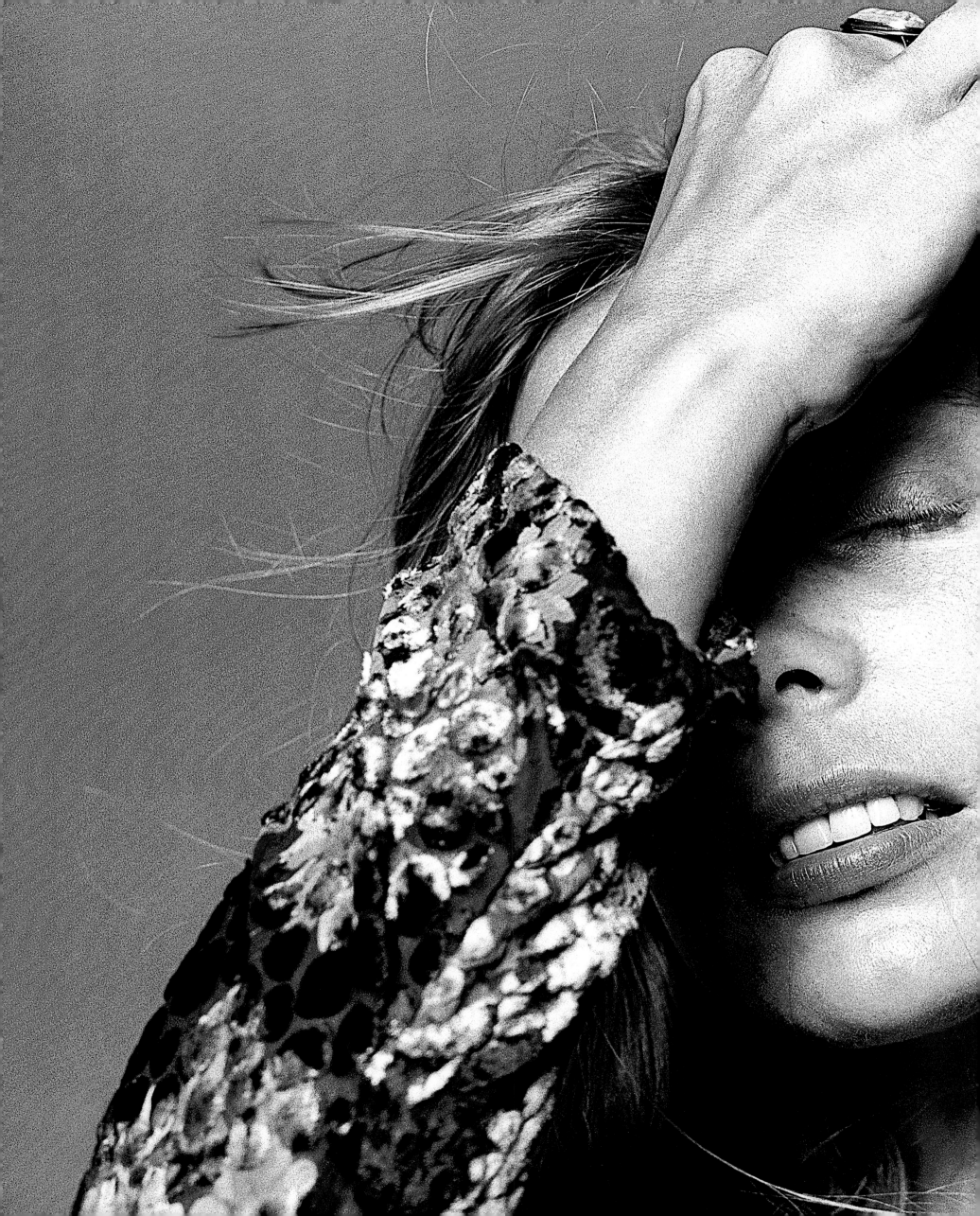

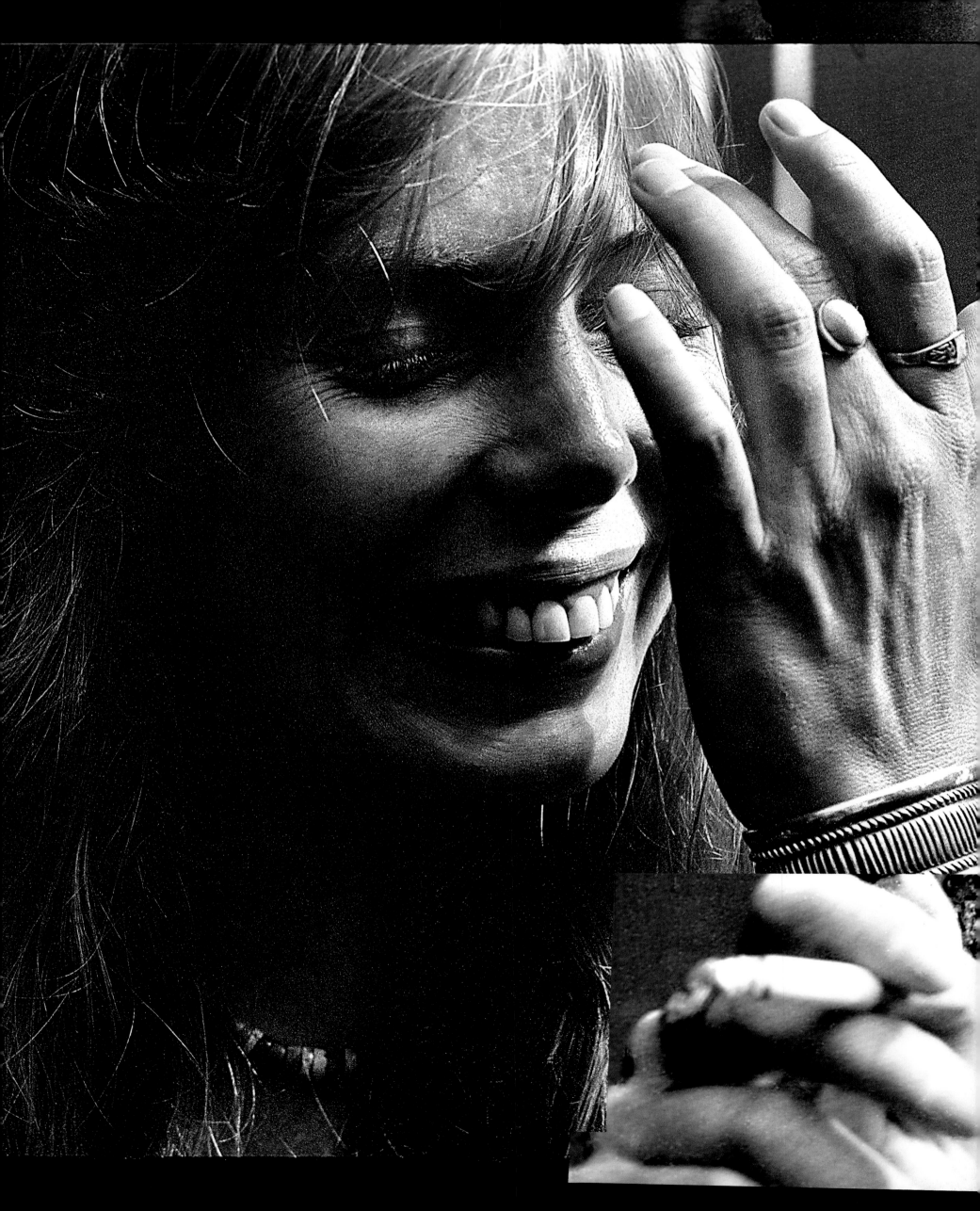

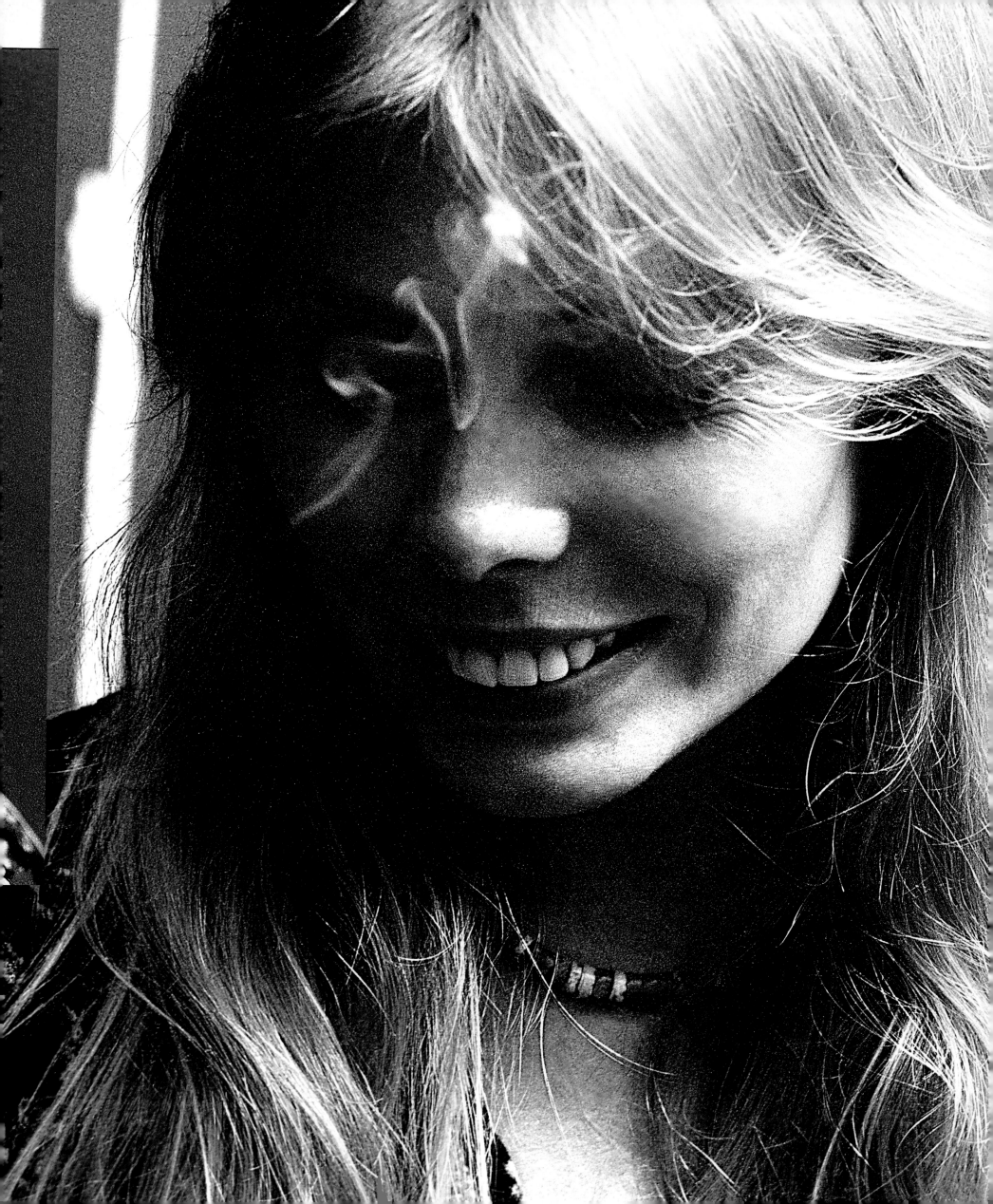

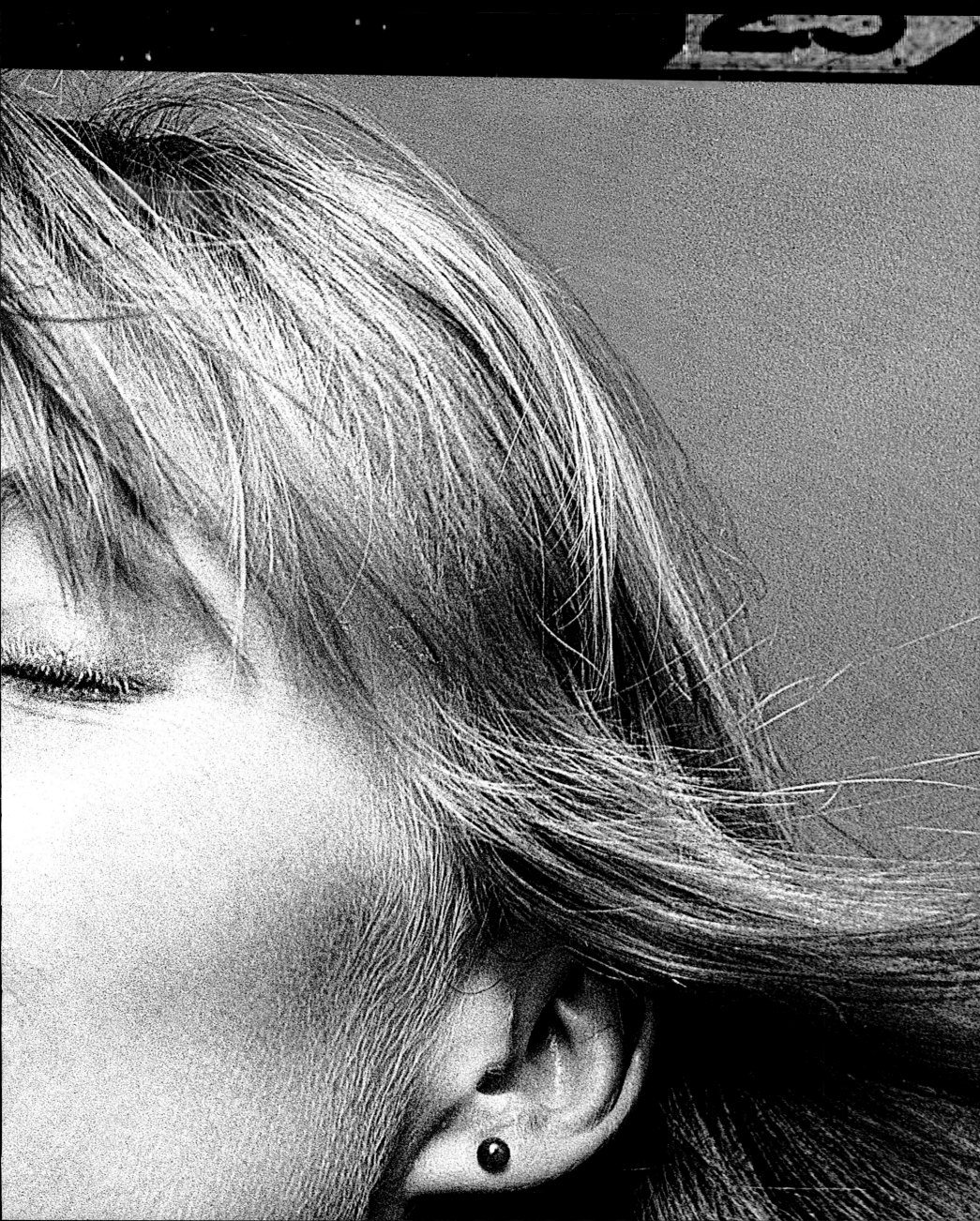

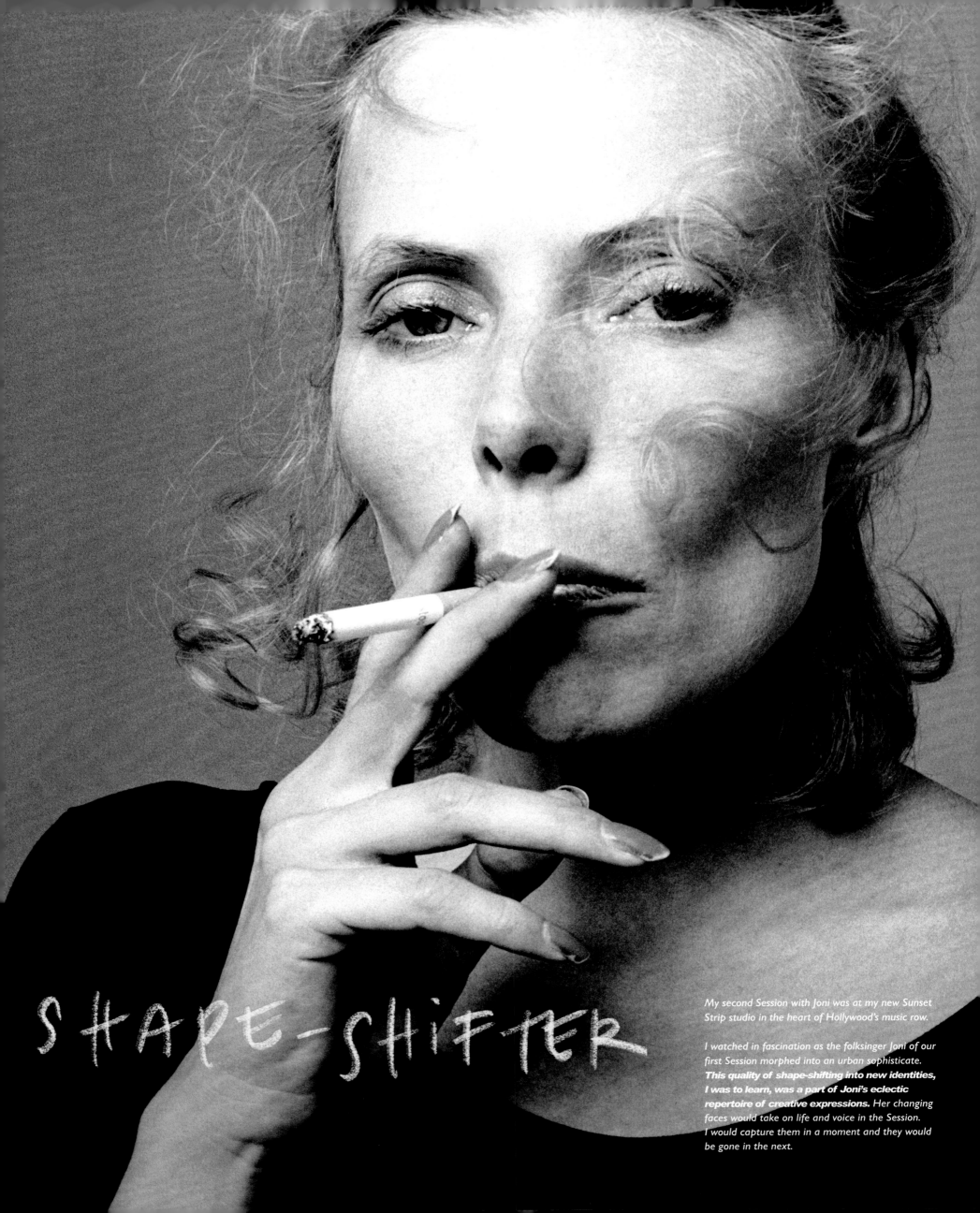

SHAPE-SHIFTER

My second Session with Joni was at my new Sunset Strip studio in the heart of Hollywood's music row.

I watched in fascination as the folksinger Joni of our first Session morphed into an urban sophisticate. **This quality of shape-shifting into new identities, I was to learn, was a part of Joni's eclectic repertoire of creative expressions.** Her changing faces would take on life and voice in the Session. I would capture them in a moment and they would be gone in the next.

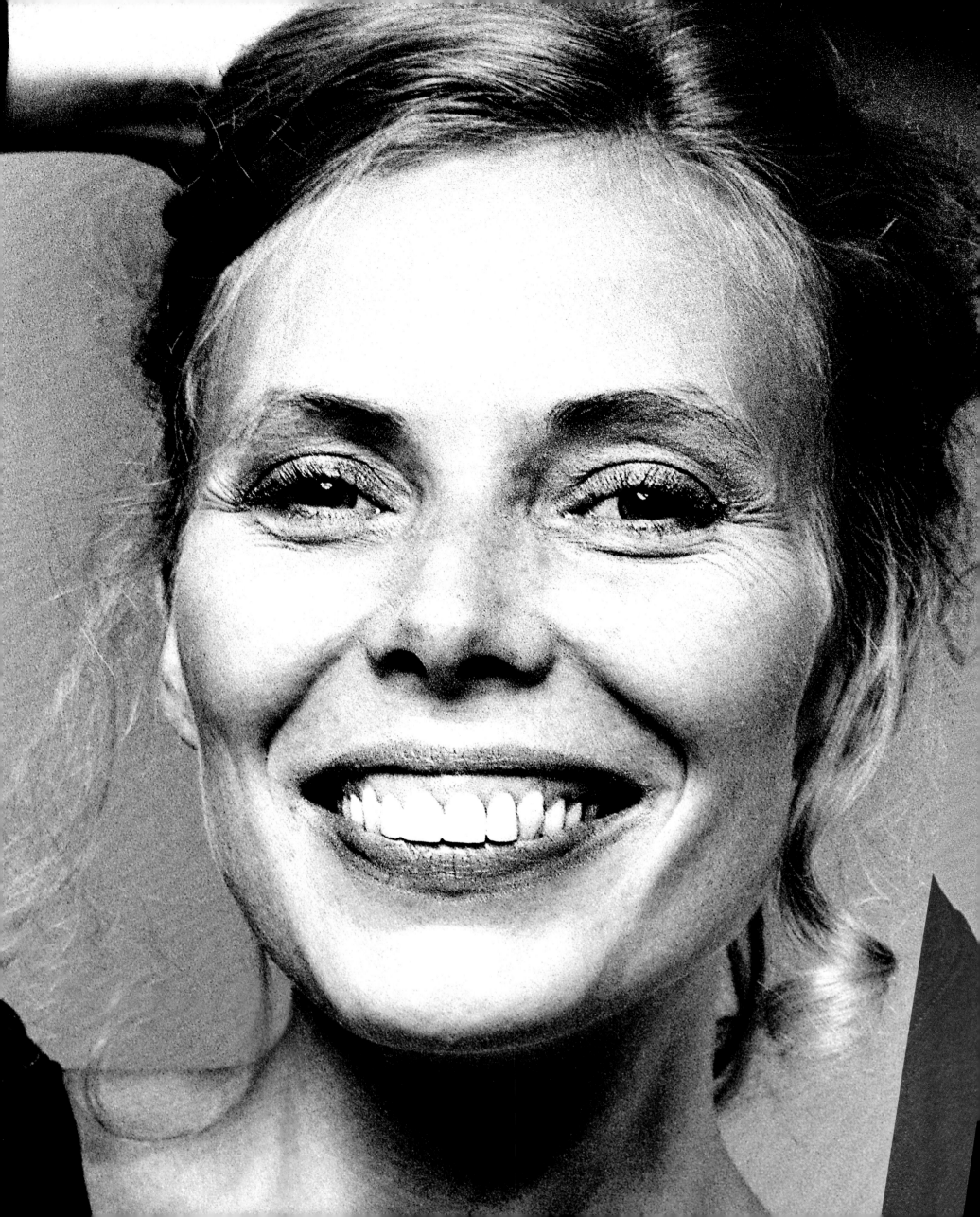

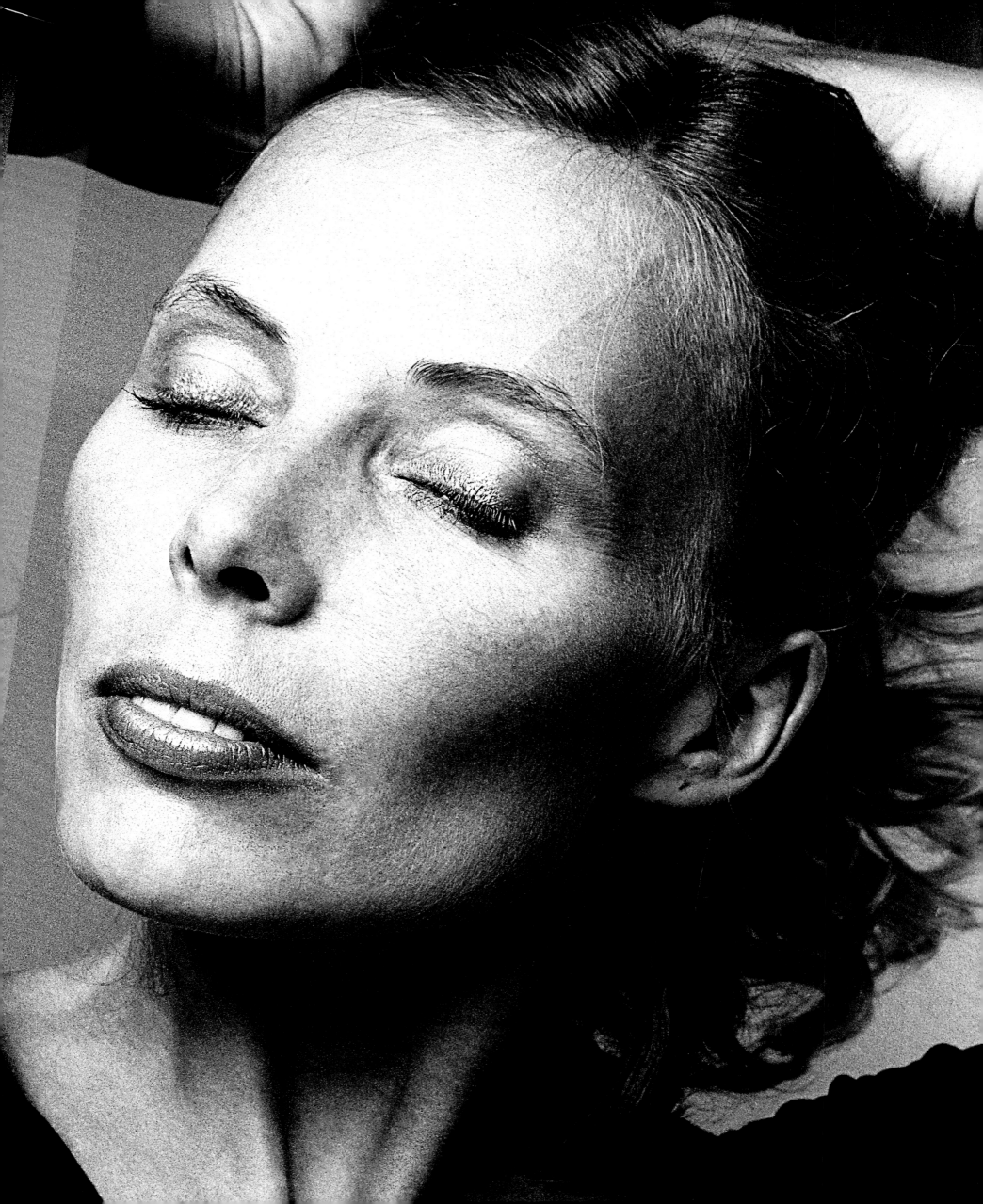

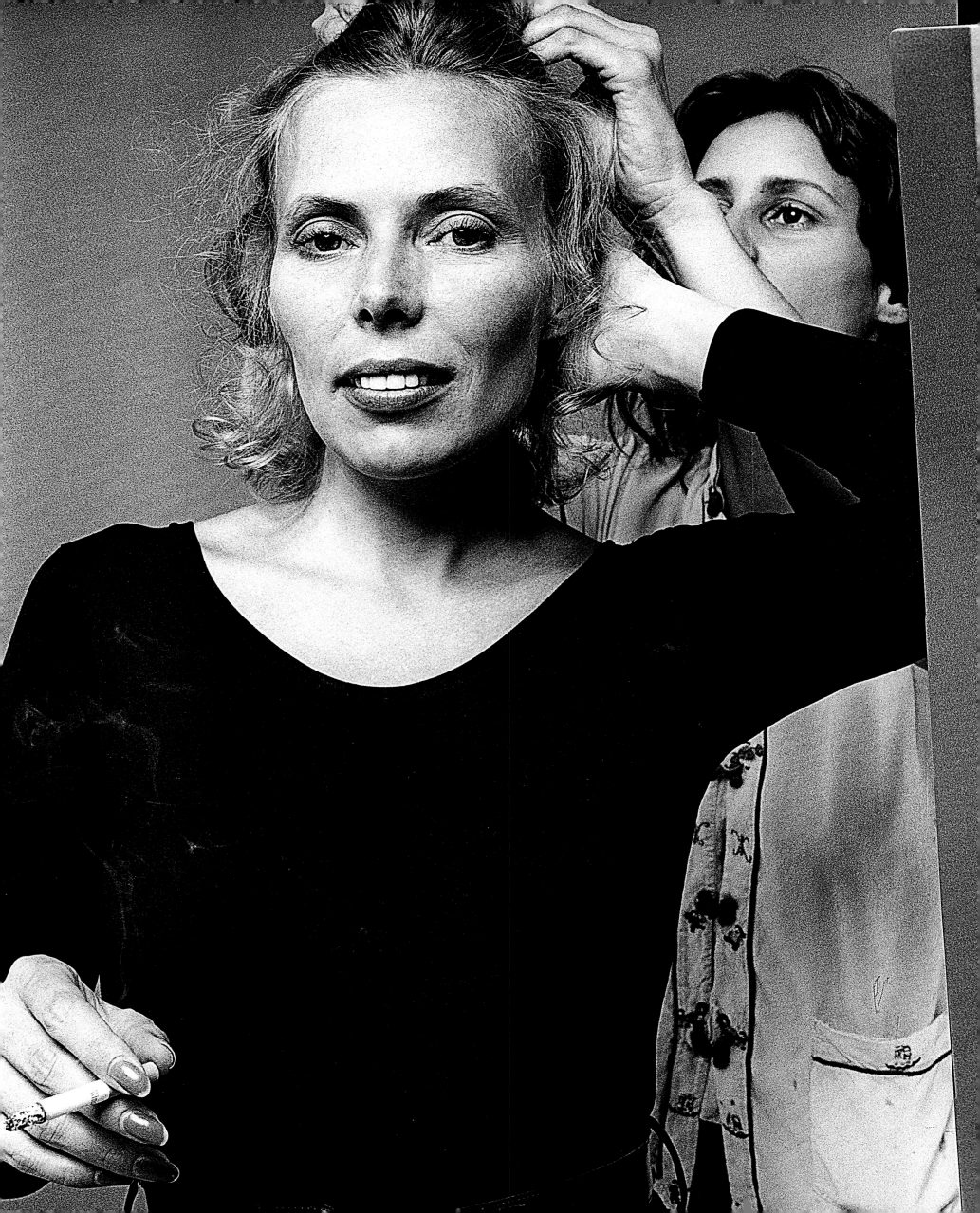

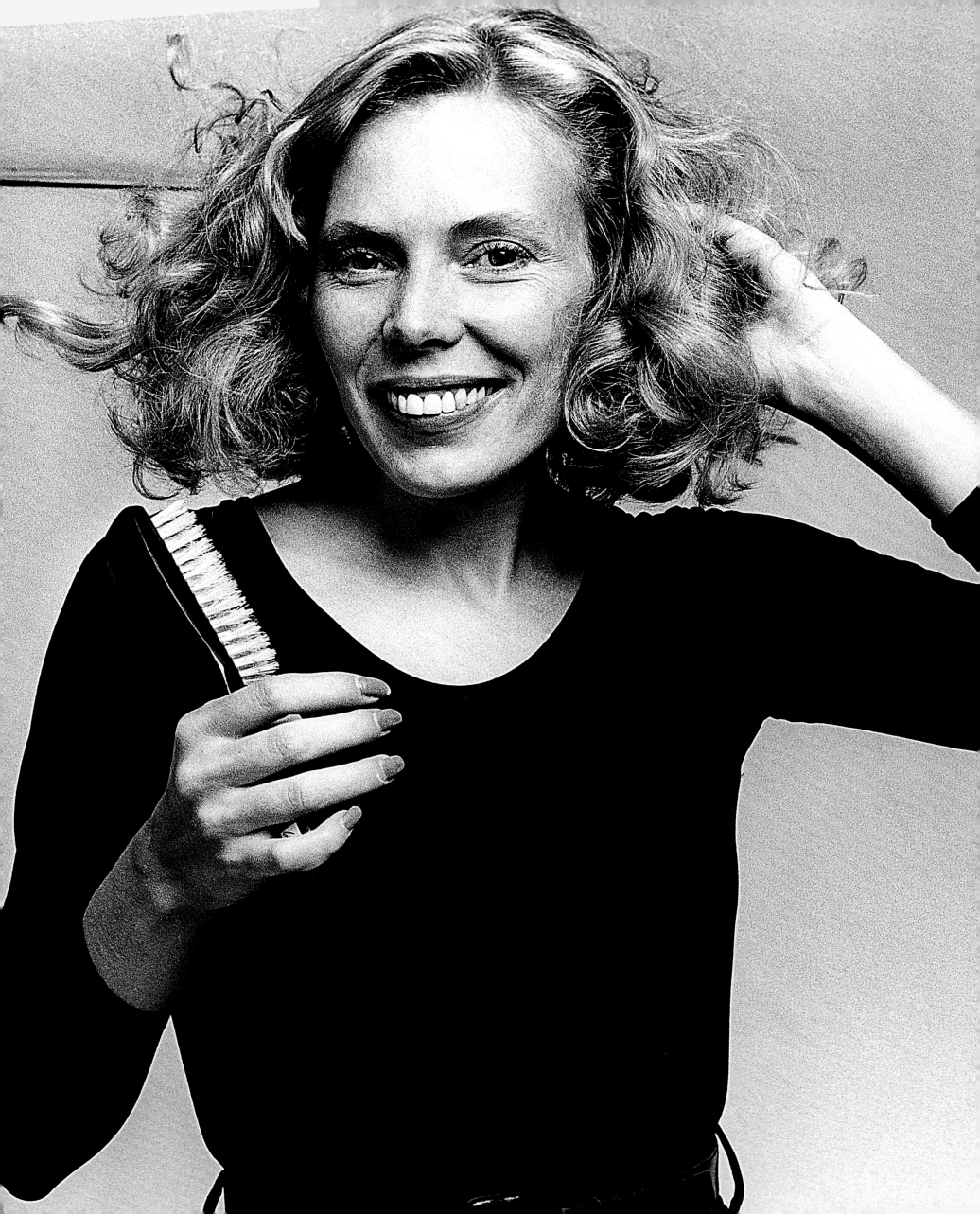

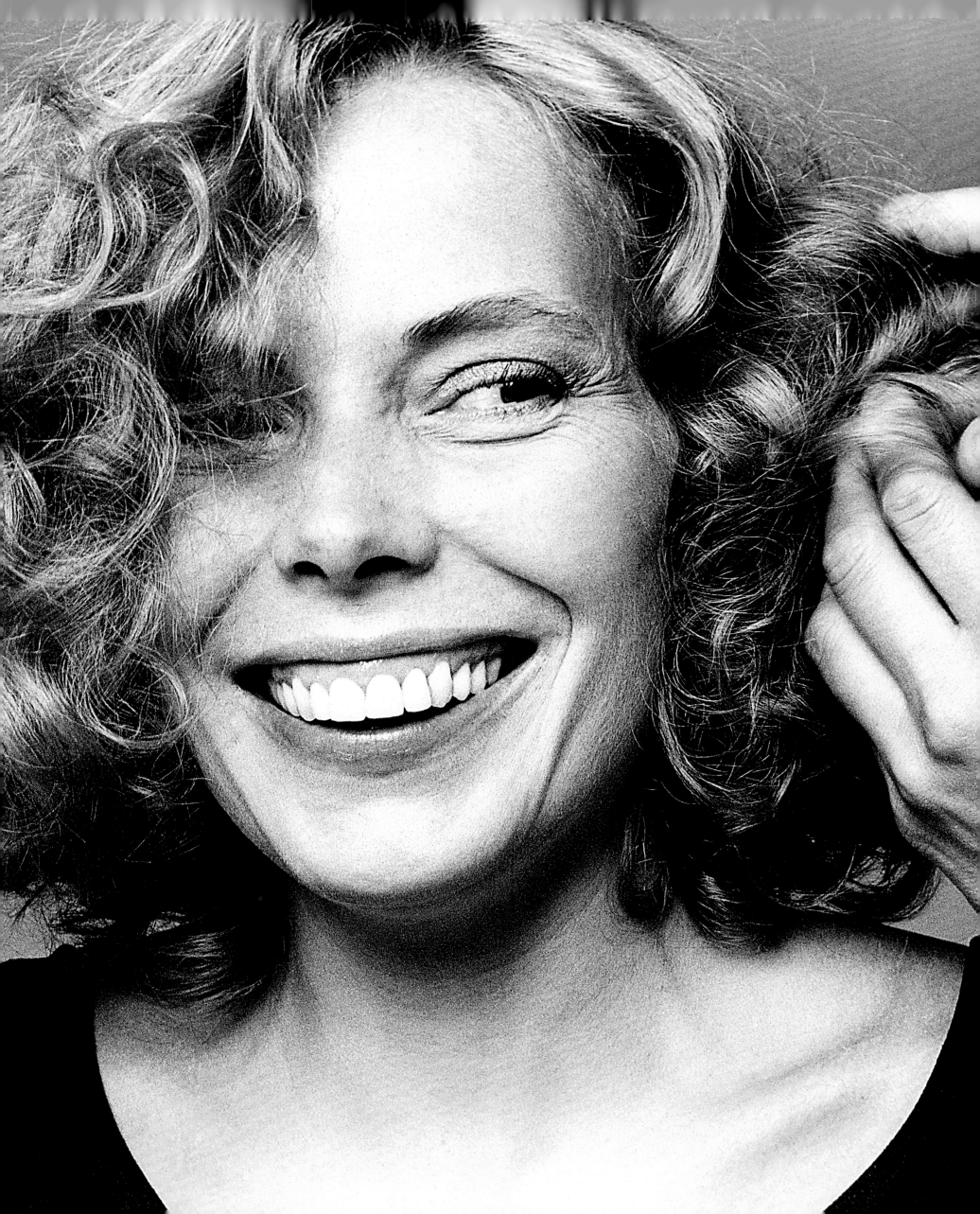

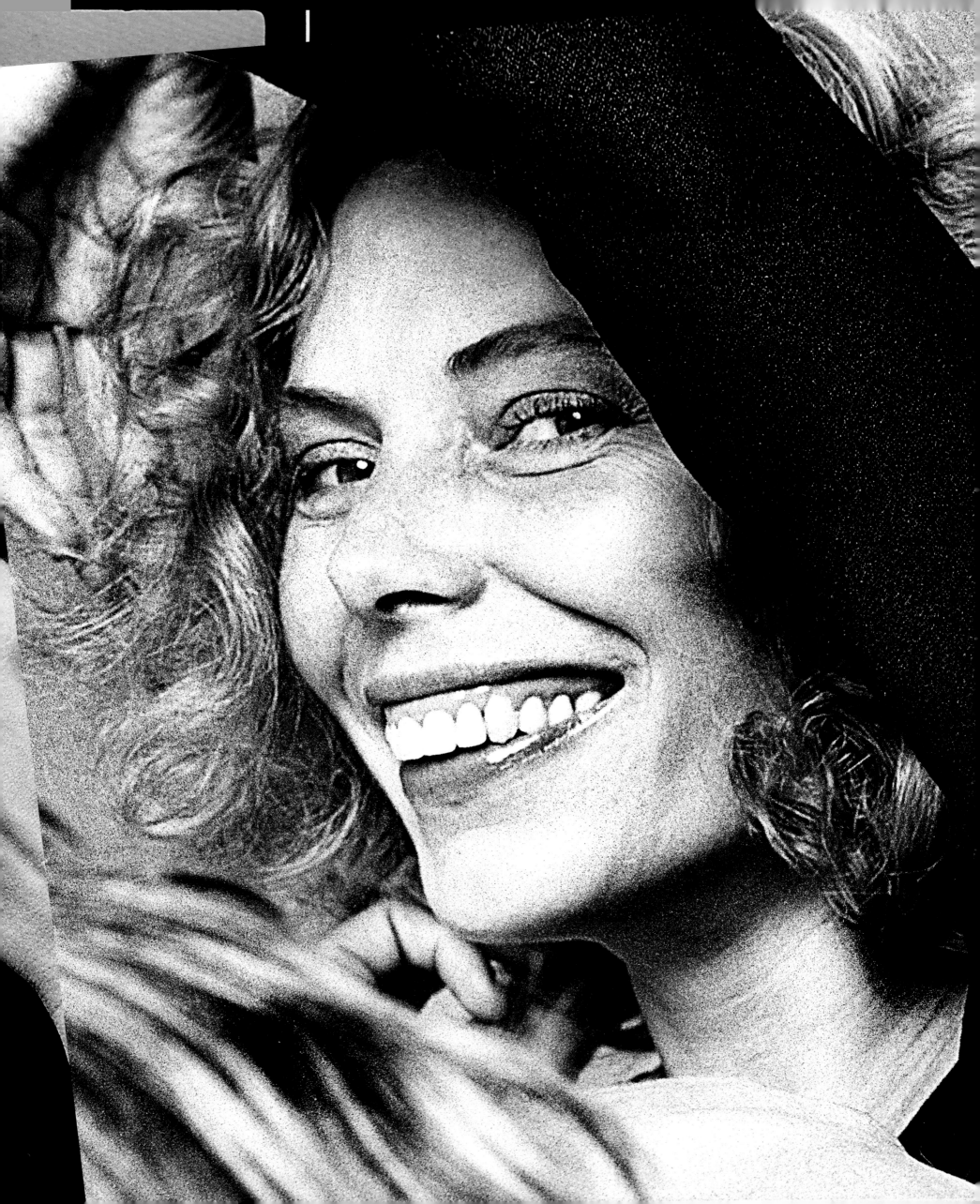

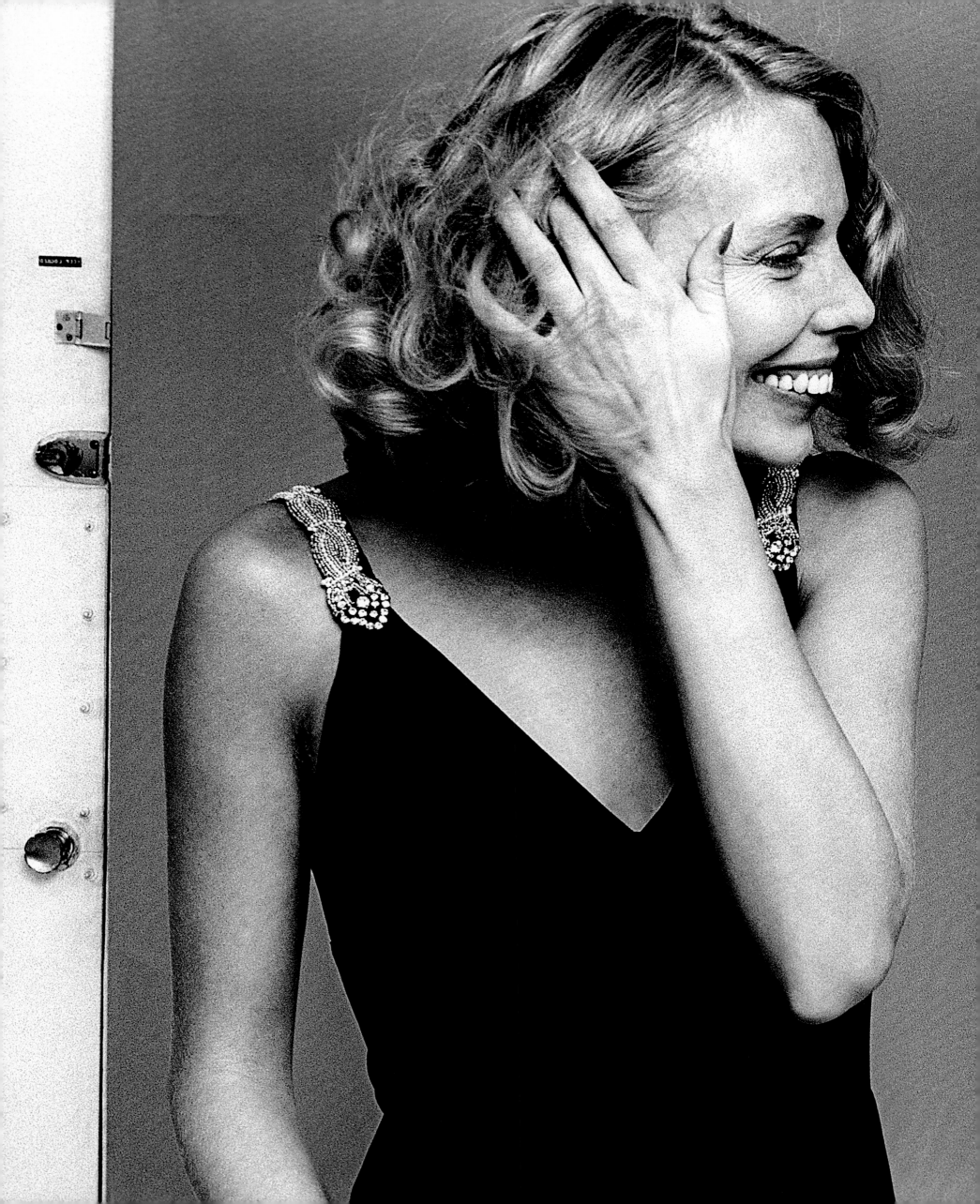

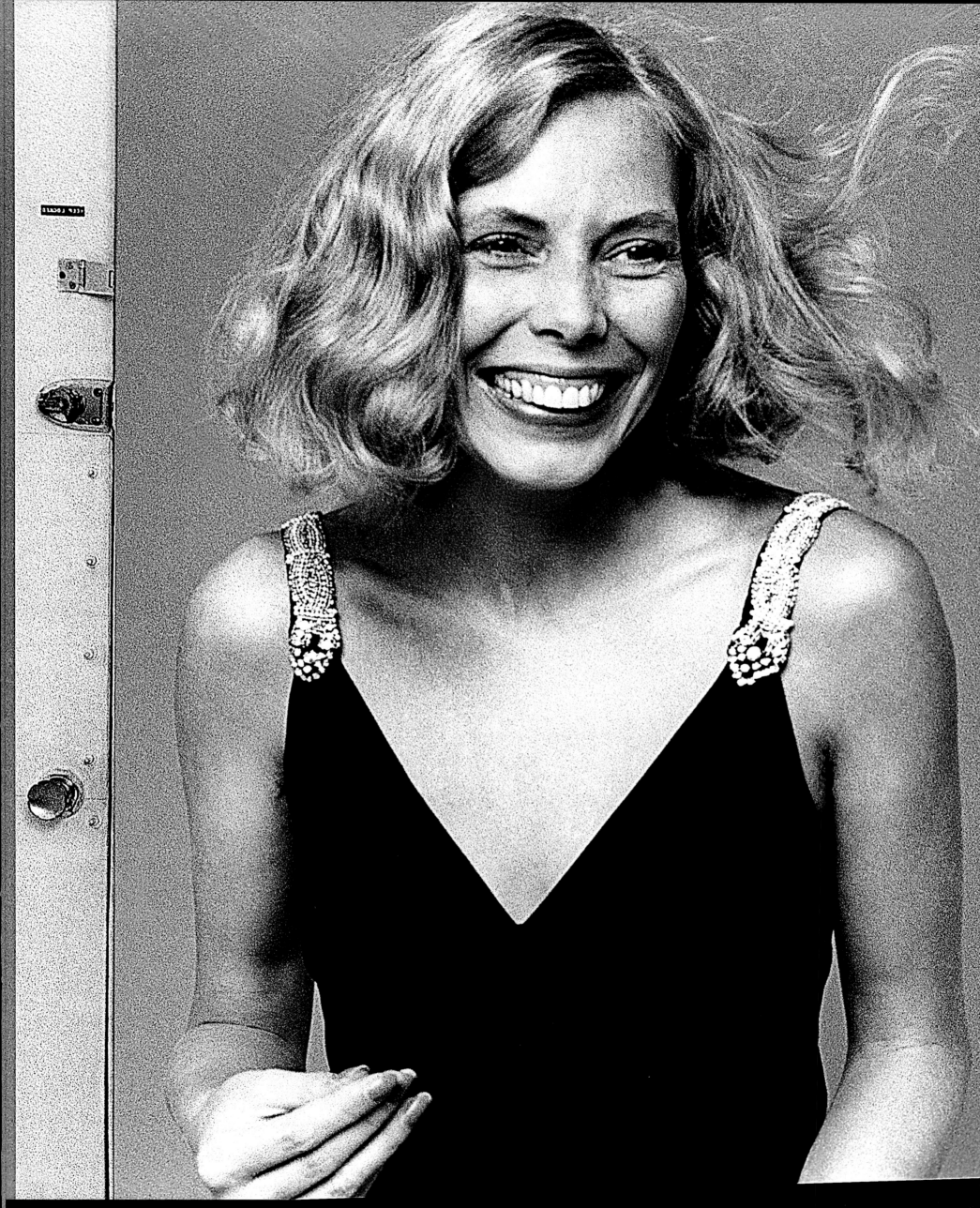

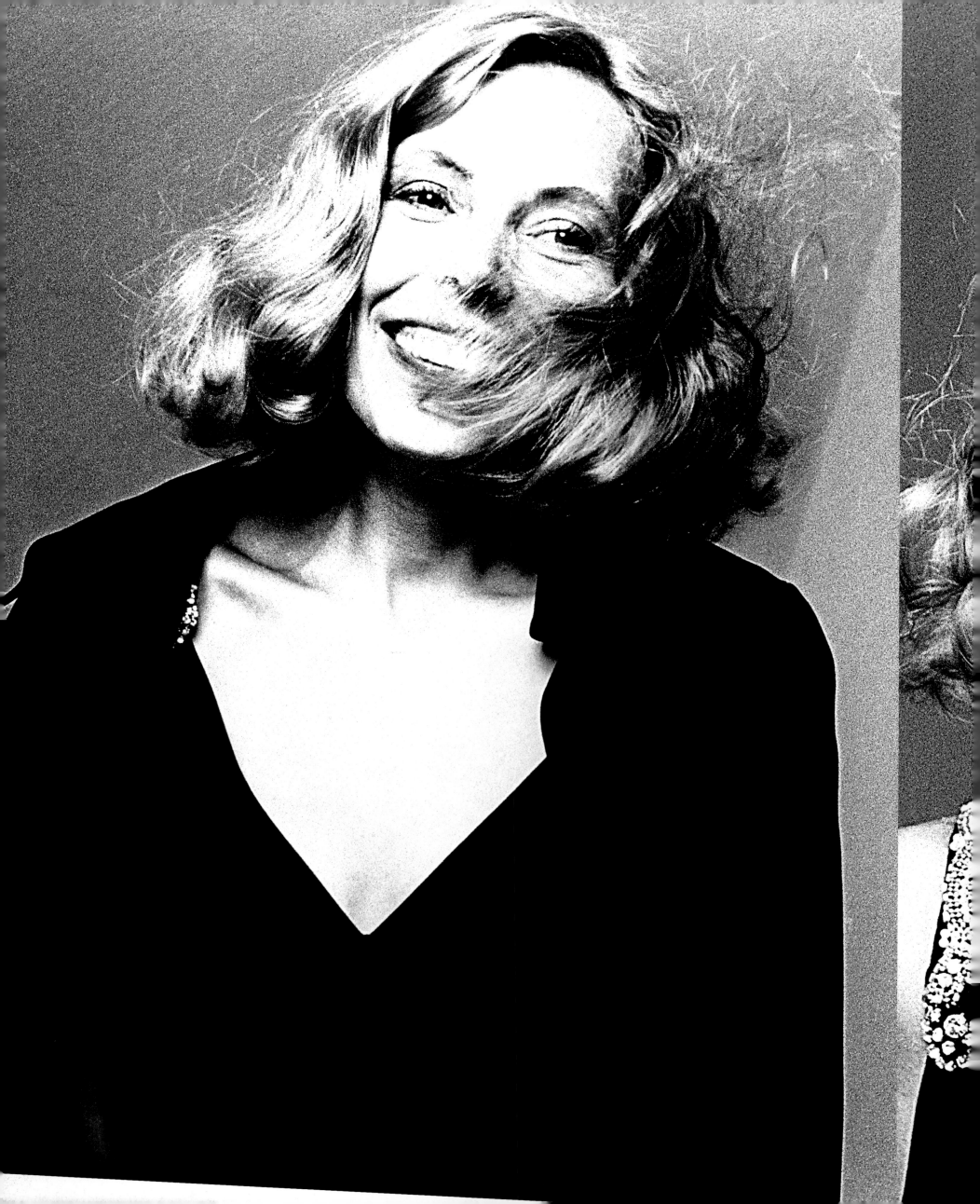

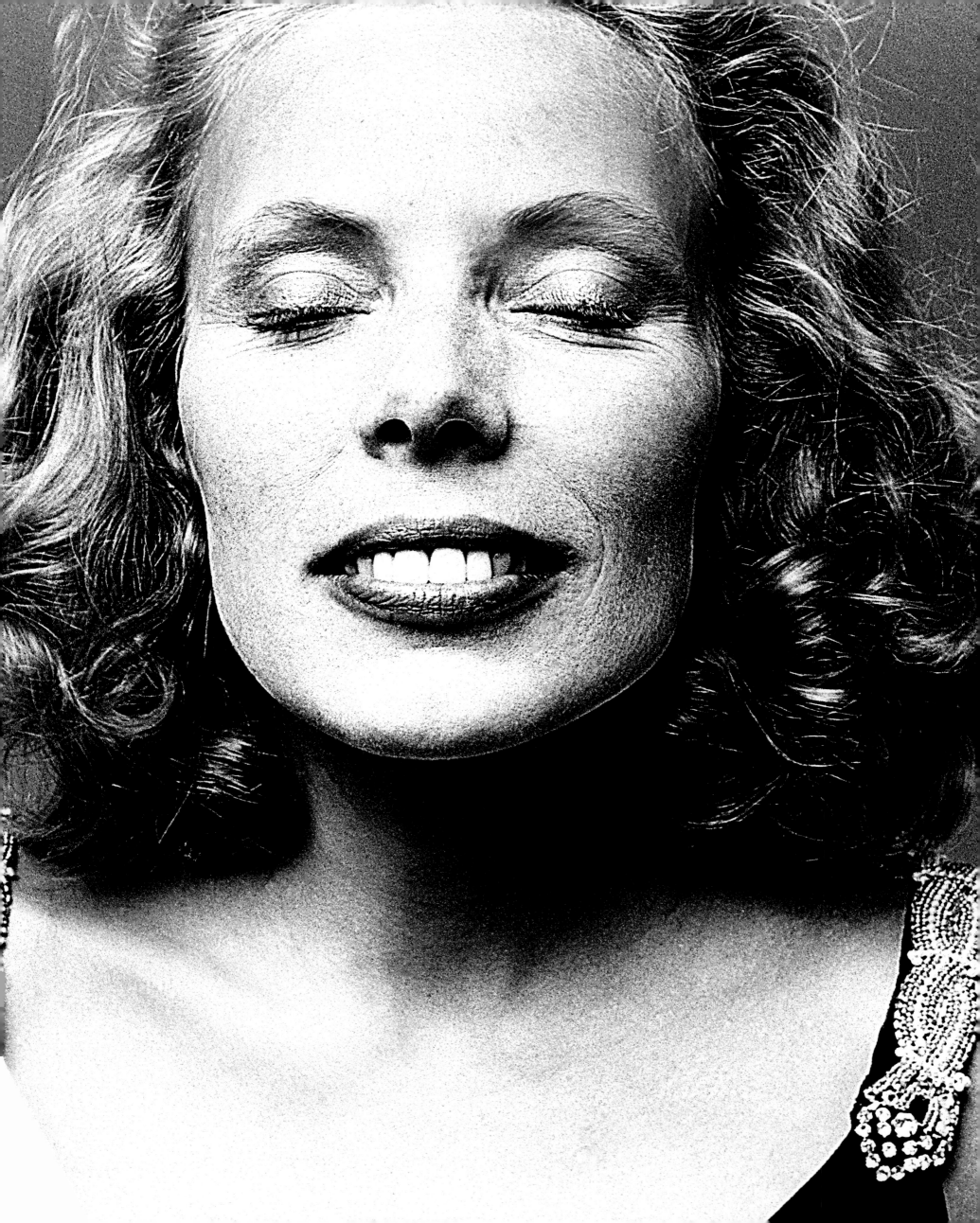

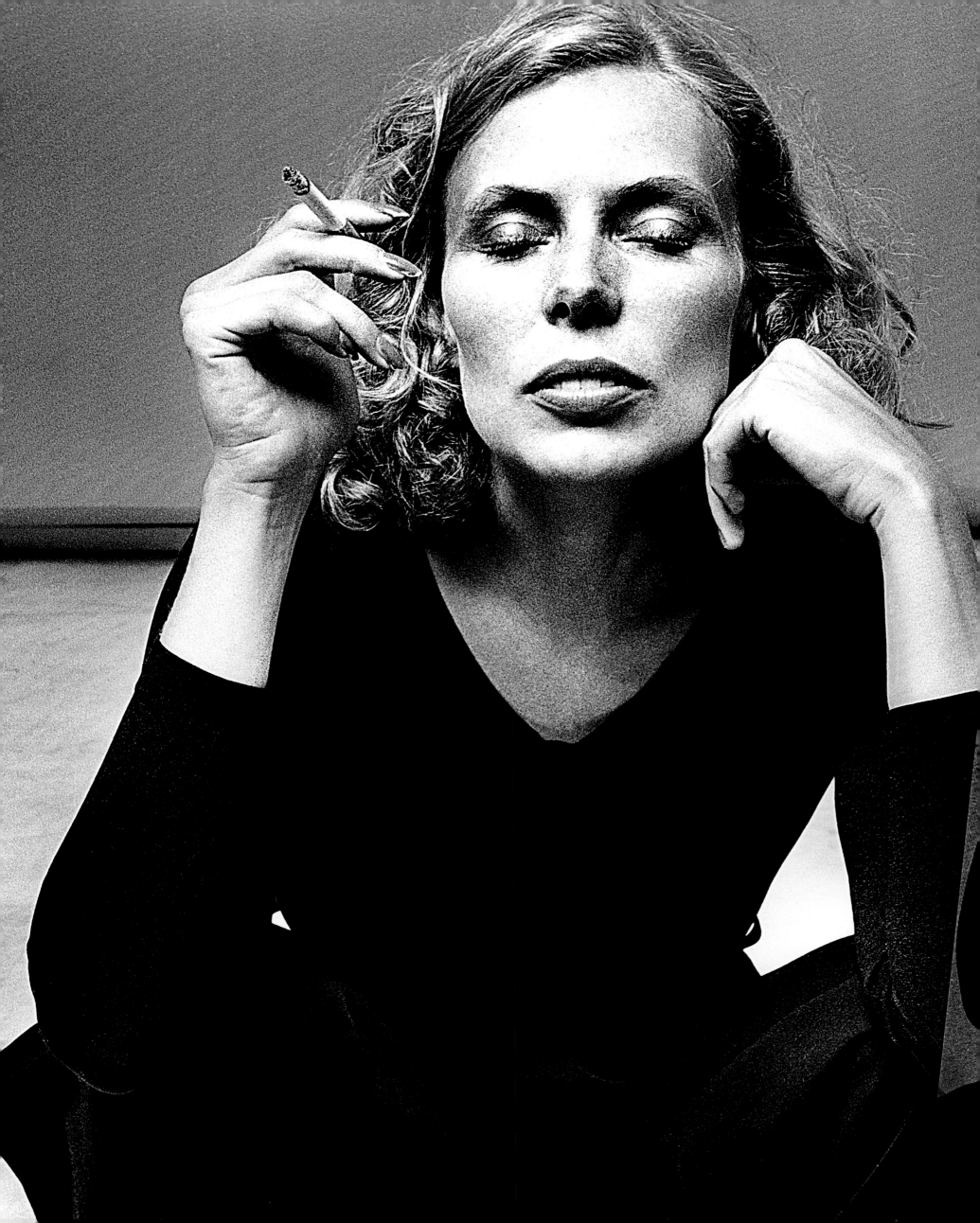

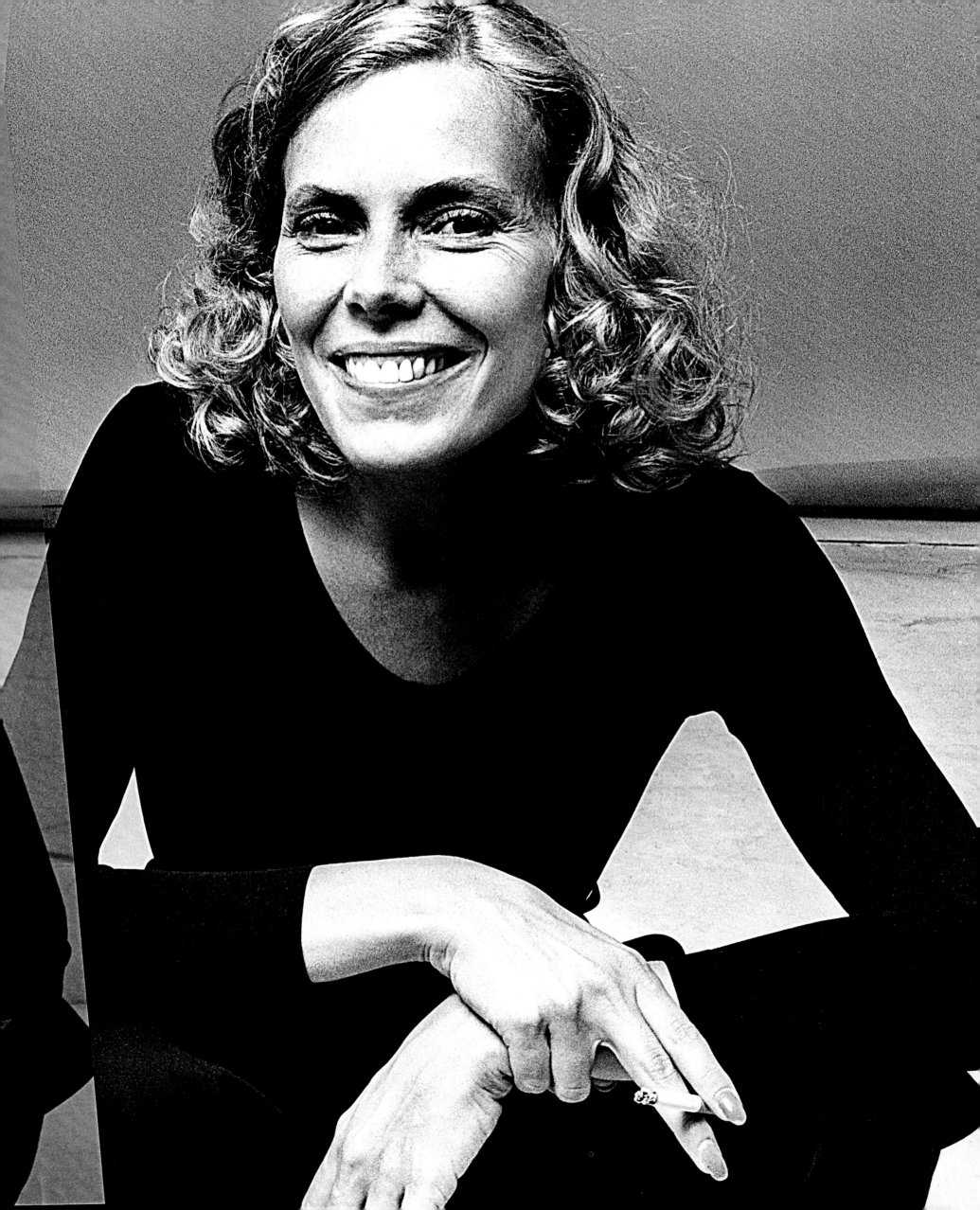

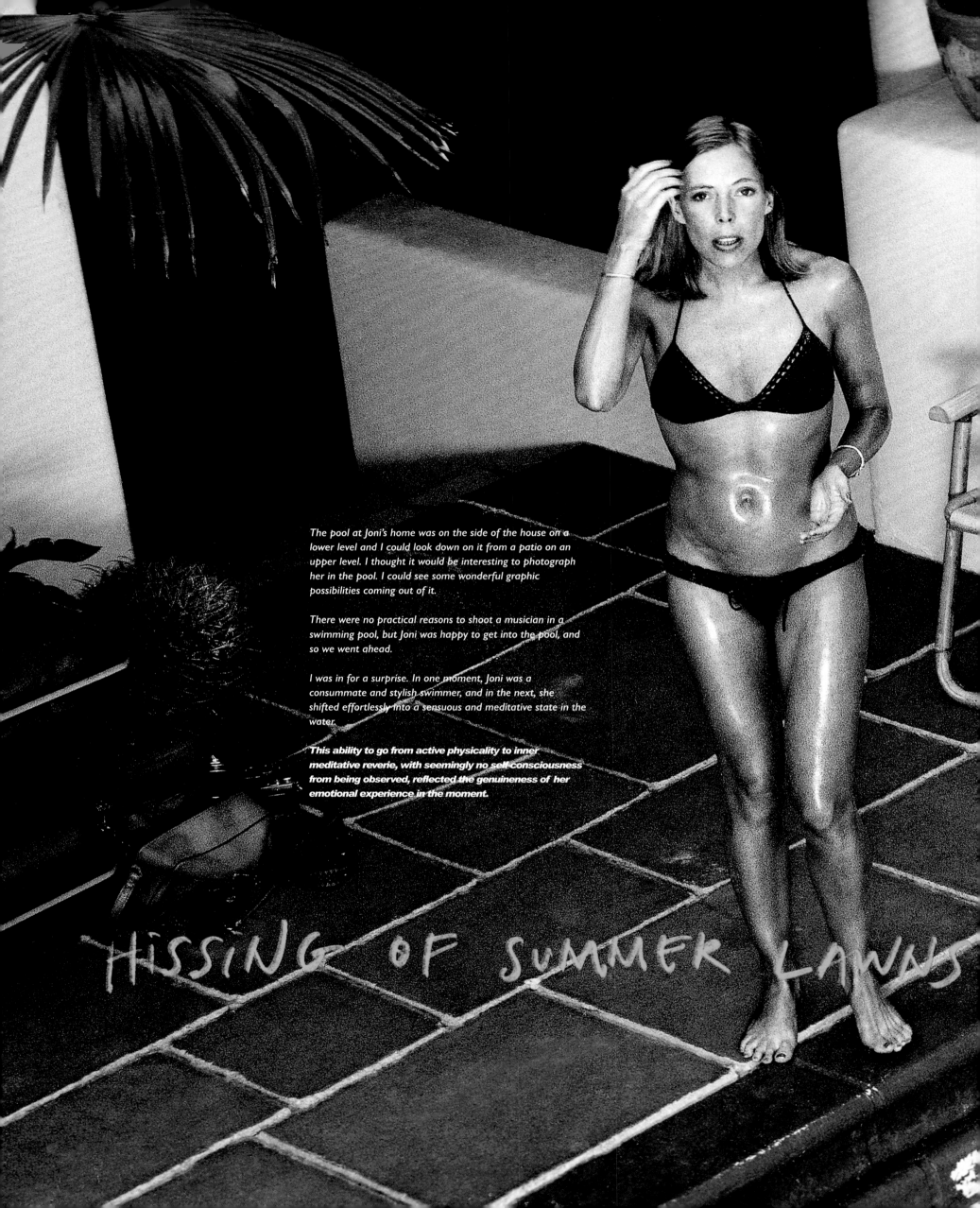

The pool at Joni's home was on the side of the house on a lower level and I could look down on it from a patio on an upper level. I thought it would be interesting to photograph her in the pool. I could see some wonderful graphic possibilities coming out of it.

There were no practical reasons to shoot a musician in a swimming pool, but Joni was happy to get into the pool, and so we went ahead.

I was in for a surprise. In one moment, Joni was a consummate and stylish swimmer, and in the next, she shifted effortlessly into a sensuous and meditative state in the water.

This ability to go from active physicality to inner meditative reverie, with seemingly no self-consciousness from being observed, reflected the genuineness of her emotional experience in the moment.

HISSING OF SUMMER LAWNS

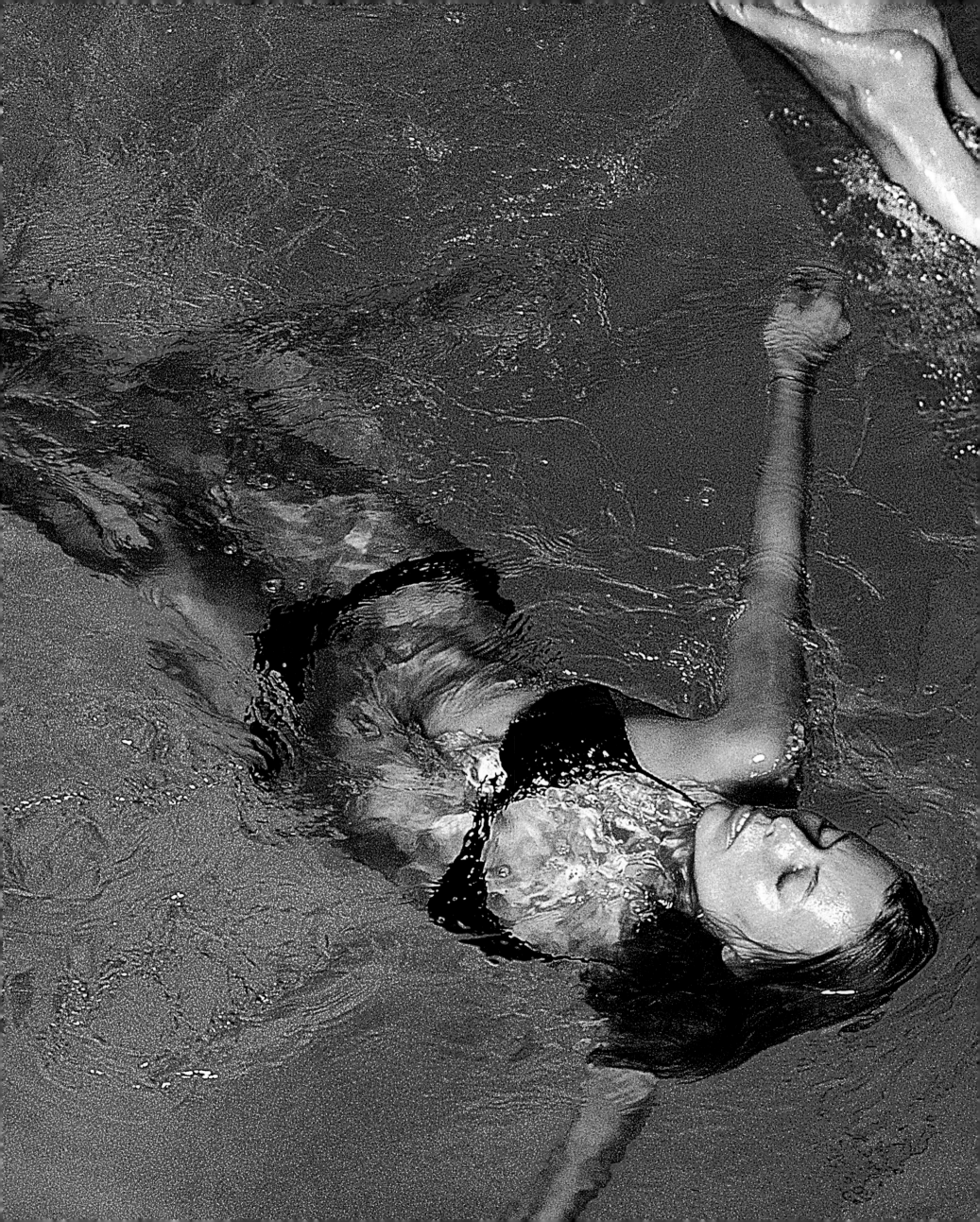

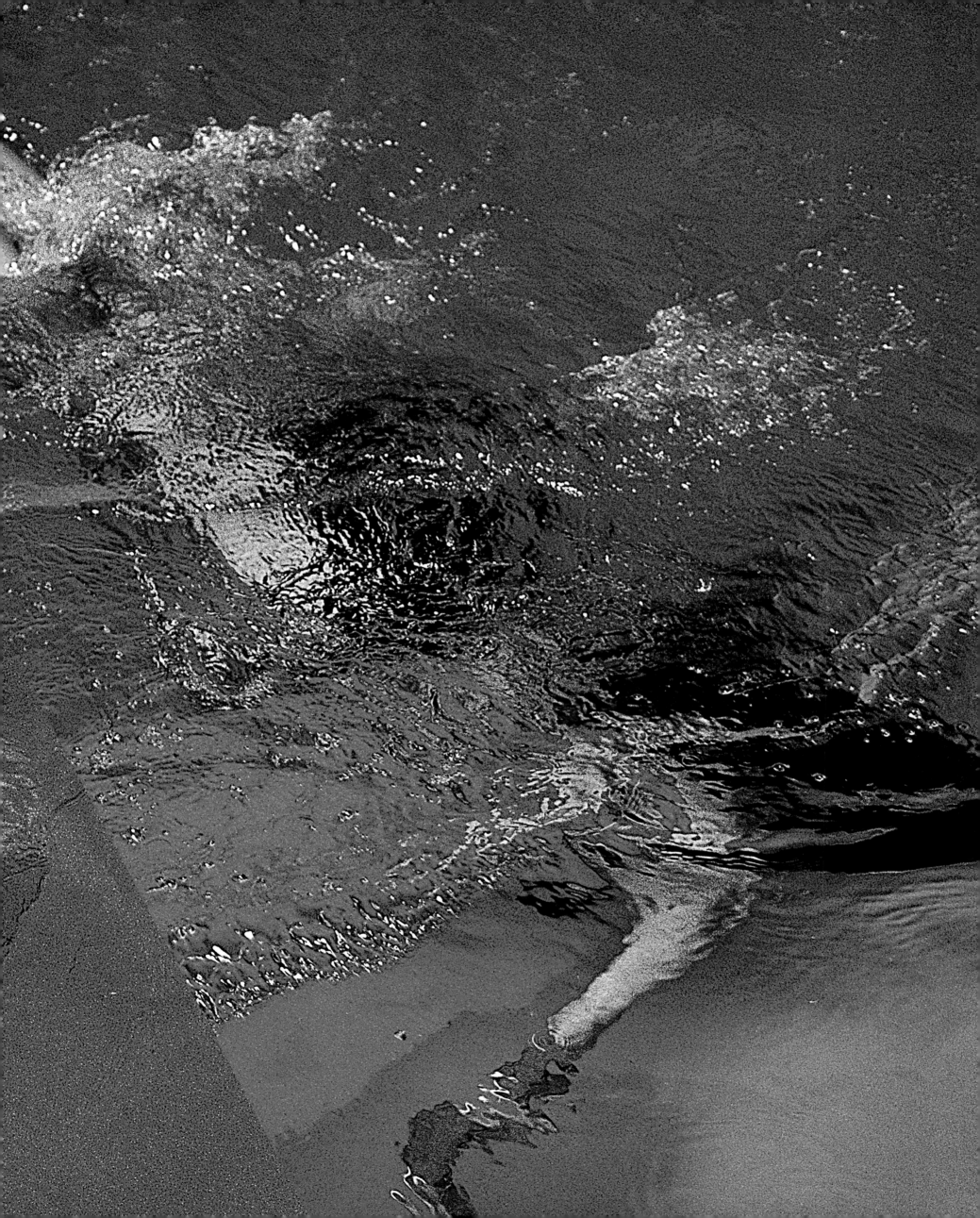

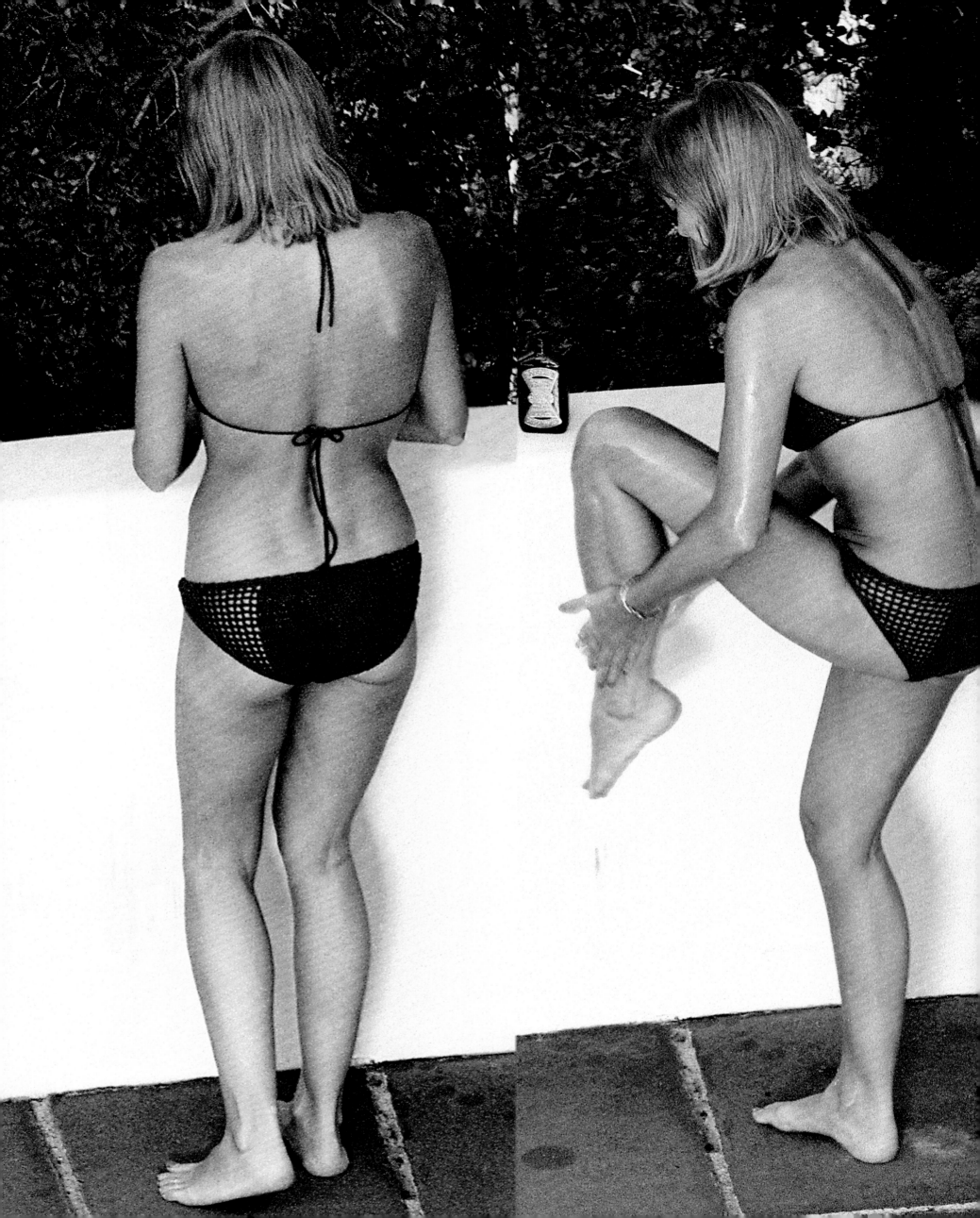

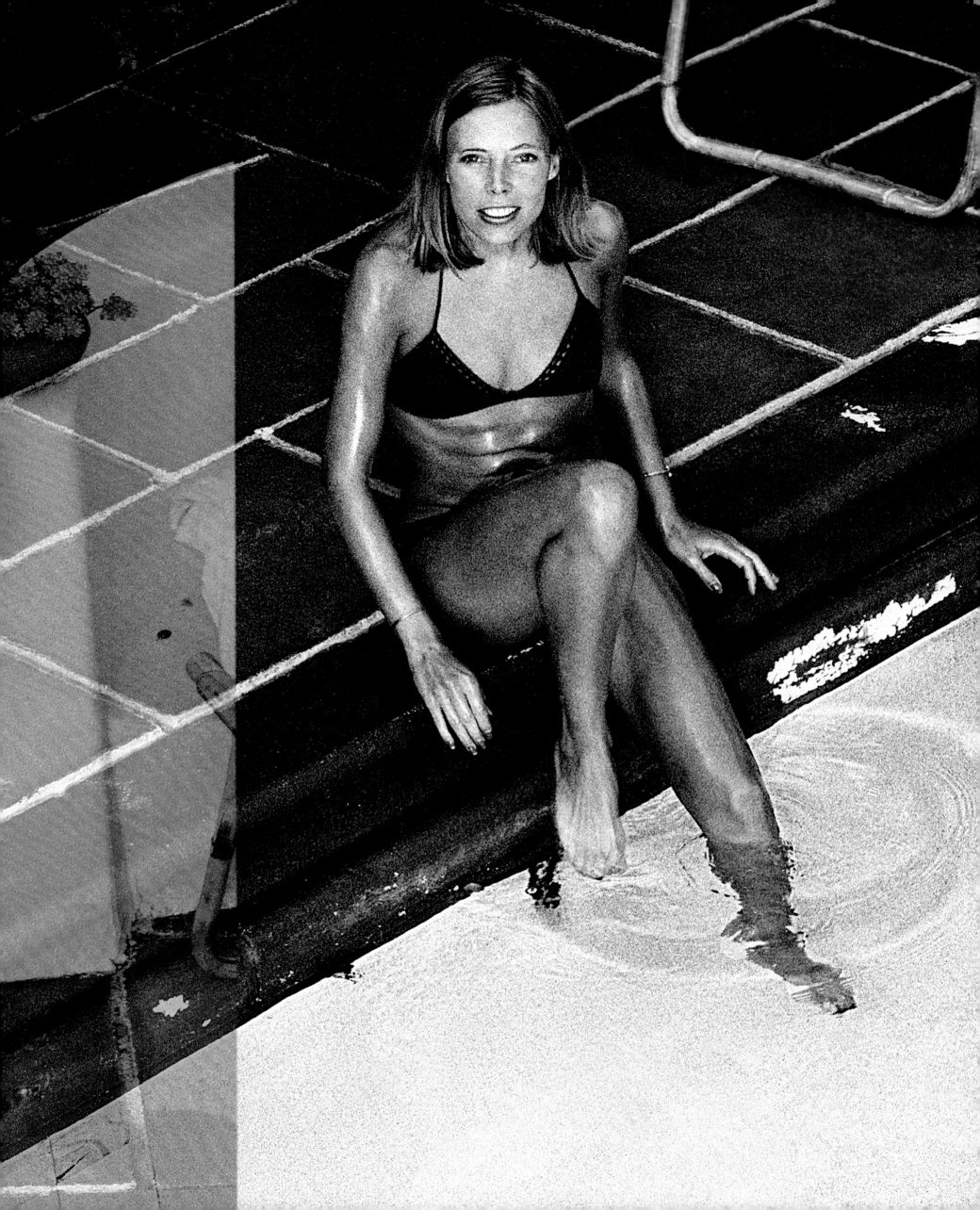

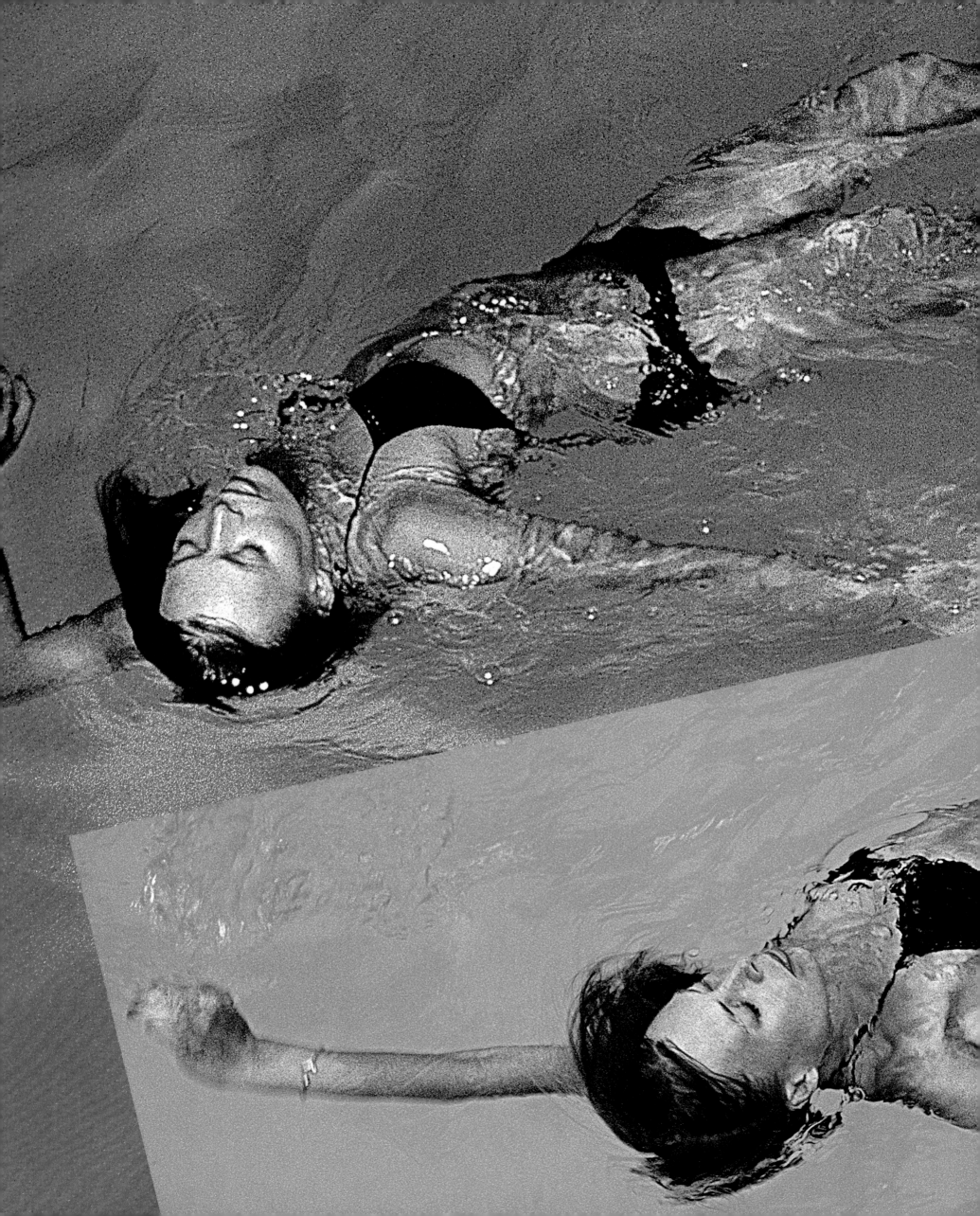

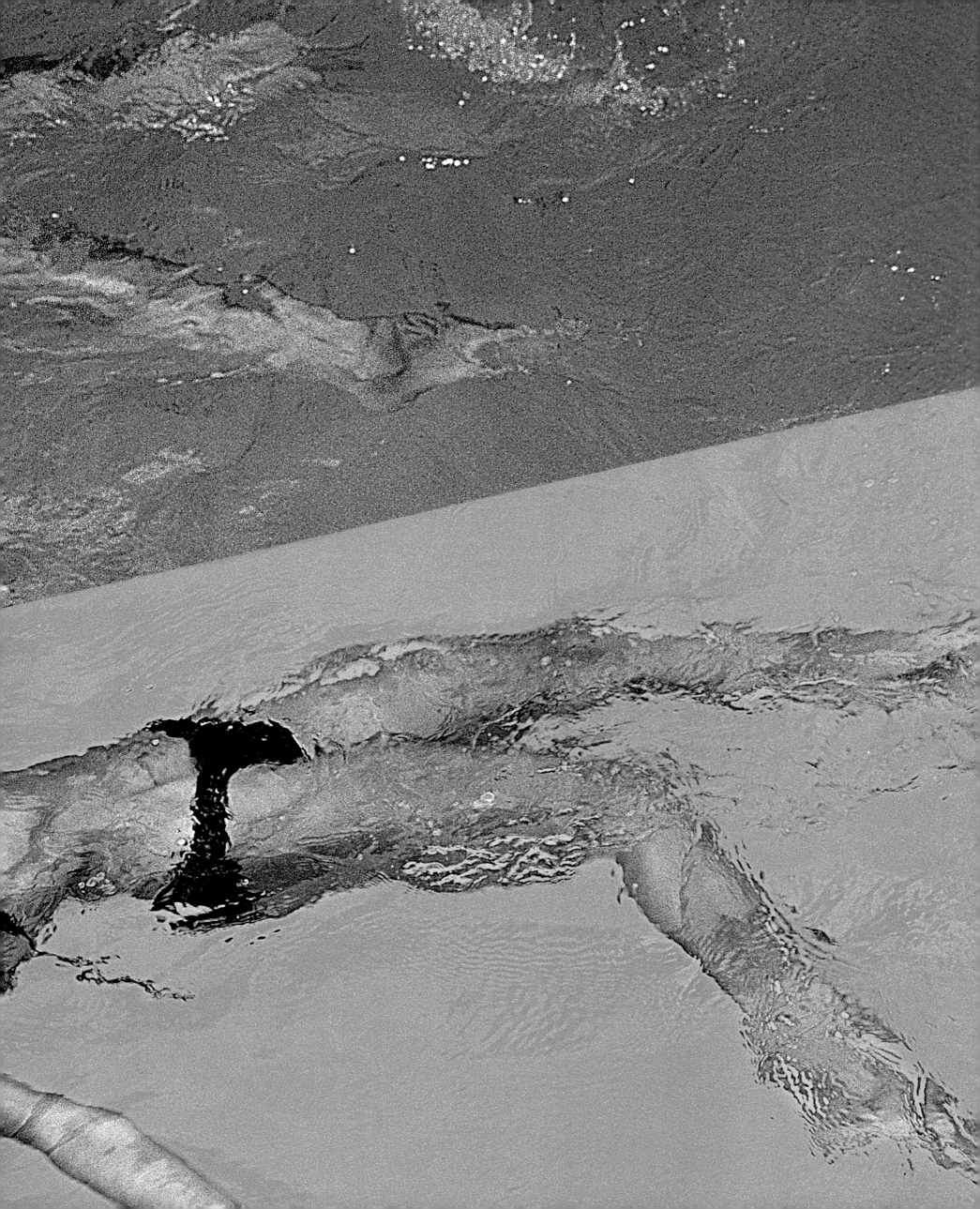

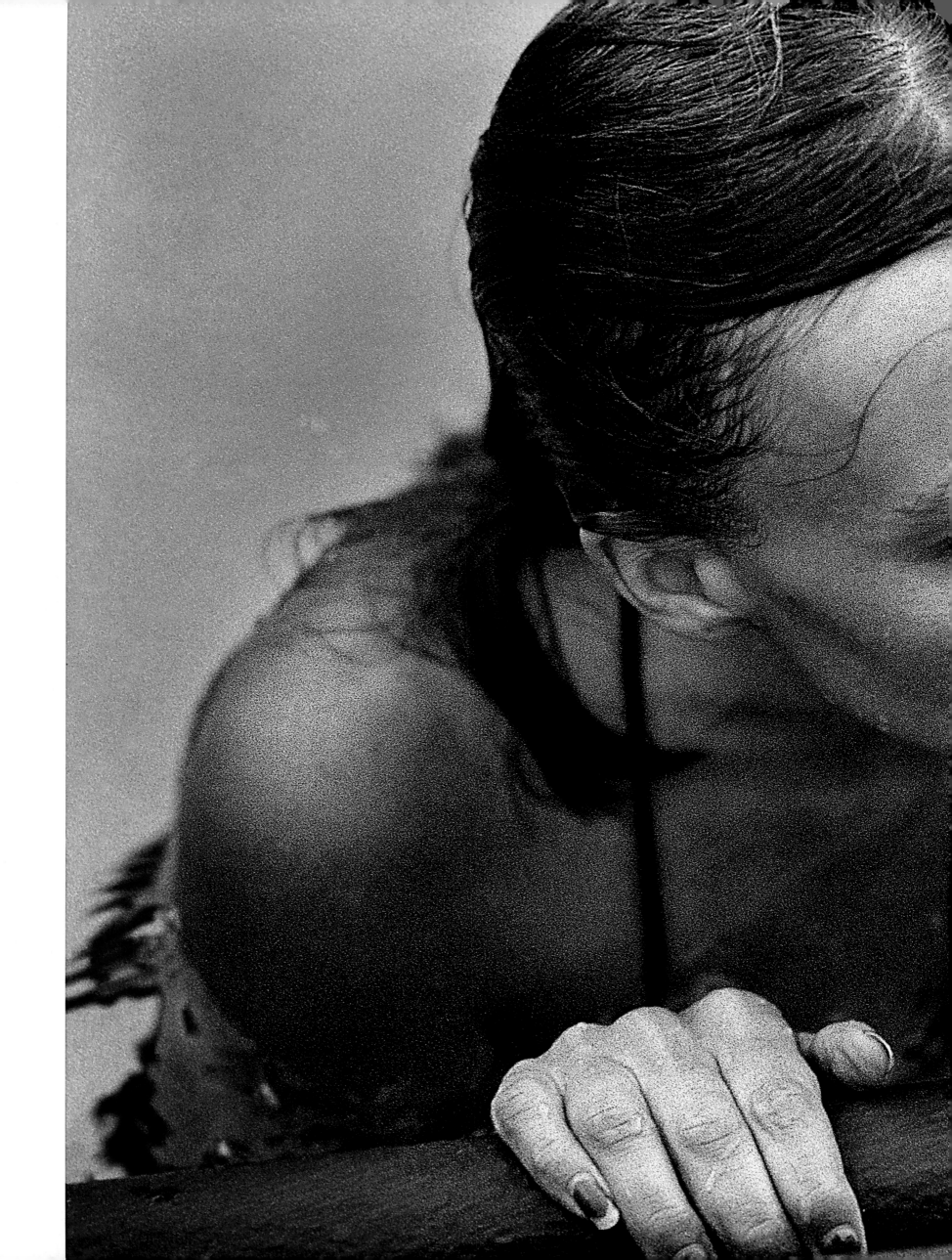

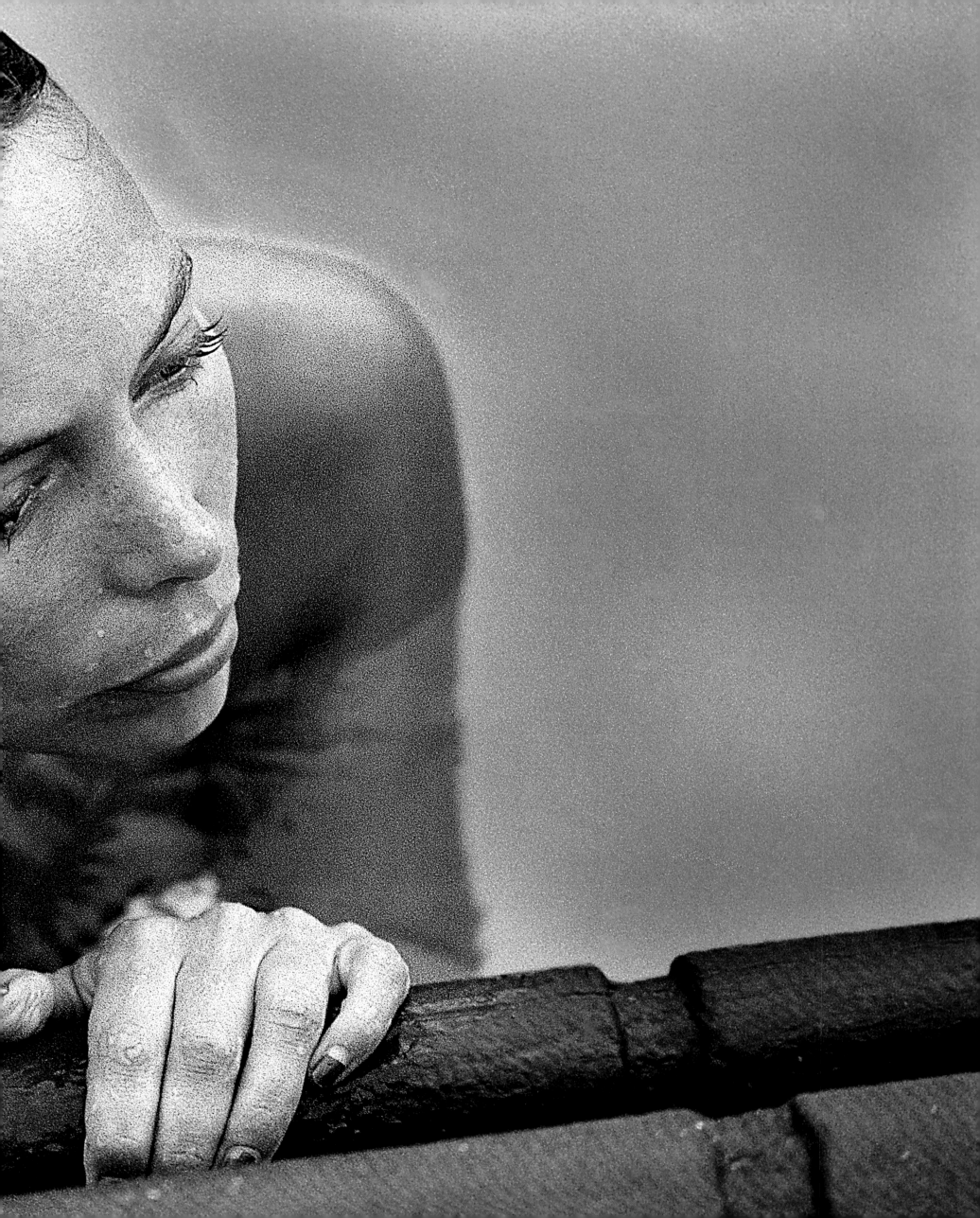

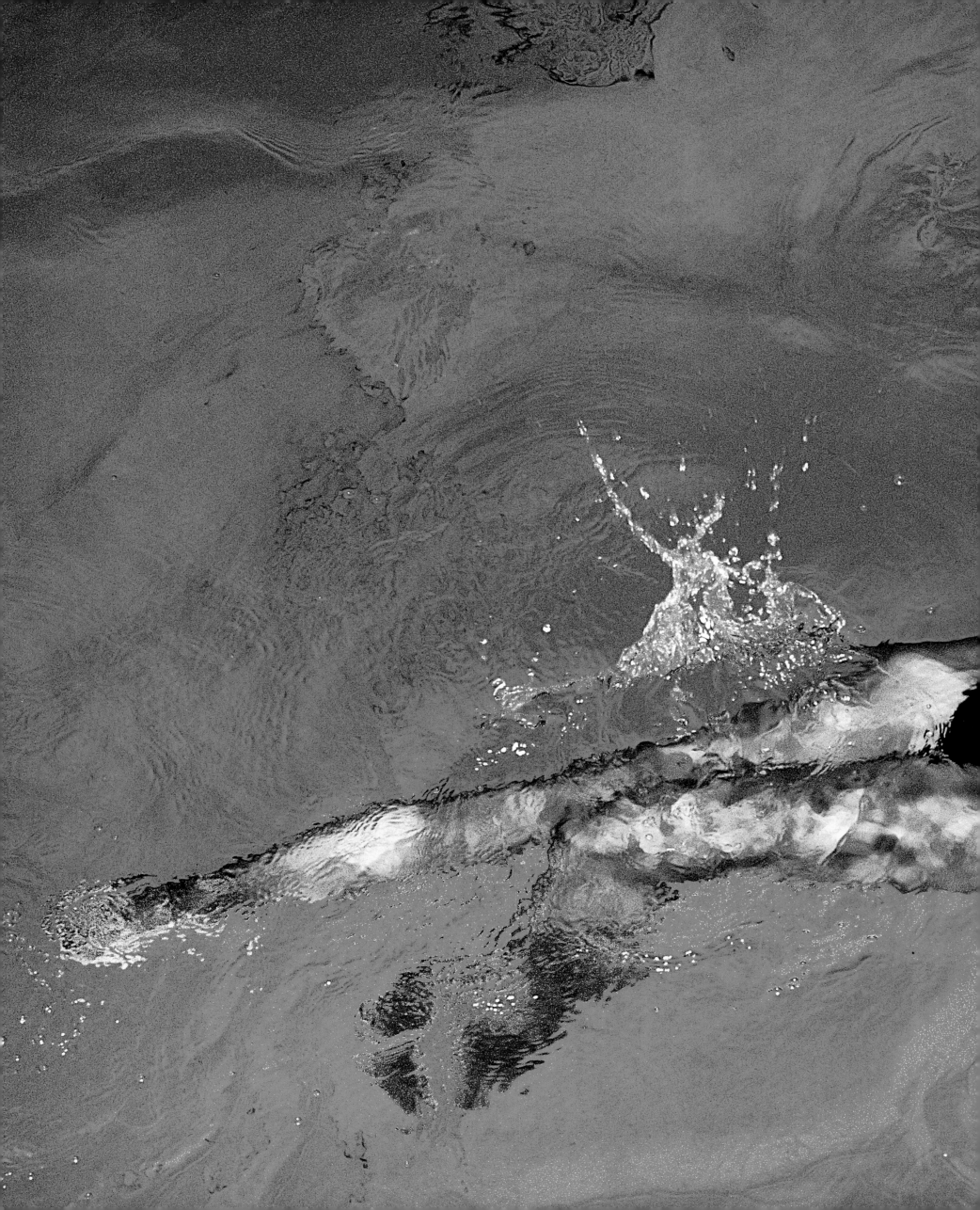

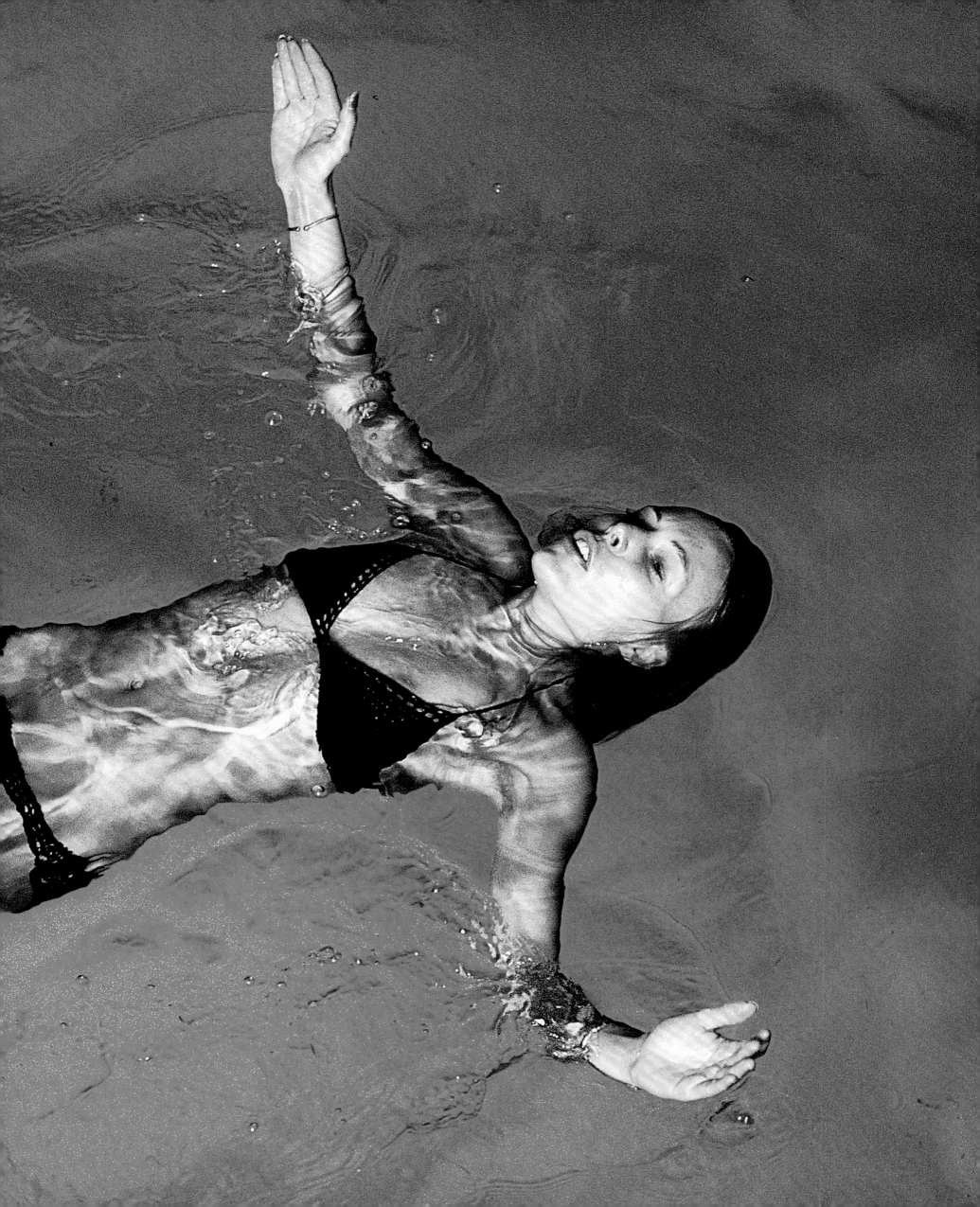

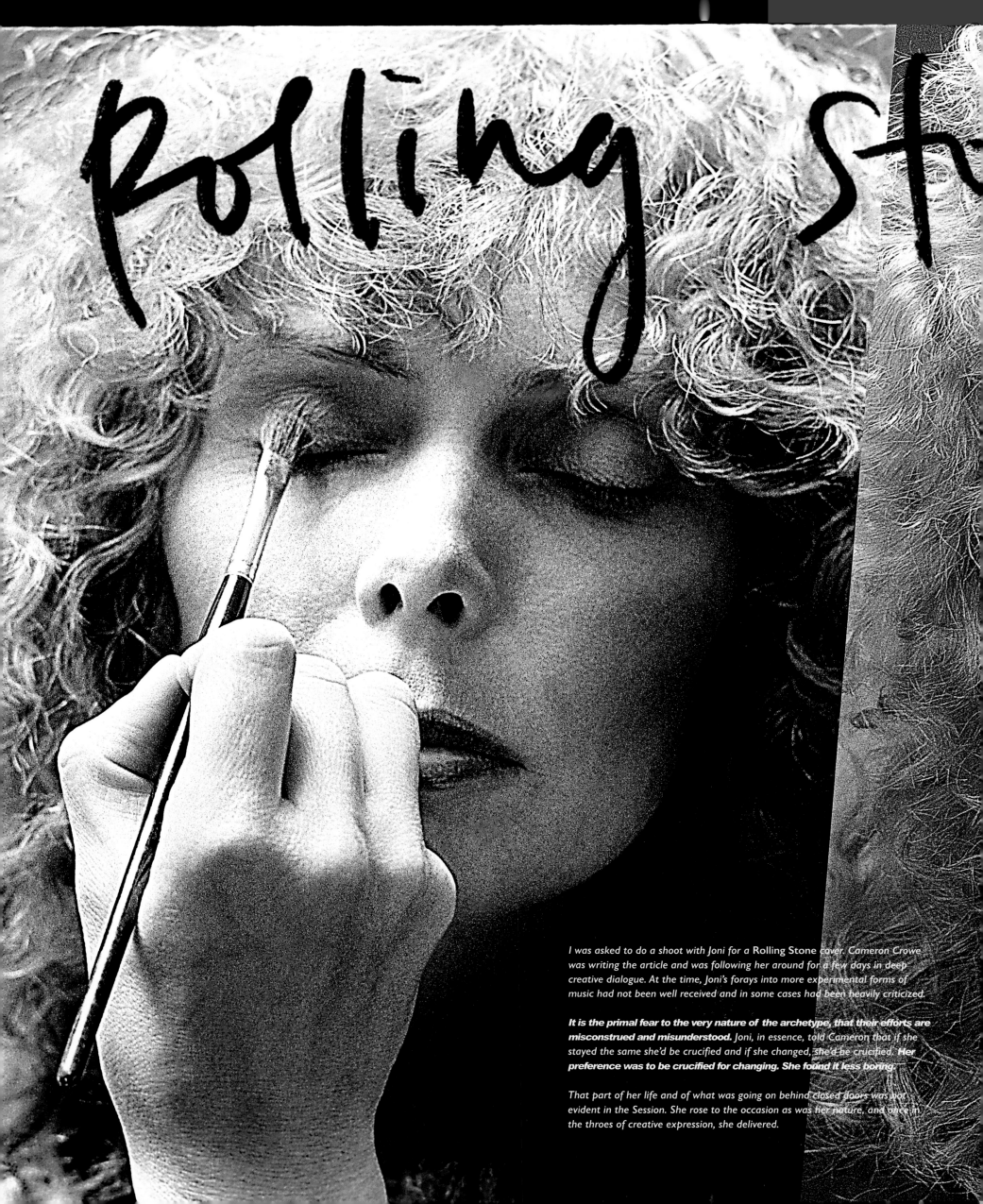

I was asked to do a shoot with Joni for a Rolling Stone cover. Cameron Crowe was writing the article and was following her around for a few days in deep creative dialogue. At the time, Joni's forays into more experimental forms of music had not been well received and in some cases had been heavily criticized.

It is the primal fear to the very nature of the archetype, that their efforts are misconstrued and misunderstood.** Joni, in essence, told Cameron that if she stayed the same she'd be crucified and if she changed, she'd be crucified. **Her preference was to be crucified for changing. She found it less boring.

That part of her life and of what was going on behind closed doors was not evident in the Session. She rose to the occasion as was her nature, and once in the throes of creative expression, she delivered.

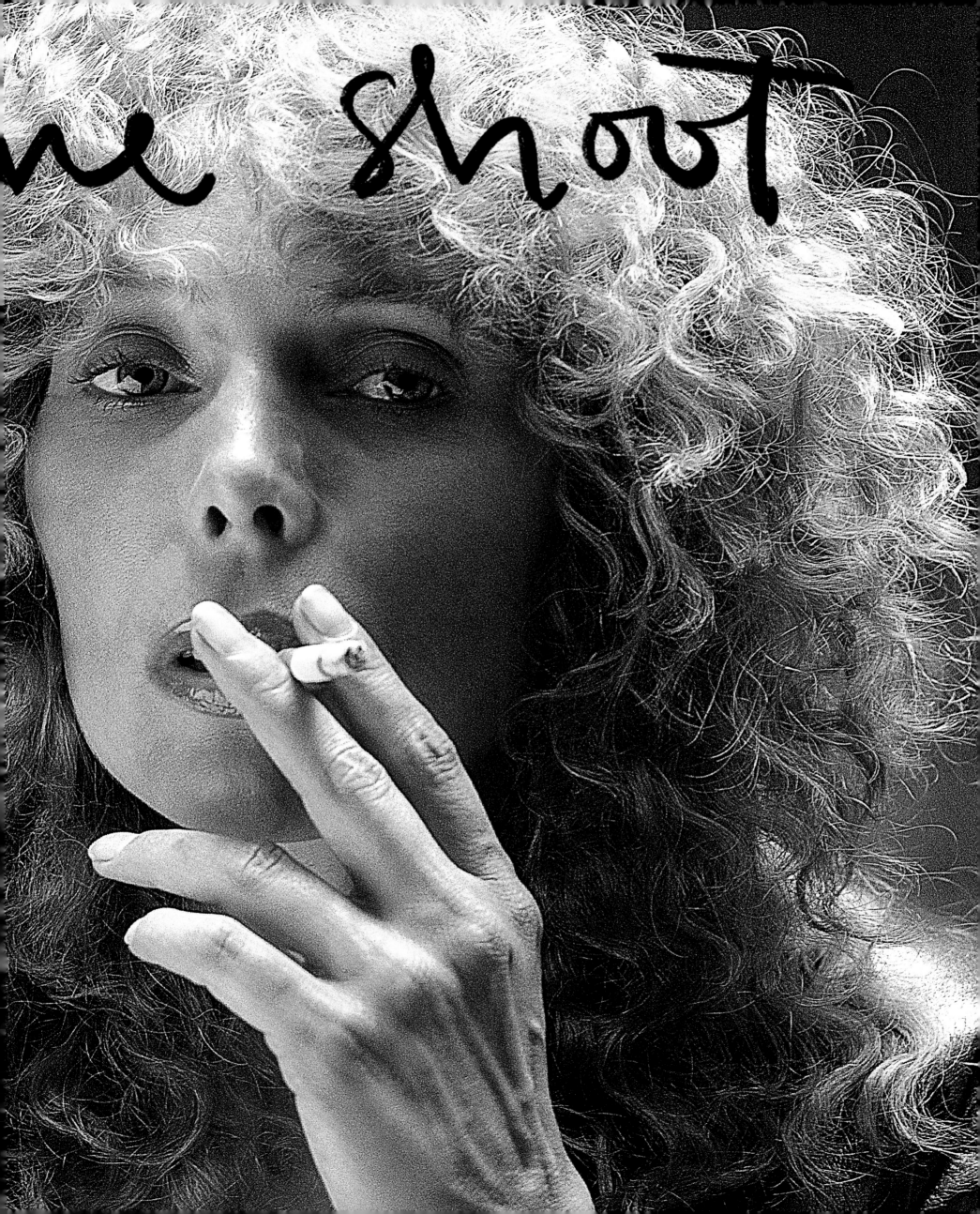

21

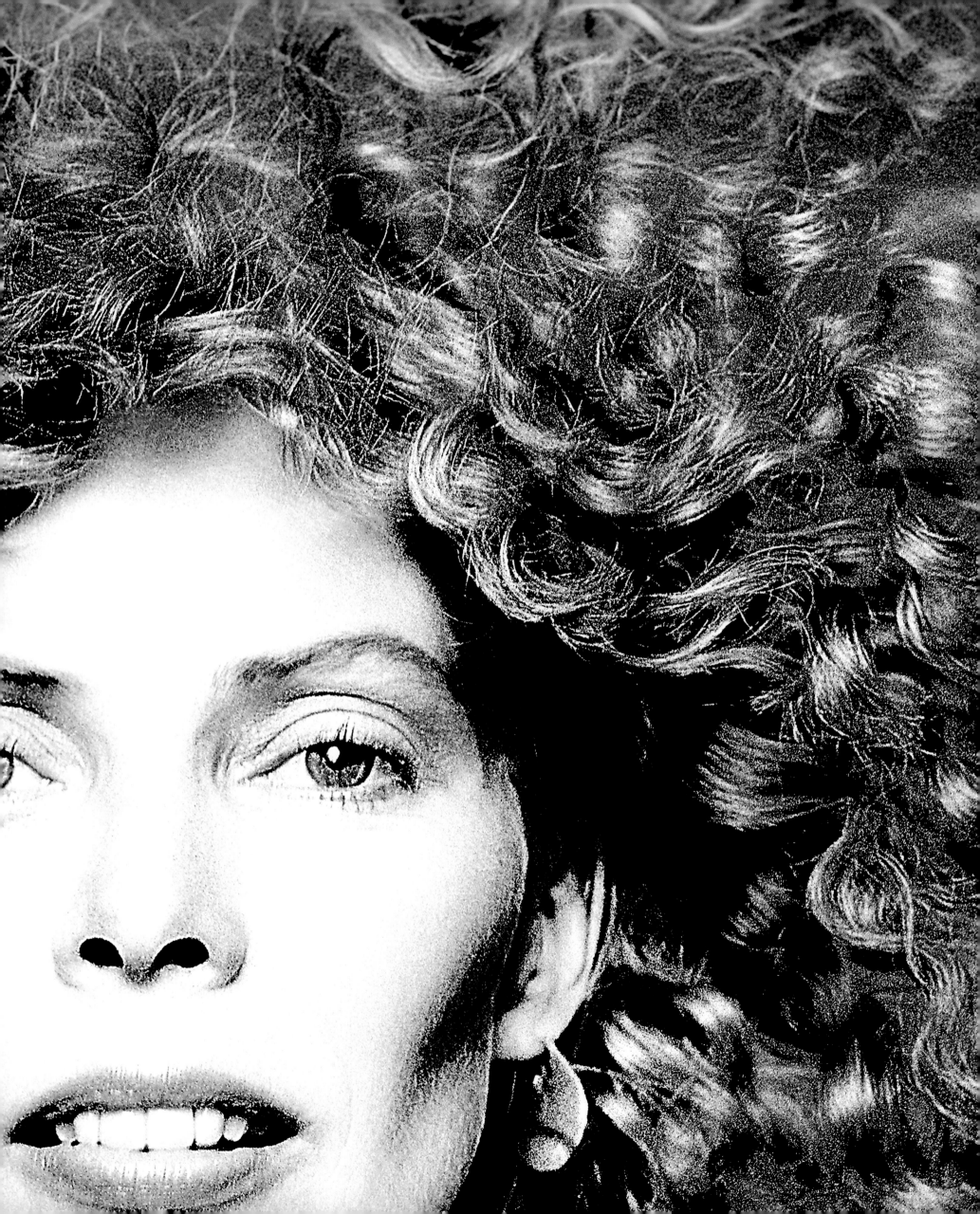

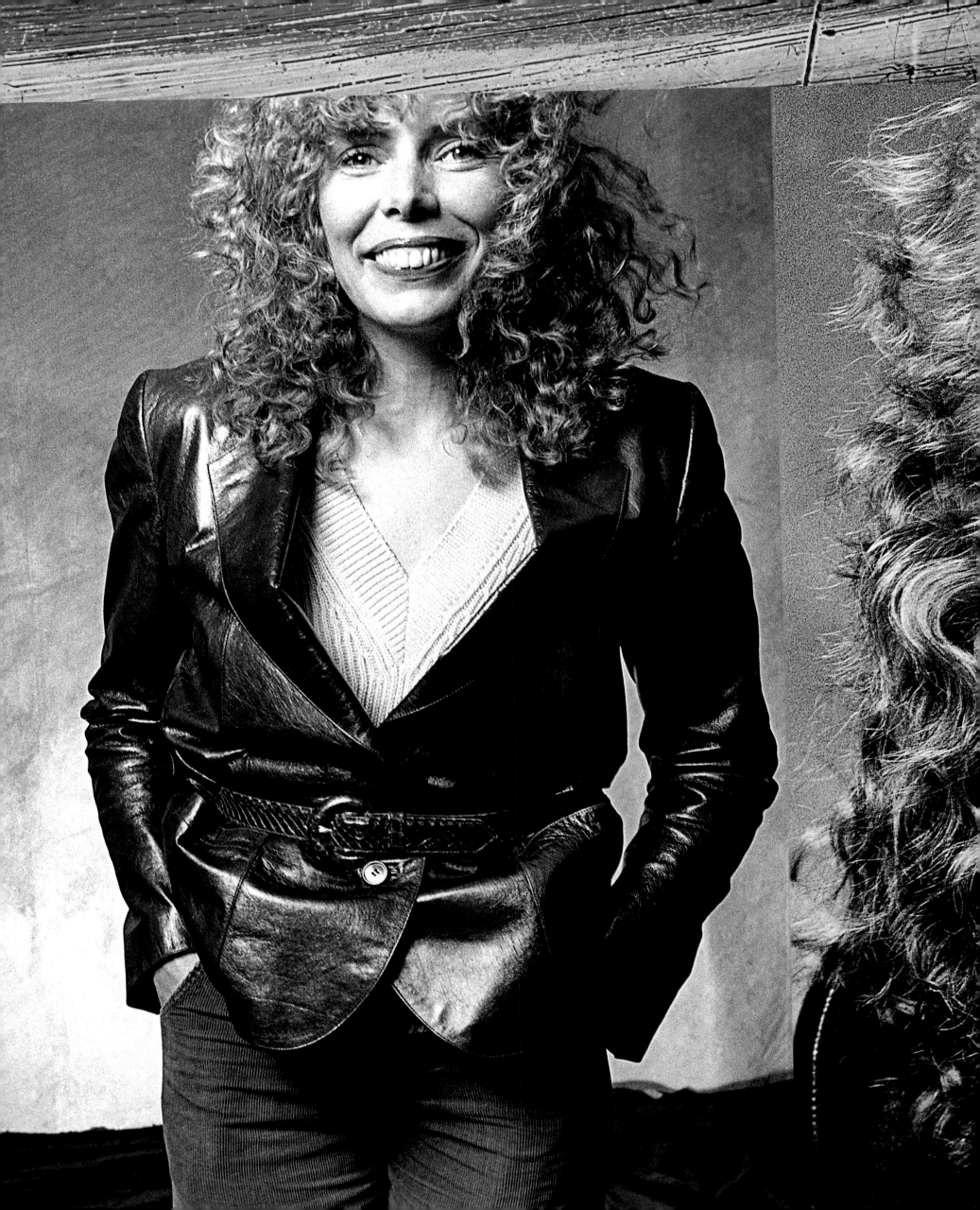

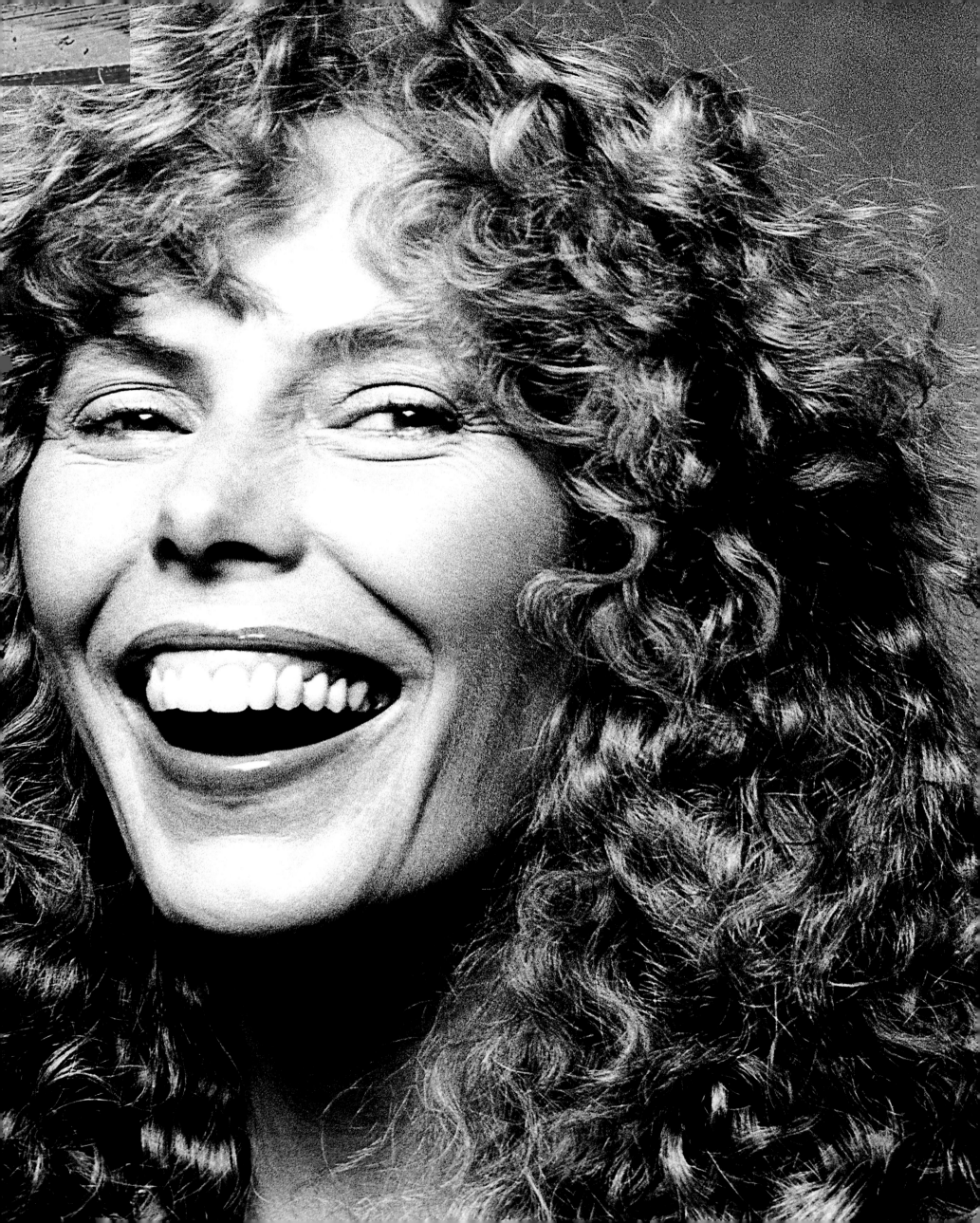

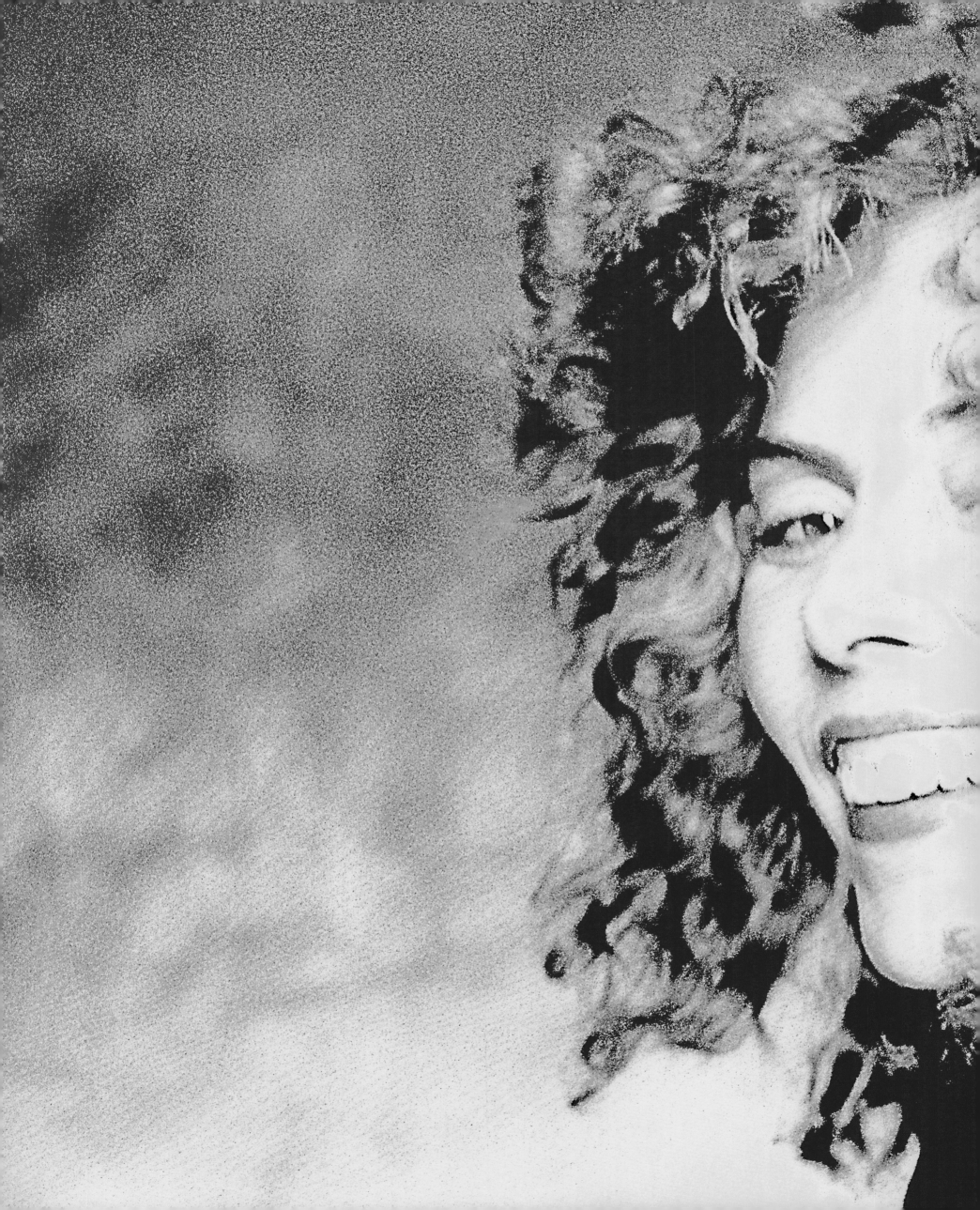

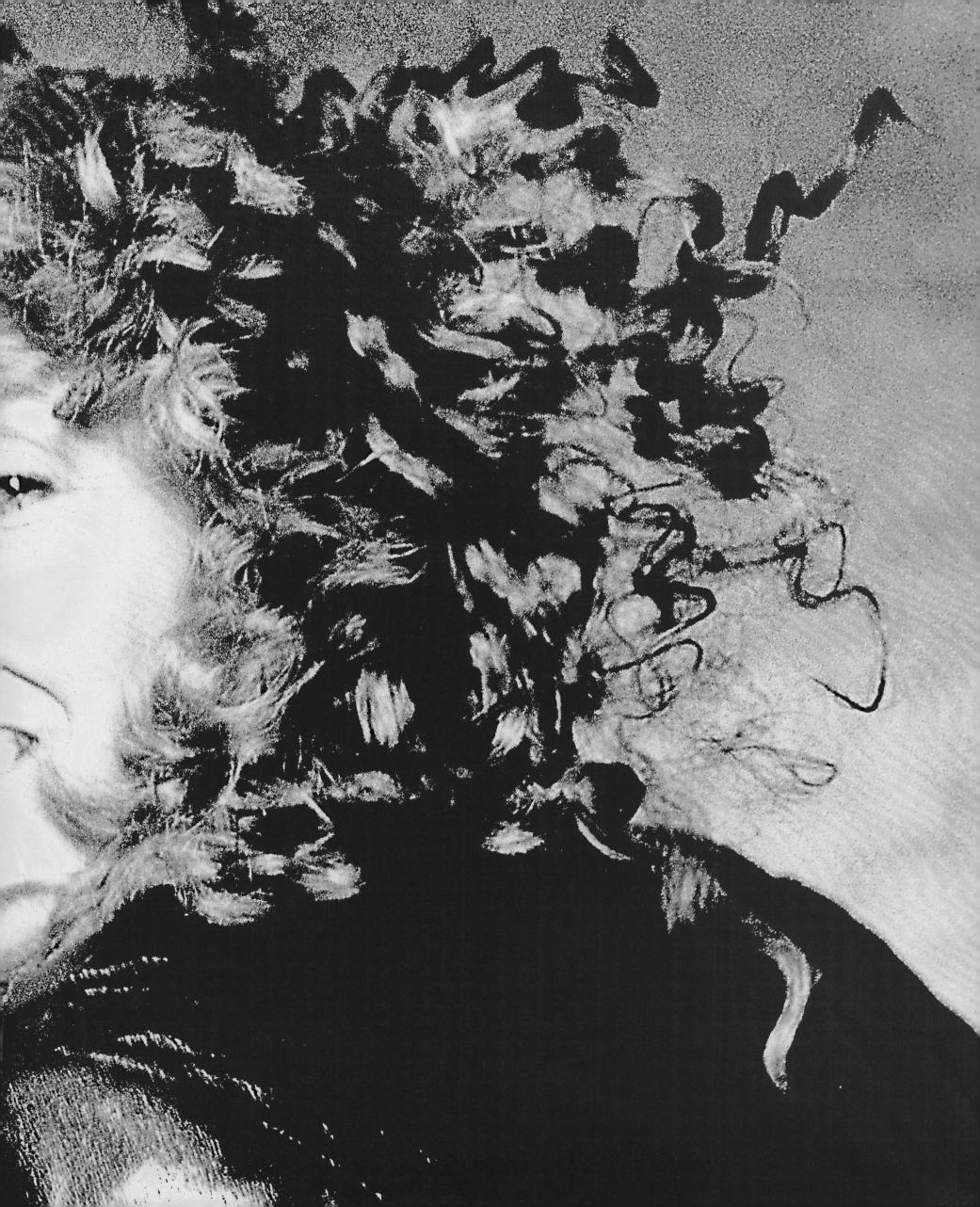

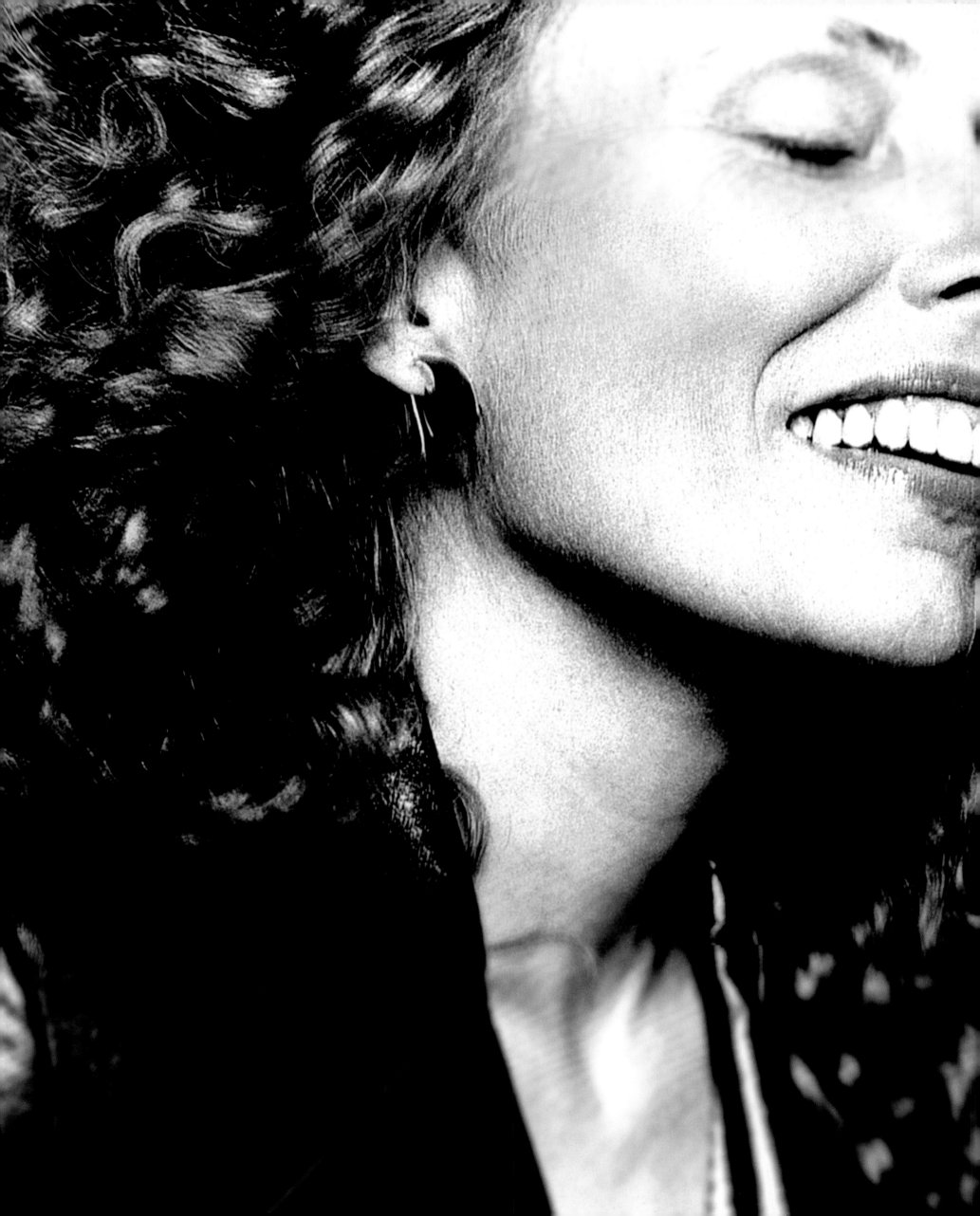

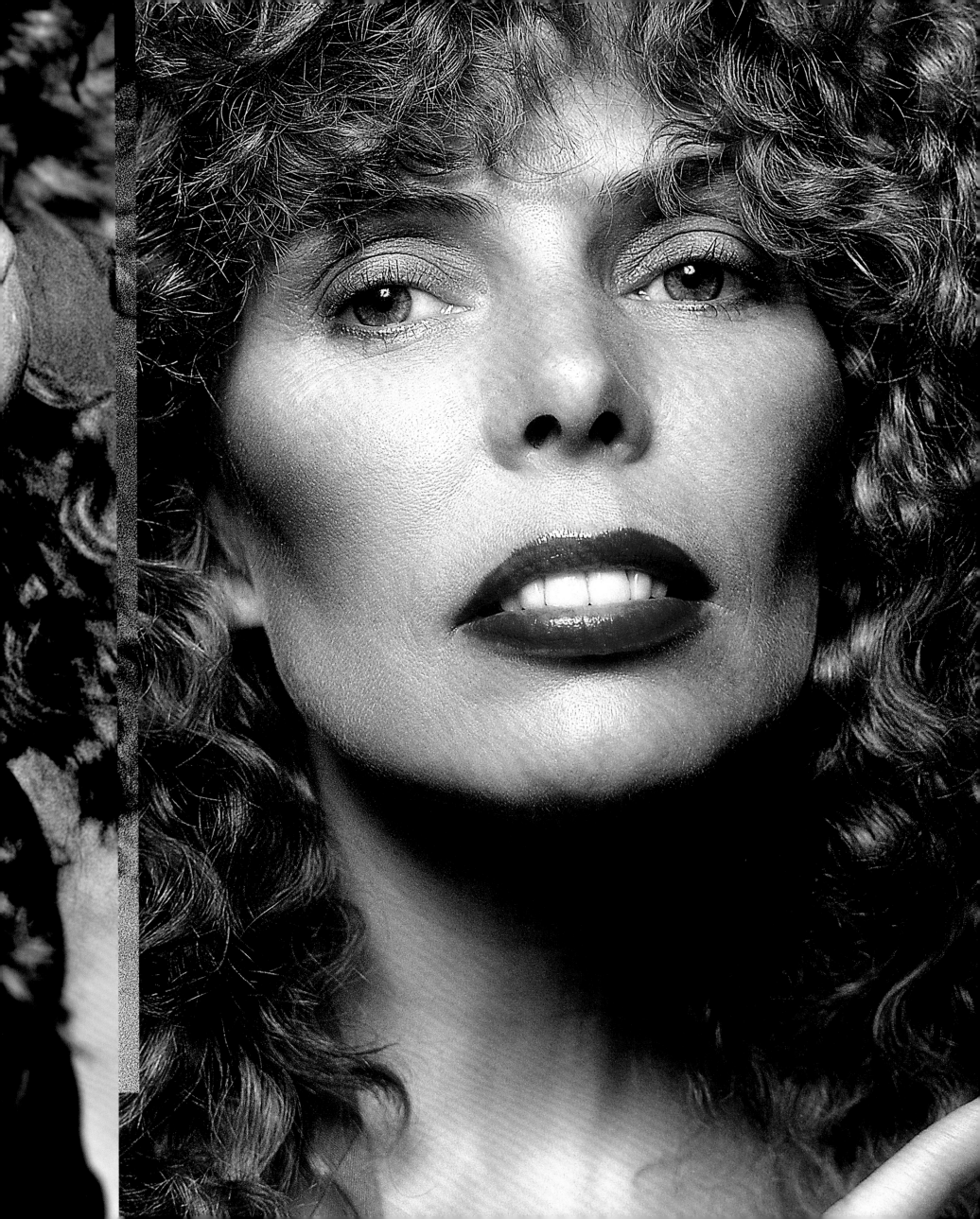

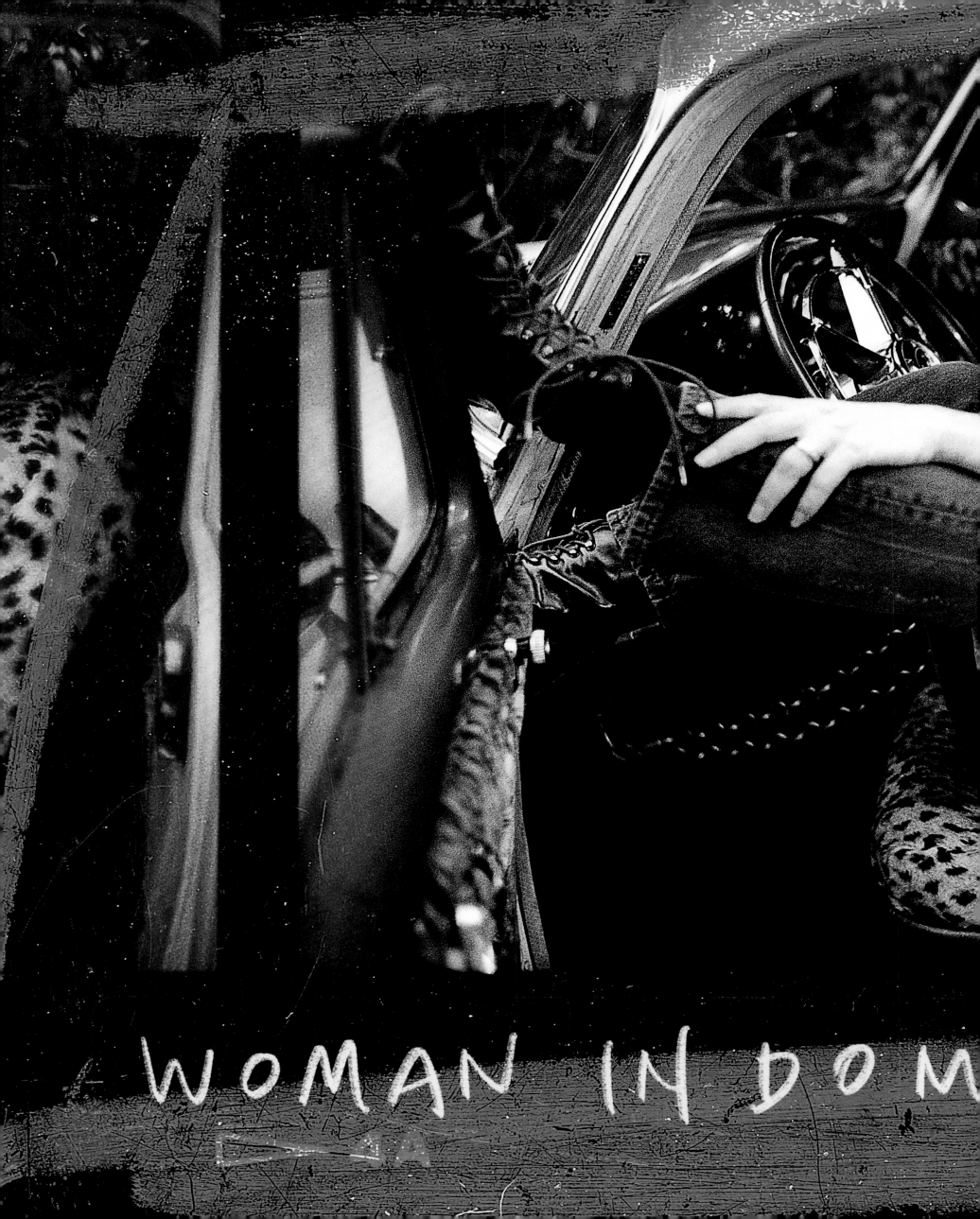

WOMAN IN DOM

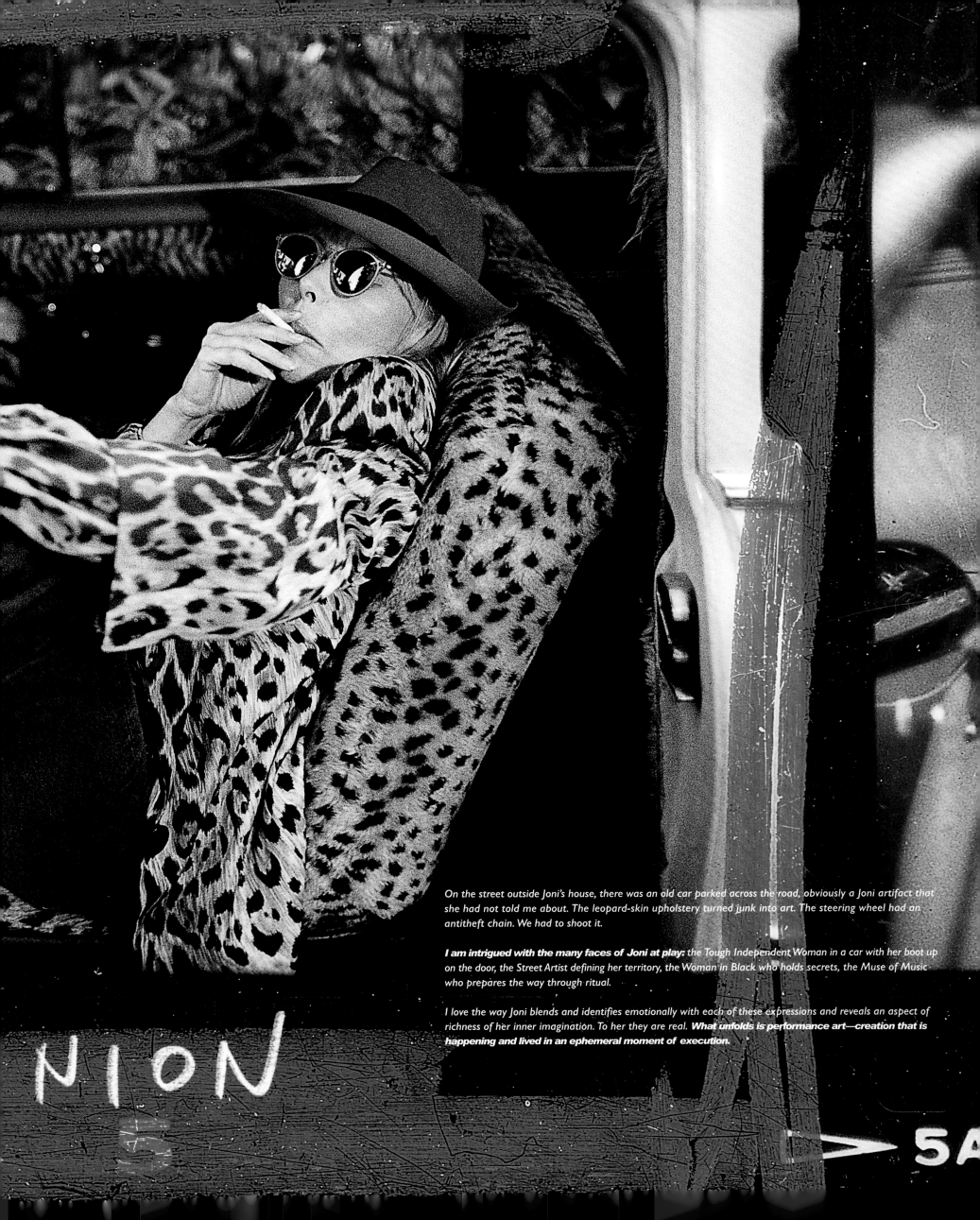

On the street outside Joni's house, there was an old car parked across the road, obviously a Joni artifact that she had not told me about. The leopard-skin upholstery turned junk into art. The steering wheel had an antitheft chain. We had to shoot it.

I am intrigued with the many faces of Joni at play: the Tough Independent Woman in a car with her boot up on the door, the Street Artist defining her territory, the Woman in Black who holds secrets, the Muse of Music who prepares the way through ritual.

I love the way Joni blends and identifies emotionally with each of these expressions and reveals an aspect of richness of her inner imagination. To her they are real. **What unfolds is performance art—creation that is happening and lived in an ephemeral moment of execution.**

NION

5A

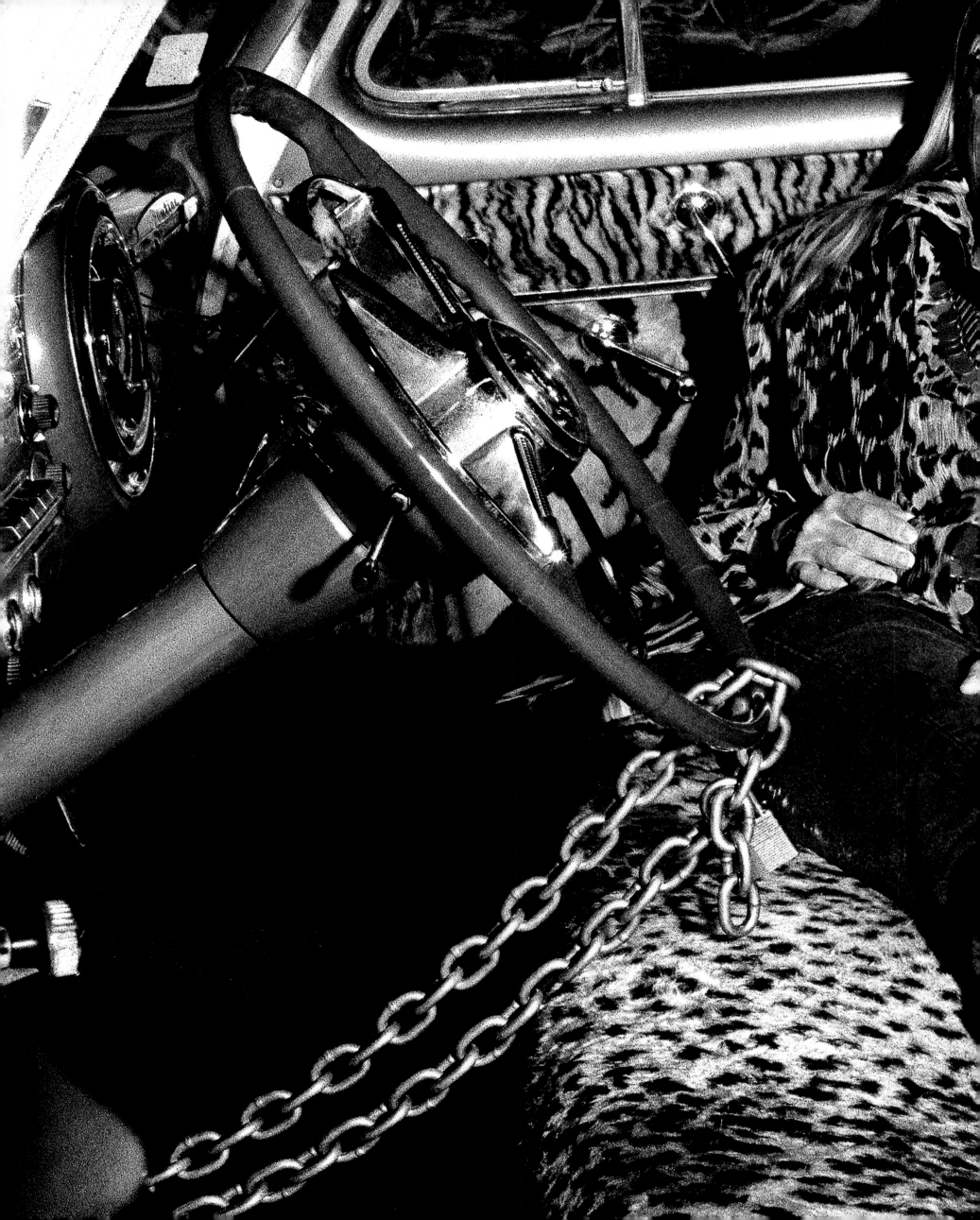

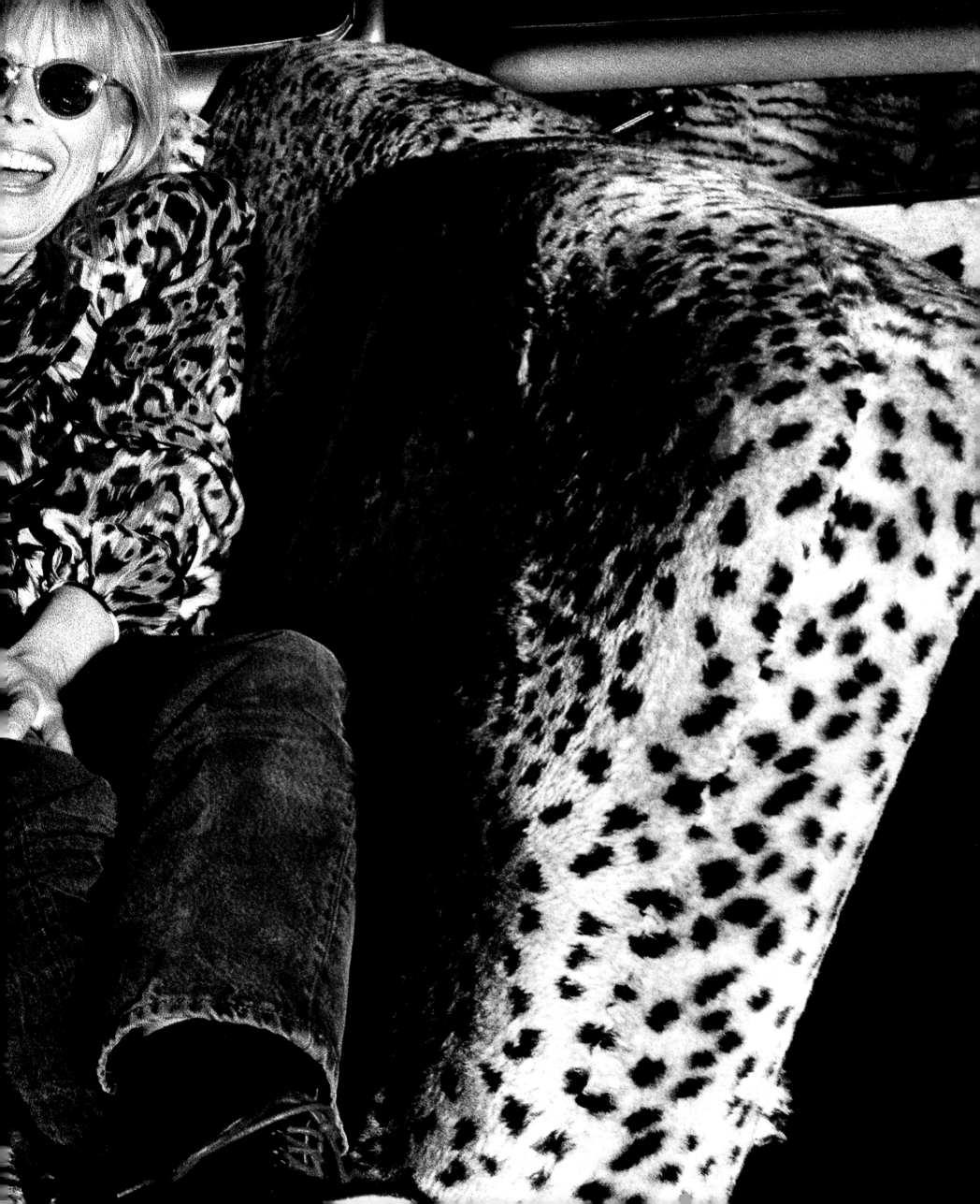

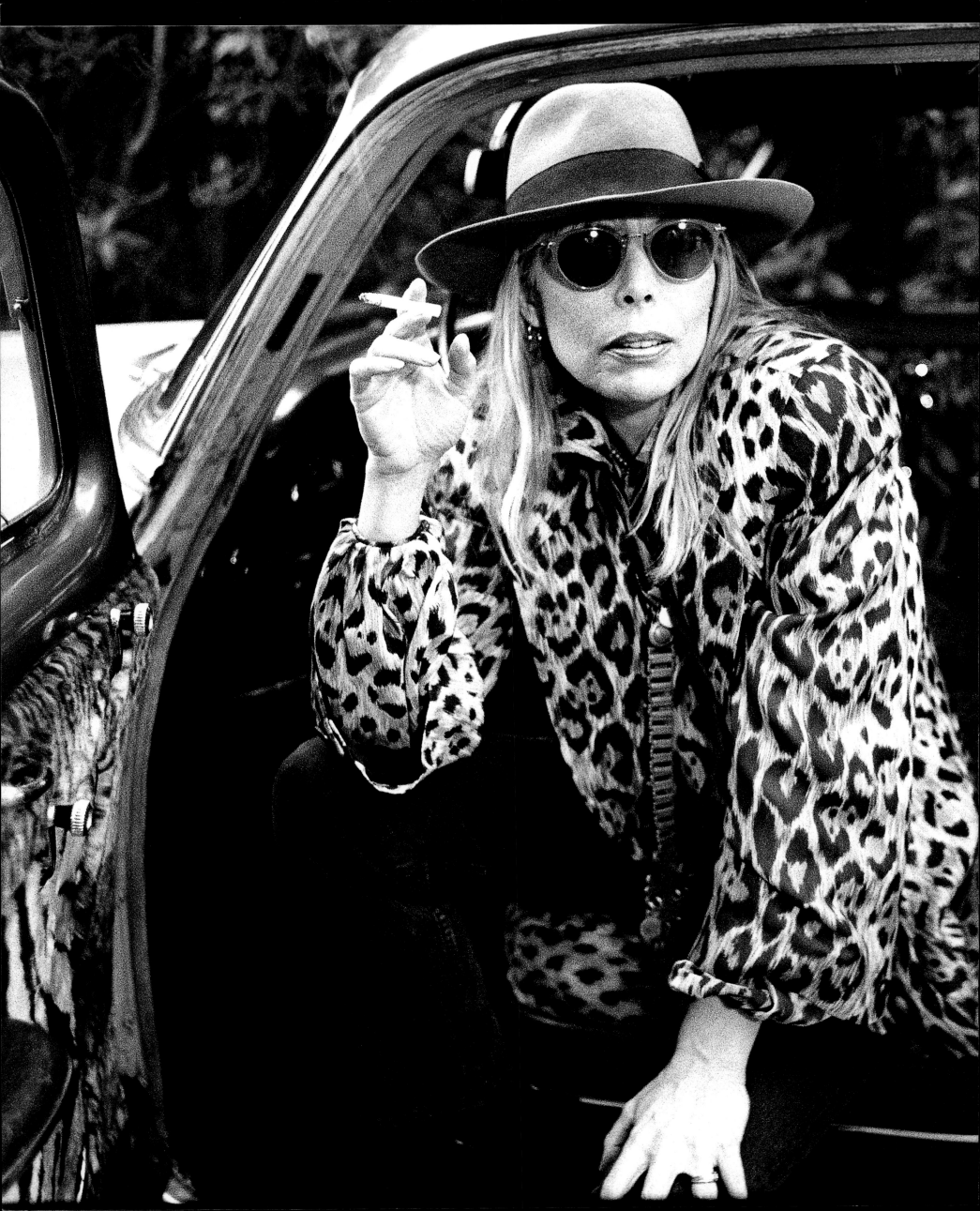

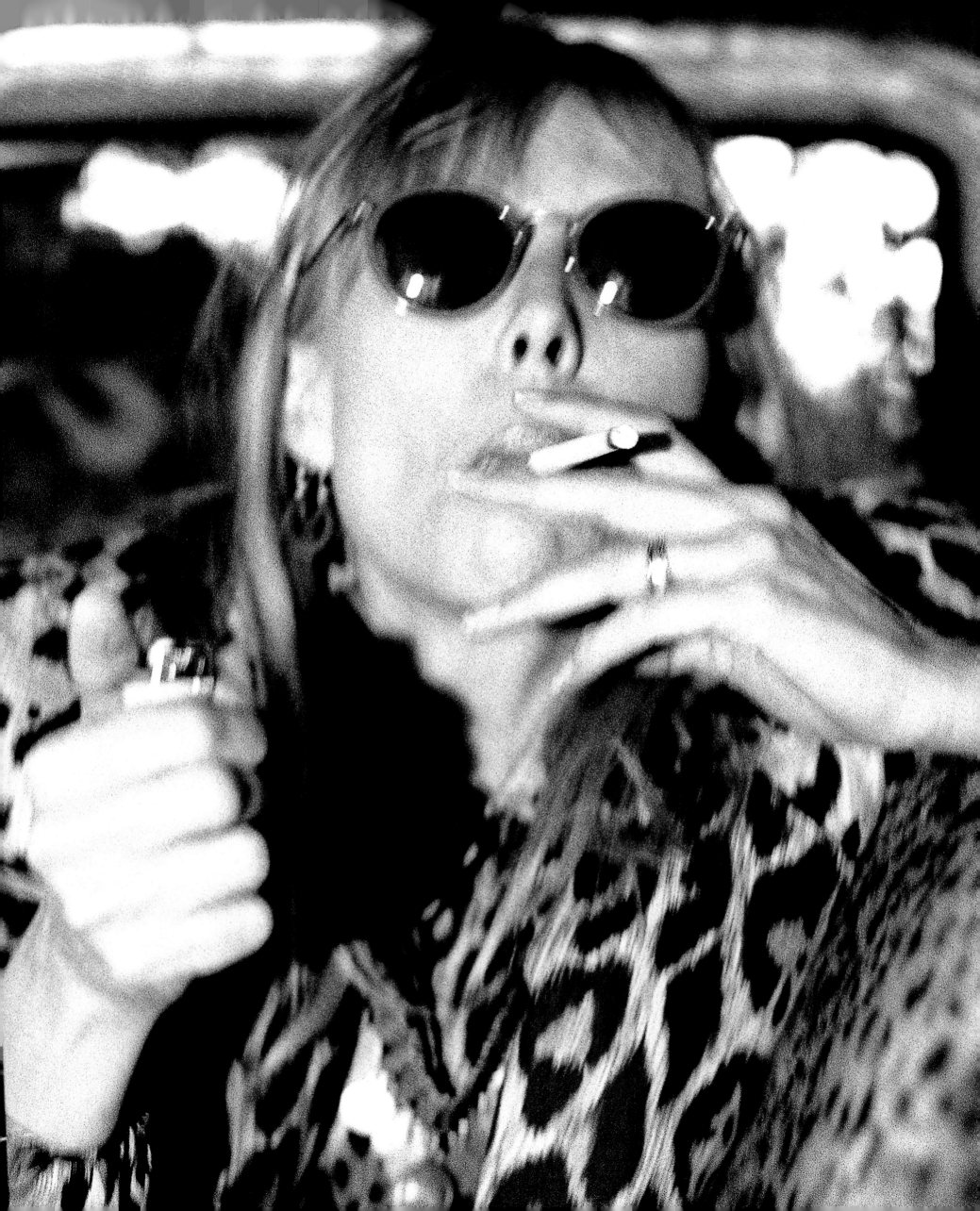

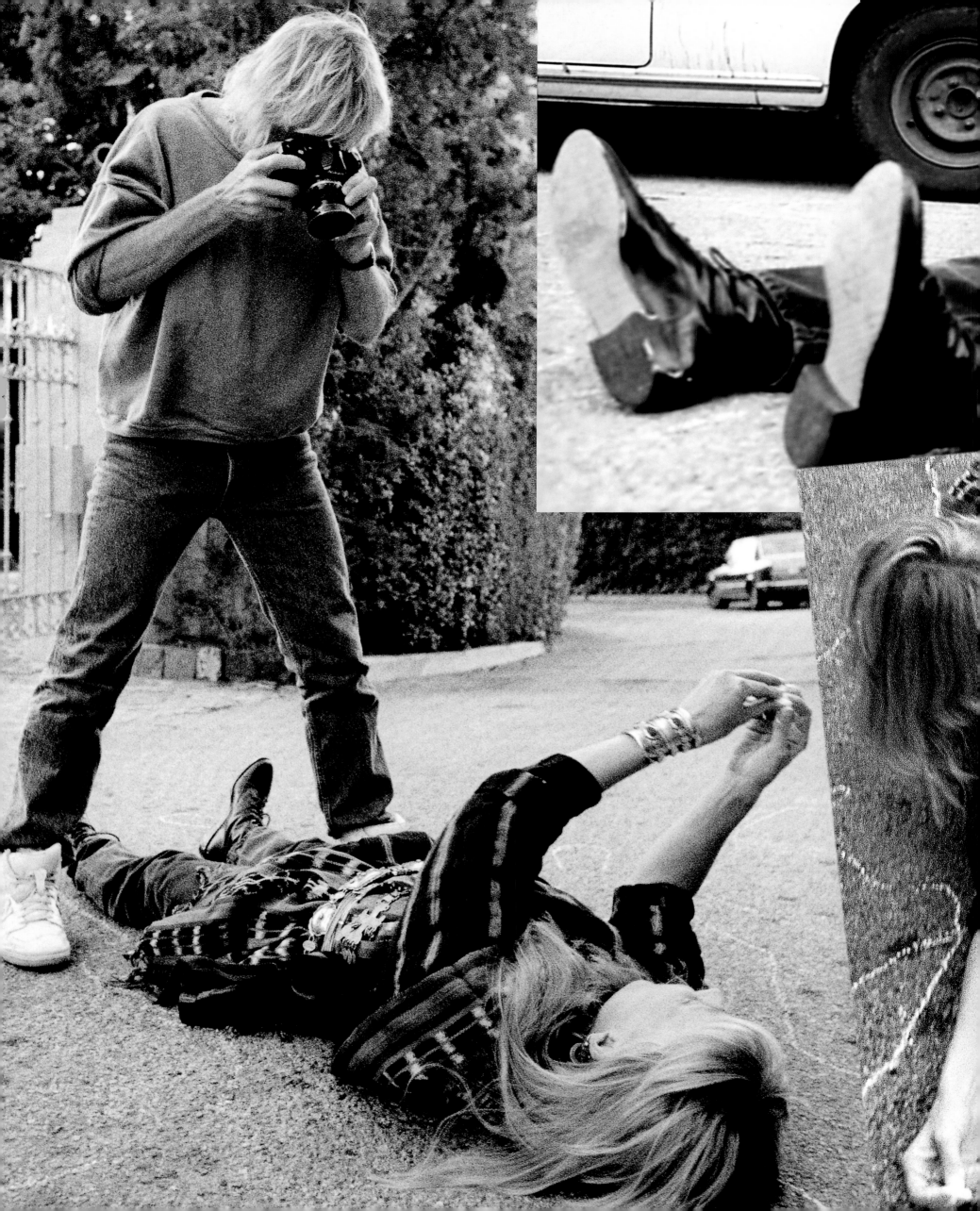

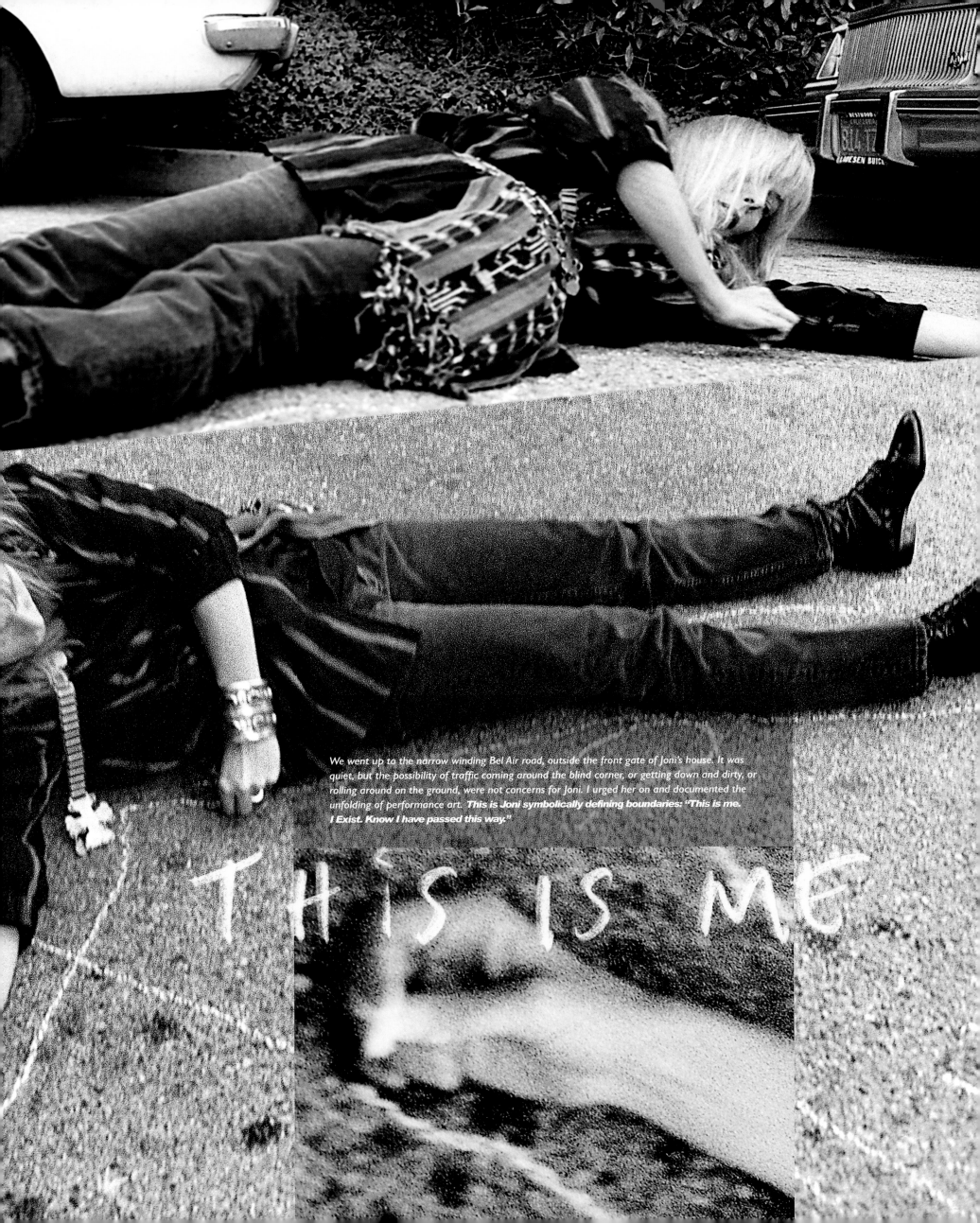

We went up to the narrow winding Bel Air road, outside the front gate of Joni's house. It was quiet, but the possibility of traffic coming around the blind corner, or getting down and dirty, or rolling around on the ground, were not concerns for Joni. I urged her on and documented the unfolding of performance art. **This is Joni symbolically defining boundaries: "This is me. I Exist. Know I have passed this way."**

THIS IS ME

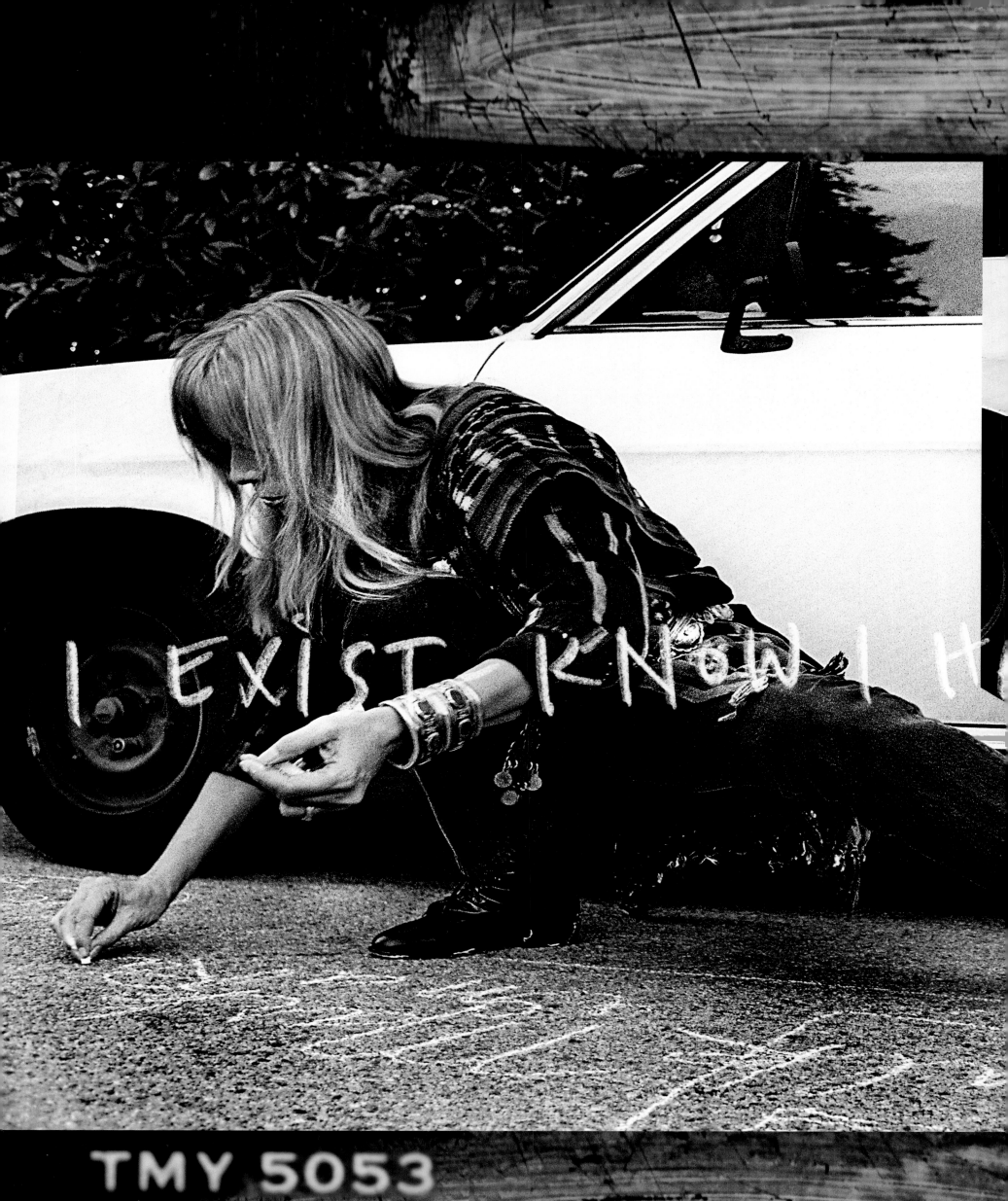

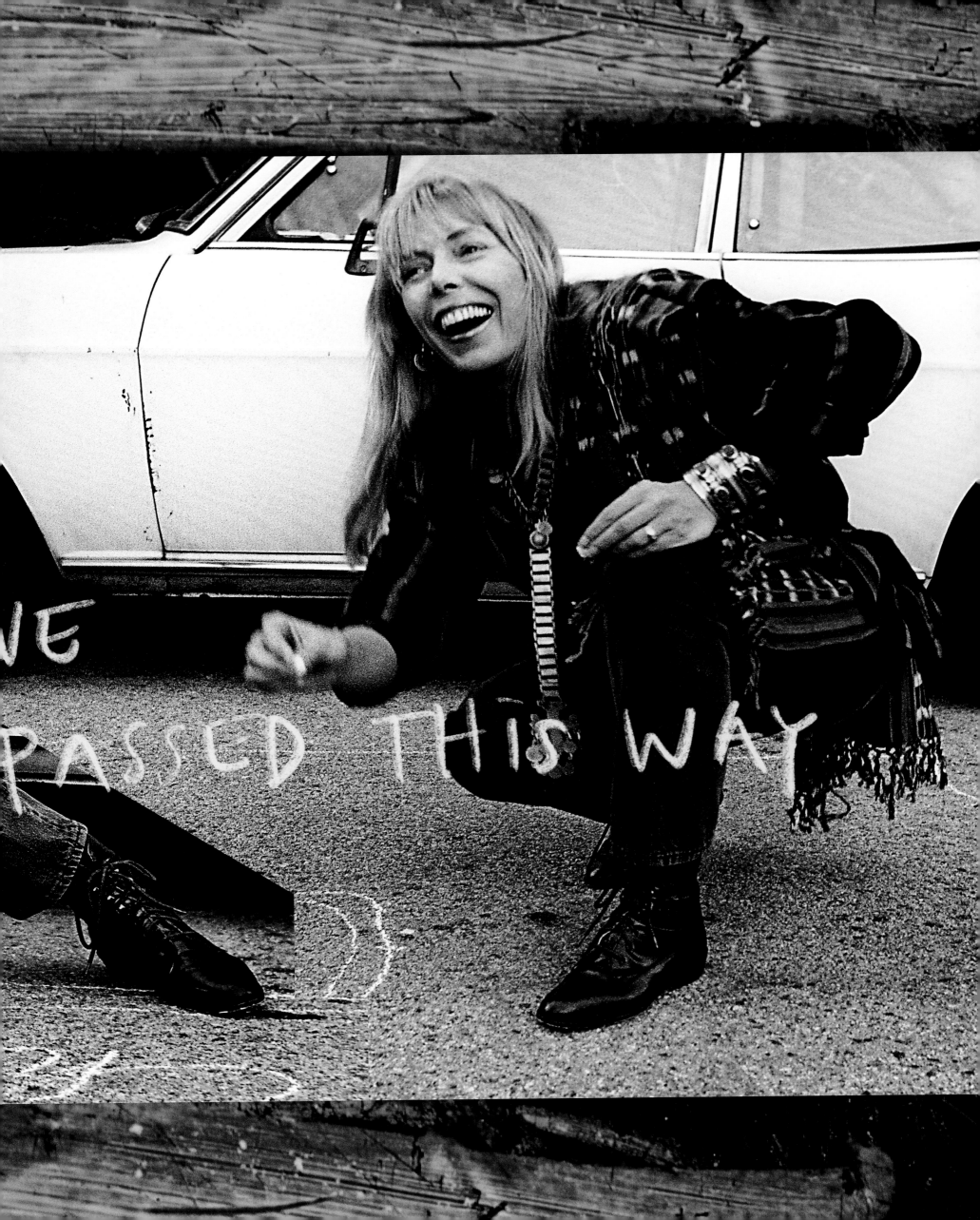

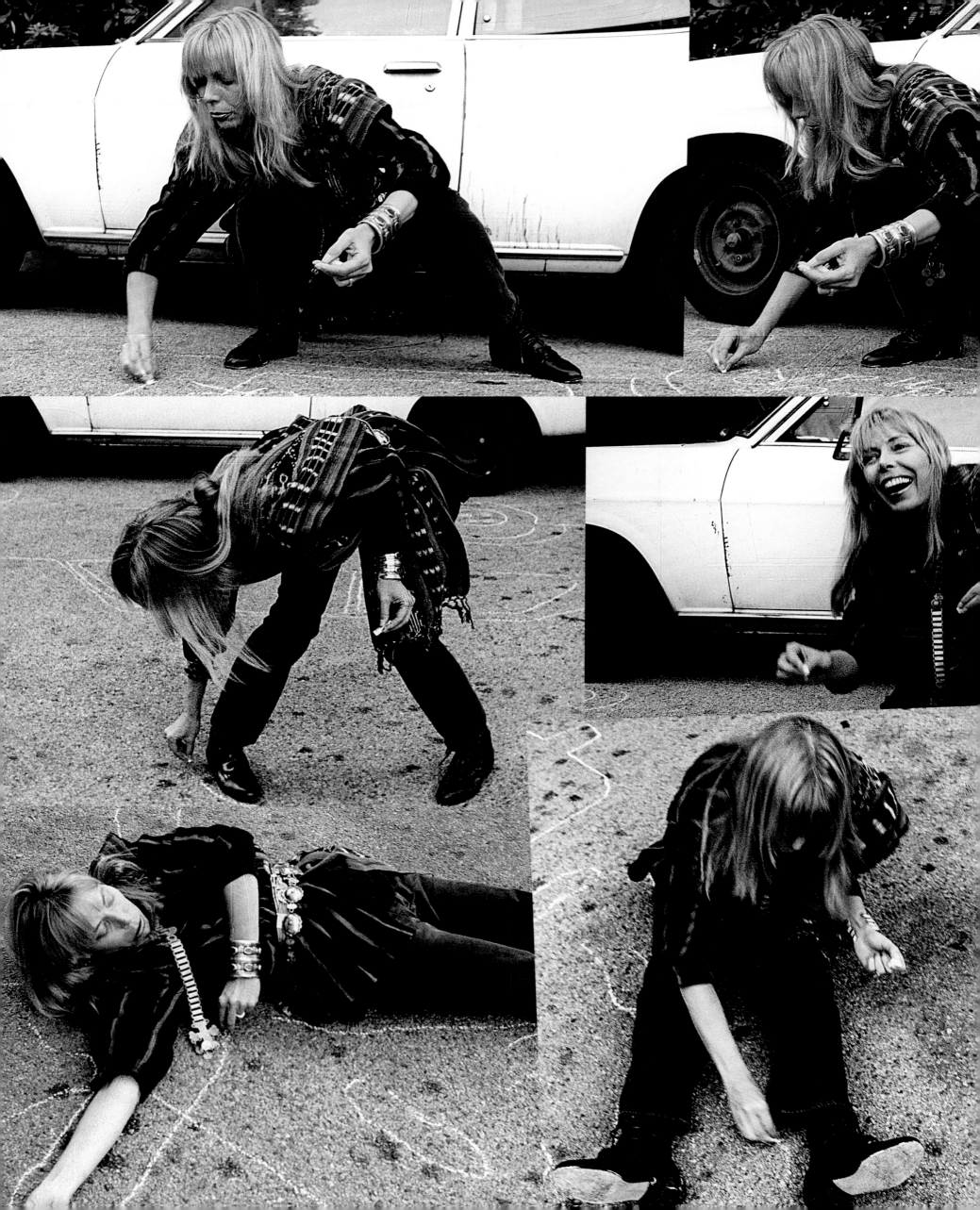

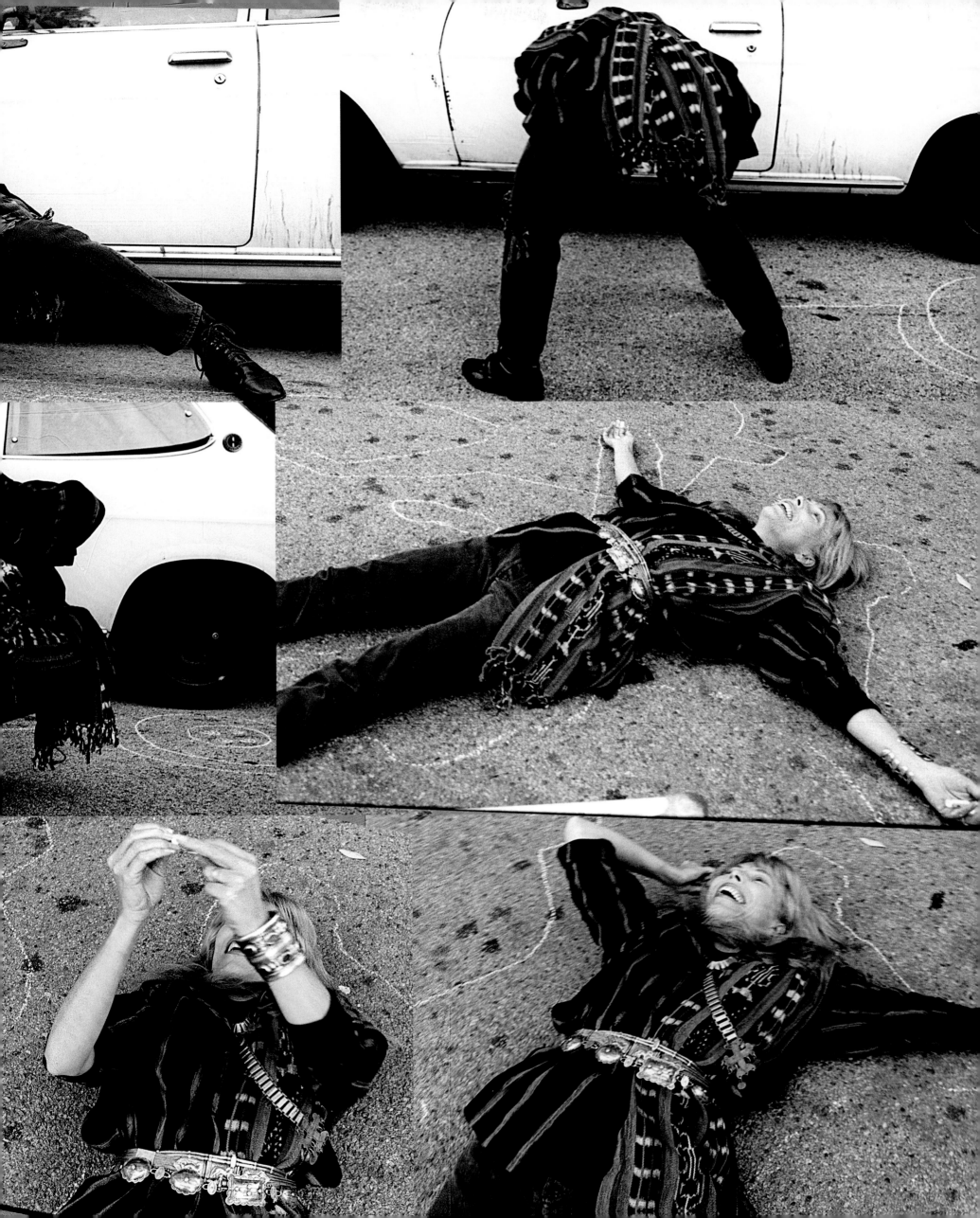

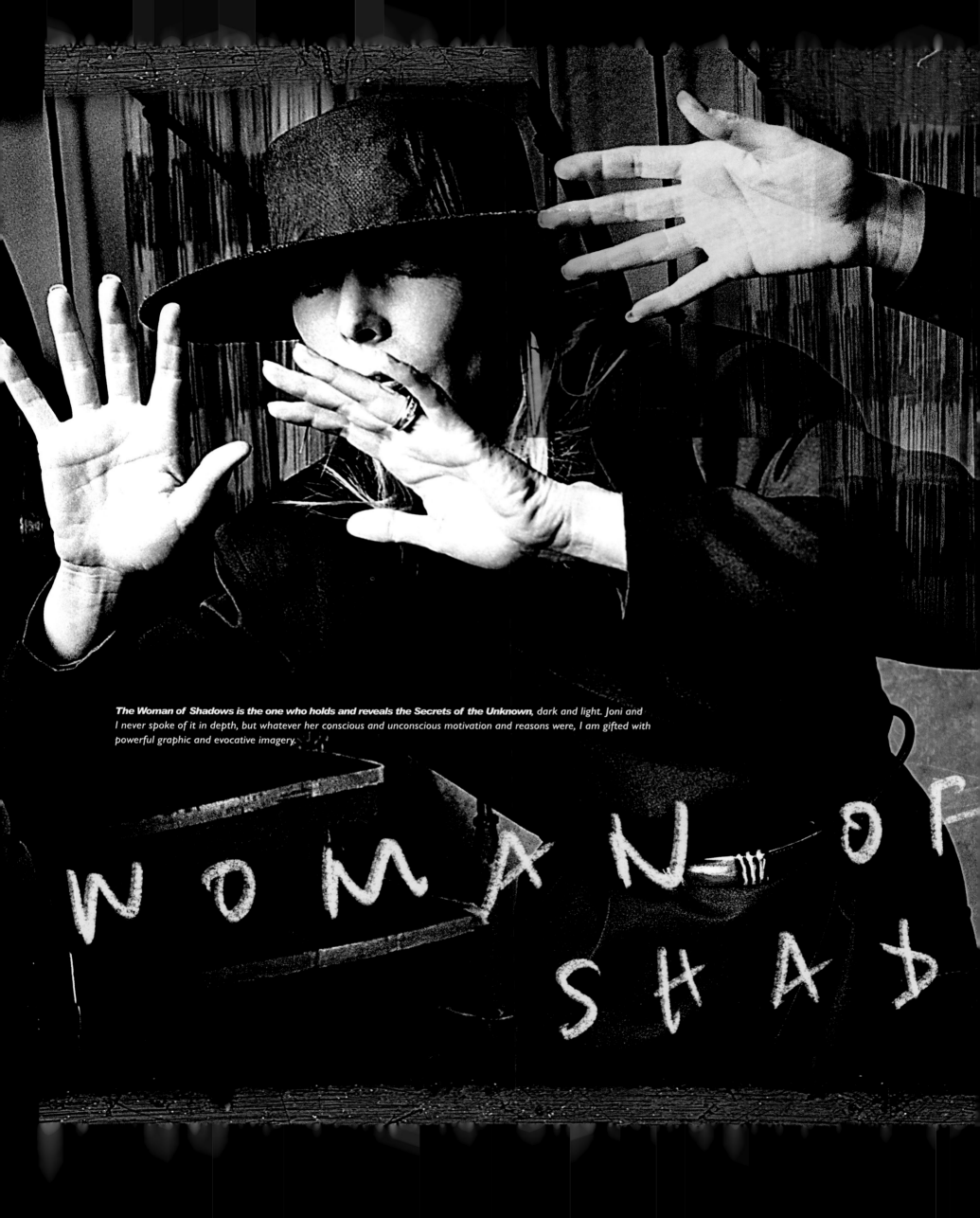

The Woman of Shadows is the one who holds and reveals the Secrets of the Unknown, dark and light. Joni and I never spoke of it in depth, but whatever her conscious and unconscious motivation and reasons were, I am gifted with powerful graphic and evocative imagery.

WOMAN OF

SHAD

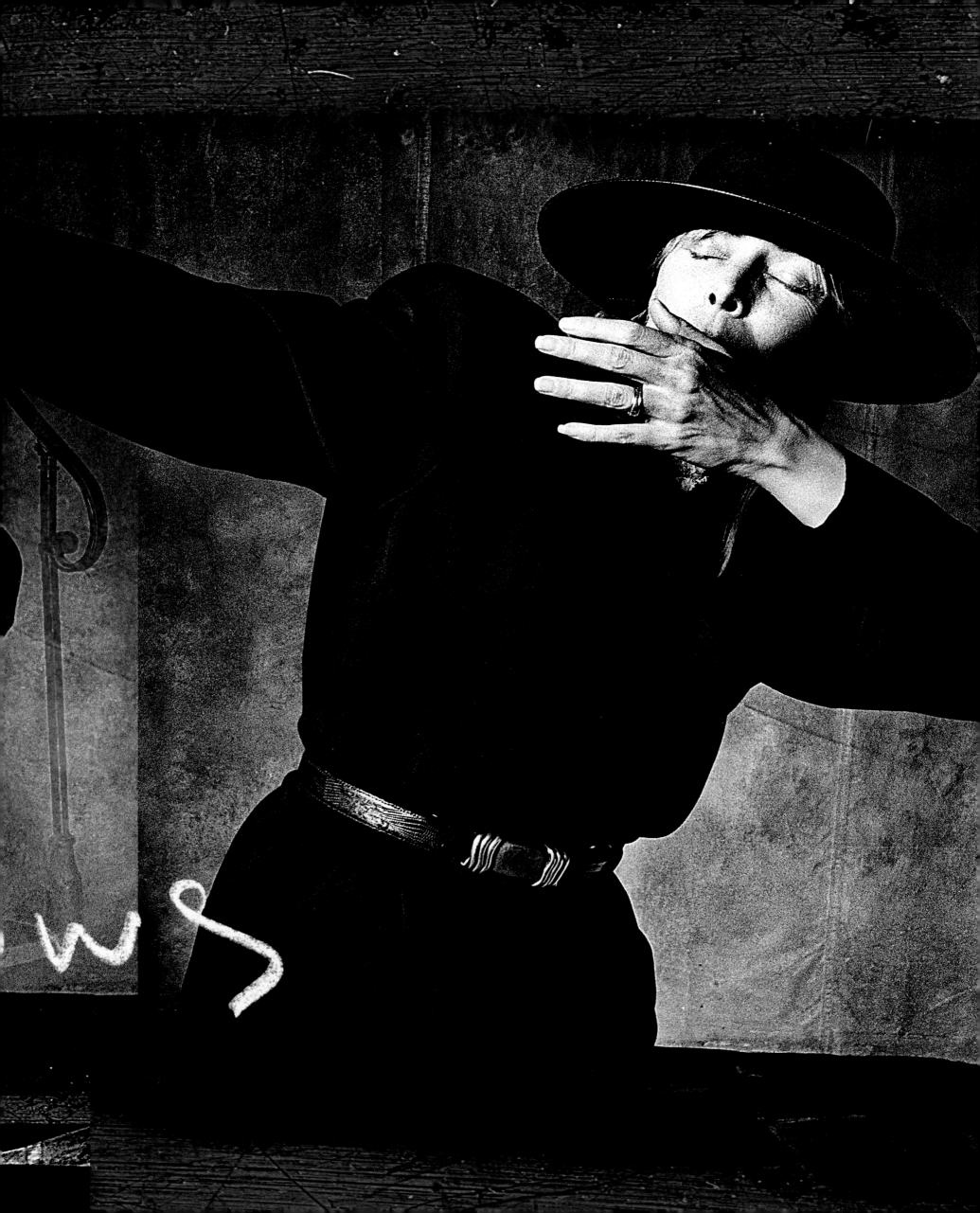

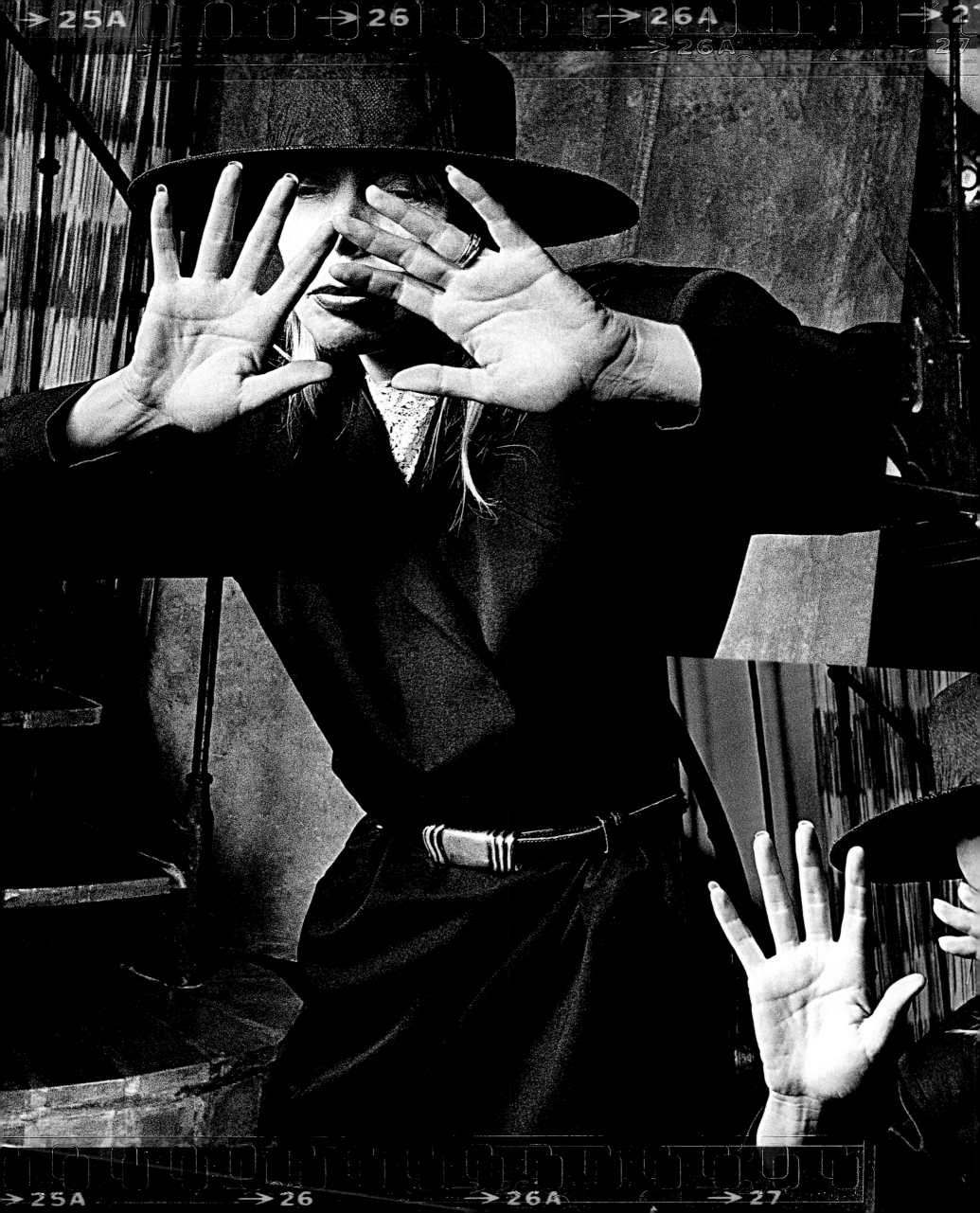

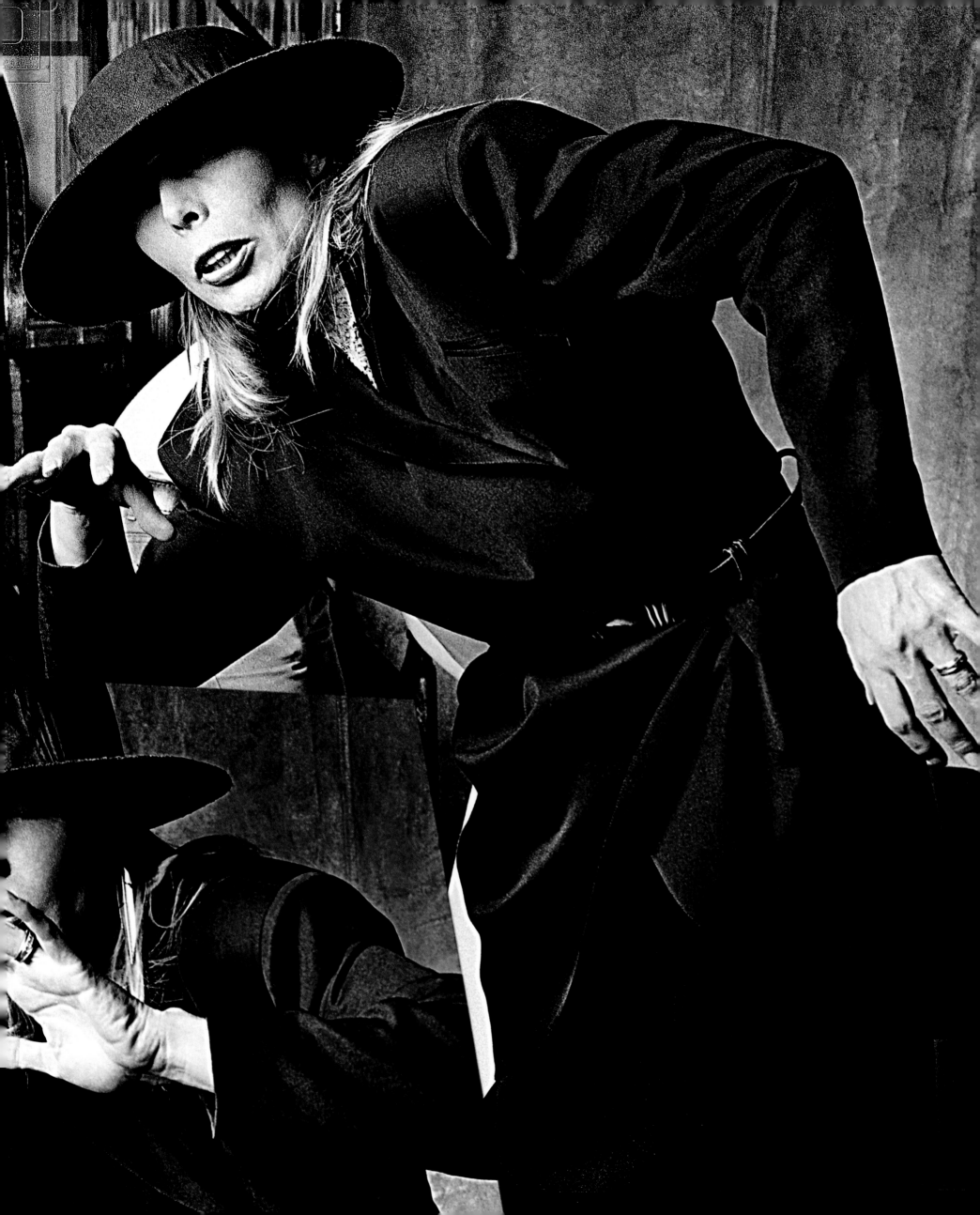

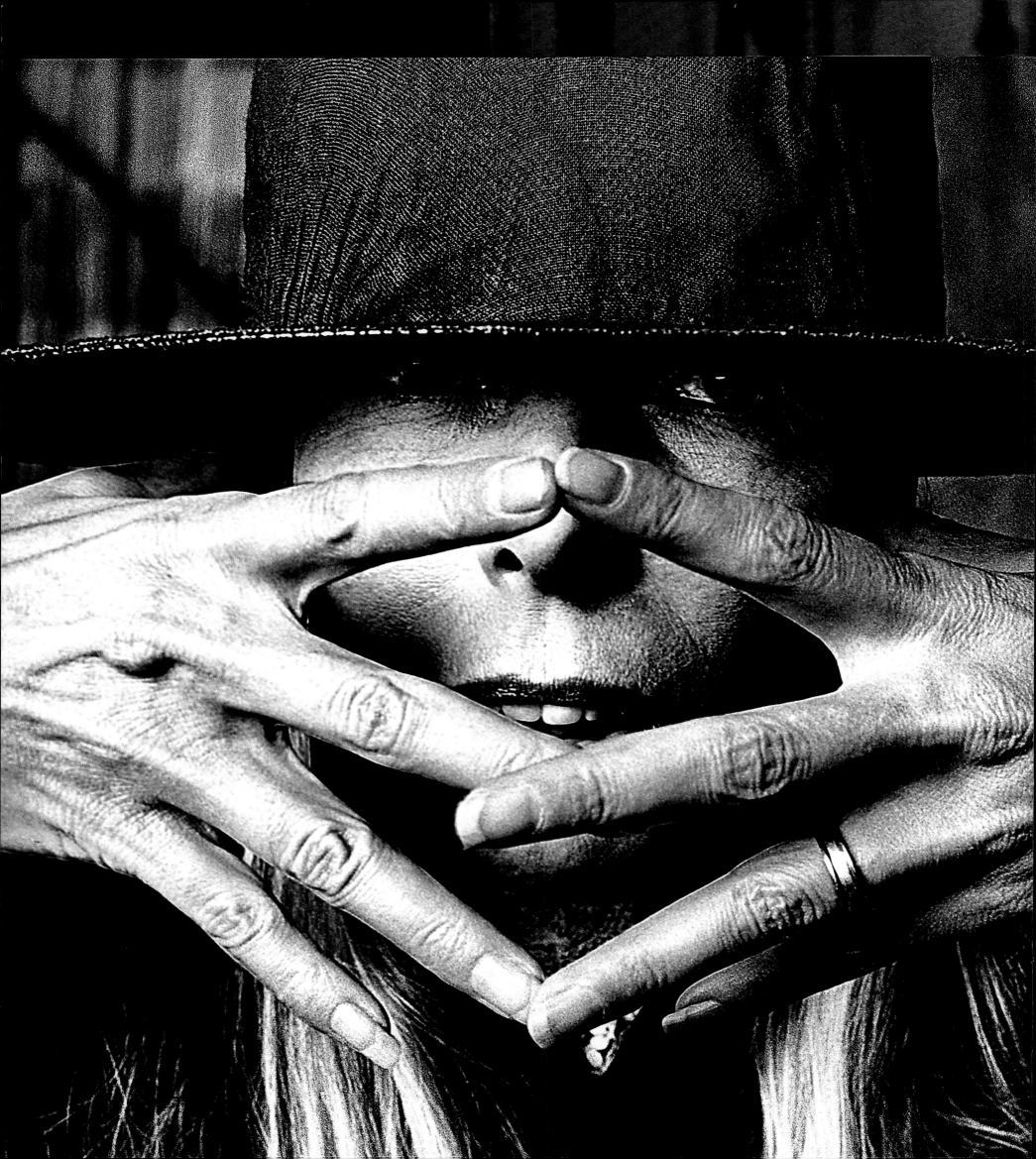

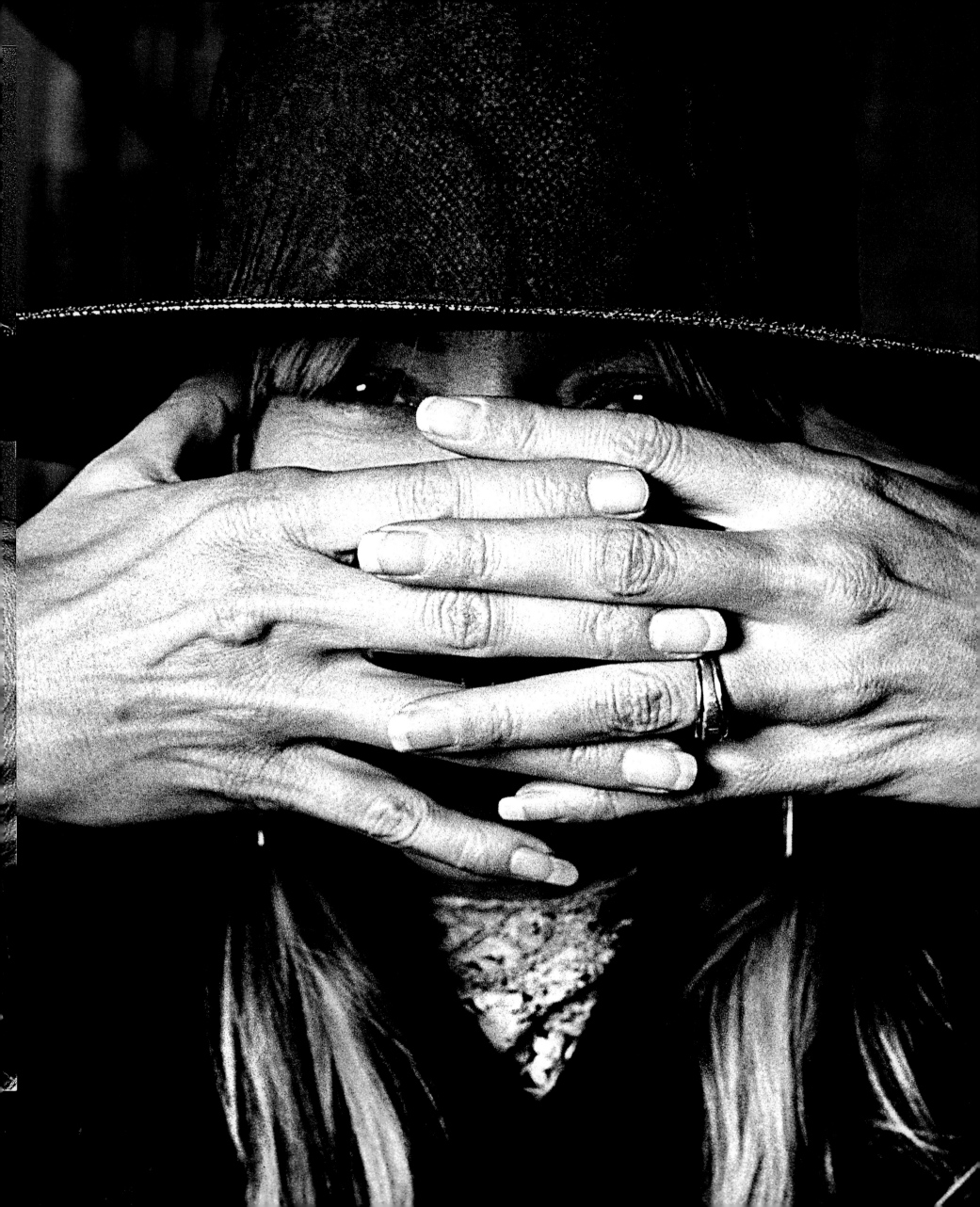

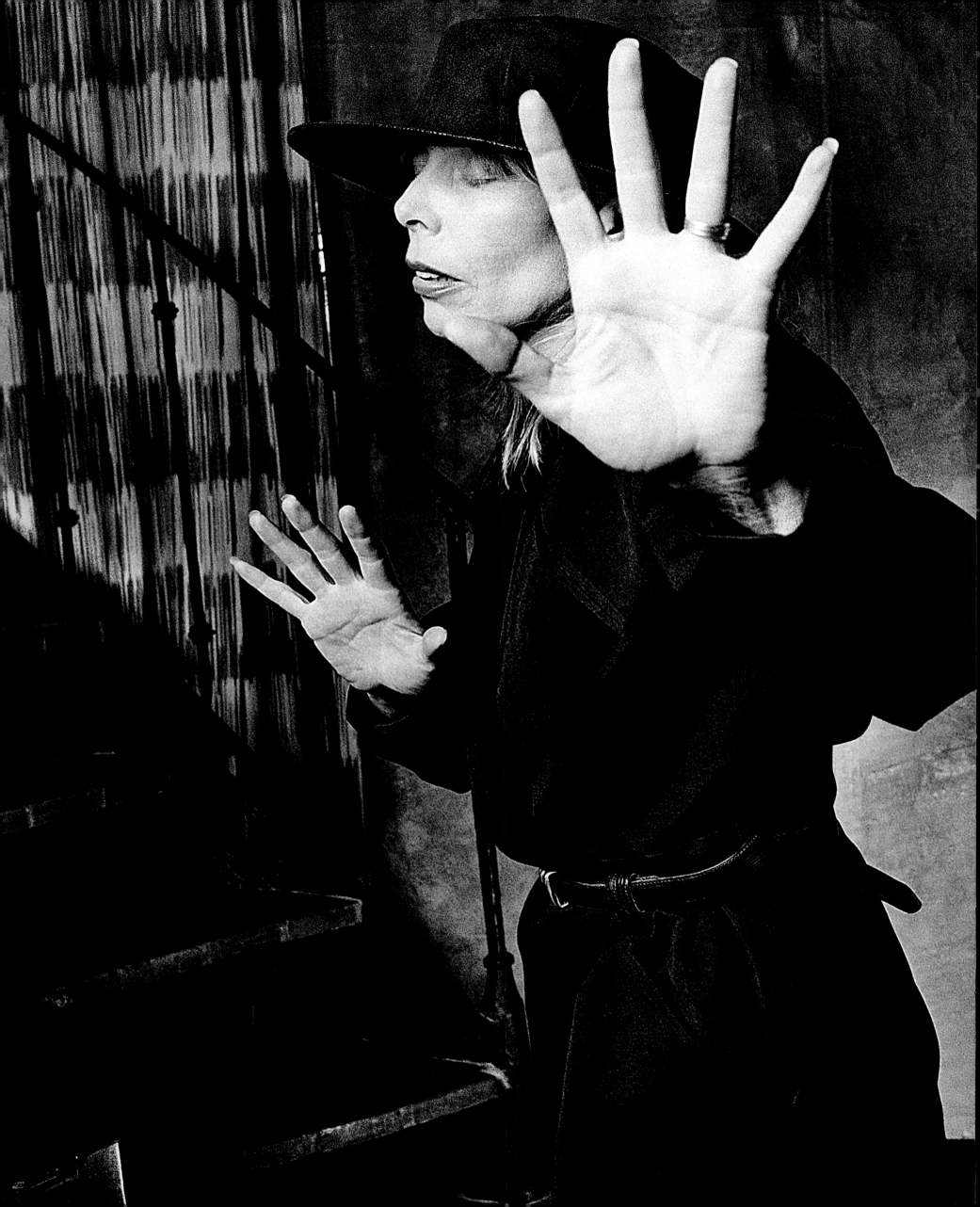

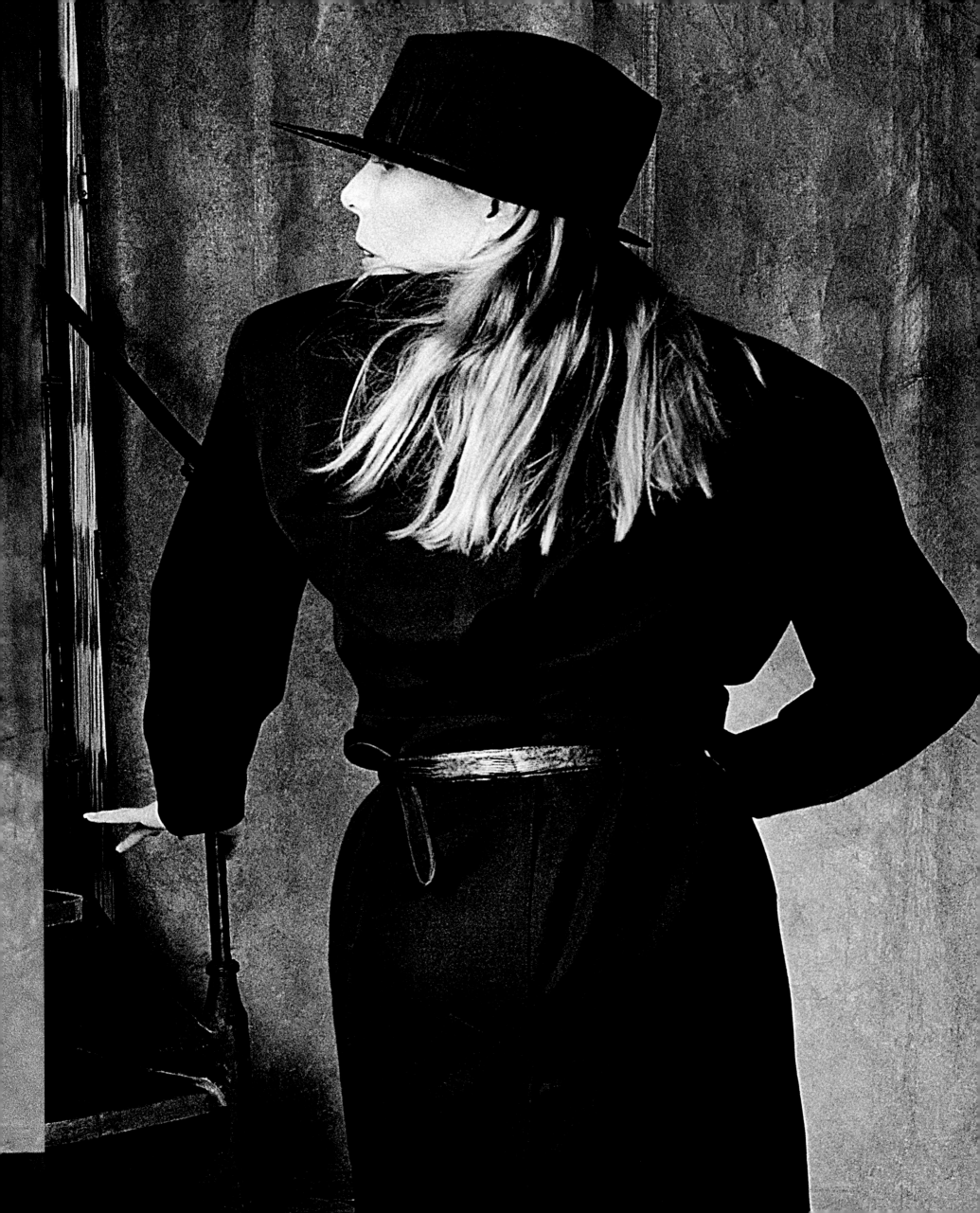

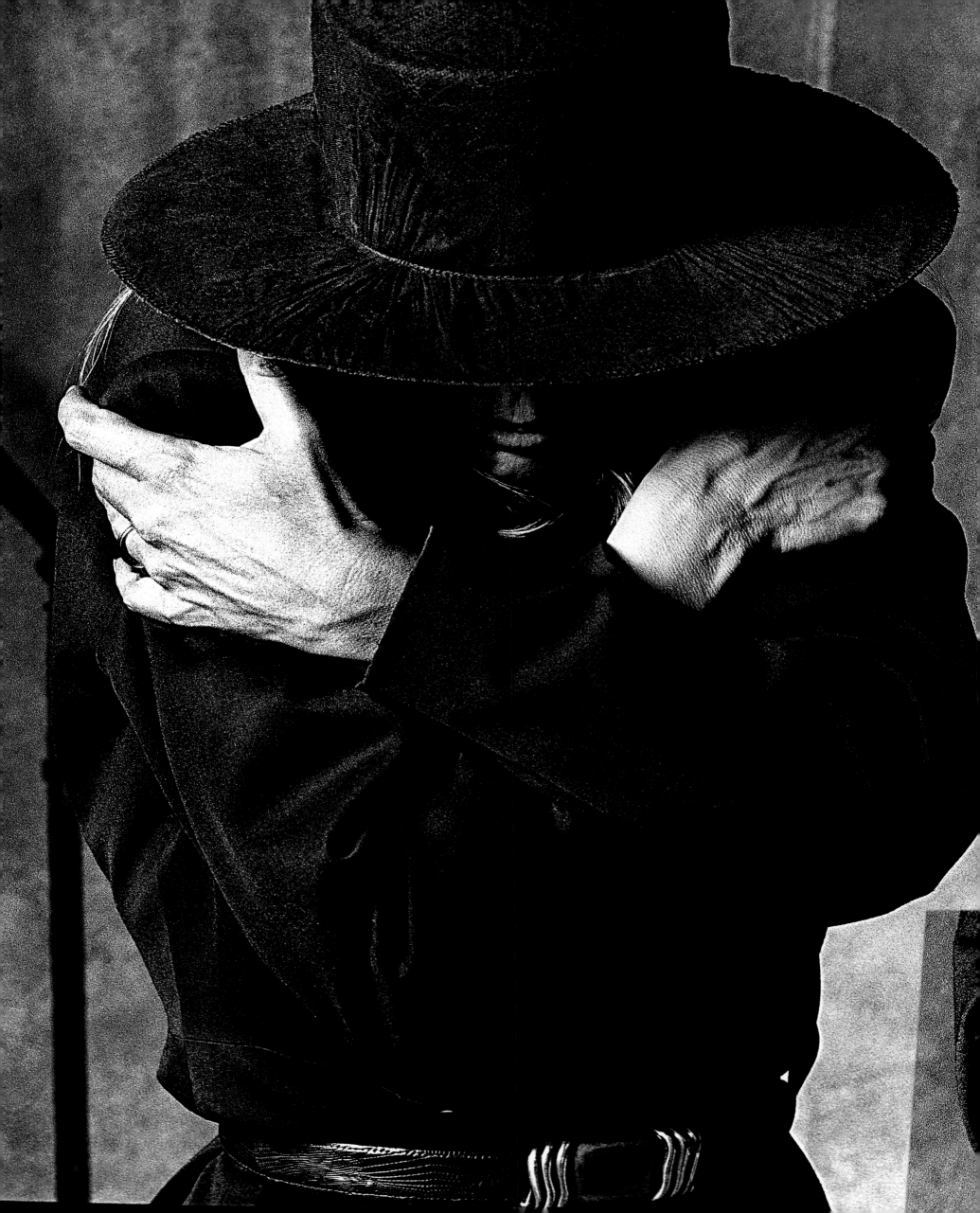

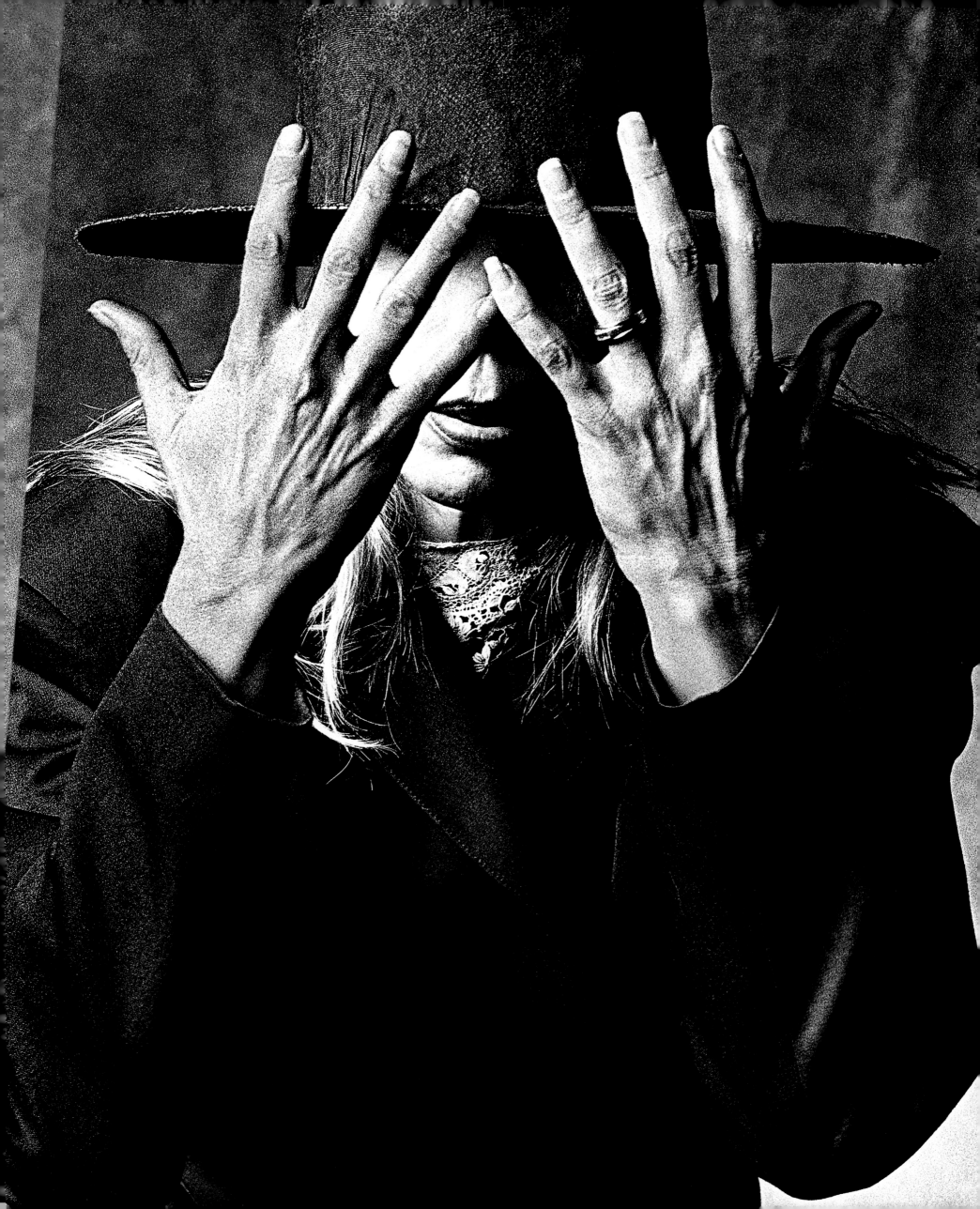

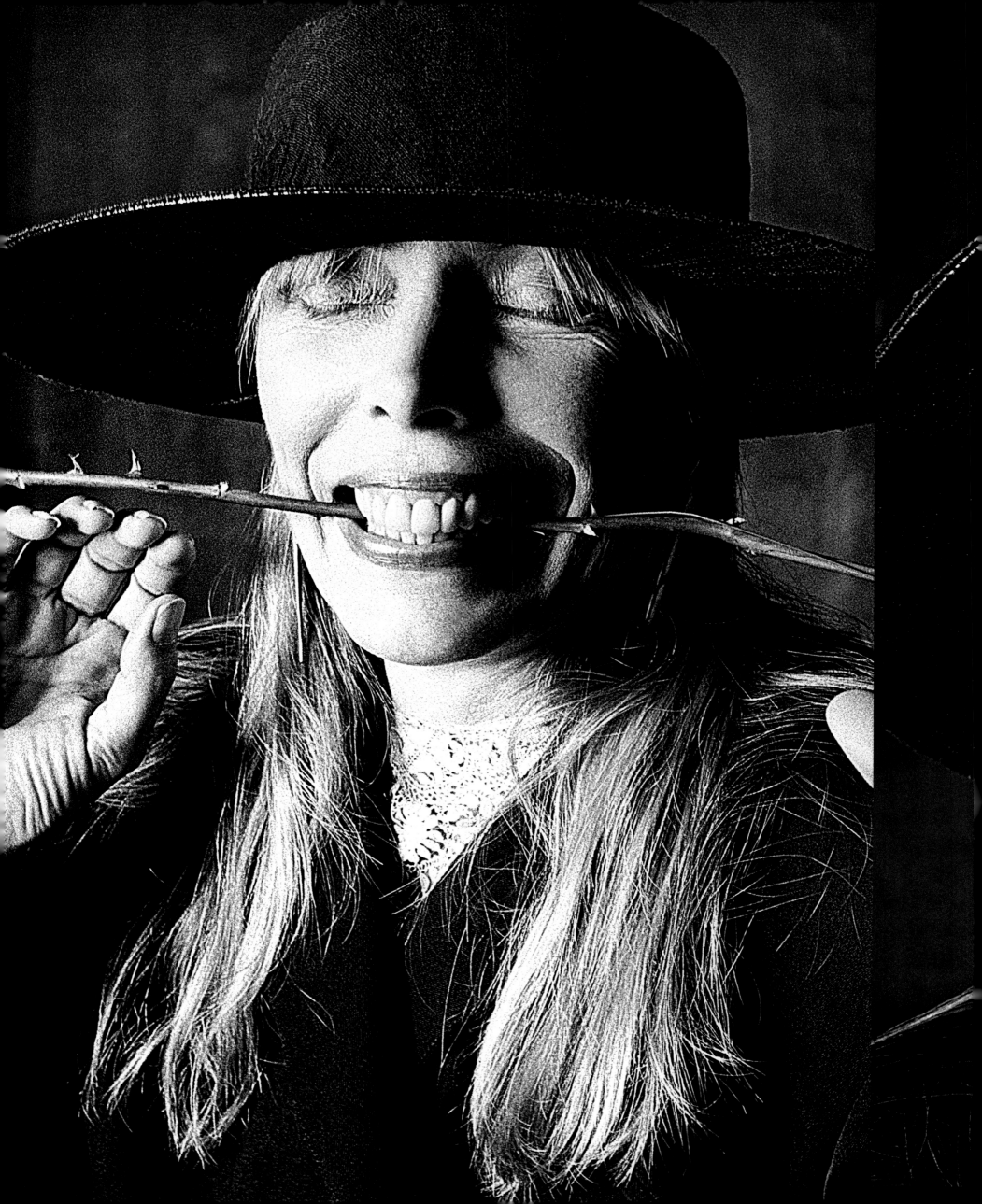

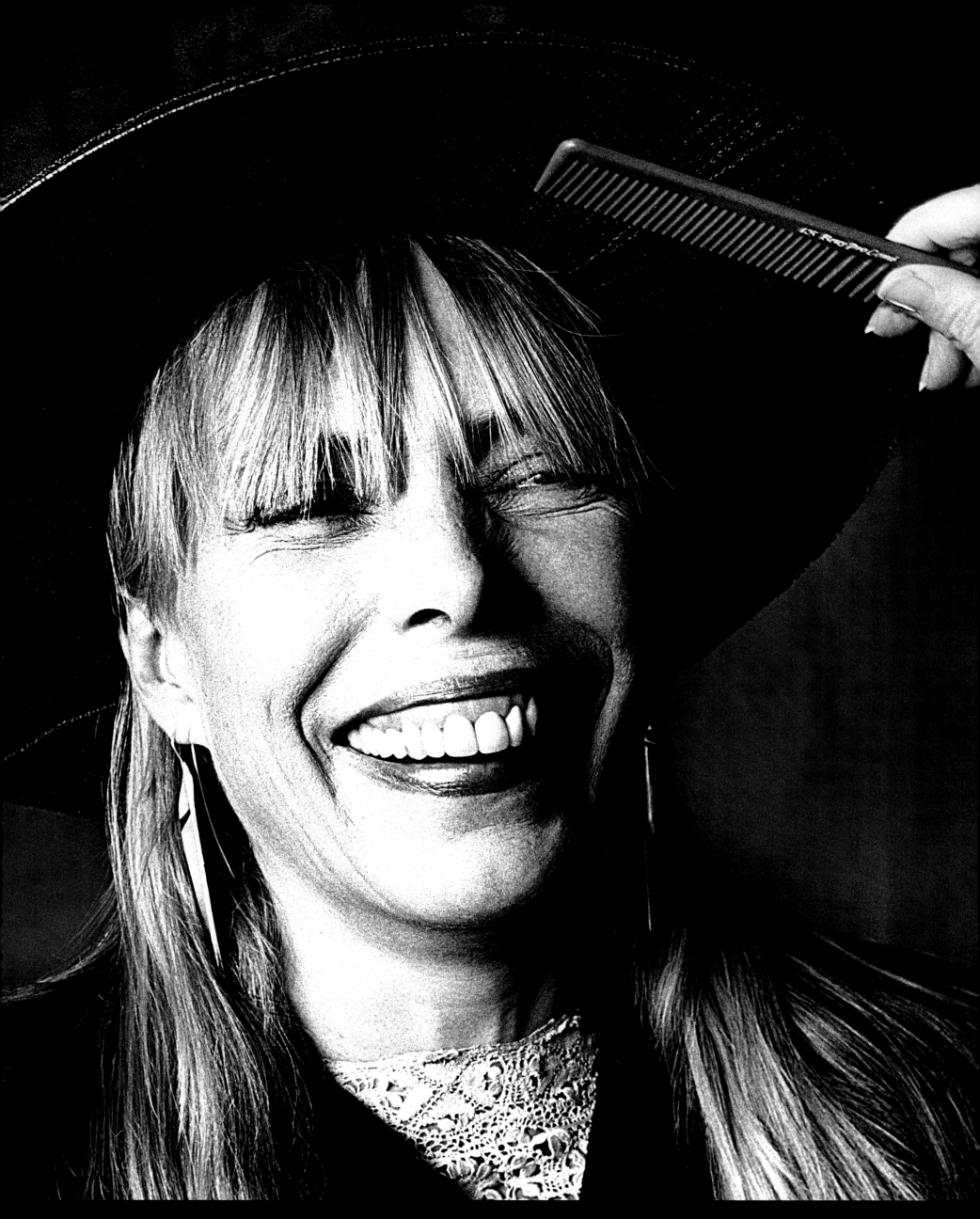

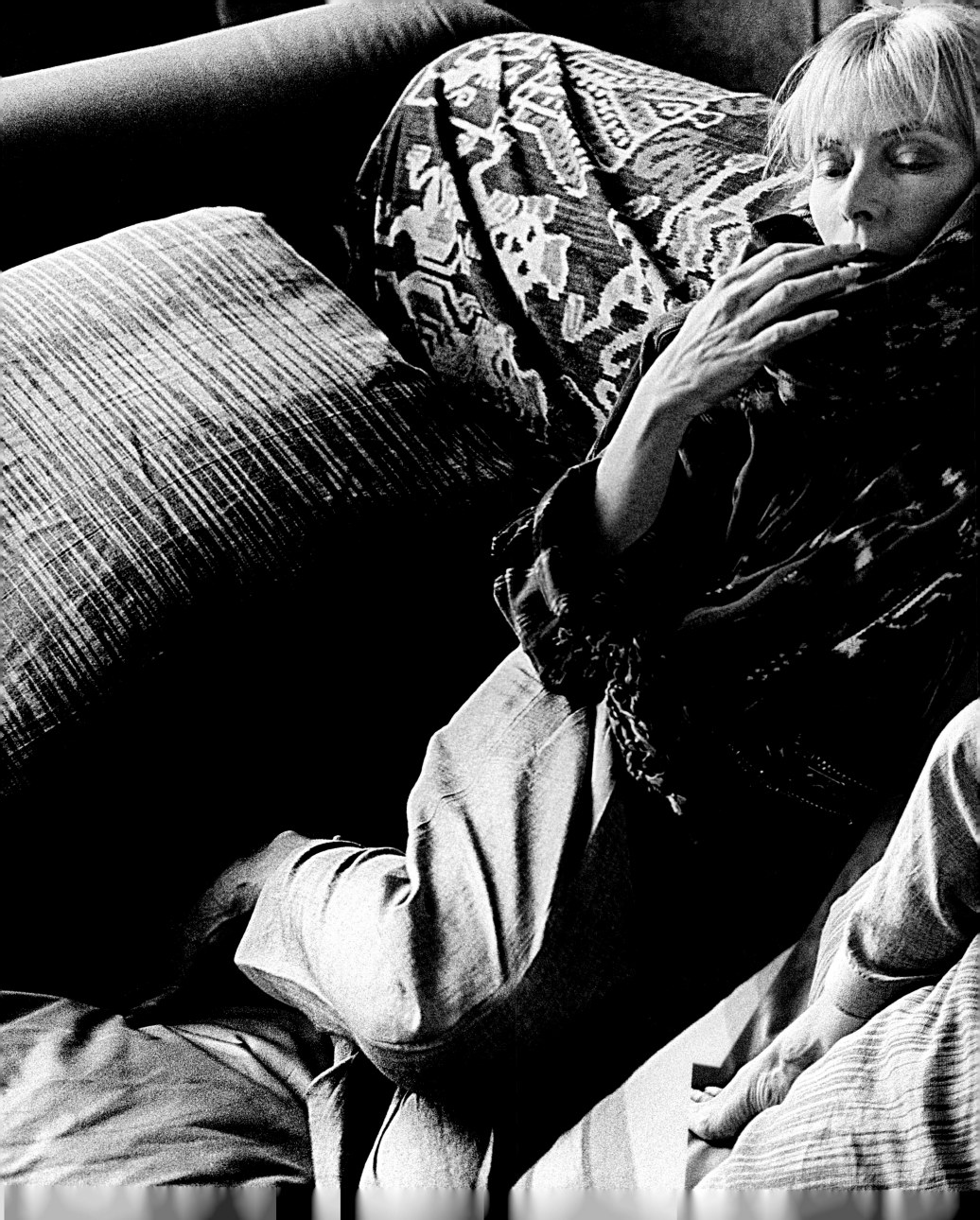

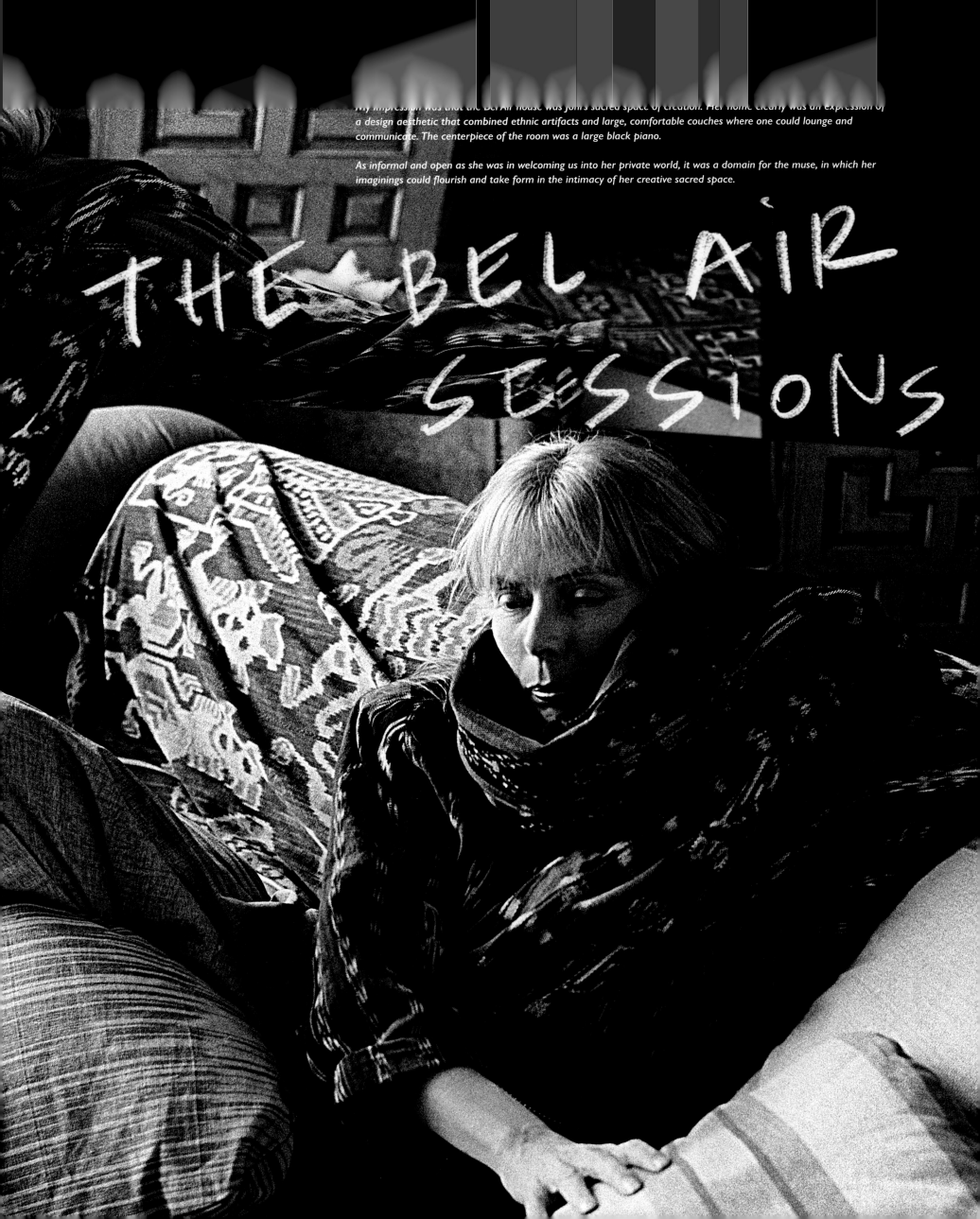

My impression was that the Bel Air house was Joni's sacred space of creation. Her home clearly was an expression of a design aesthetic that combined ethnic artifacts and large, comfortable couches where one could lounge and communicate. The centerpiece of the room was a large black piano.

As informal and open as she was in welcoming us into her private world, it was a domain for the muse, in which her imaginings could flourish and take form in the intimacy of her creative sacred space.

THE BEL AIR SESSIONS

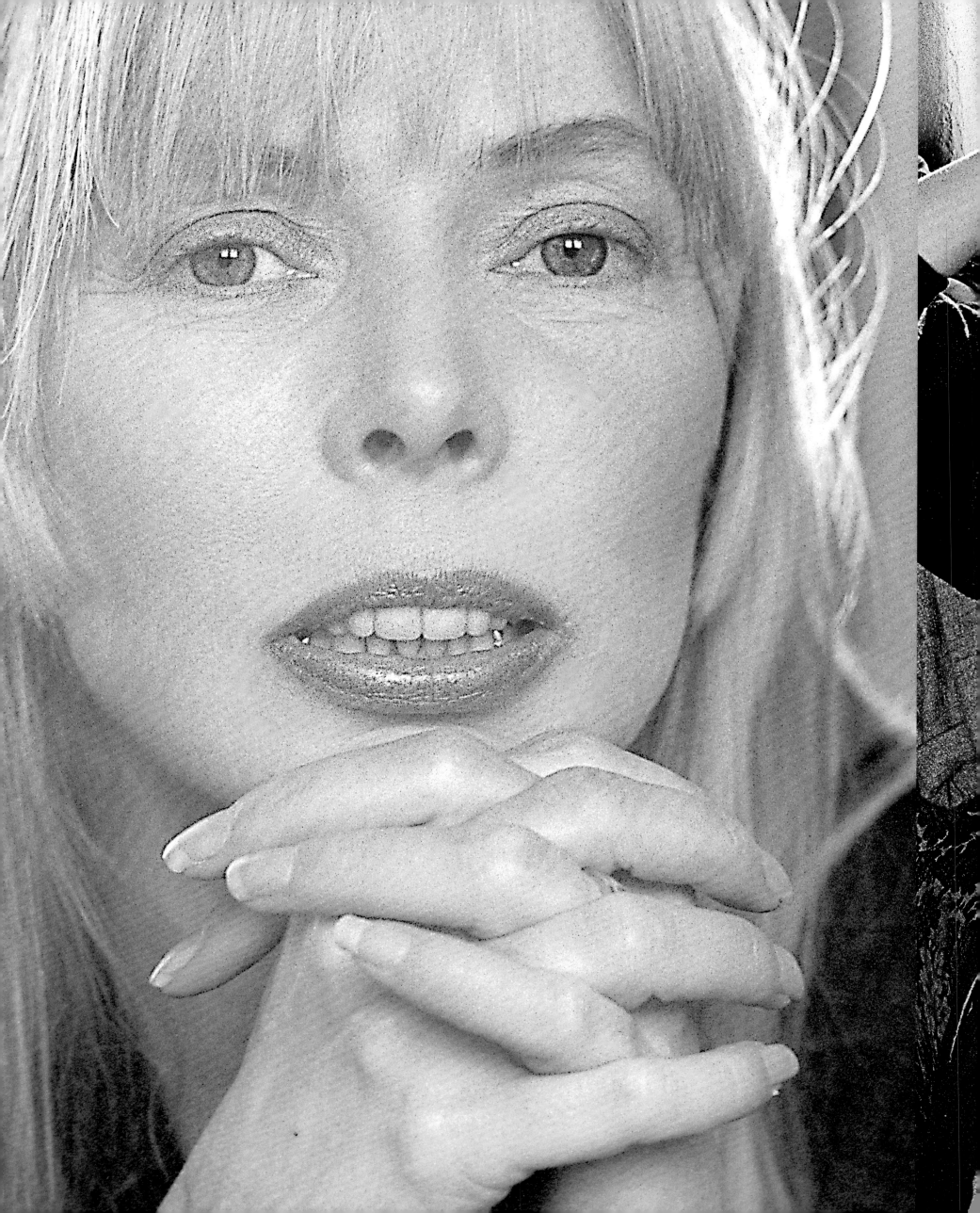

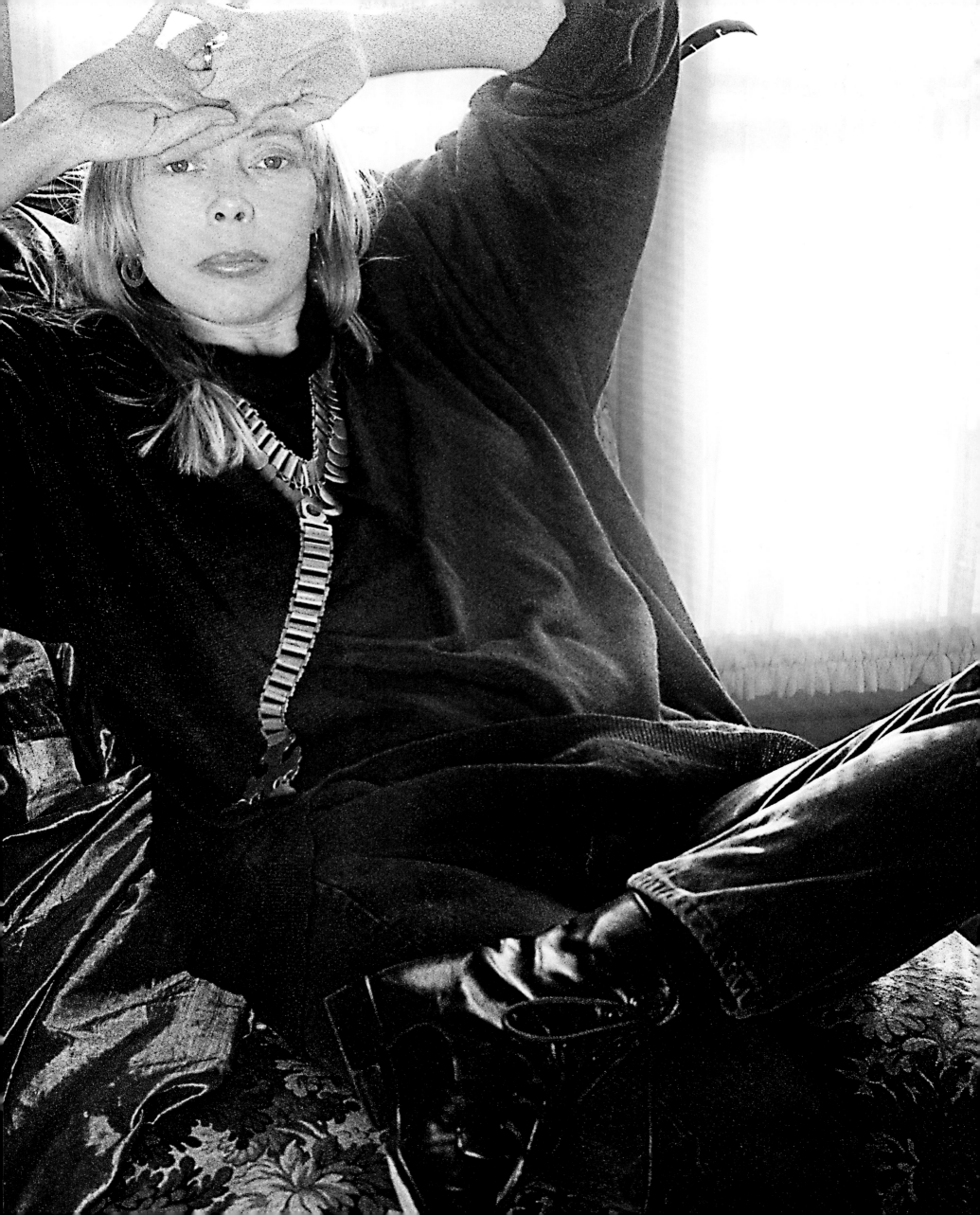

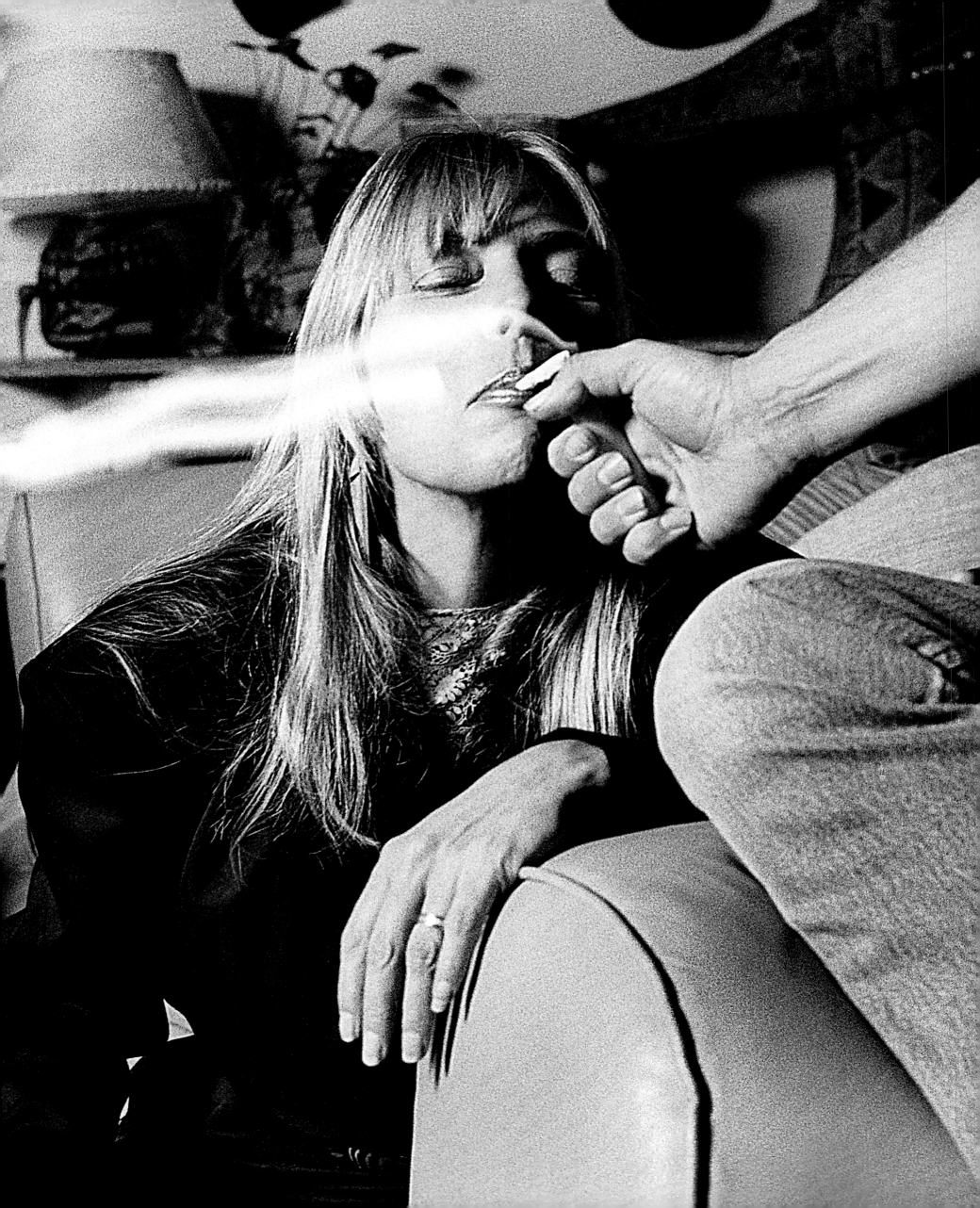

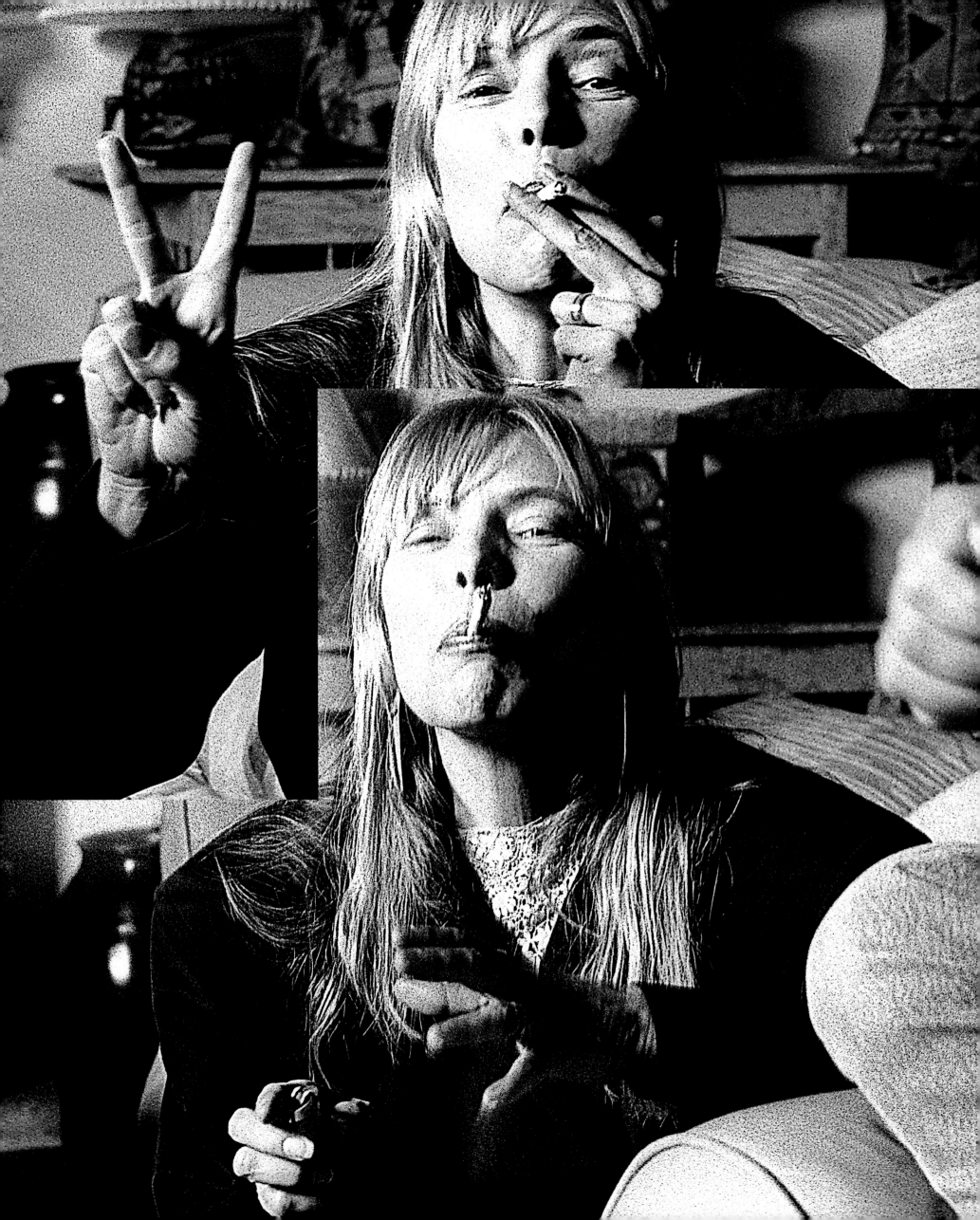

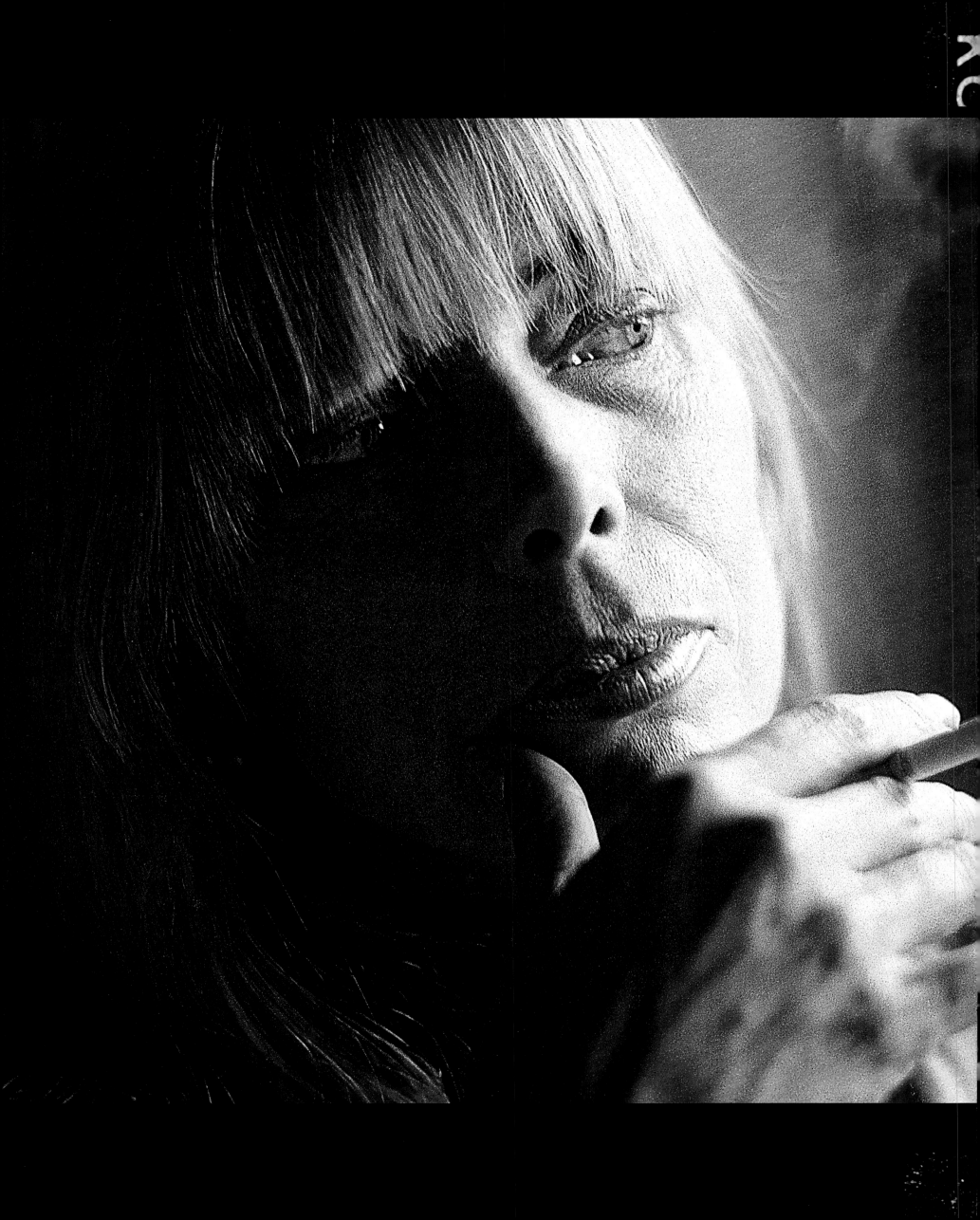

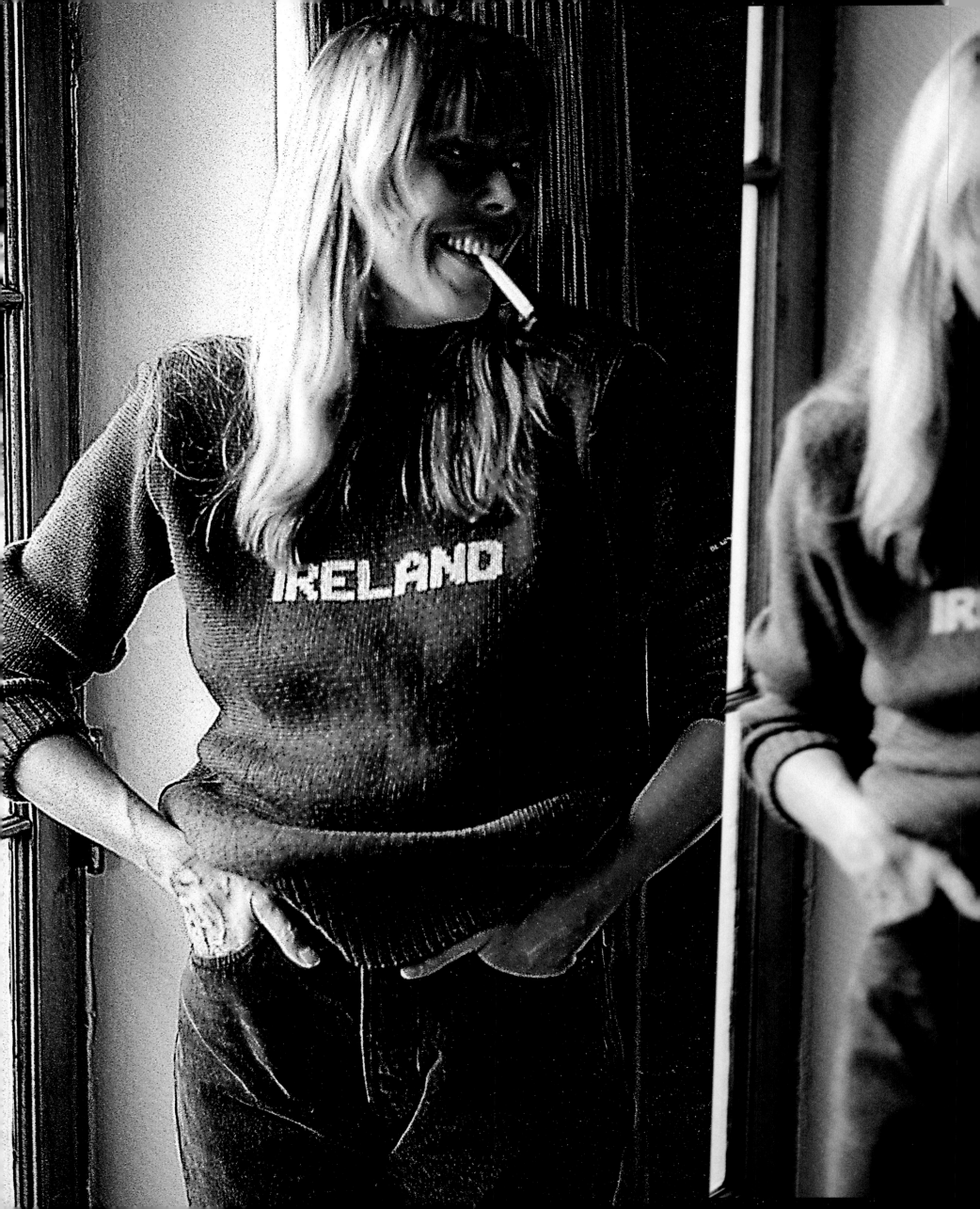

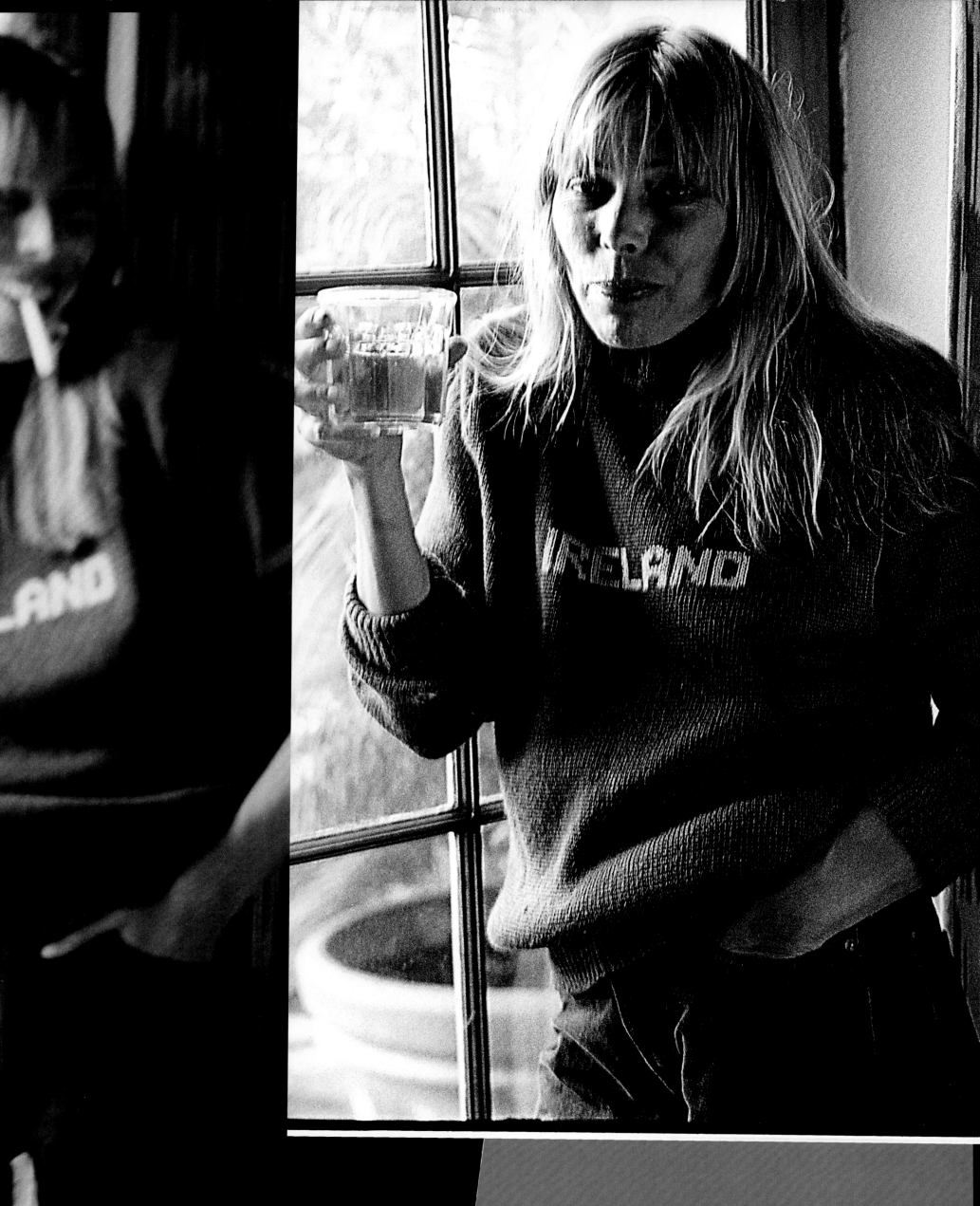

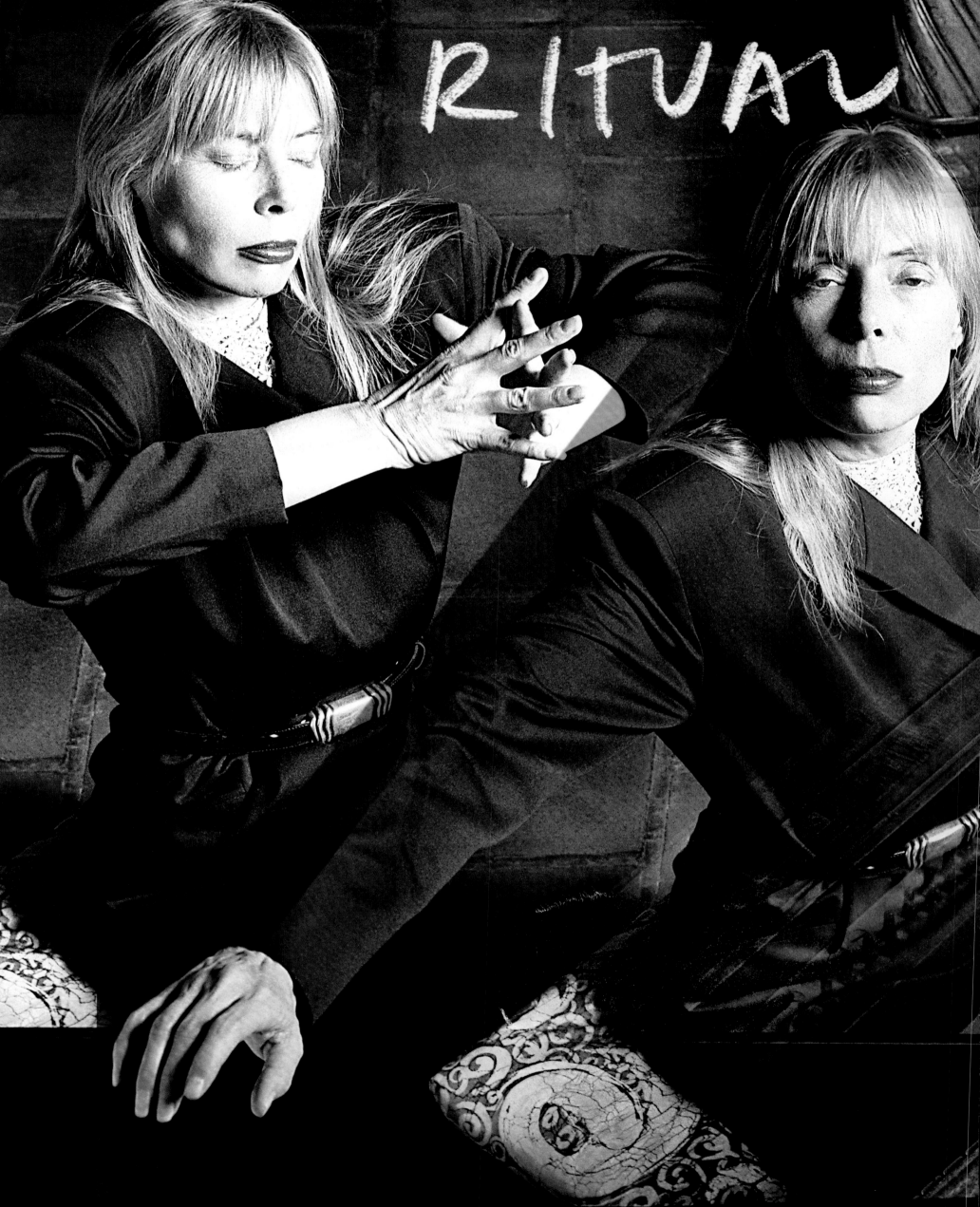

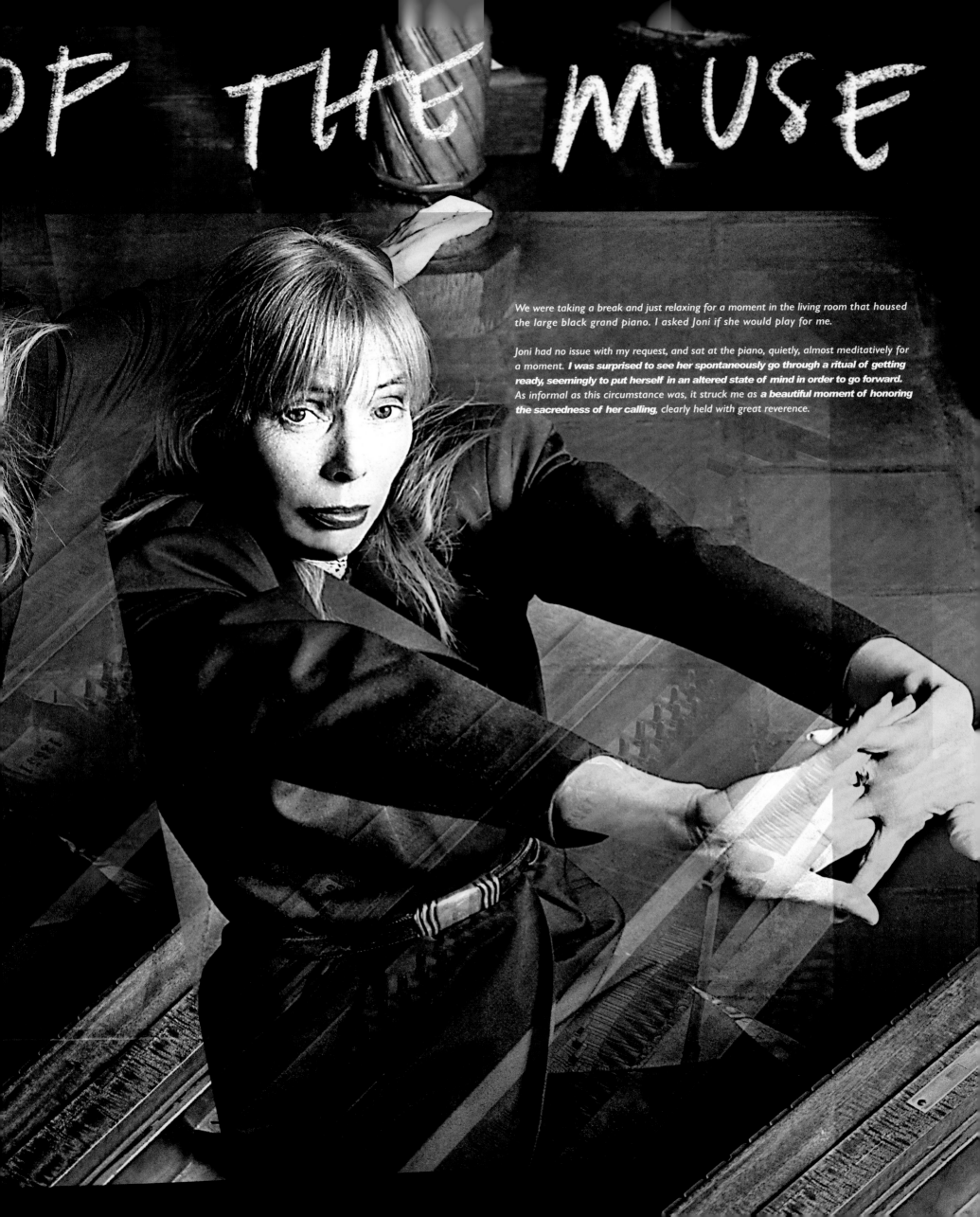

We were taking a break and just relaxing for a moment in the living room that housed the large black grand piano. I asked Joni if she would play for me.

Joni had no issue with my request, and sat at the piano, quietly, almost meditatively for a moment. *I was surprised to see her spontaneously go through a ritual of getting ready, seemingly to put herself in an altered state of mind in order to go forward.* As informal as this circumstance was, it struck me as *a beautiful moment of honoring the sacredness of her calling,* clearly held with great reverence.

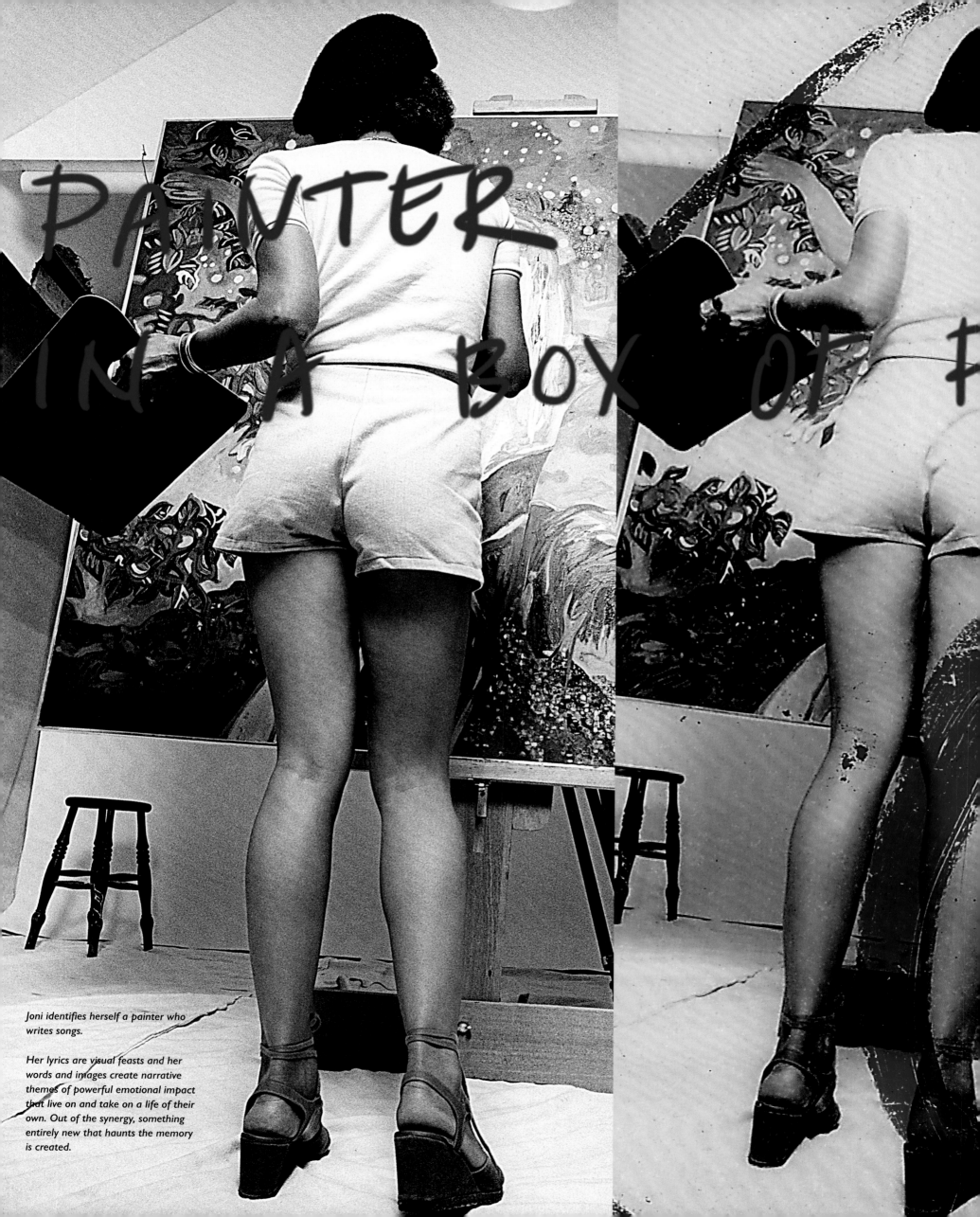

PAINTER IN A BOX OF P

Joni identifies herself a painter who writes songs.

Her lyrics are visual feasts and her words and images create narrative themes of powerful emotional impact that live on and take on a life of their own. Out of the synergy, something entirely new that haunts the memory is created.

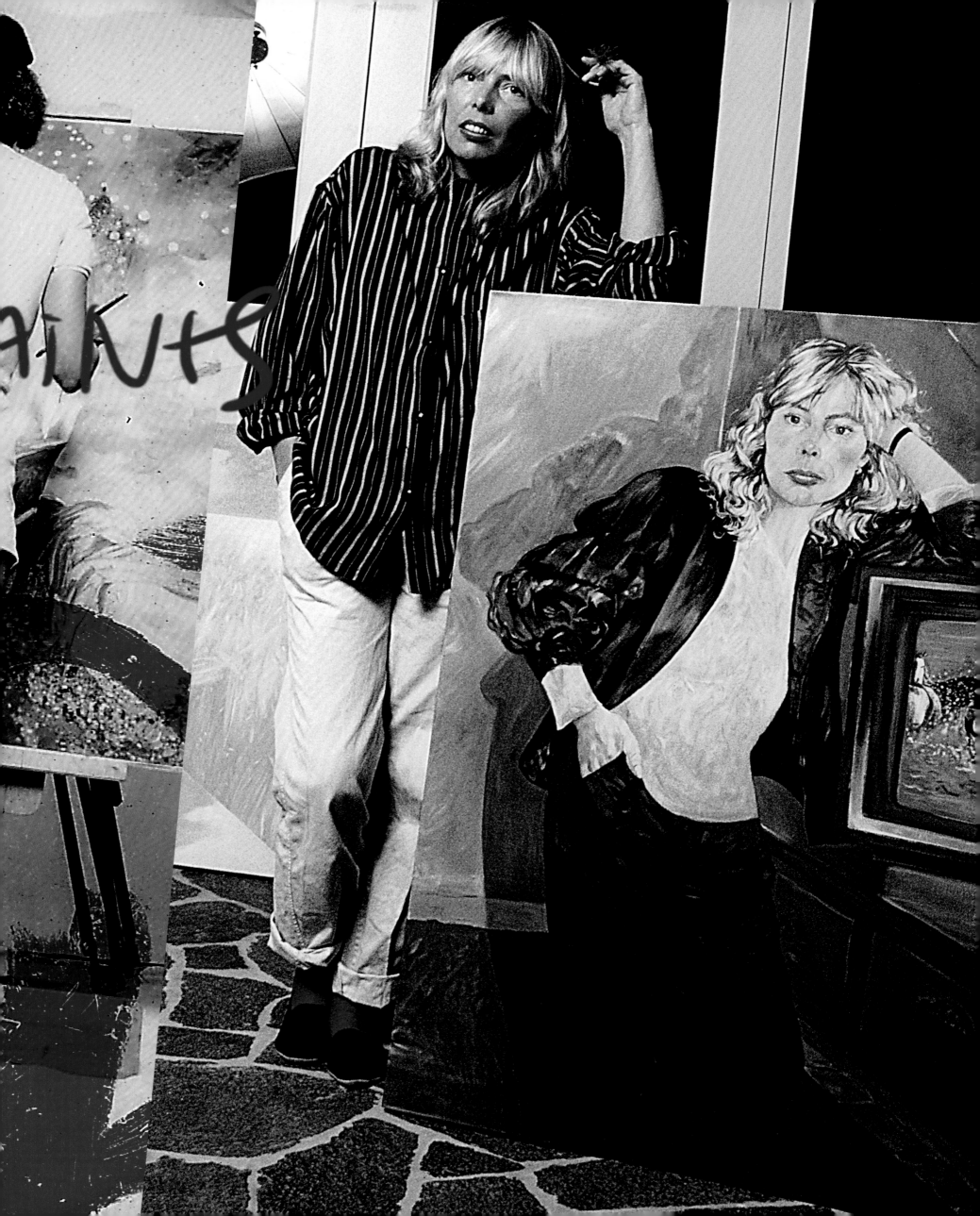

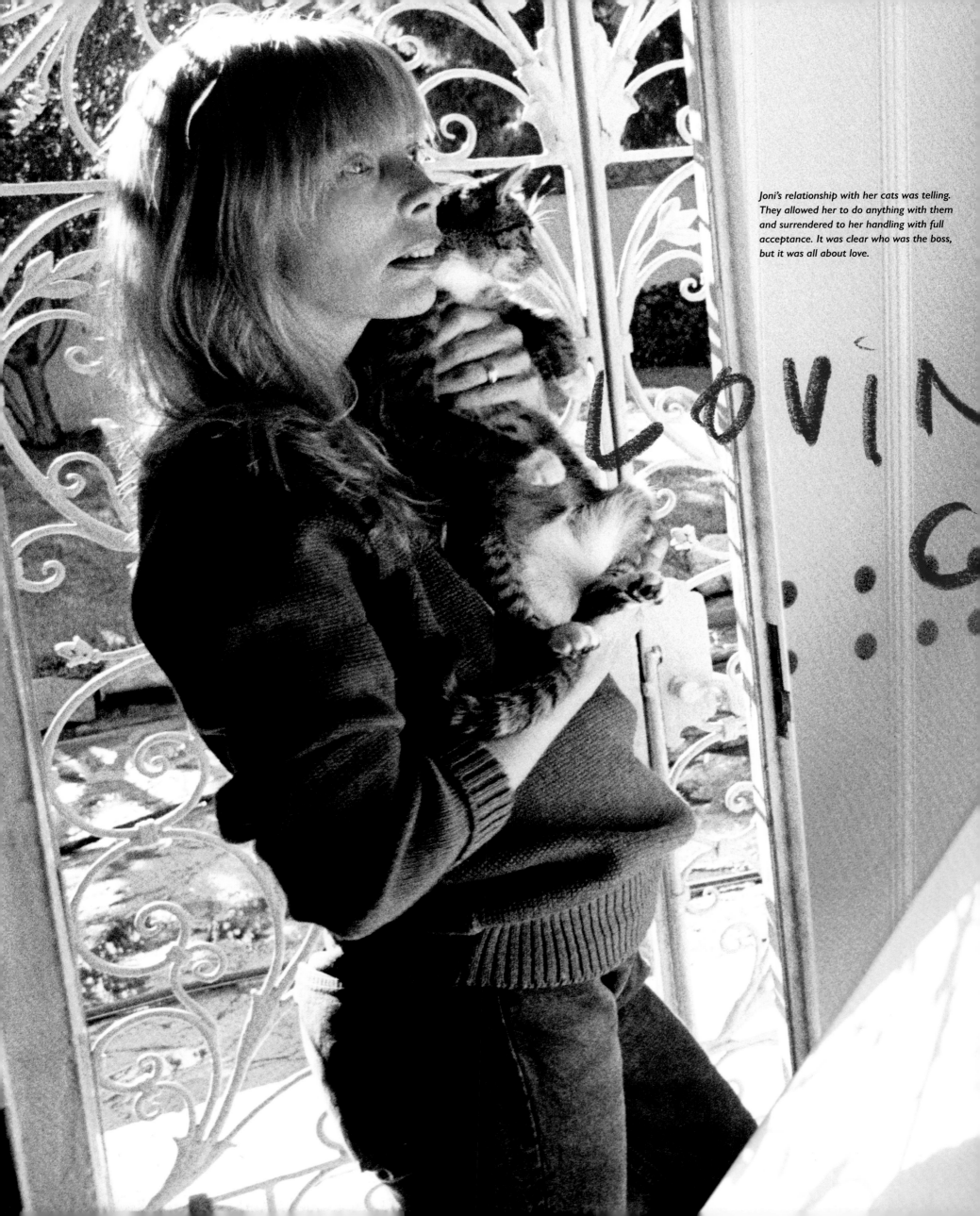

Joni's relationship with her cats was telling. They allowed her to do anything with them and surrendered to her handling with full acceptance. It was clear who was the boss, but it was all about love.

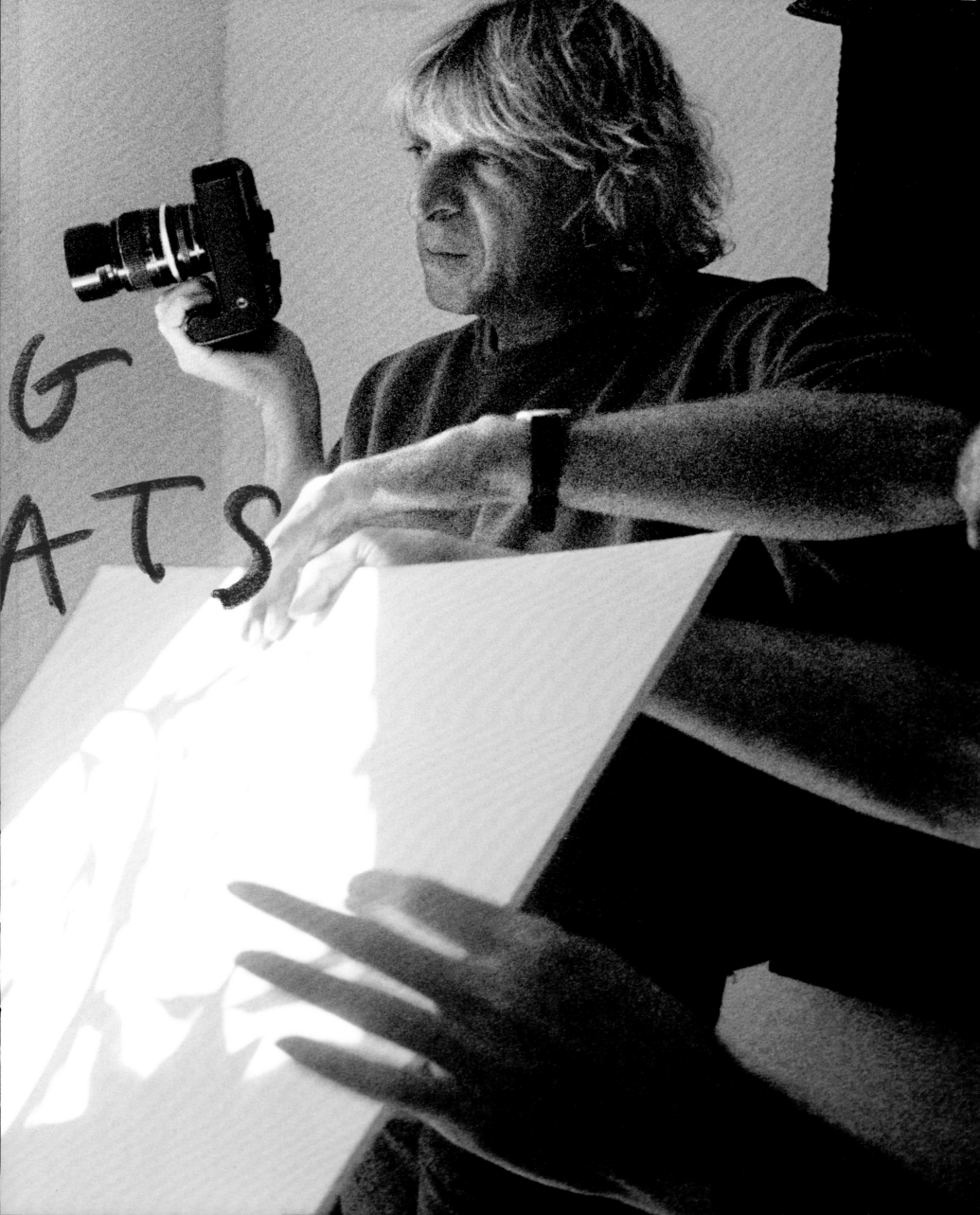

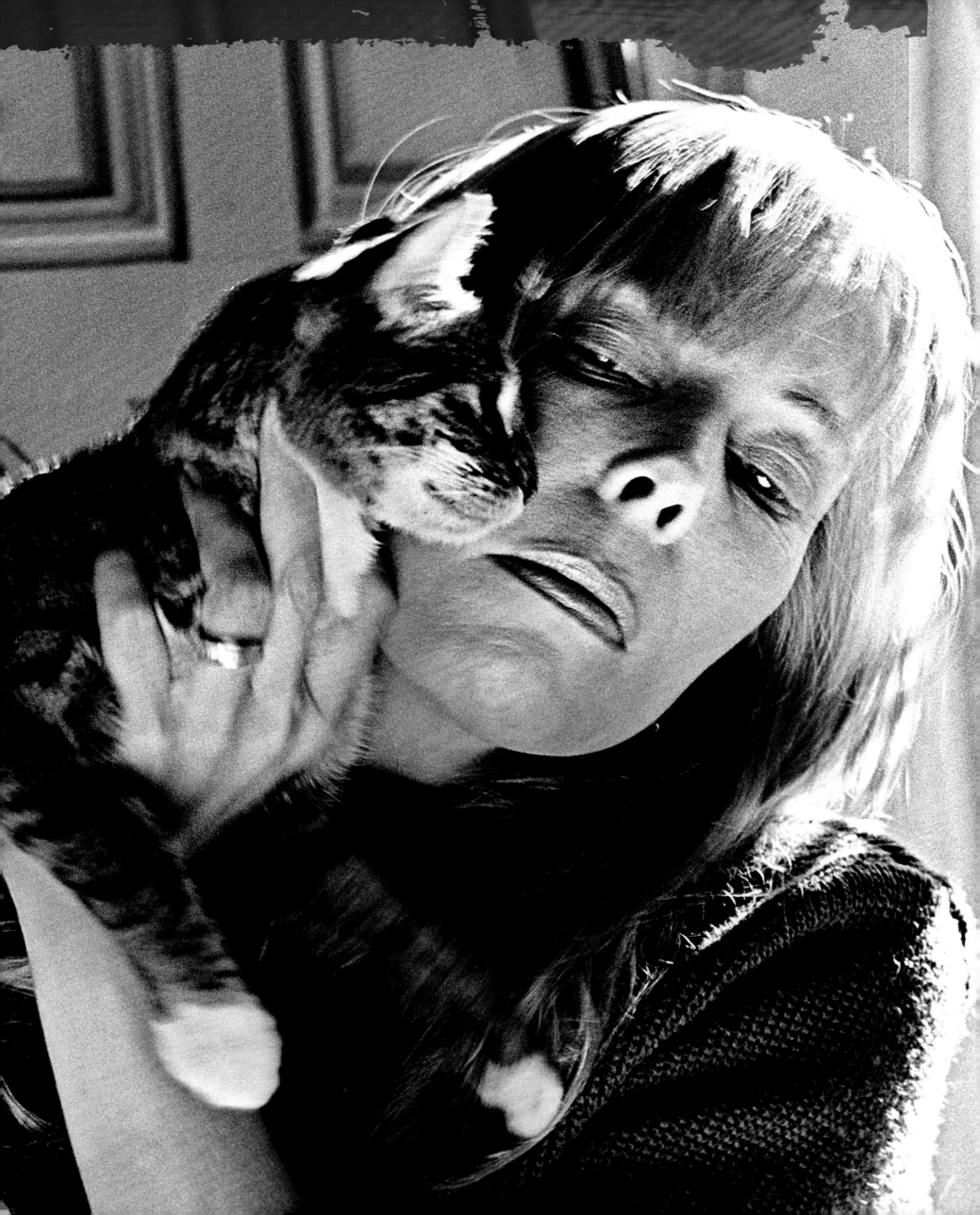

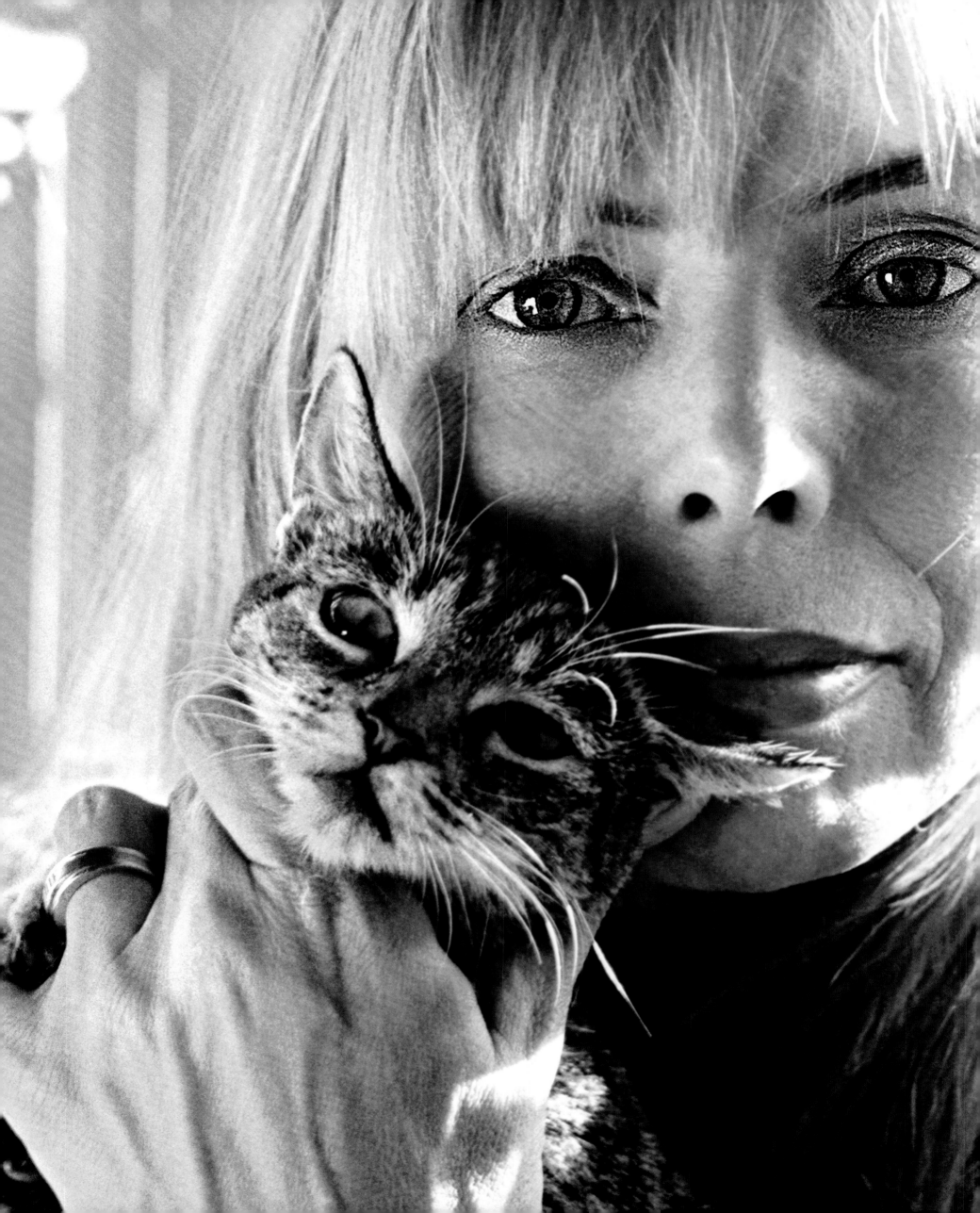

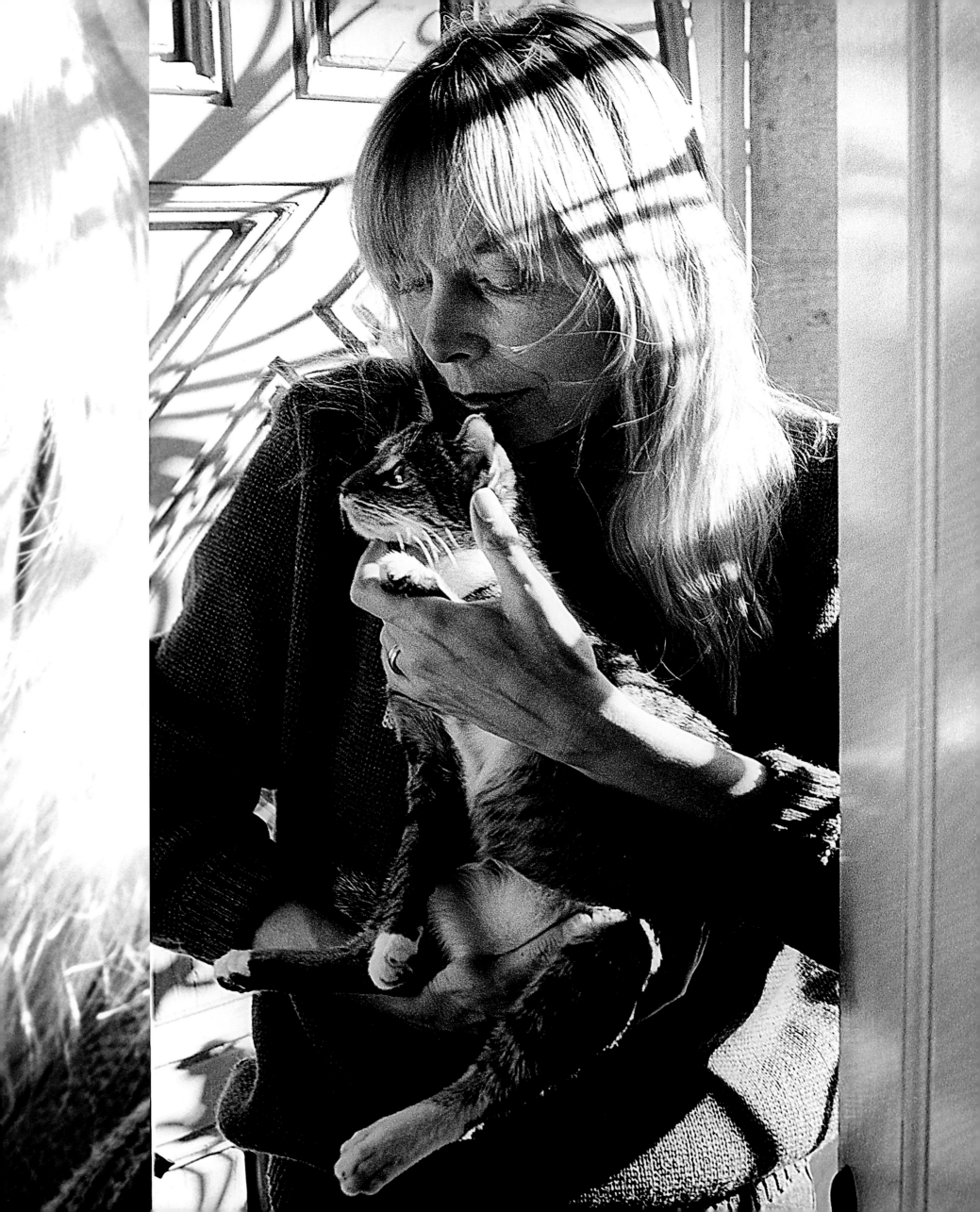

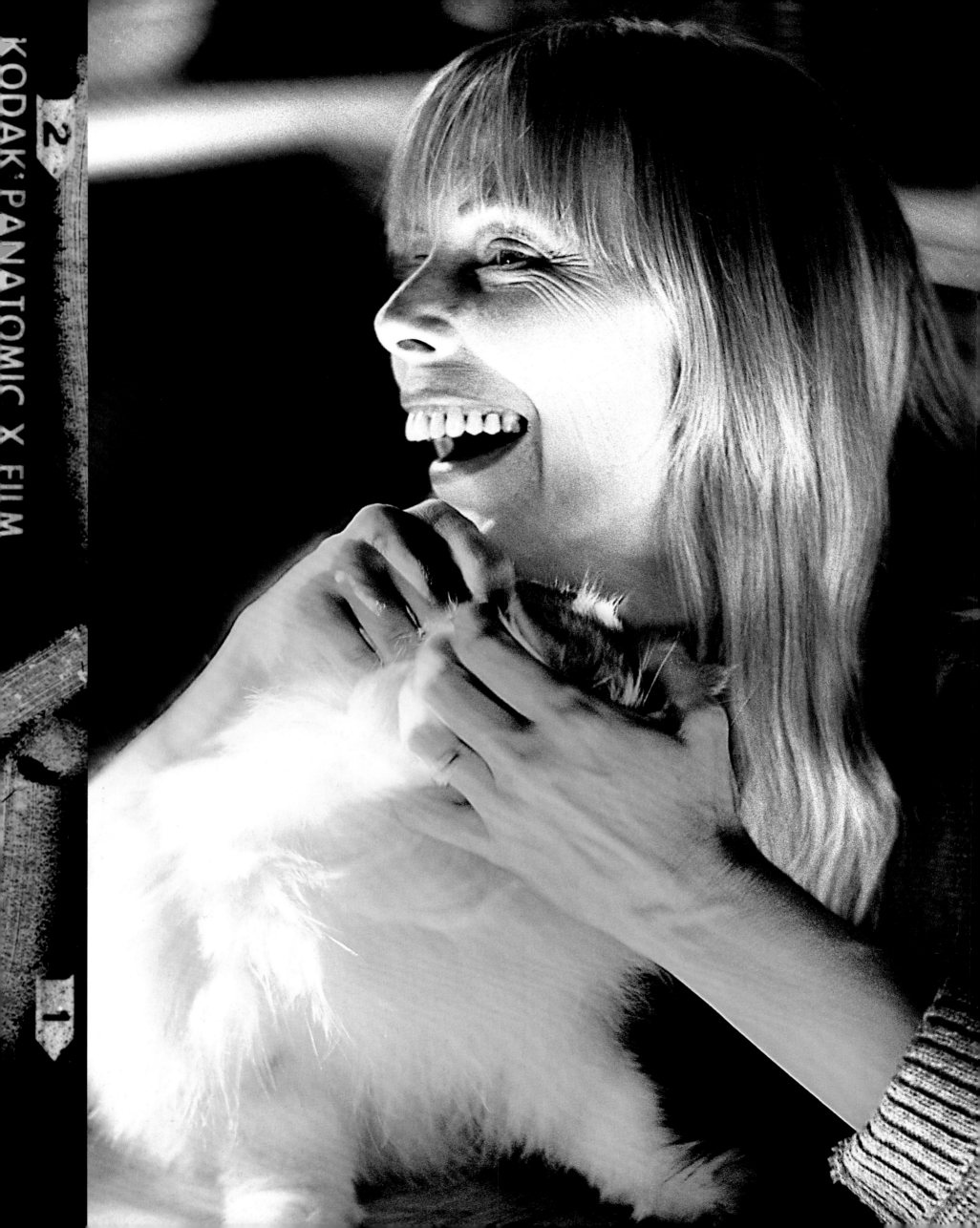

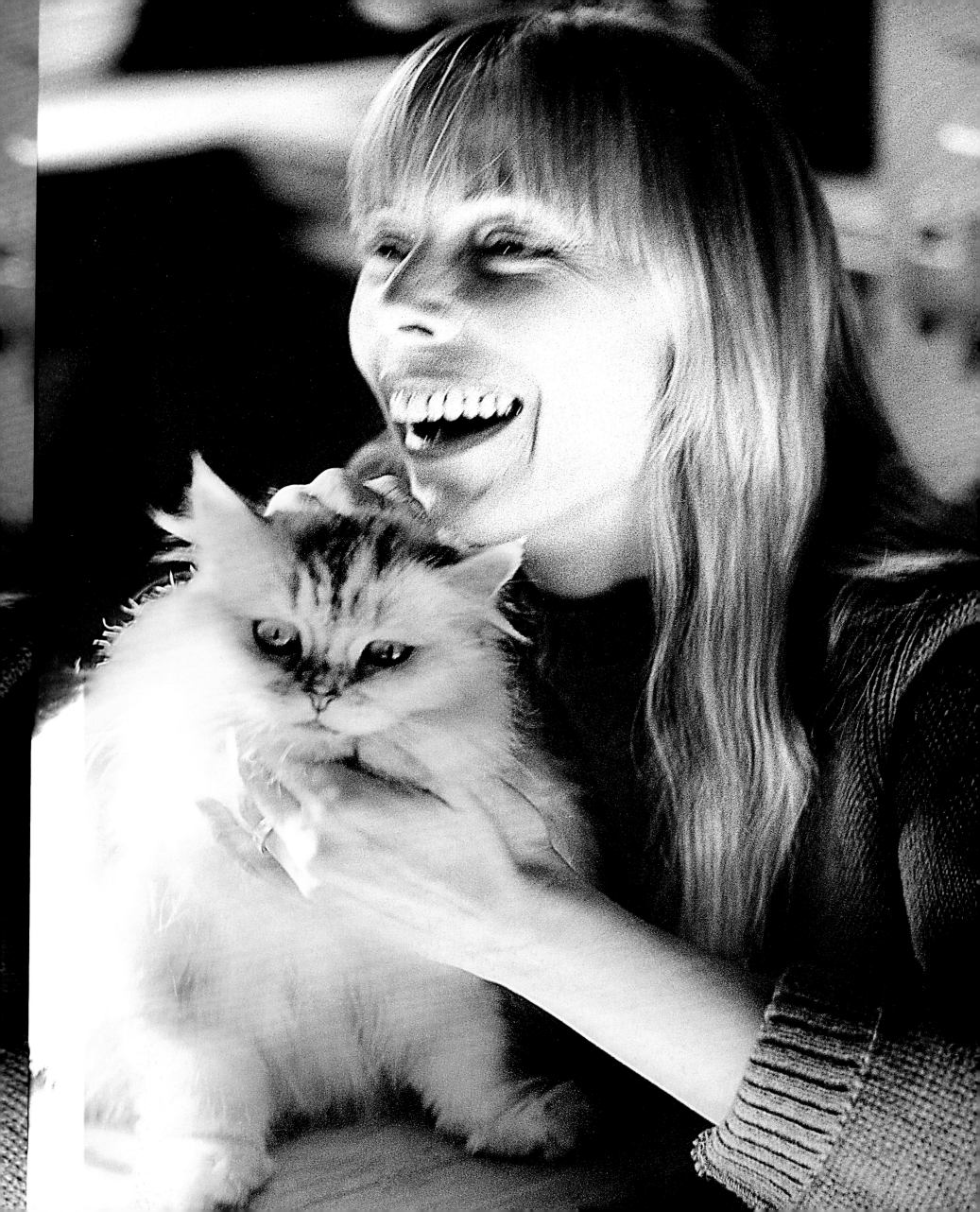

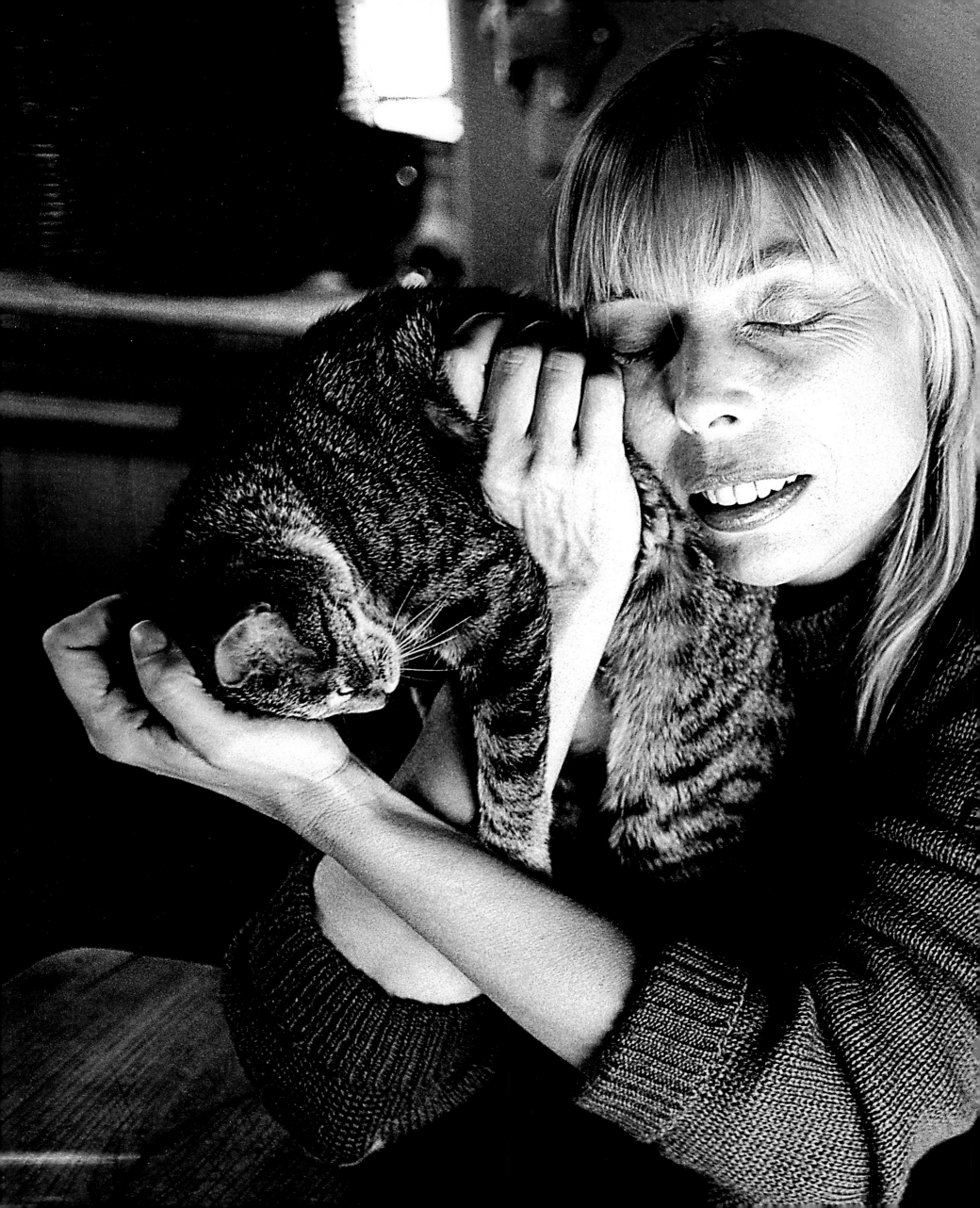

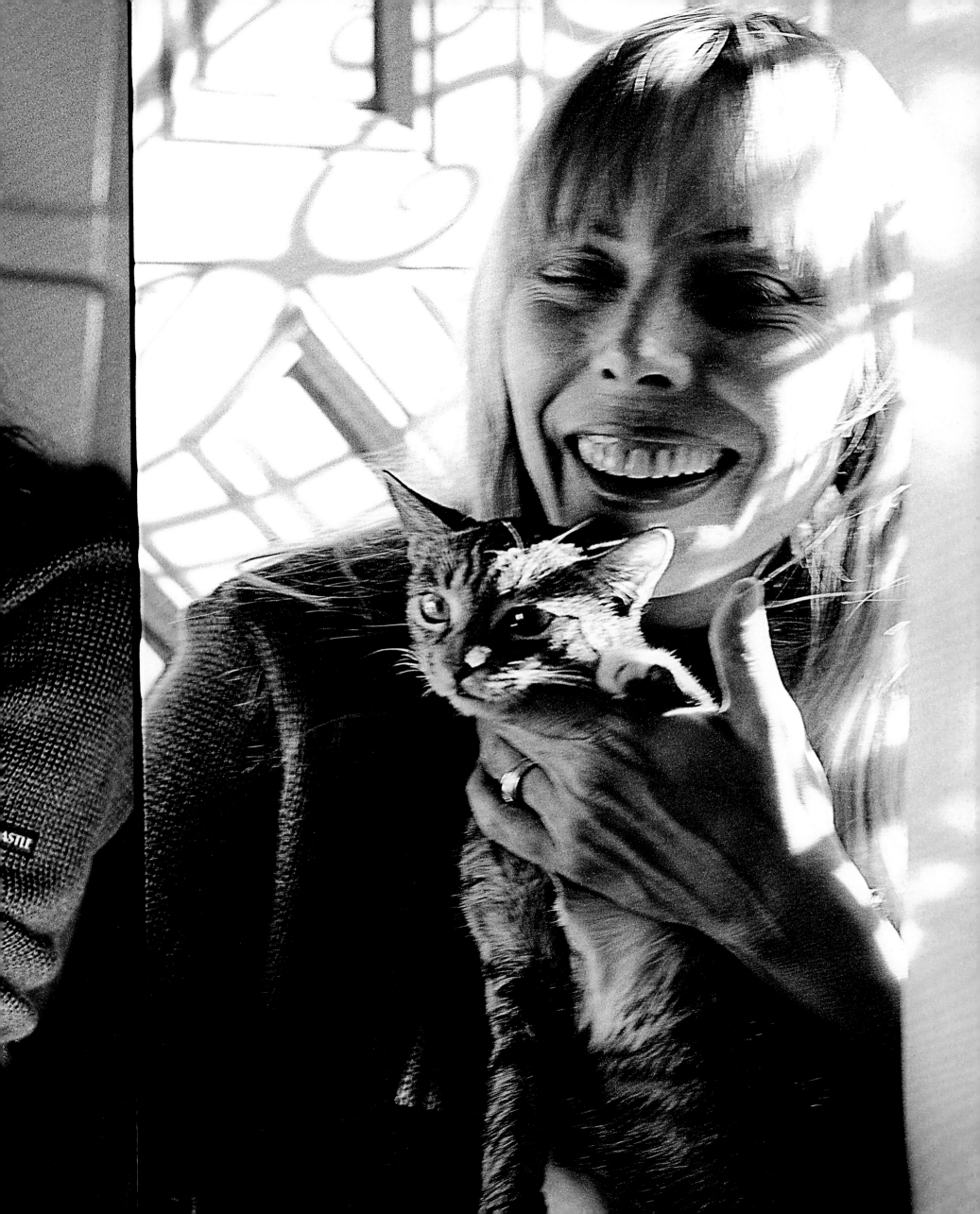

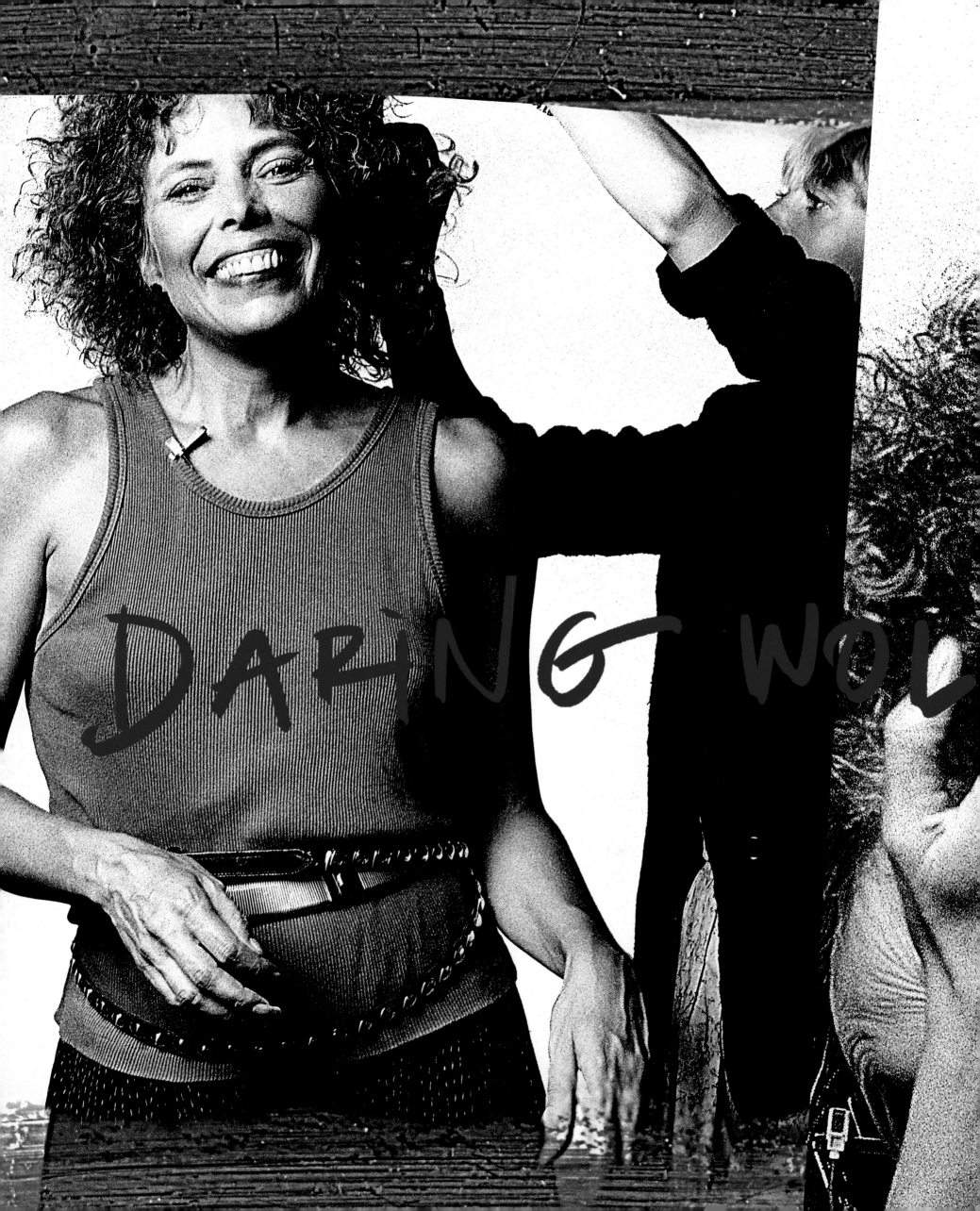

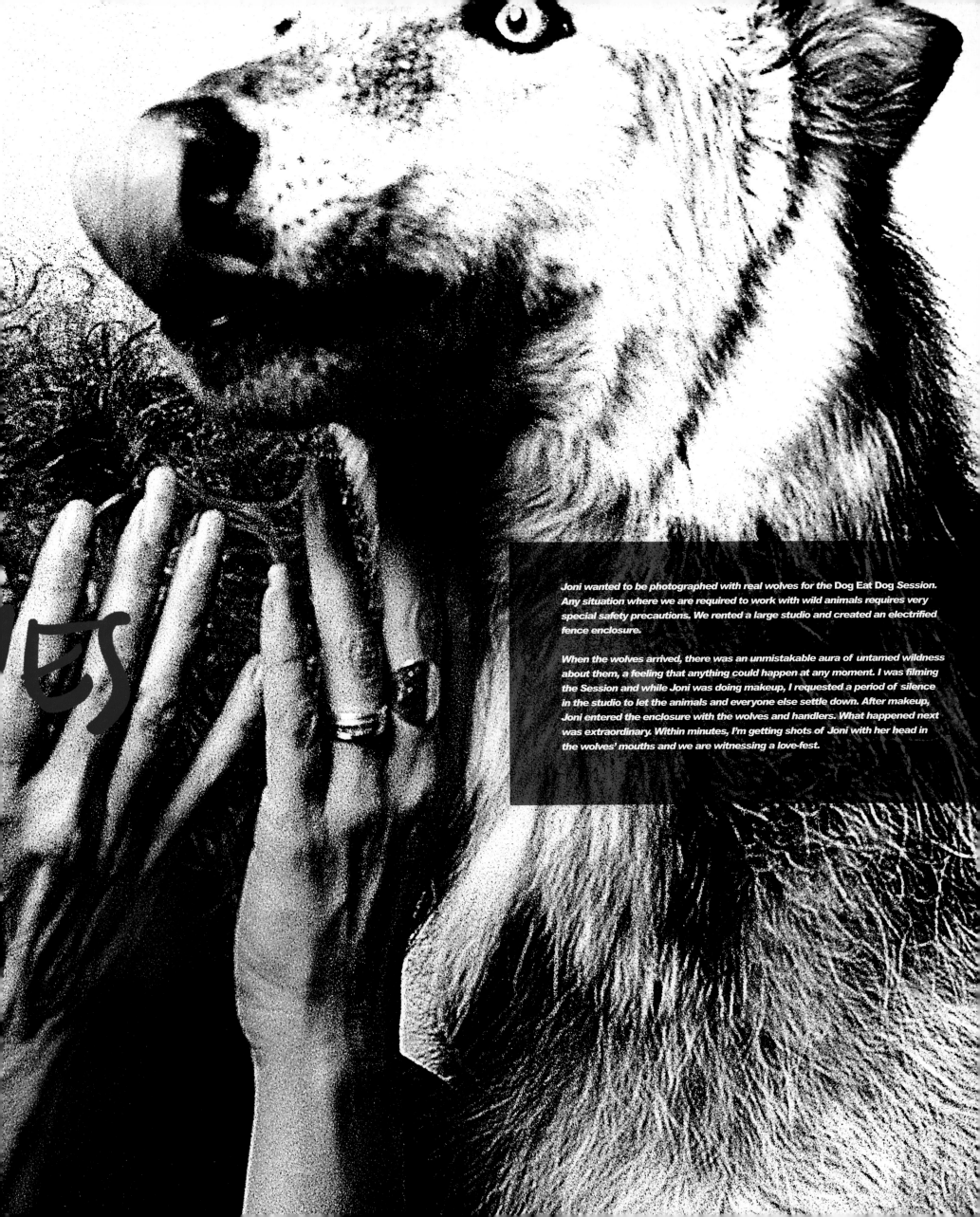

Joni wanted to be photographed with real wolves for the Dog Eat Dog Session. Any situation where we are required to work with wild animals requires very special safety precautions. We rented a large studio and created an electrified fence enclosure.

When the wolves arrived, there was an unmistakable aura of untamed wildness about them, a feeling that anything could happen at any moment. I was filming the Session and while Joni was doing makeup, I requested a period of silence in the studio to let the animals and everyone else settle down. After makeup, Joni entered the enclosure with the wolves and handlers. What happened next was extraordinary. Within minutes, I'm getting shots of Joni with her head in the wolves' mouths and we are witnessing a love-fest.

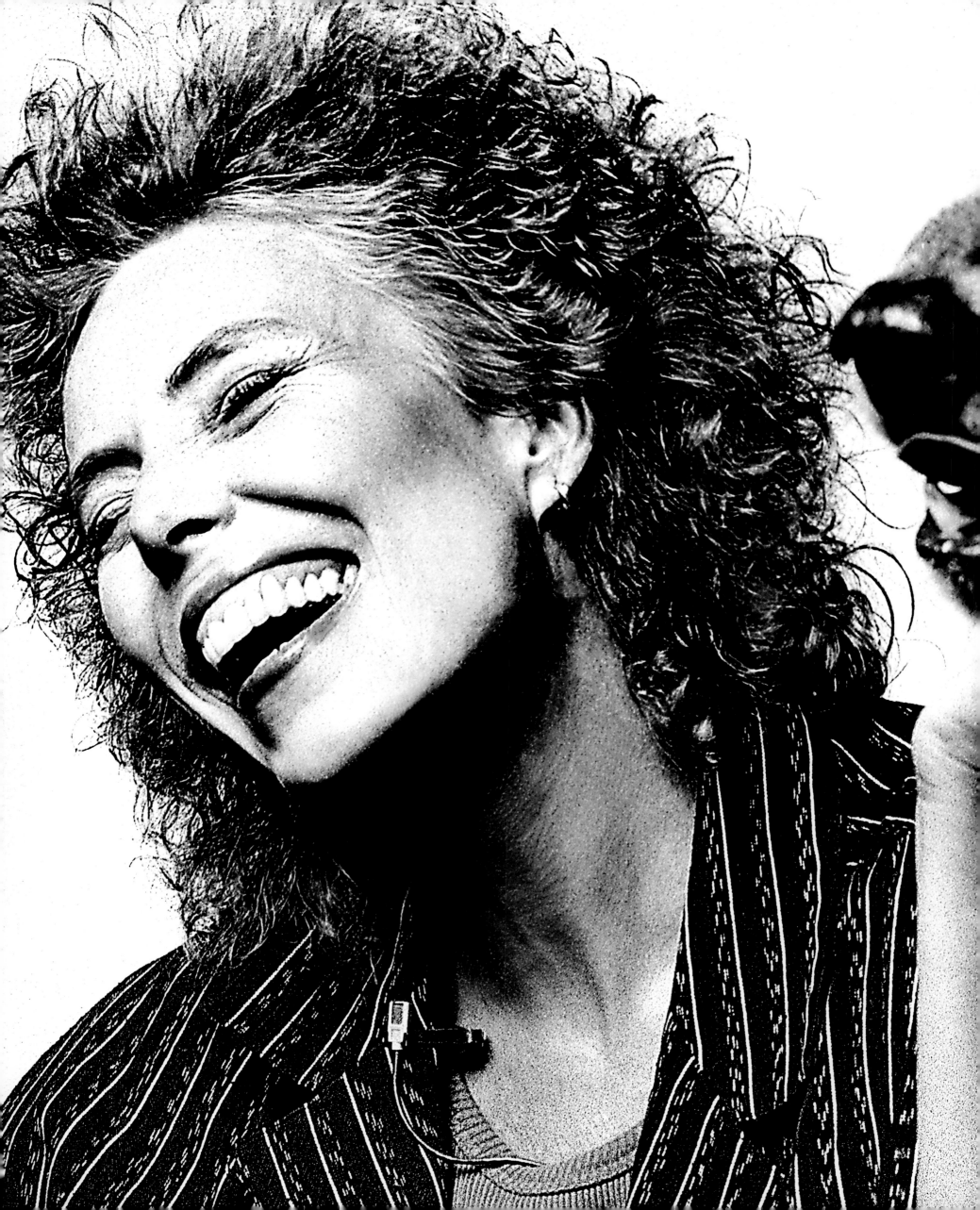

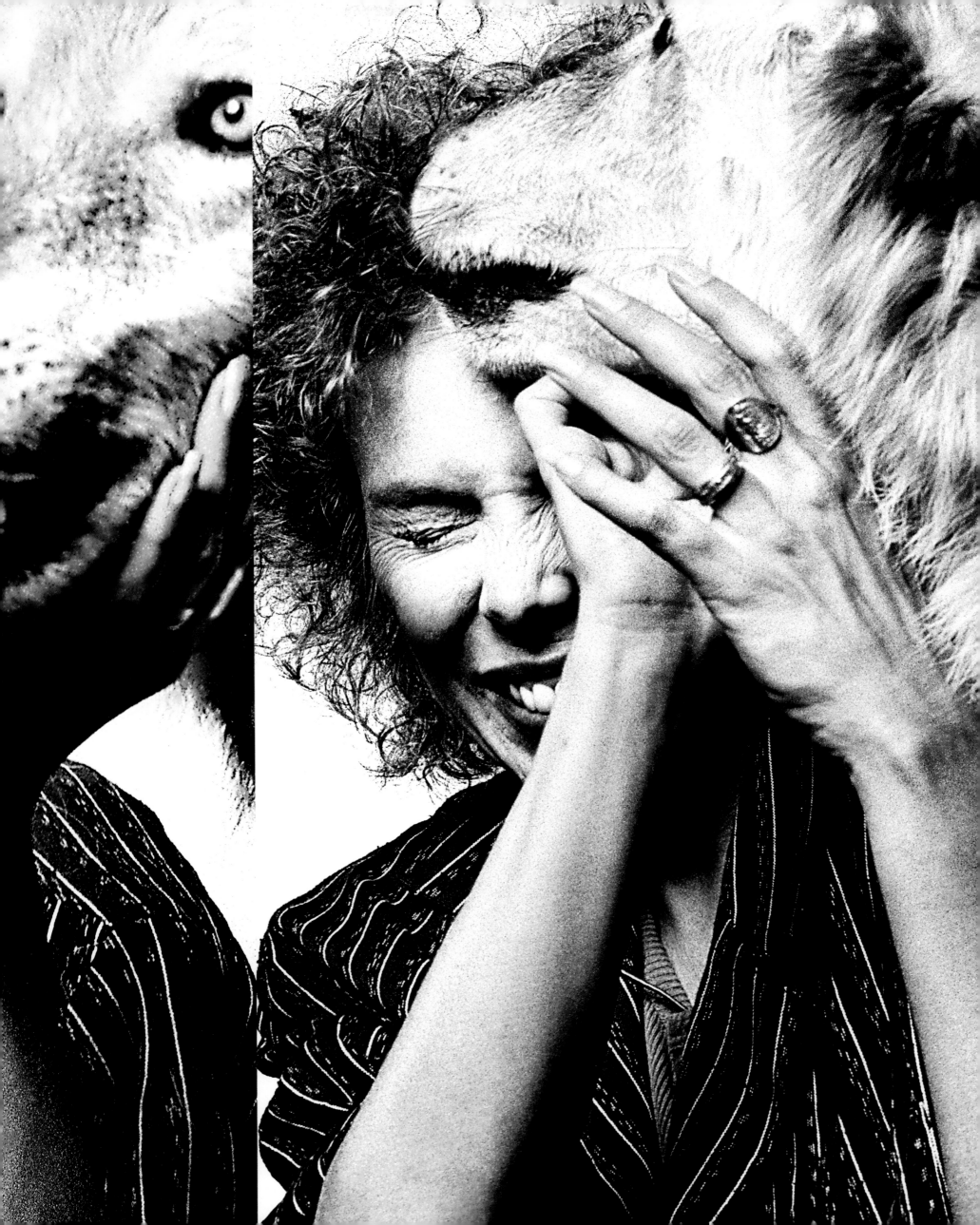

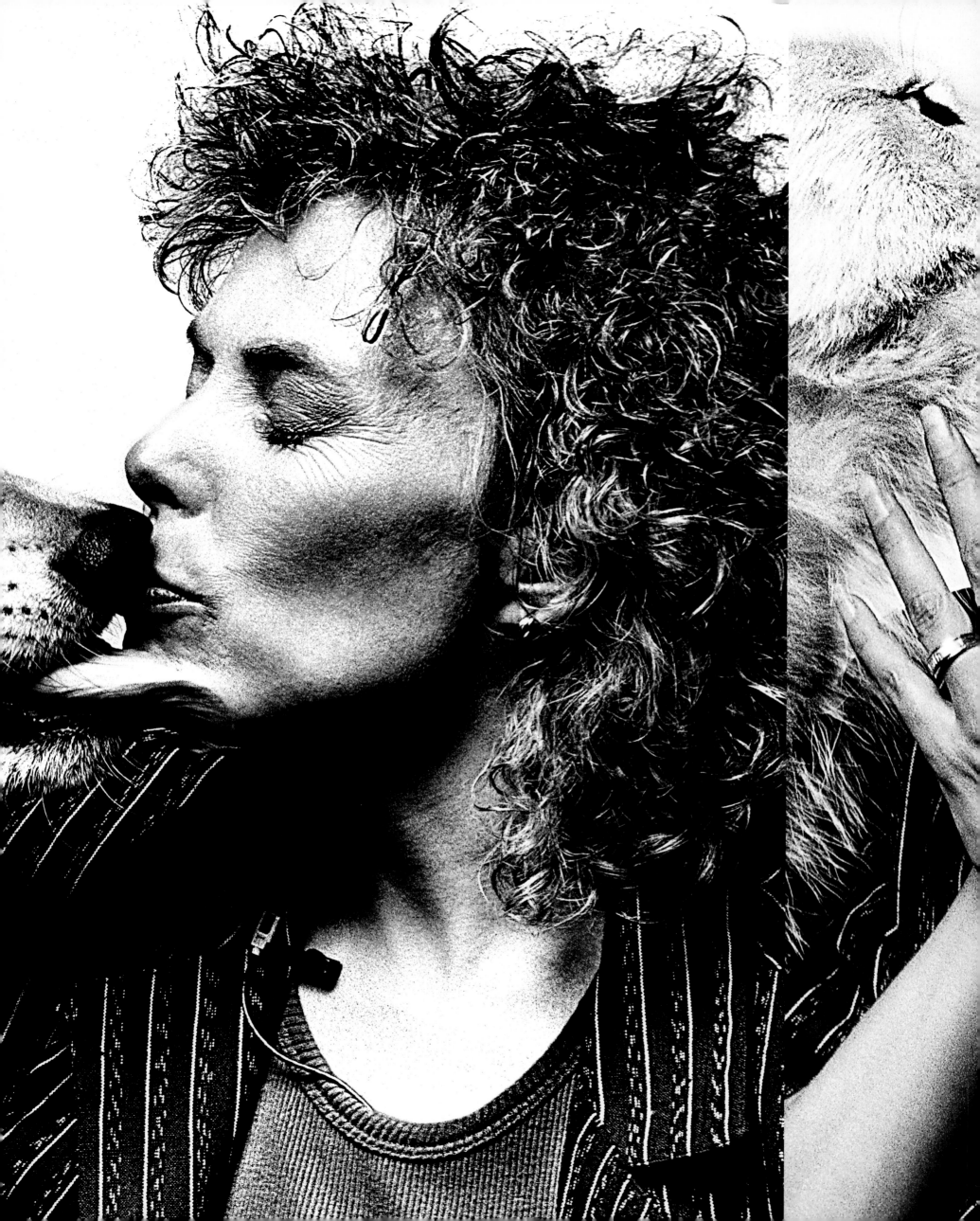

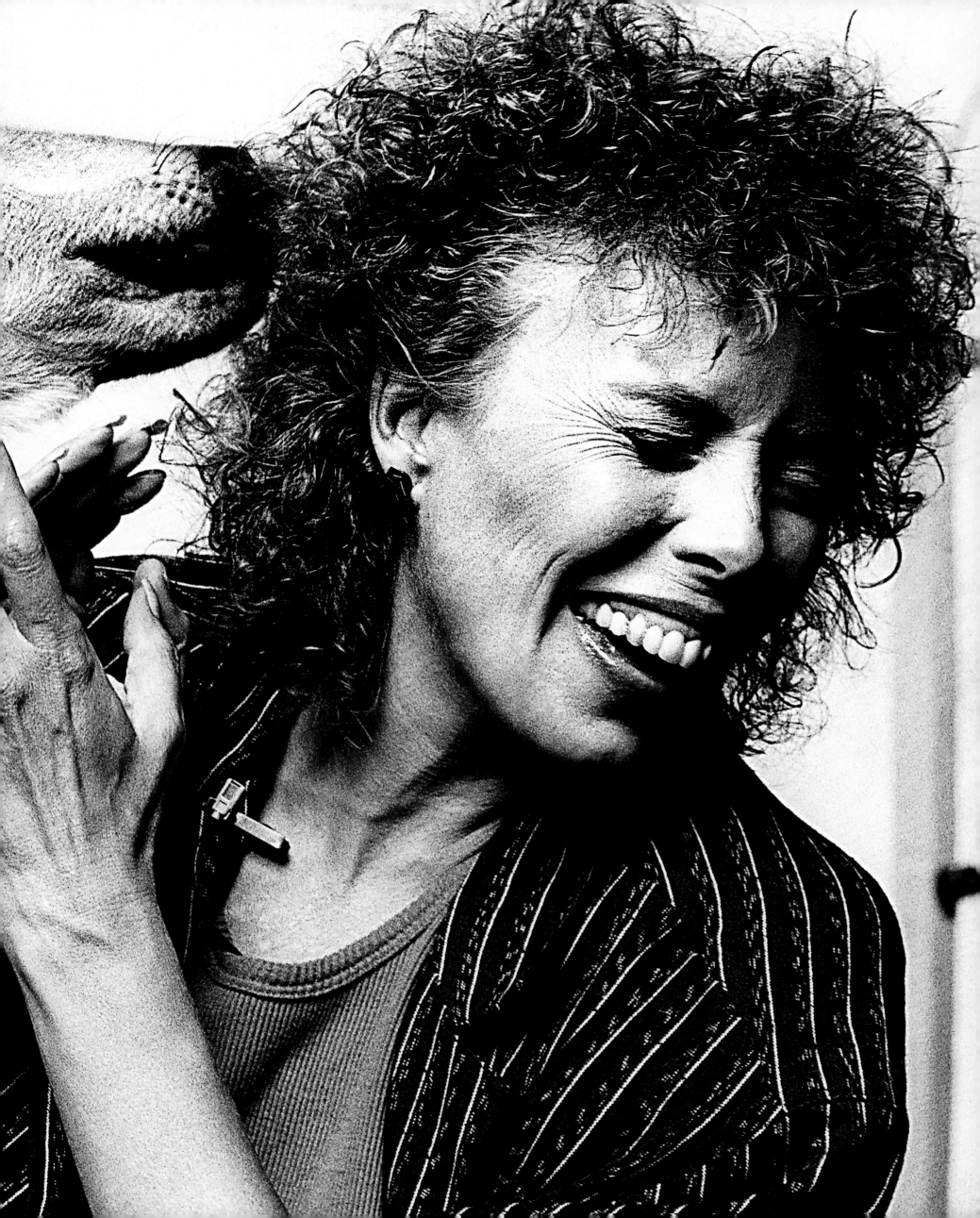

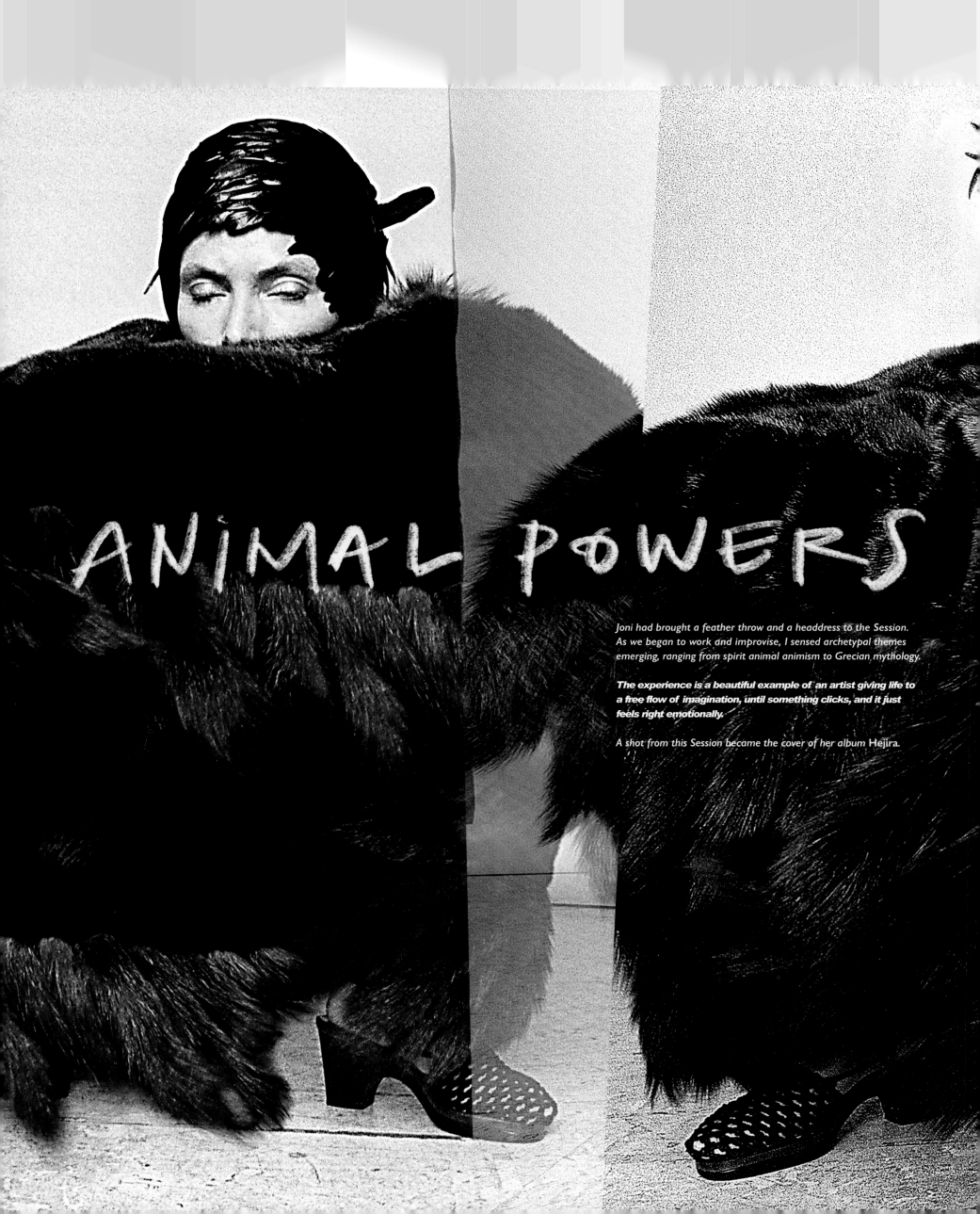

ANIMAL POWERS

Joni had brought a feather throw and a headdress to the Session. As we began to work and improvise, I sensed archetypal themes emerging, ranging from spirit animal animism to Grecian mythology.

The experience is a beautiful example of an artist giving life to a free flow of imagination, until something clicks, and it just feels right emotionally.

A shot from this Session became the cover of her album Hejira.

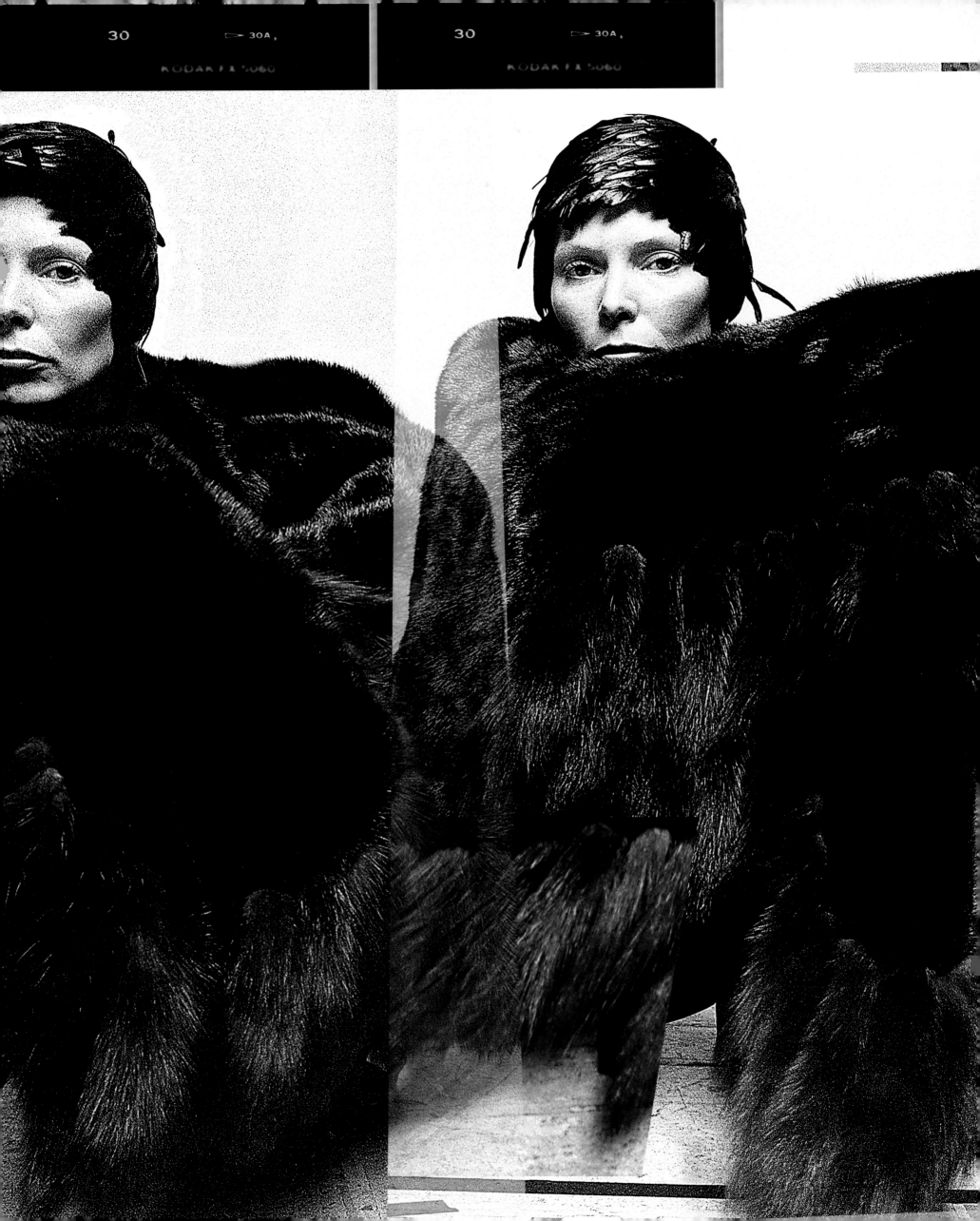

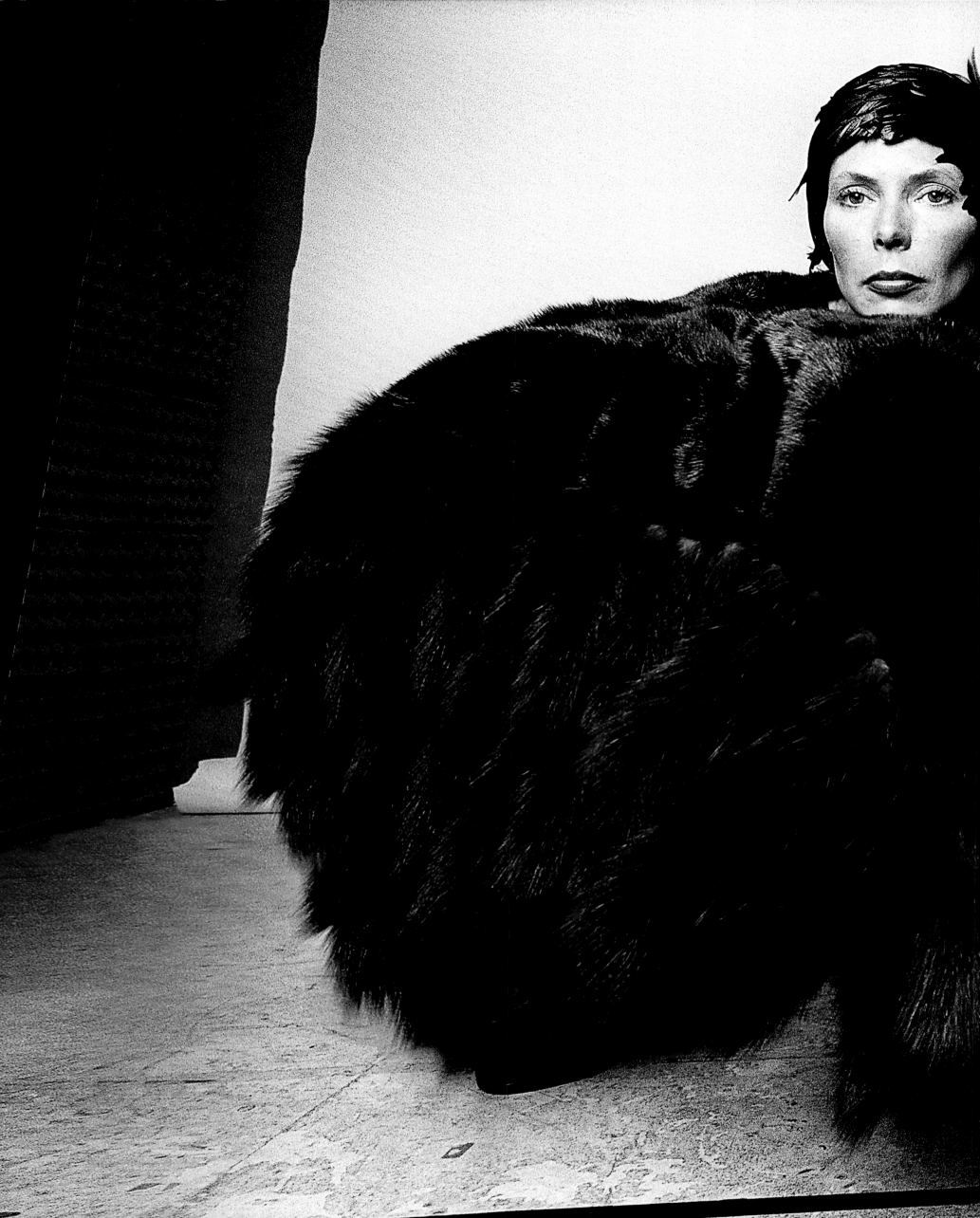

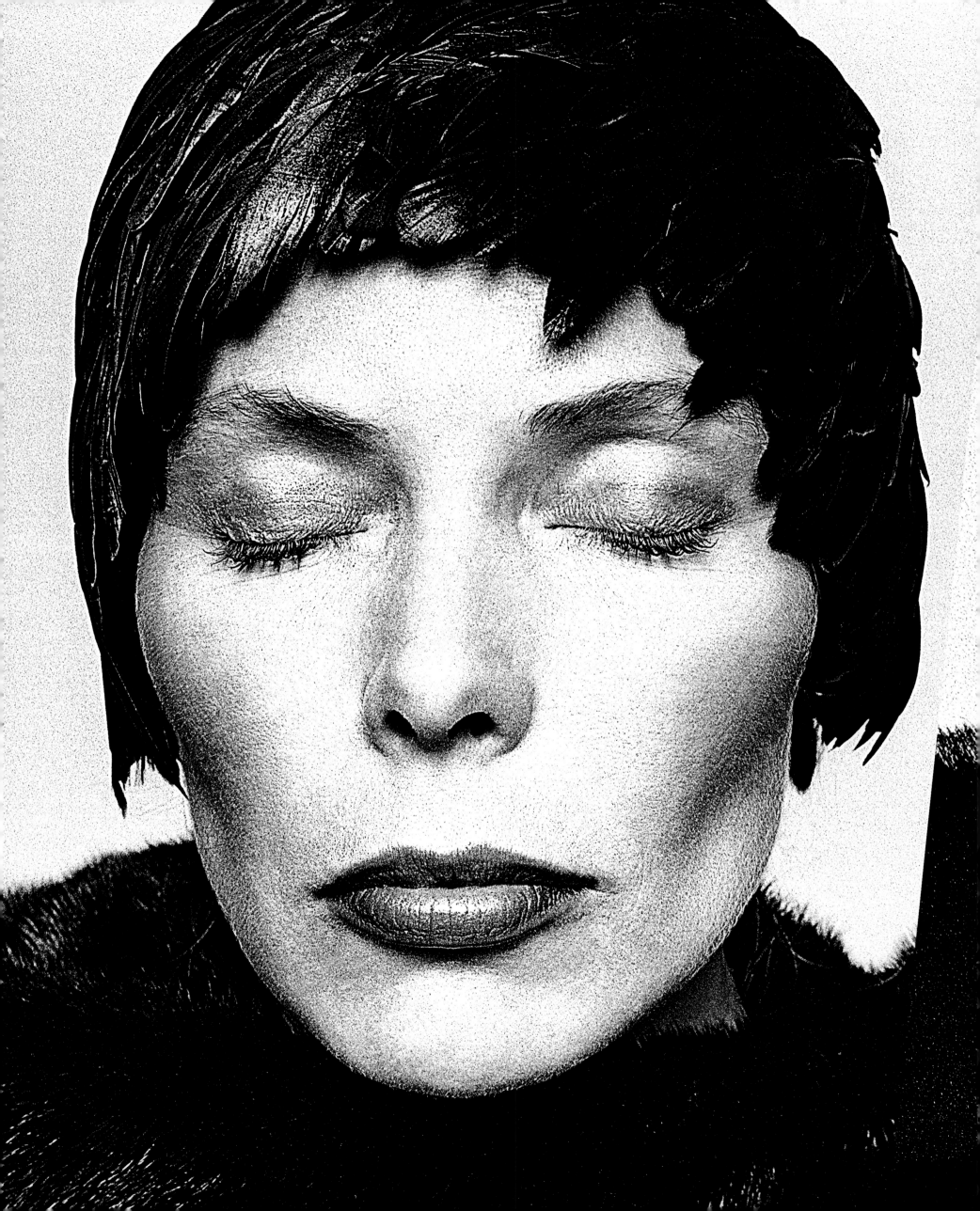

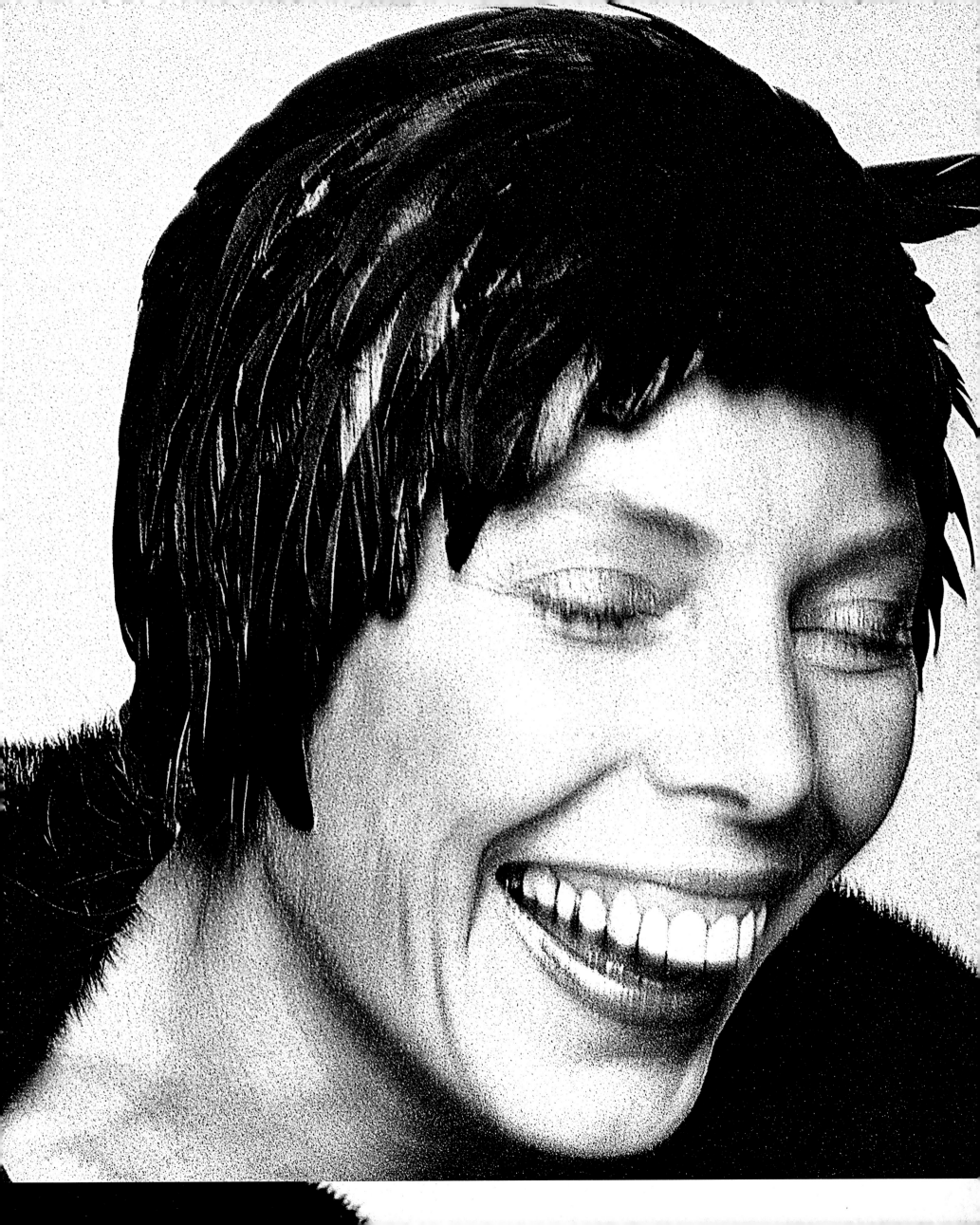

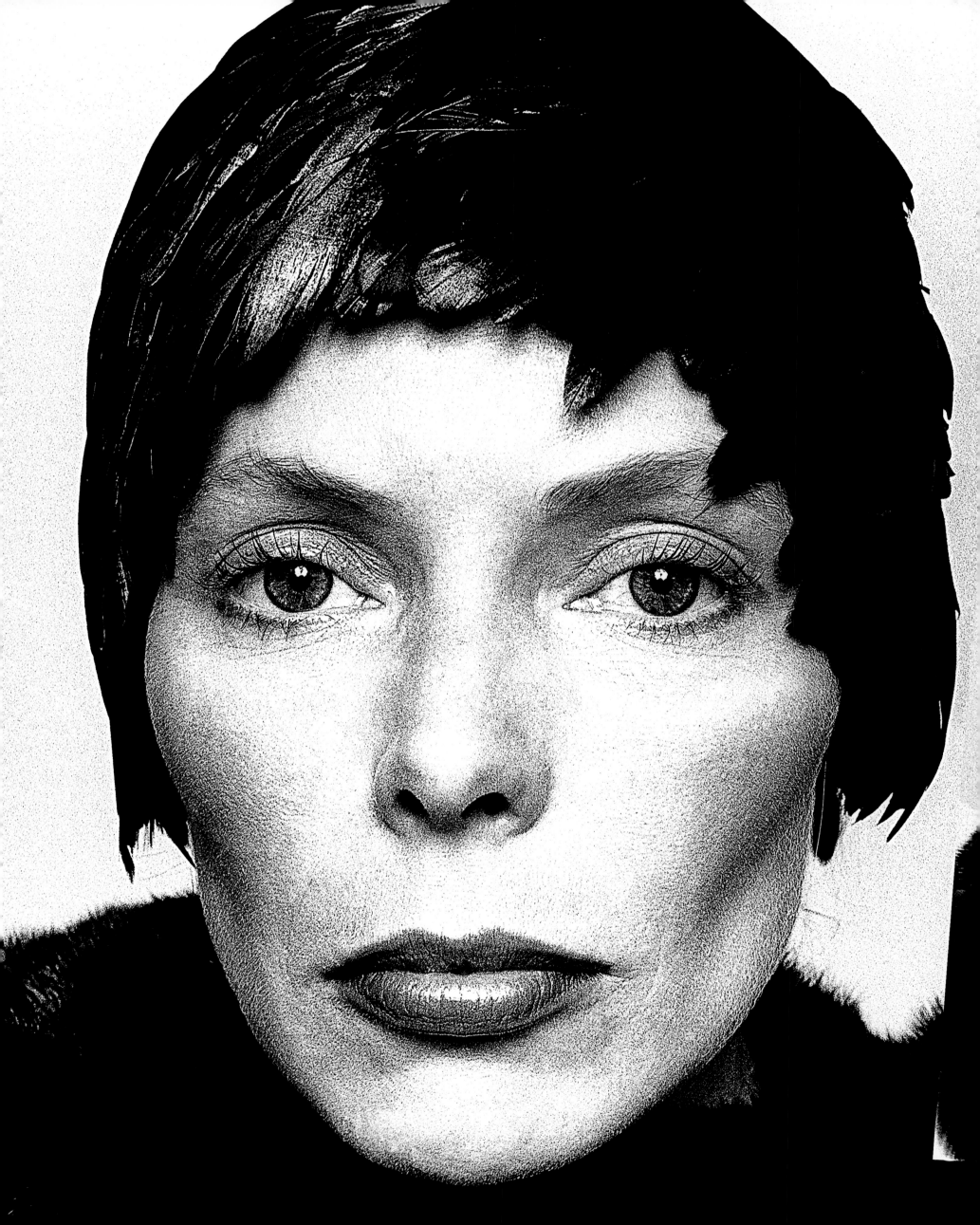

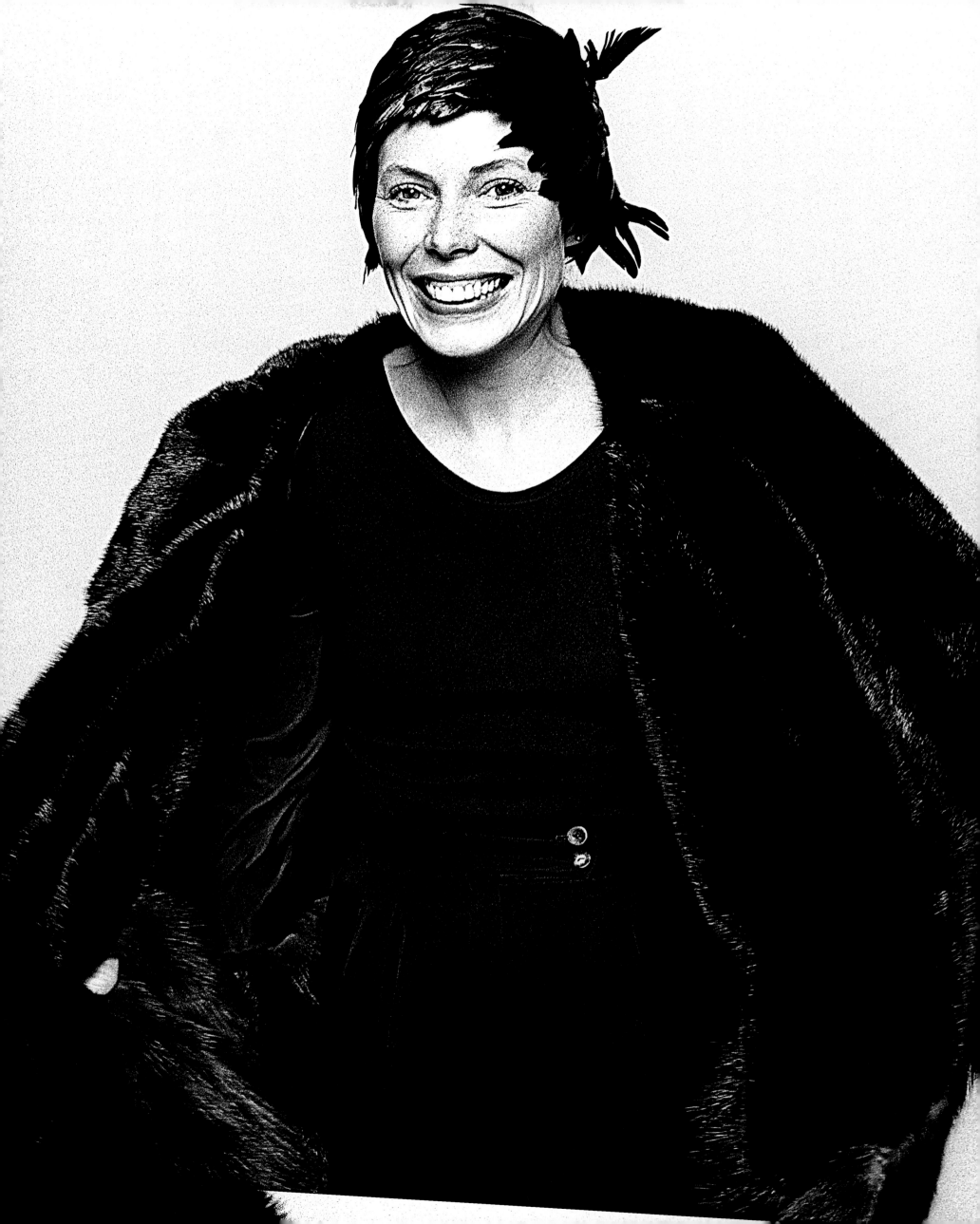

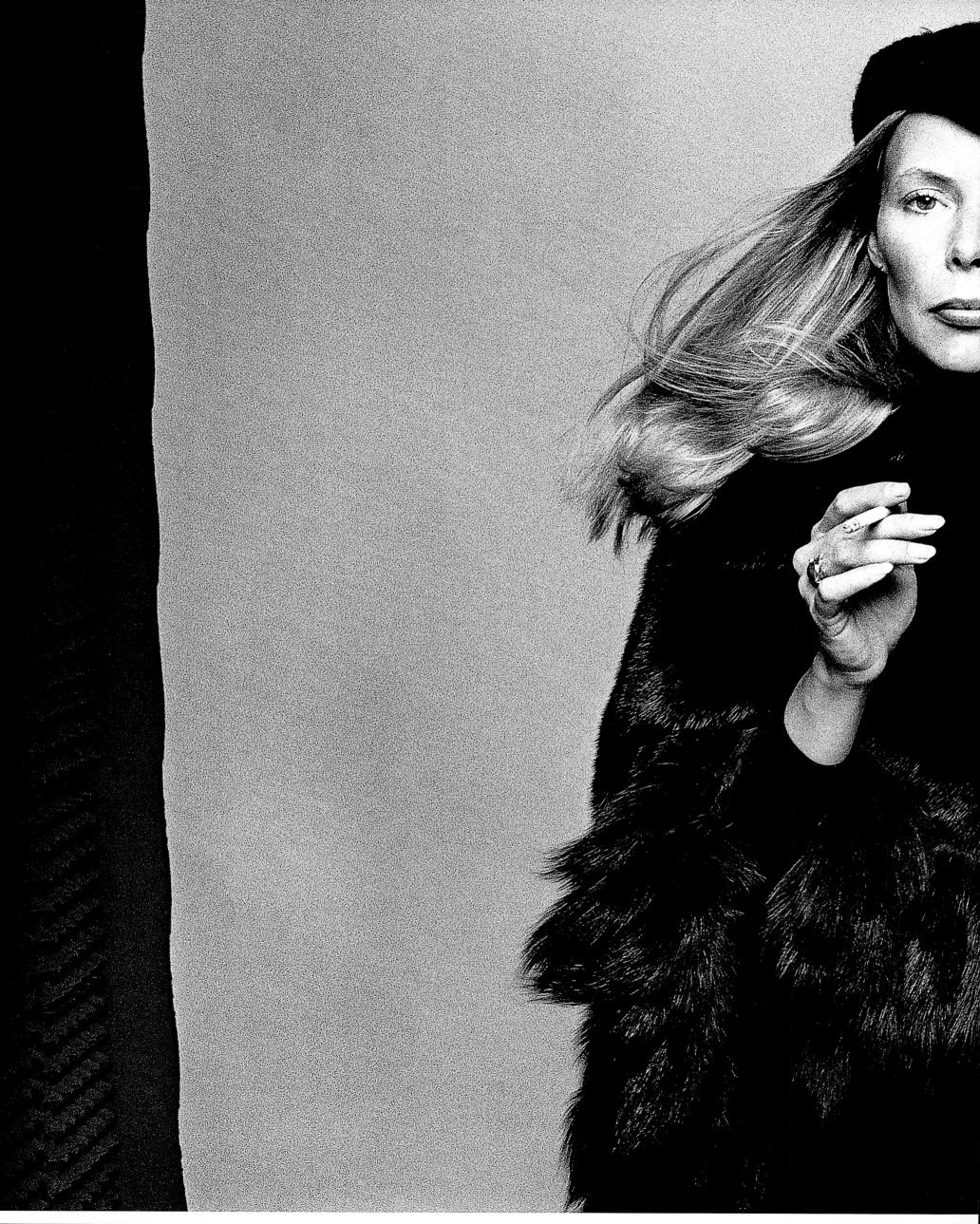

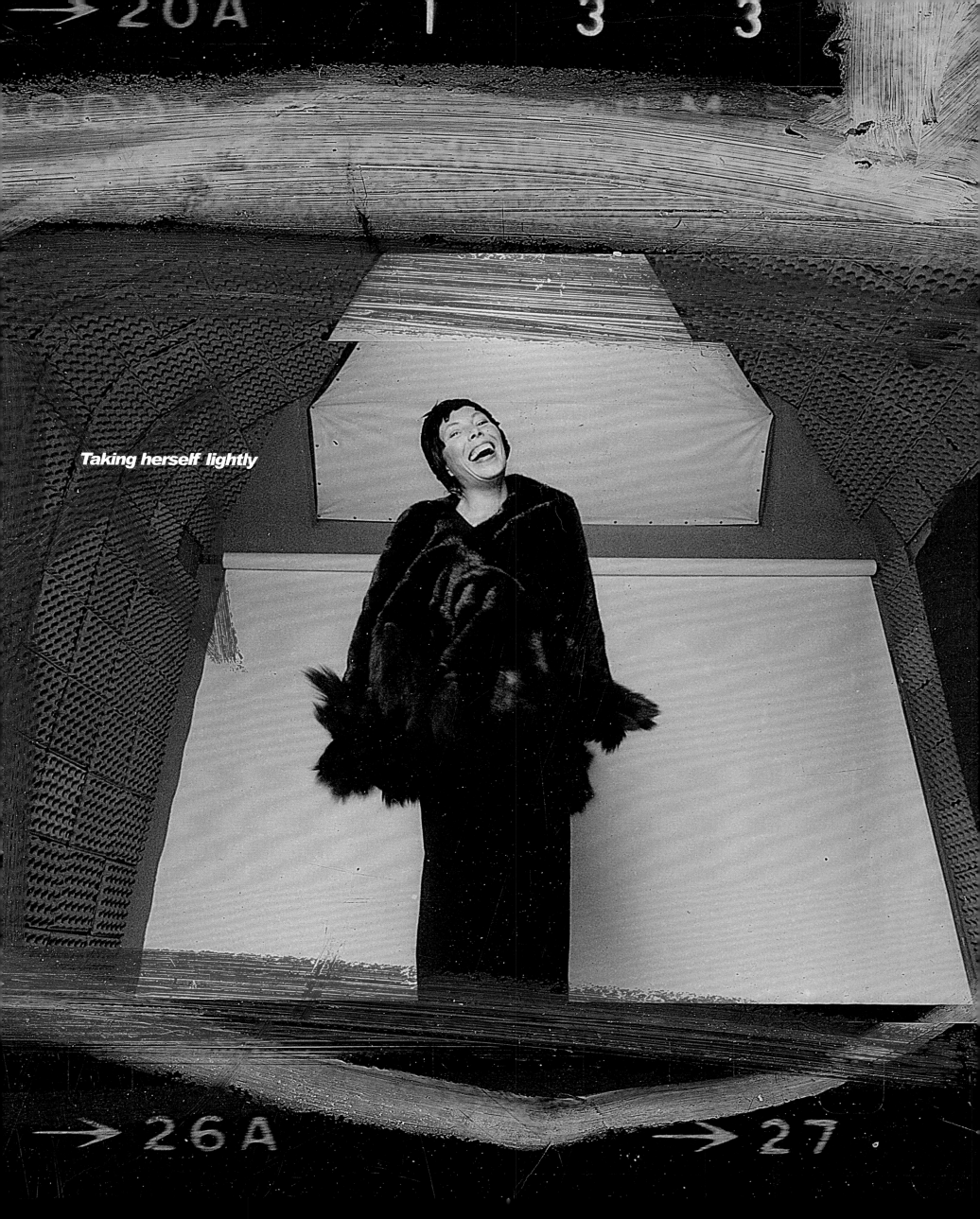

Taking herself lightly

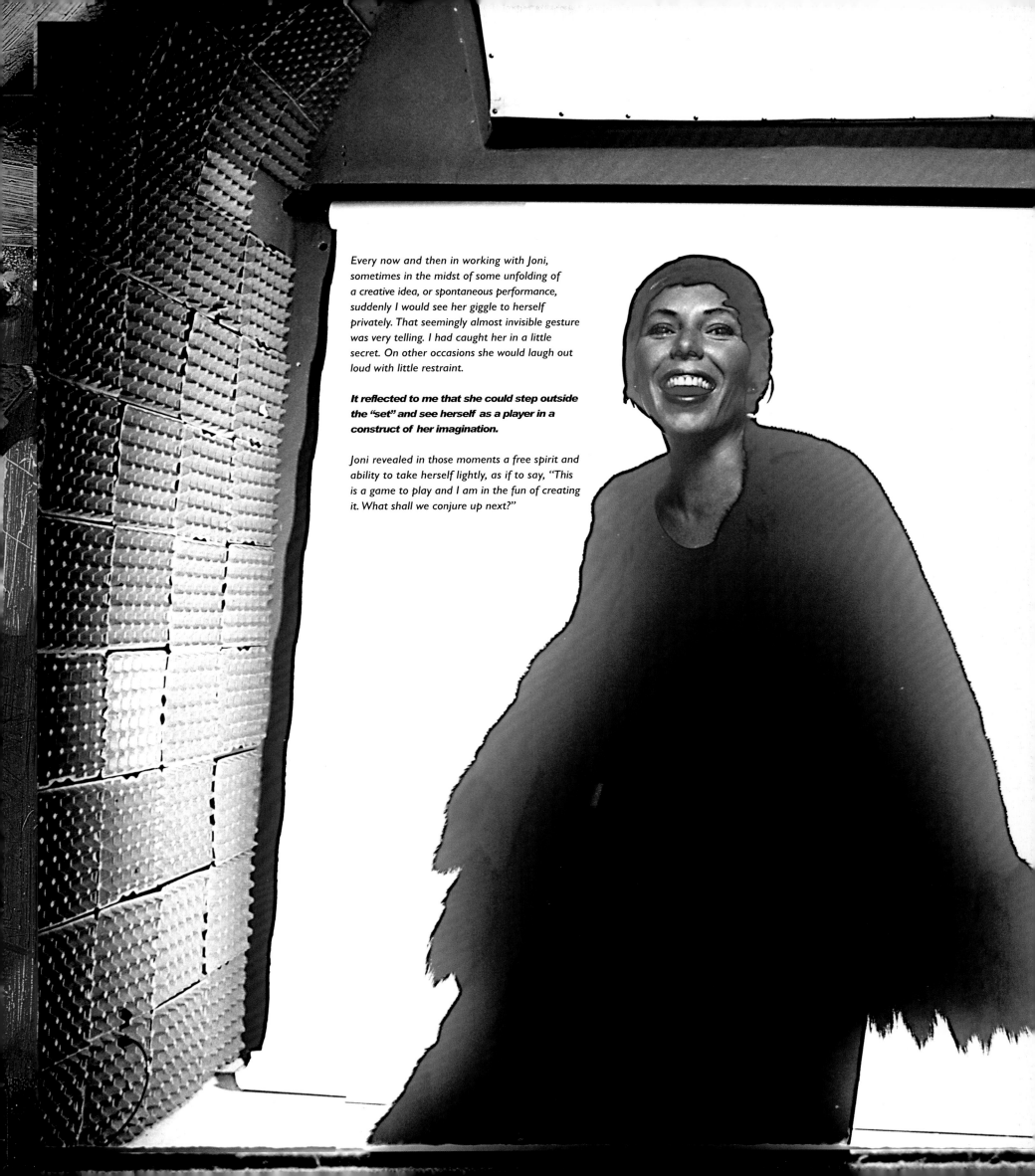

Every now and then in working with Joni, sometimes in the midst of some unfolding of a creative idea, or spontaneous performance, suddenly I would see her giggle to herself privately. That seemingly almost invisible gesture was very telling. I had caught her in a little secret. On other occasions she would laugh out loud with little restraint.

It reflected to me that she could step outside the "set" and see herself as a player in a construct of her imagination.

Joni revealed in those moments a free spirit and ability to take herself lightly, as if to say, "This is a game to play and I am in the fun of creating it. What shall we conjure up next?"

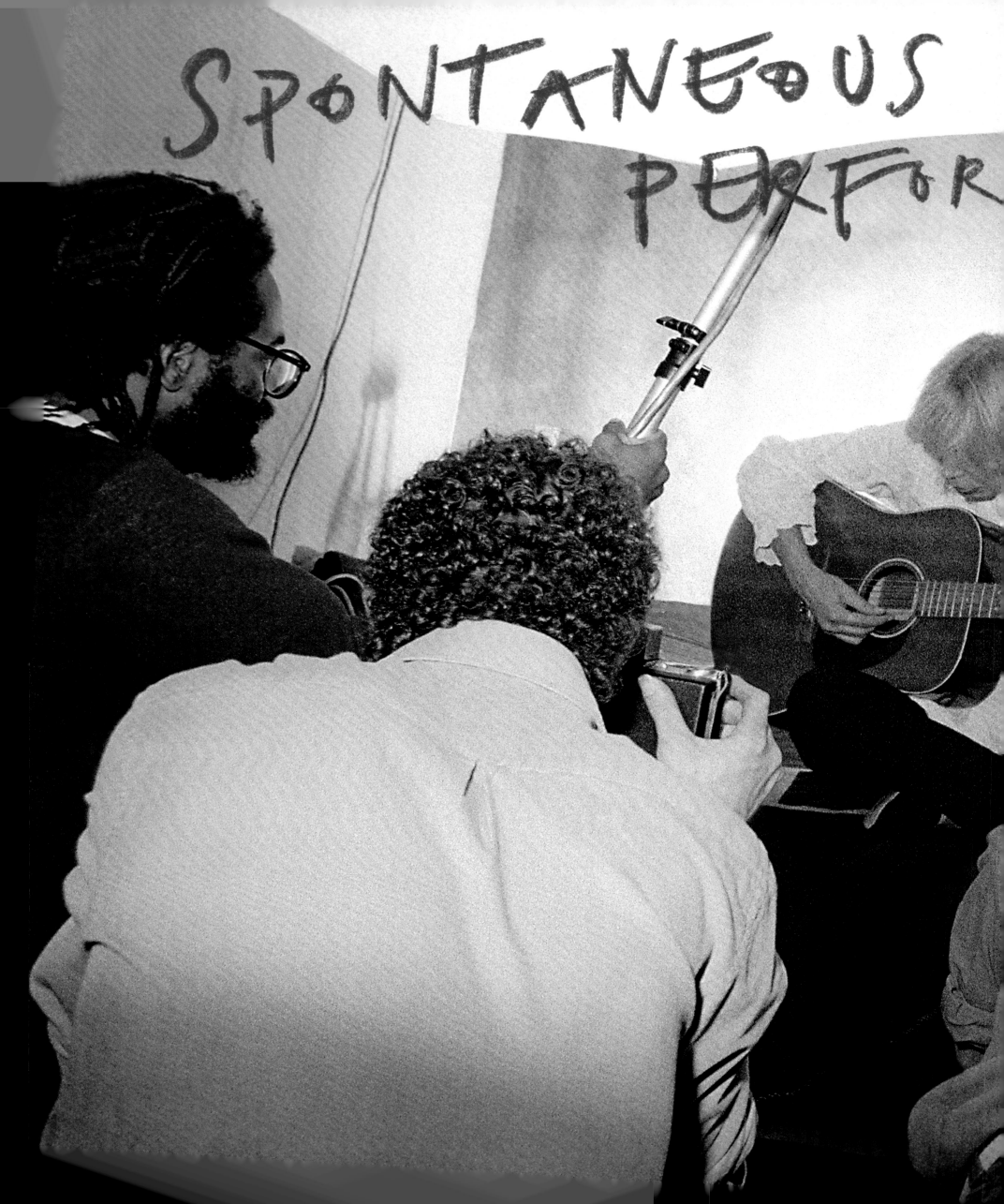

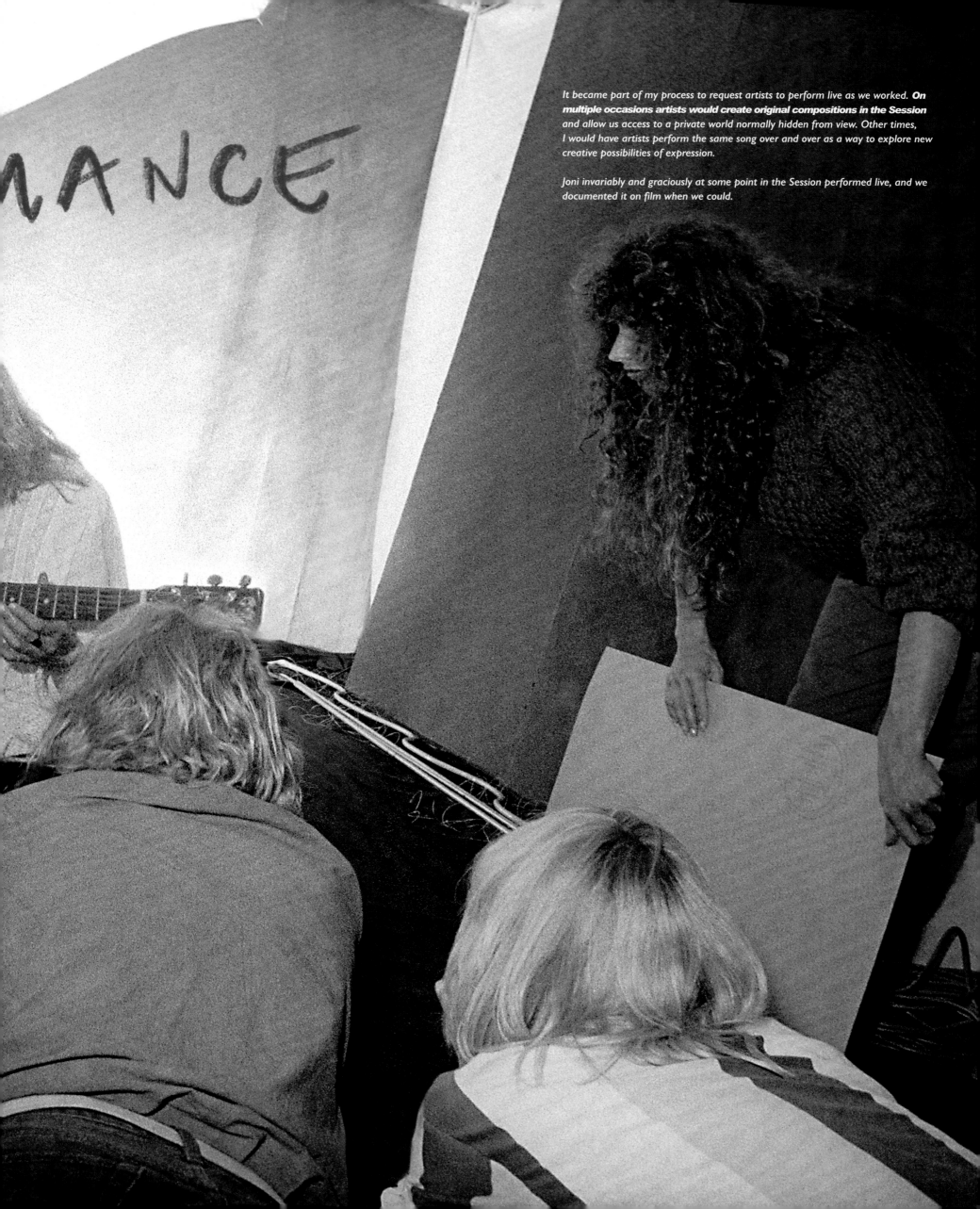

It became part of my process to request artists to perform live as we worked. **On multiple occasions artists would create original compositions in the Session** and allow us access to a private world normally hidden from view. Other times, I would have artists perform the same song over and over as a way to explore new creative possibilities of expression.

Joni invariably and graciously at some point in the Session performed live, and we documented it on film when we could.

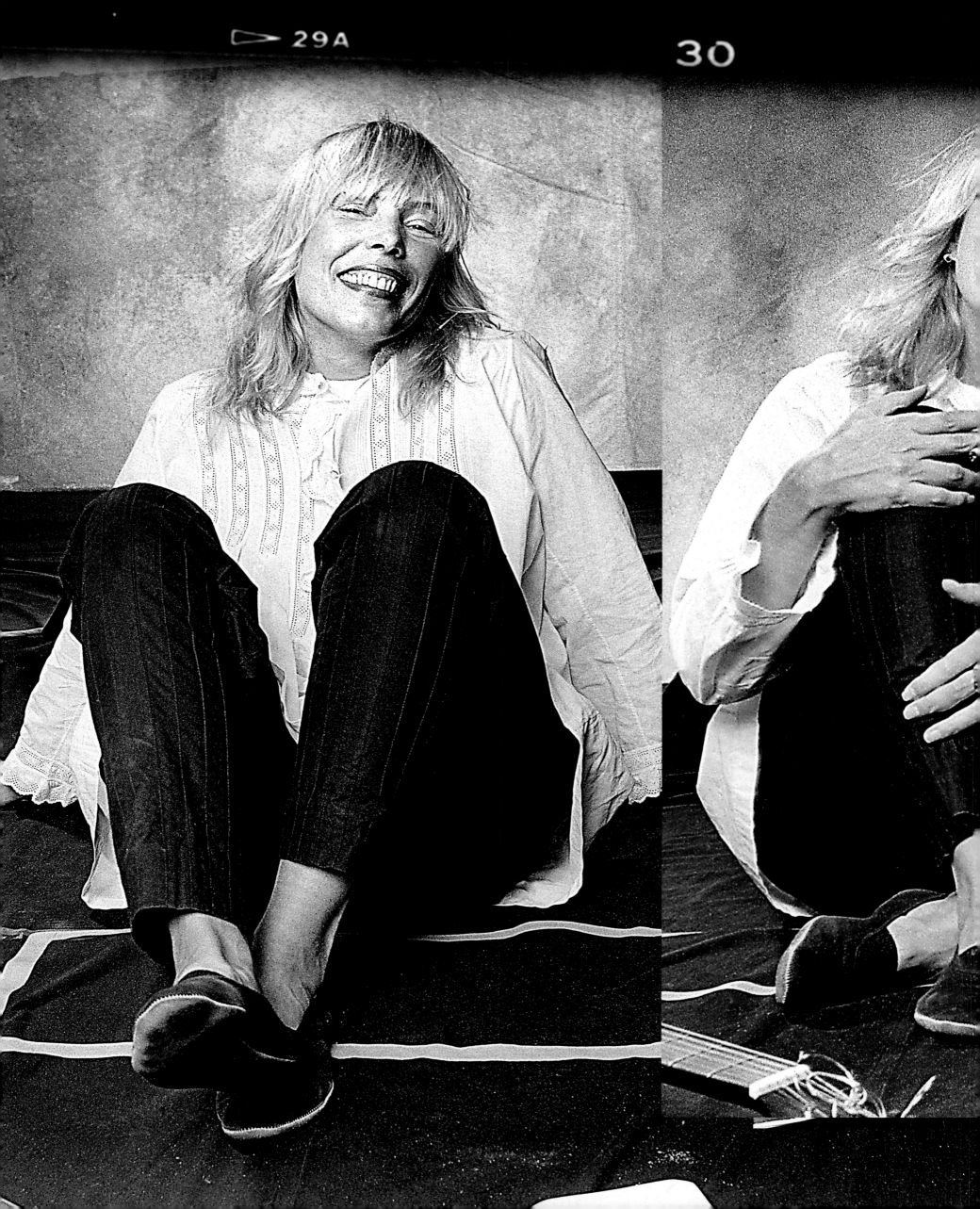

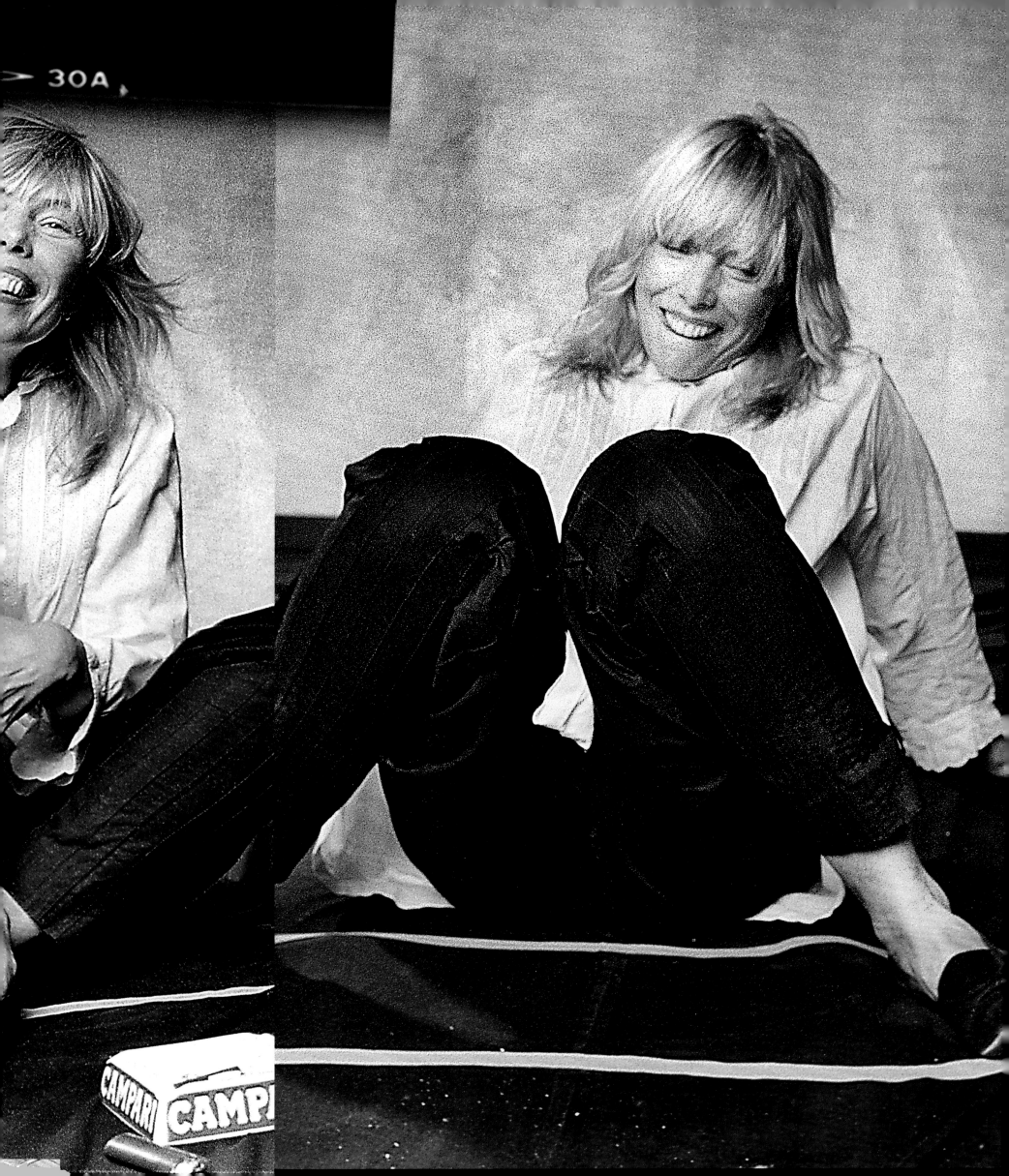

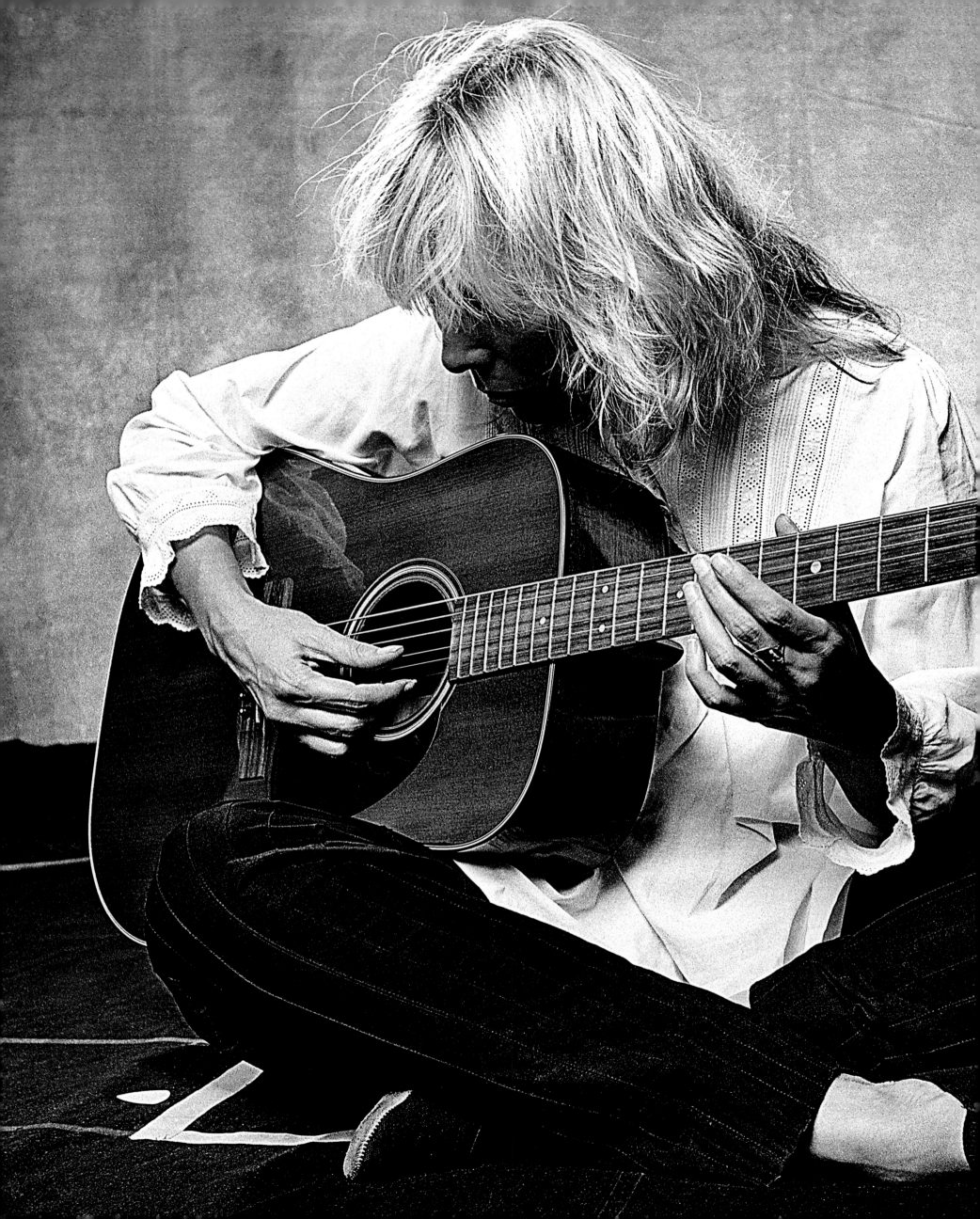

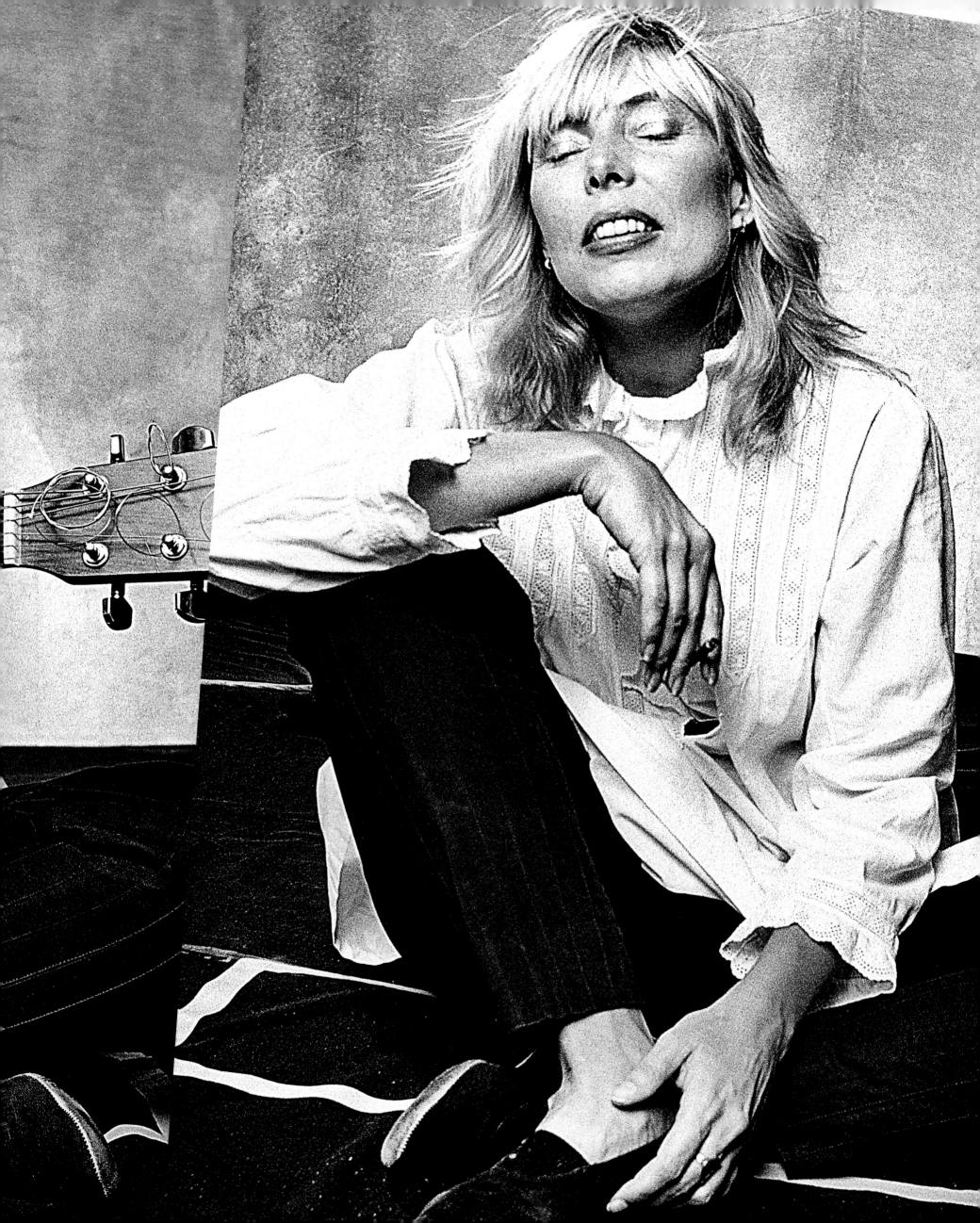

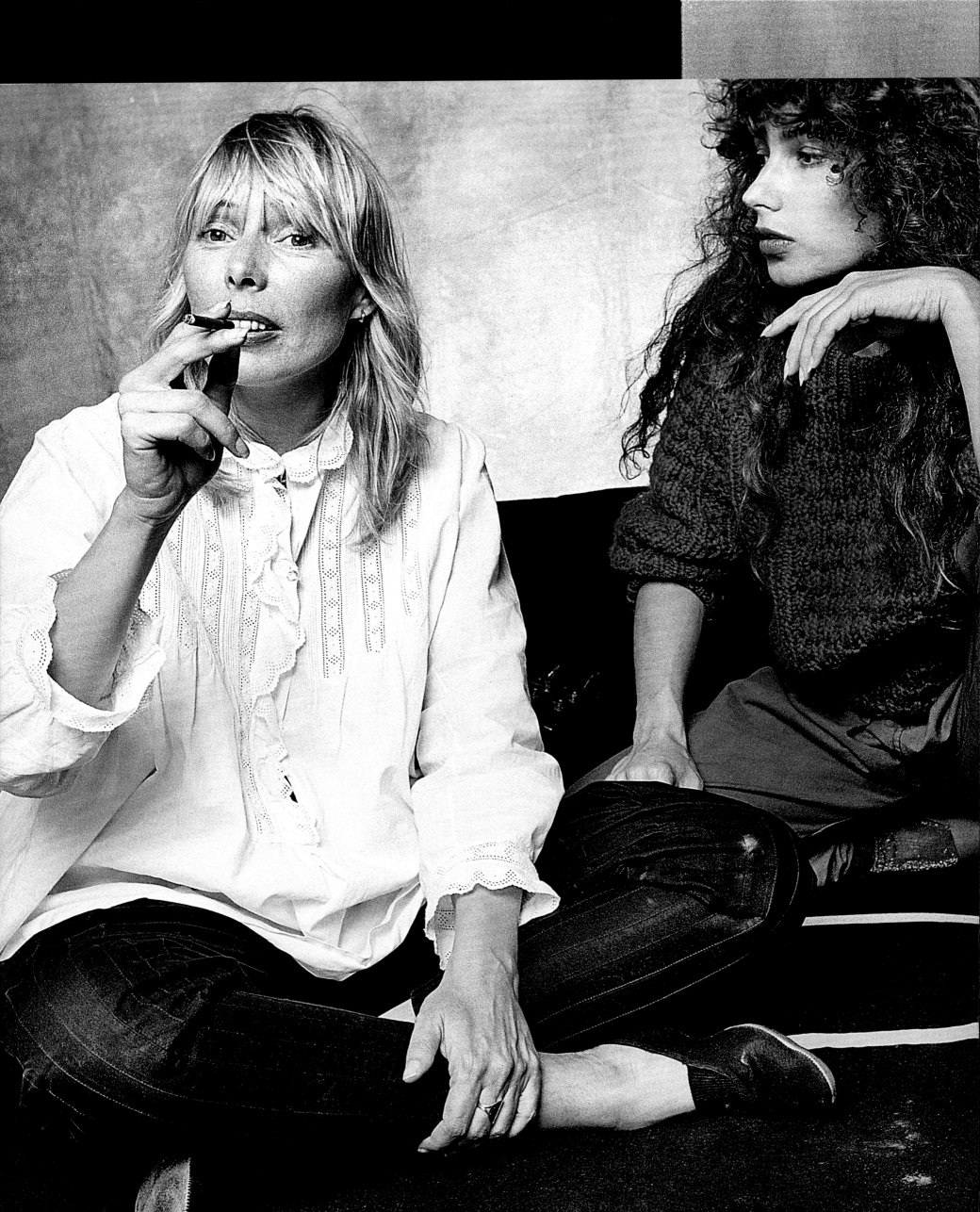

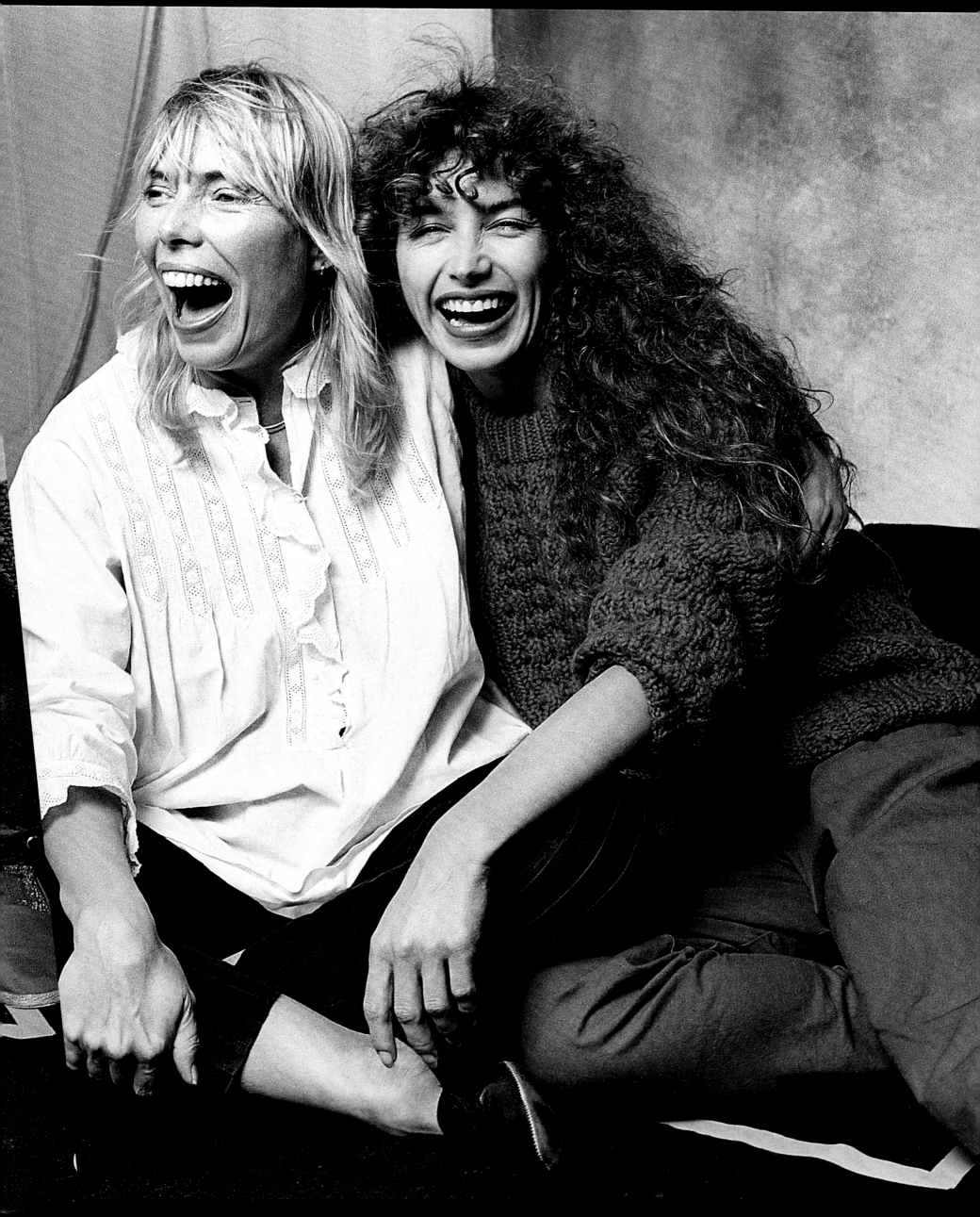

IN THE ZONE

Joni gets a shoulder massage in a short break during a Session. Darius Anthony, my longtime assistant, and my wife, Sue, share a private moment. Without missing a beat, we would get back to work with a level of intensity that Joni was always up for.

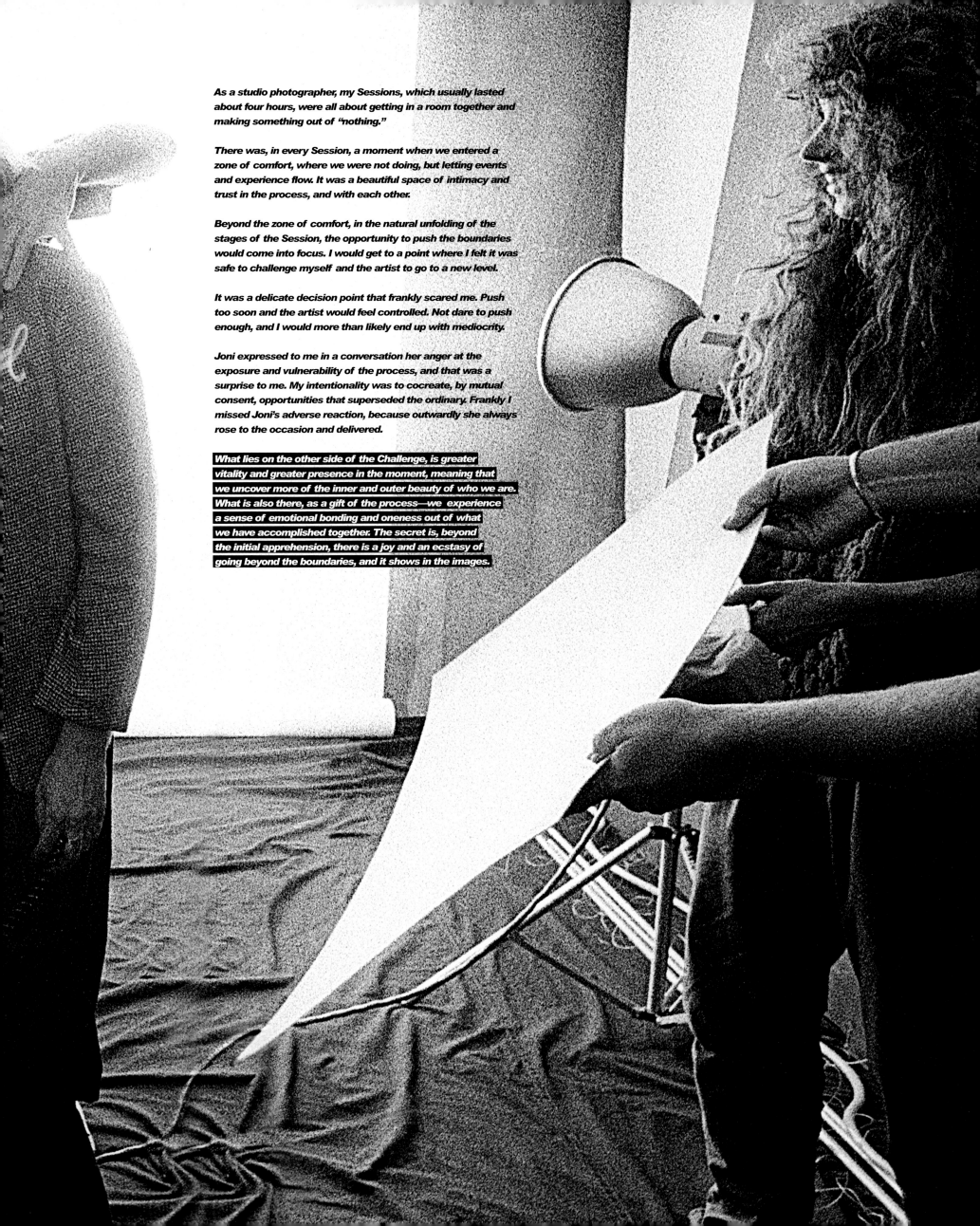

As a studio photographer, my Sessions, which usually lasted about four hours, were all about getting in a room together and making something out of "nothing."

There was, in every Session, a moment when we entered a zone of comfort, where we were not doing, but letting events and experience flow. It was a beautiful space of intimacy and trust in the process, and with each other.

Beyond the zone of comfort, in the natural unfolding of the stages of the Session, the opportunity to push the boundaries would come into focus. I would get to a point where I felt it was safe to challenge myself and the artist to go to a new level.

It was a delicate decision point that frankly scared me. Push too soon and the artist would feel controlled. Not dare to push enough, and I would more than likely end up with mediocrity.

Joni expressed to me in a conversation her anger at the exposure and vulnerability of the process, and that was a surprise to me. My intentionality was to cocreate, by mutual consent, opportunities that superseded the ordinary. Frankly I missed Joni's adverse reaction, because outwardly she always rose to the occasion and delivered.

What lies on the other side of the Challenge, is greater vitality and greater presence in the moment, meaning that we uncover more of the inner and outer beauty of who we are. What is also there, as a gift of the process—we experience a sense of emotional bonding and oneness out of what we have accomplished together. The secret is, beyond the initial apprehension, there is a joy and an ecstasy of going beyond the boundaries, and it shows in the images.

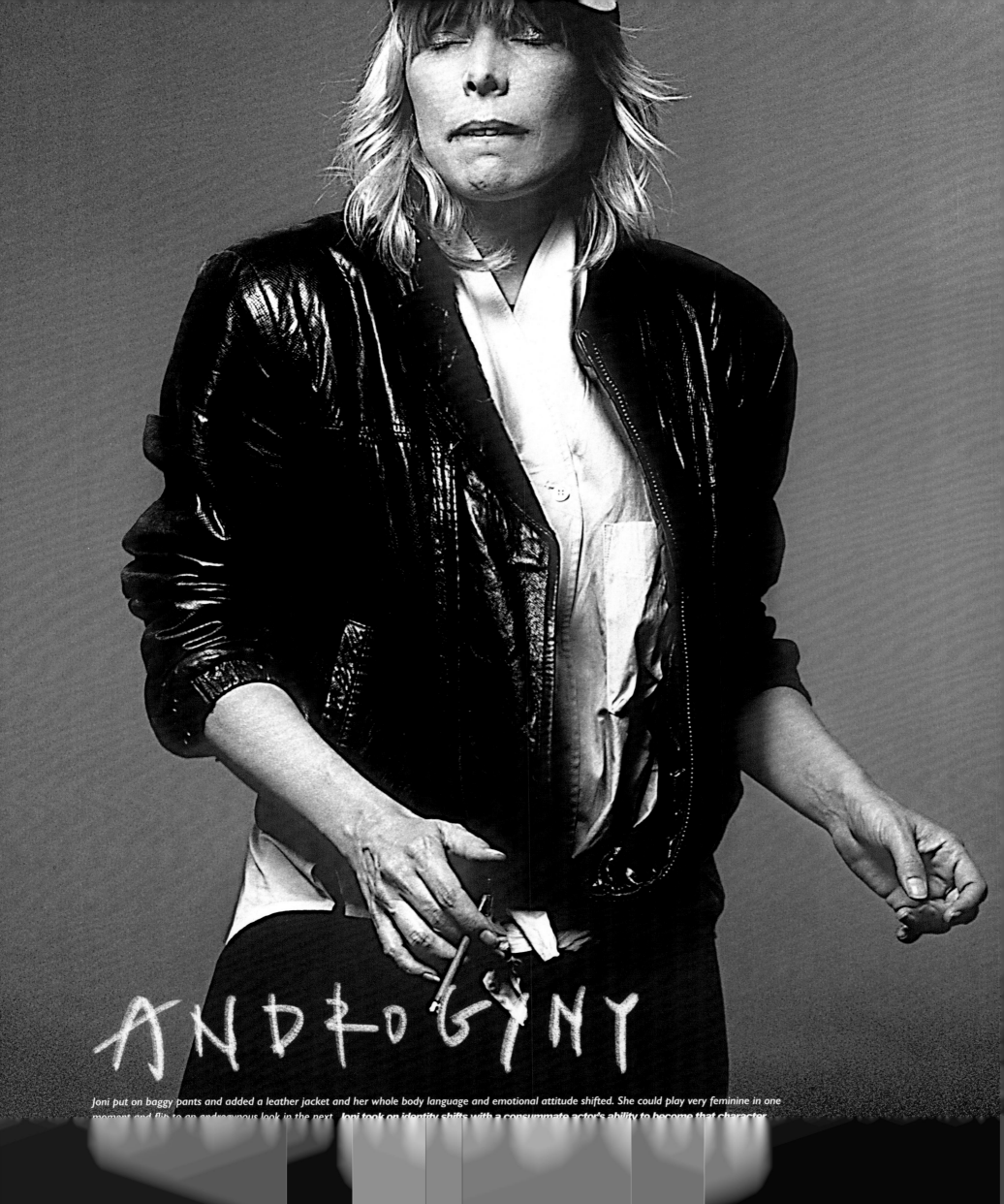

ANDROGYNY

Joni put on baggy pants and added a leather jacket and her whole body language and emotional attitude shifted. She could play very feminine in one moment and flip to an androgynous look in the next. Joni took on identity shifts with a consummate actor's ability to become that character.

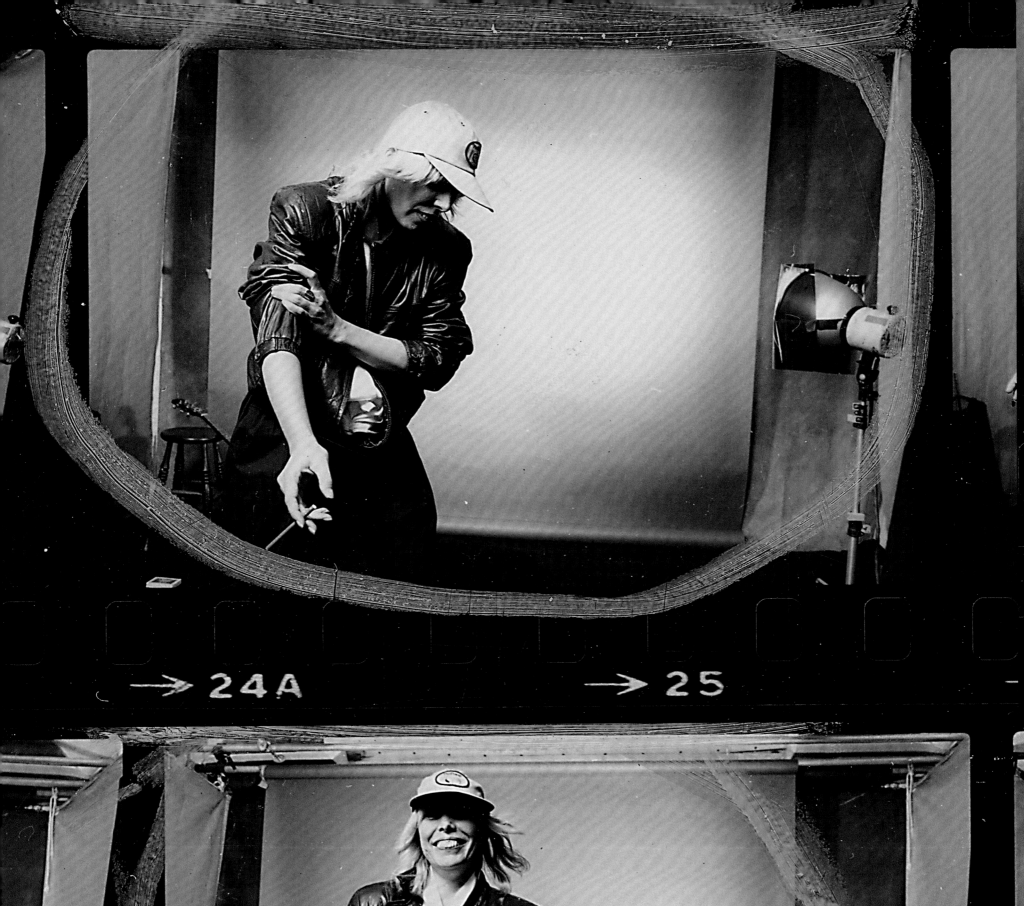

→ 24A → 25

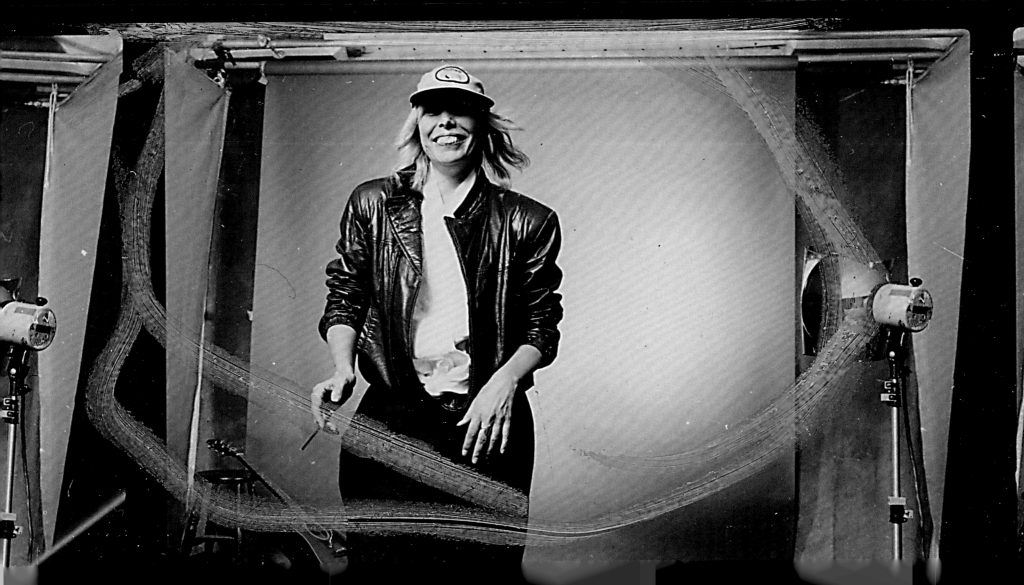

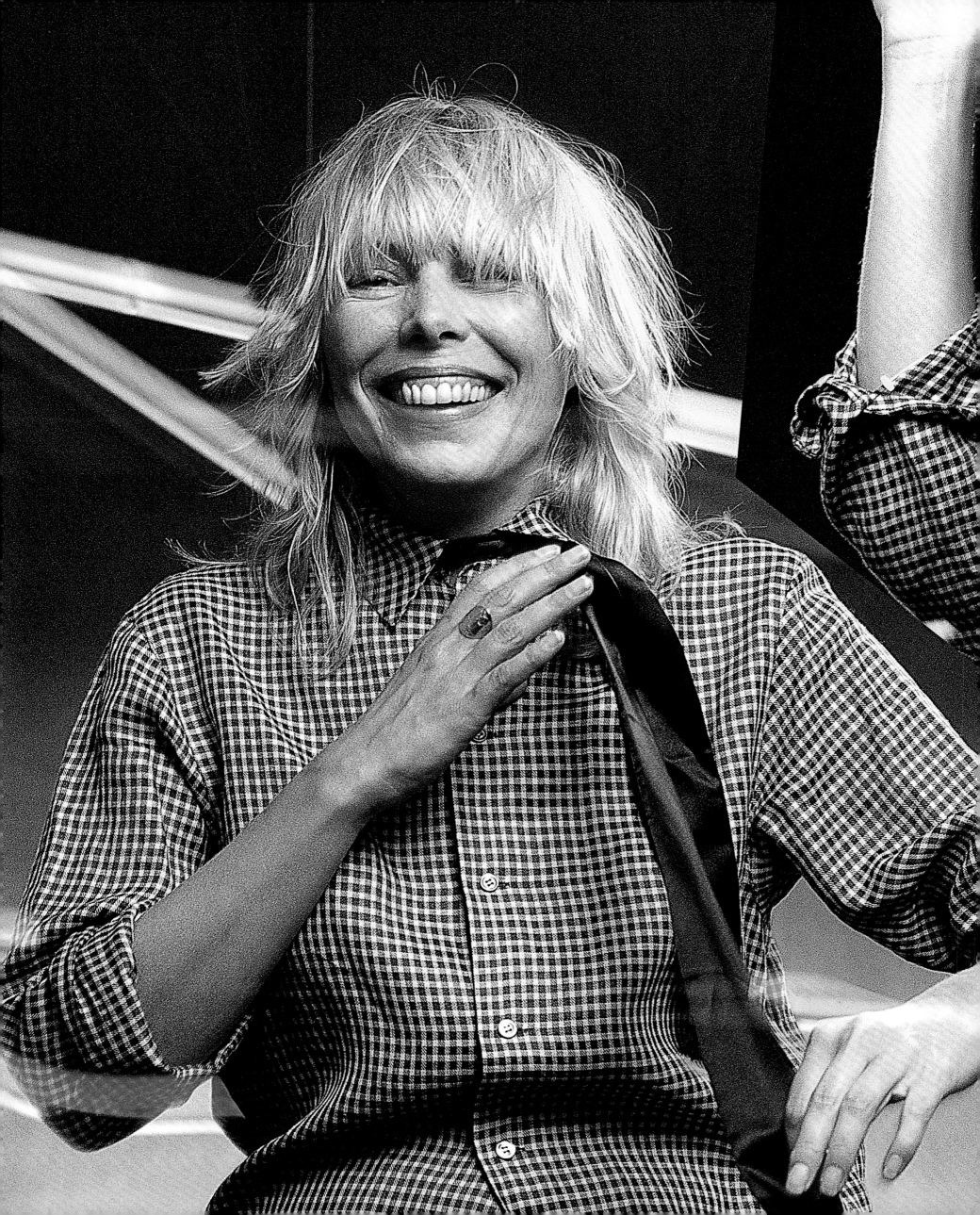

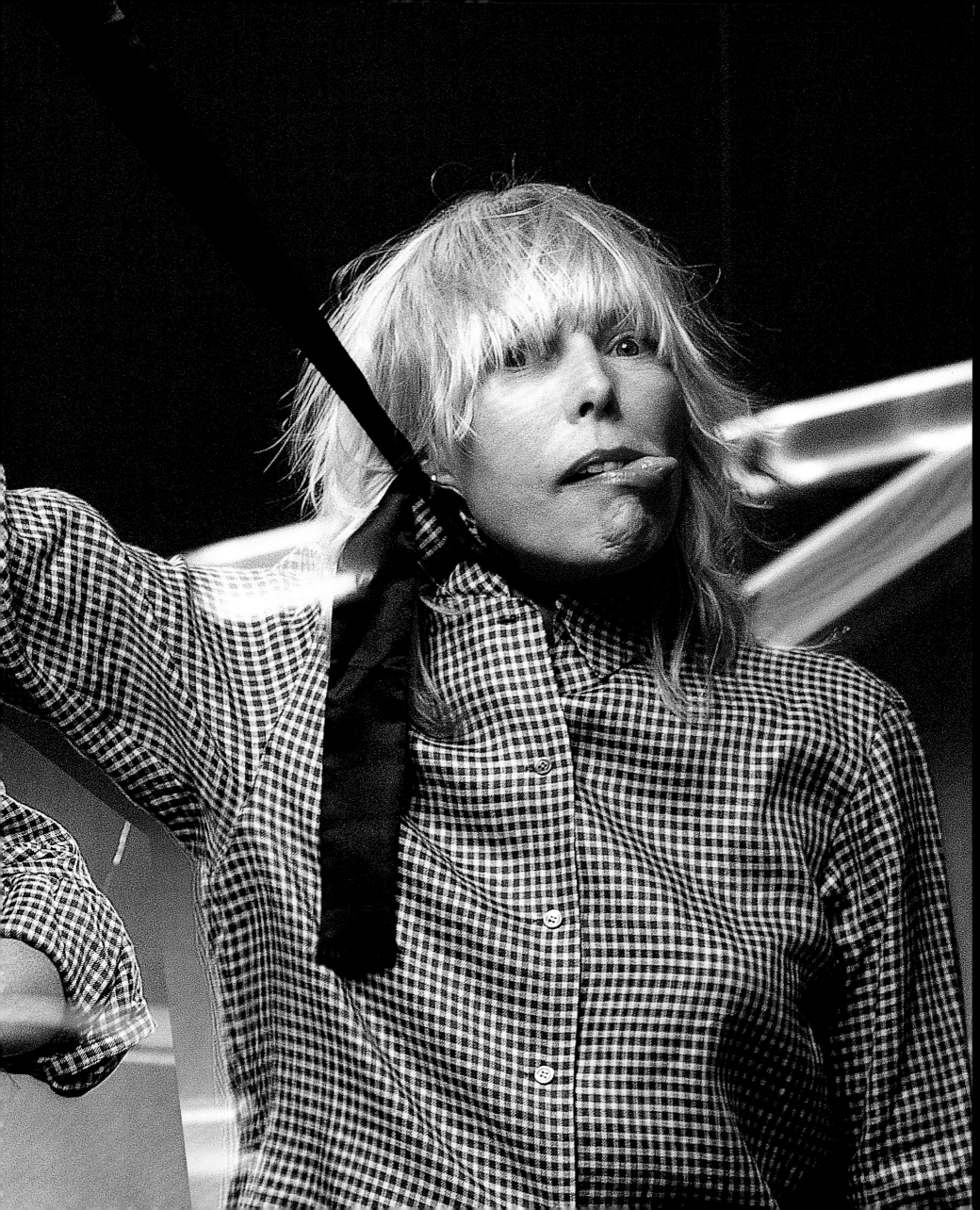

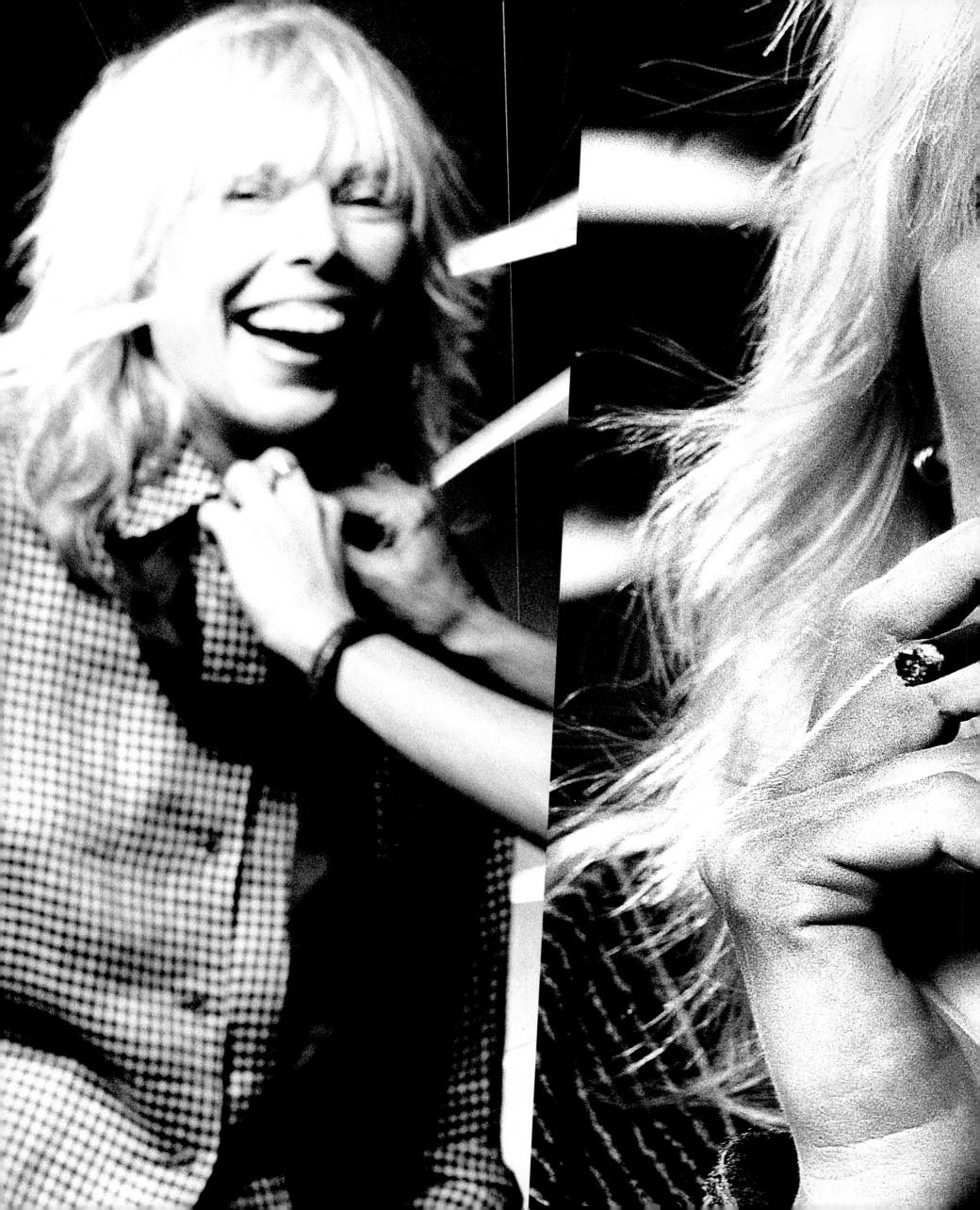

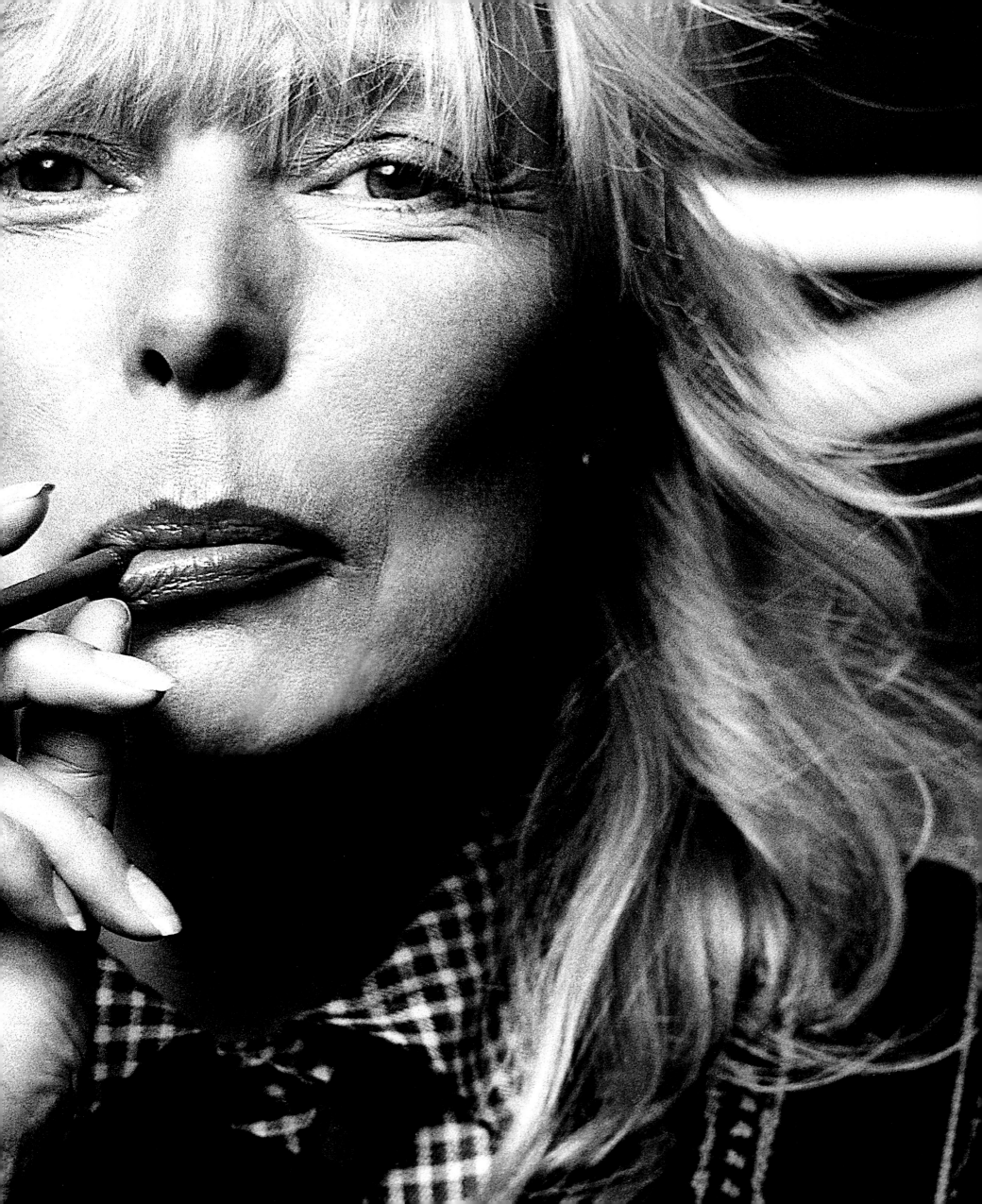

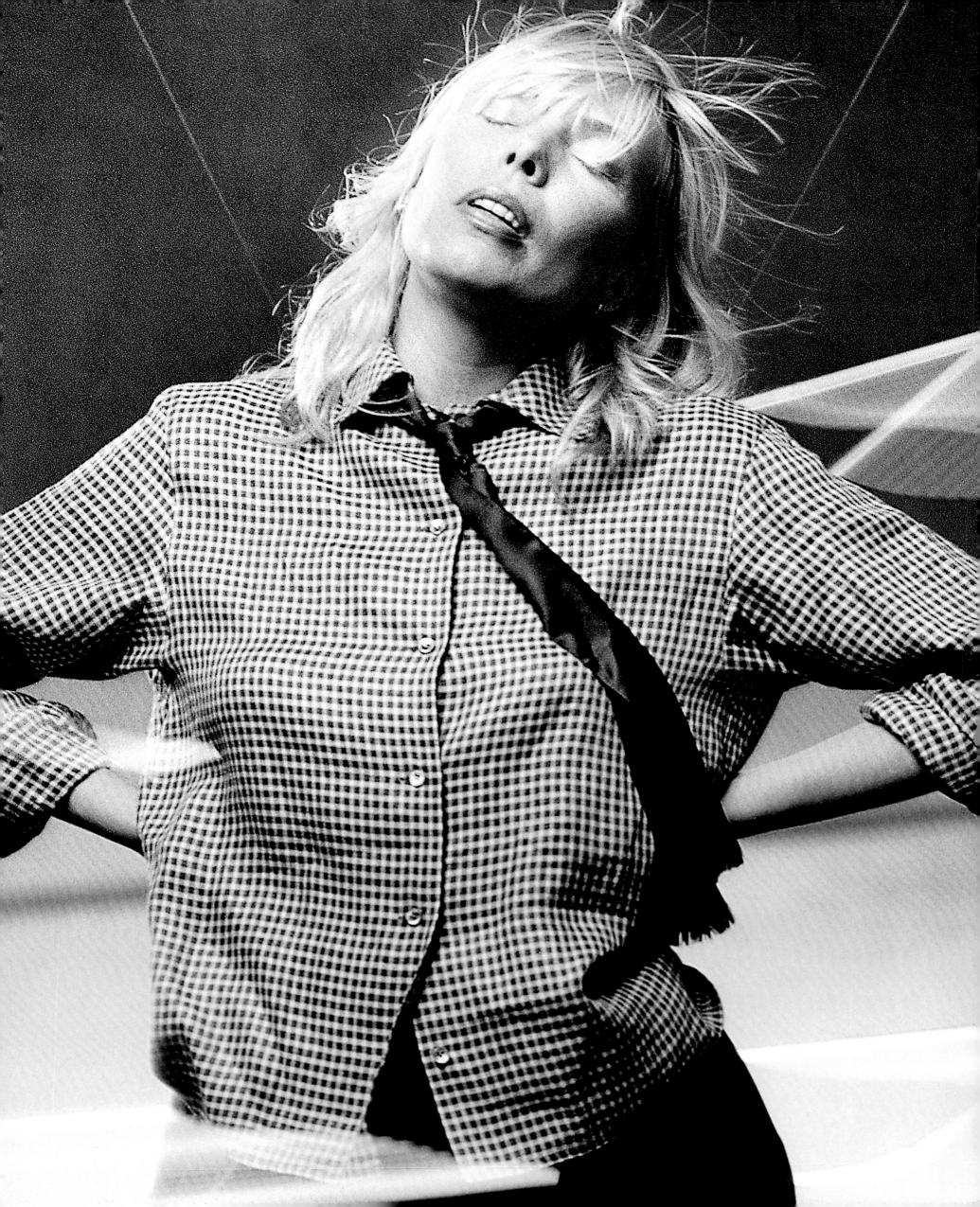

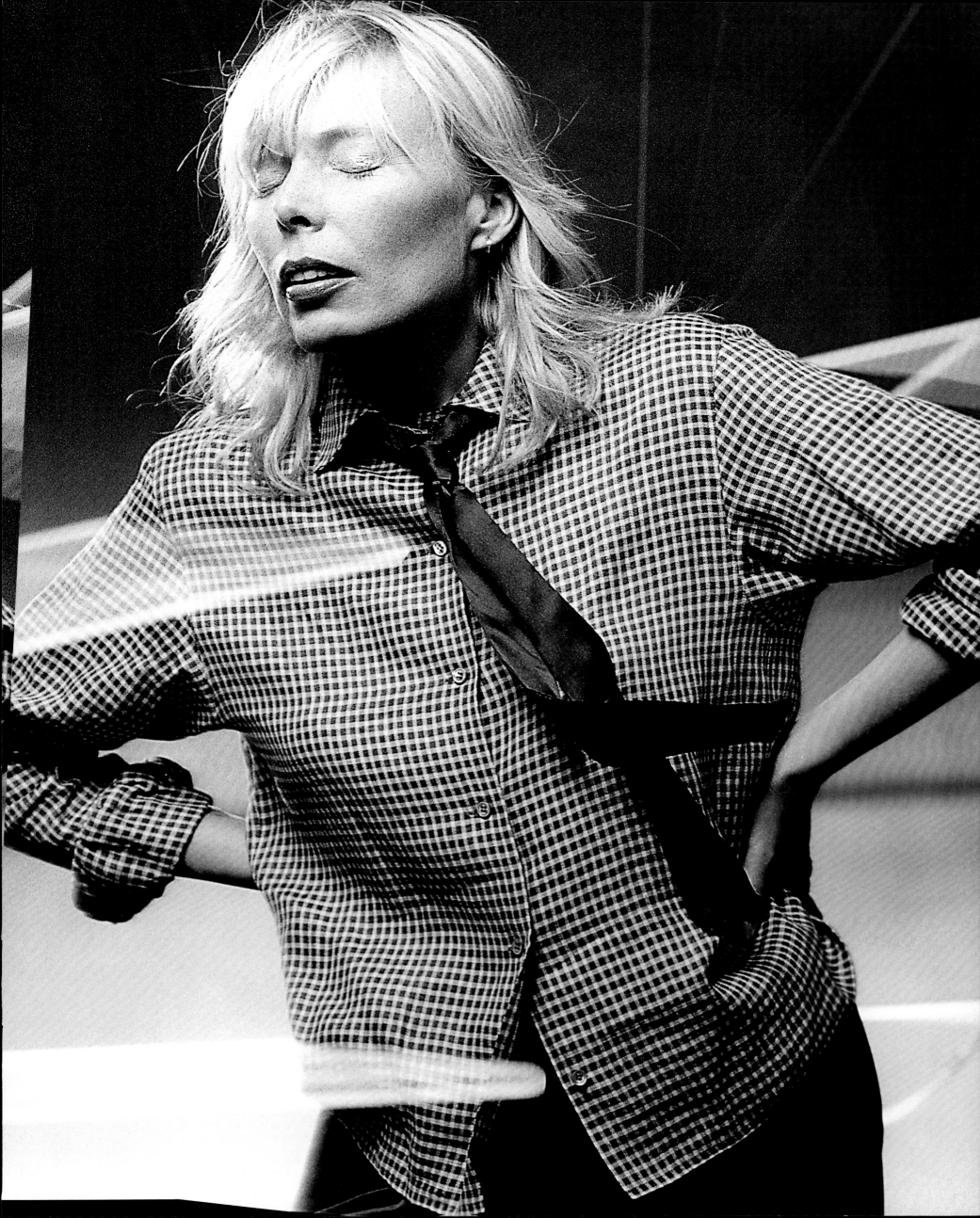

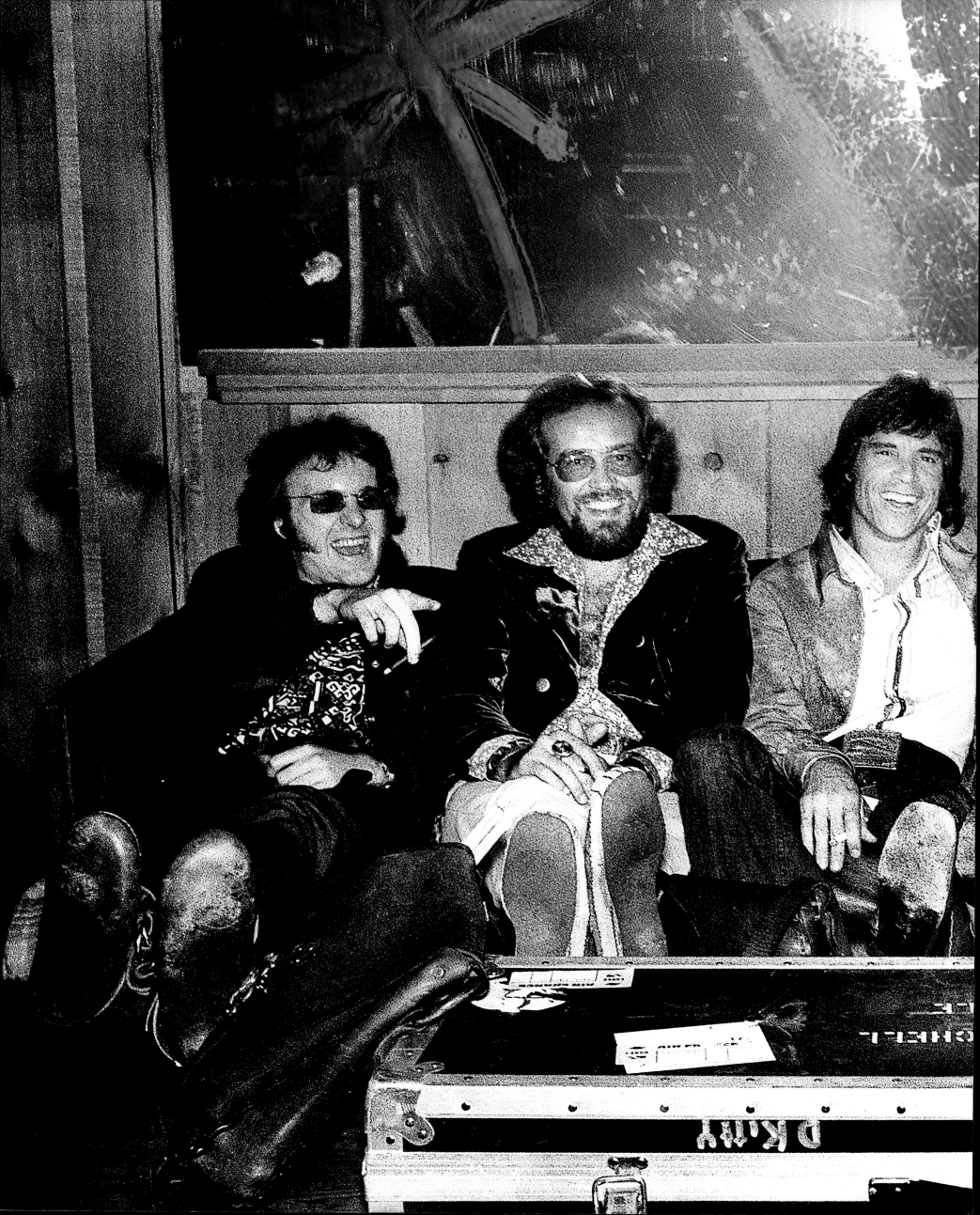

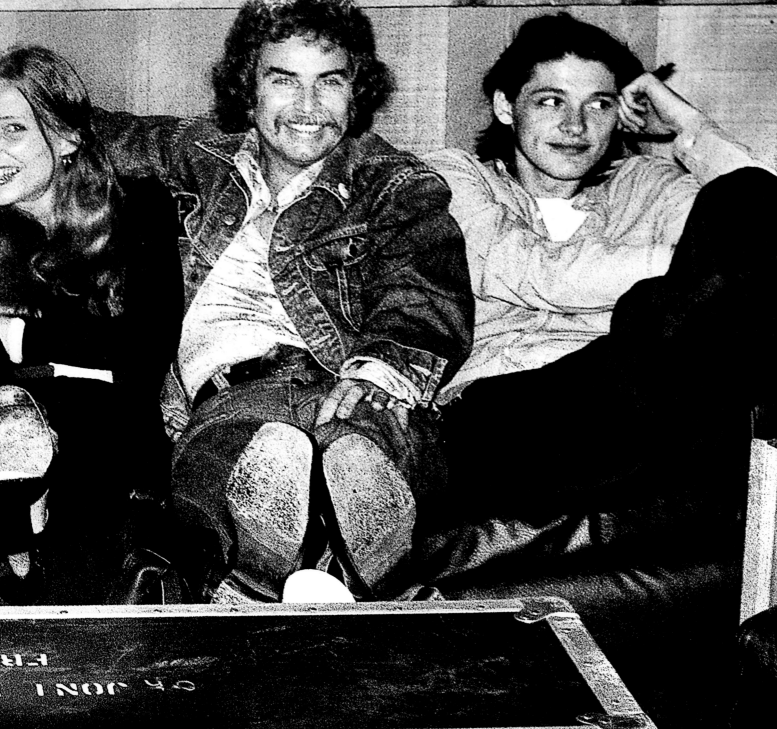

A & M STUDIOS

Tom Scott
Roger Kellaway
John Guerin
Joni
Max Bennett
Robben Ford

INSTRUMENT.

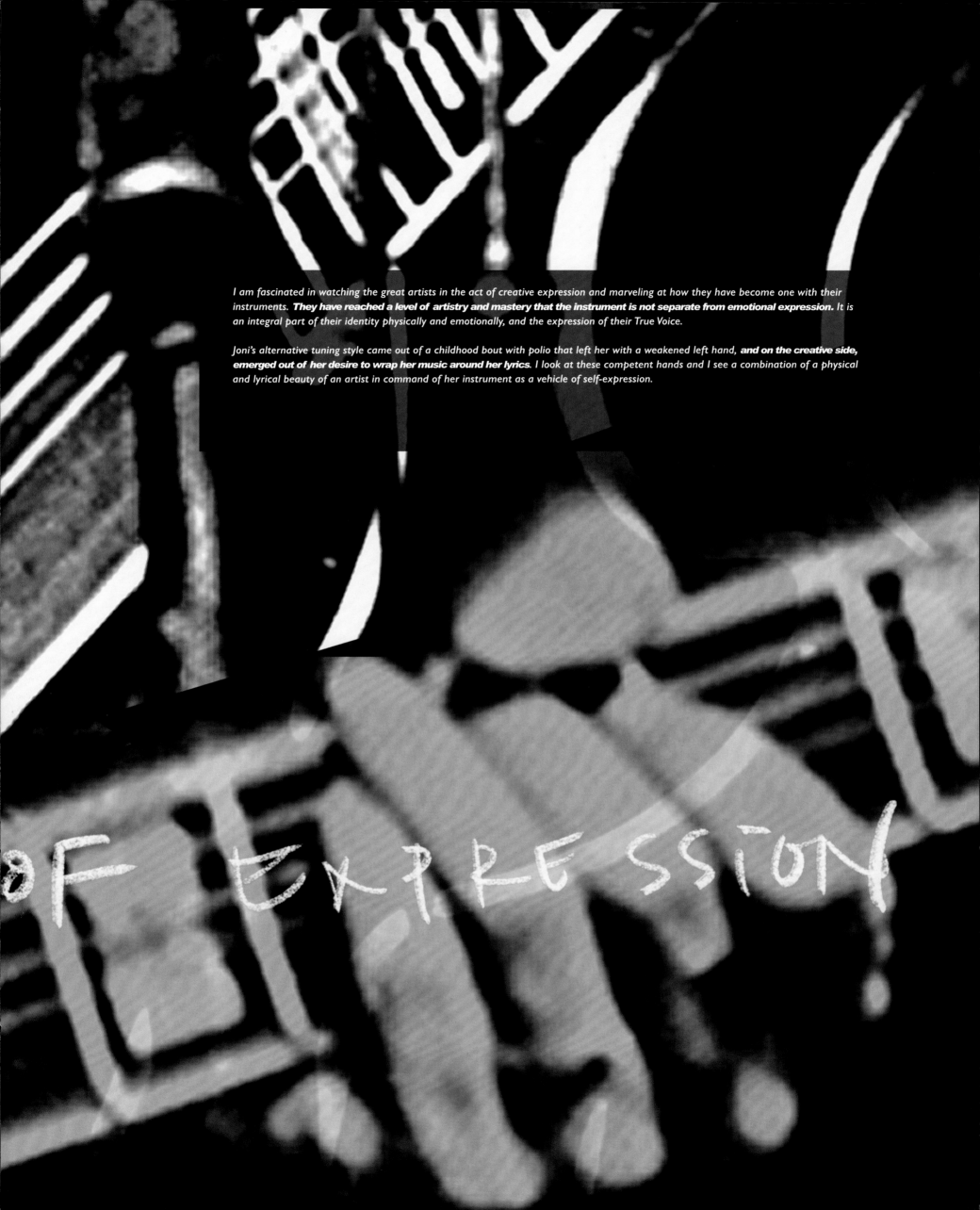

I am fascinated in watching the great artists in the act of creative expression and marveling at how they have become one with their instruments. **They have reached a level of artistry and mastery that the instrument is not separate from emotional expression.** It is an integral part of their identity physically and emotionally, and the expression of their True Voice.

Joni's alternative tuning style came out of a childhood bout with polio that left her with a weakened left hand, **and on the creative side, emerged out of her desire to wrap her music around her lyrics.** I look at these competent hands and I see a combination of a physical and lyrical beauty of an artist in command of her instrument as a vehicle of self-expression.

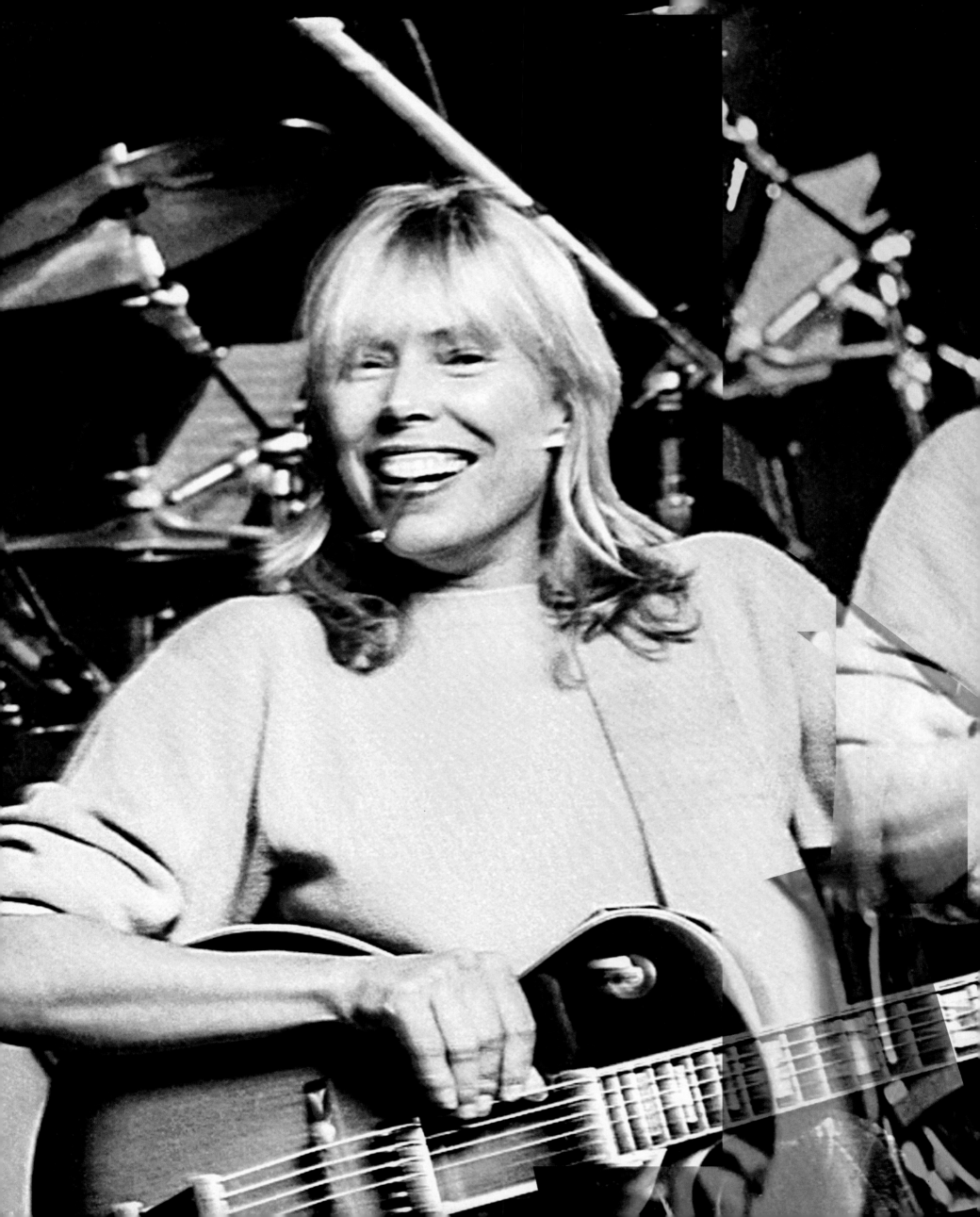

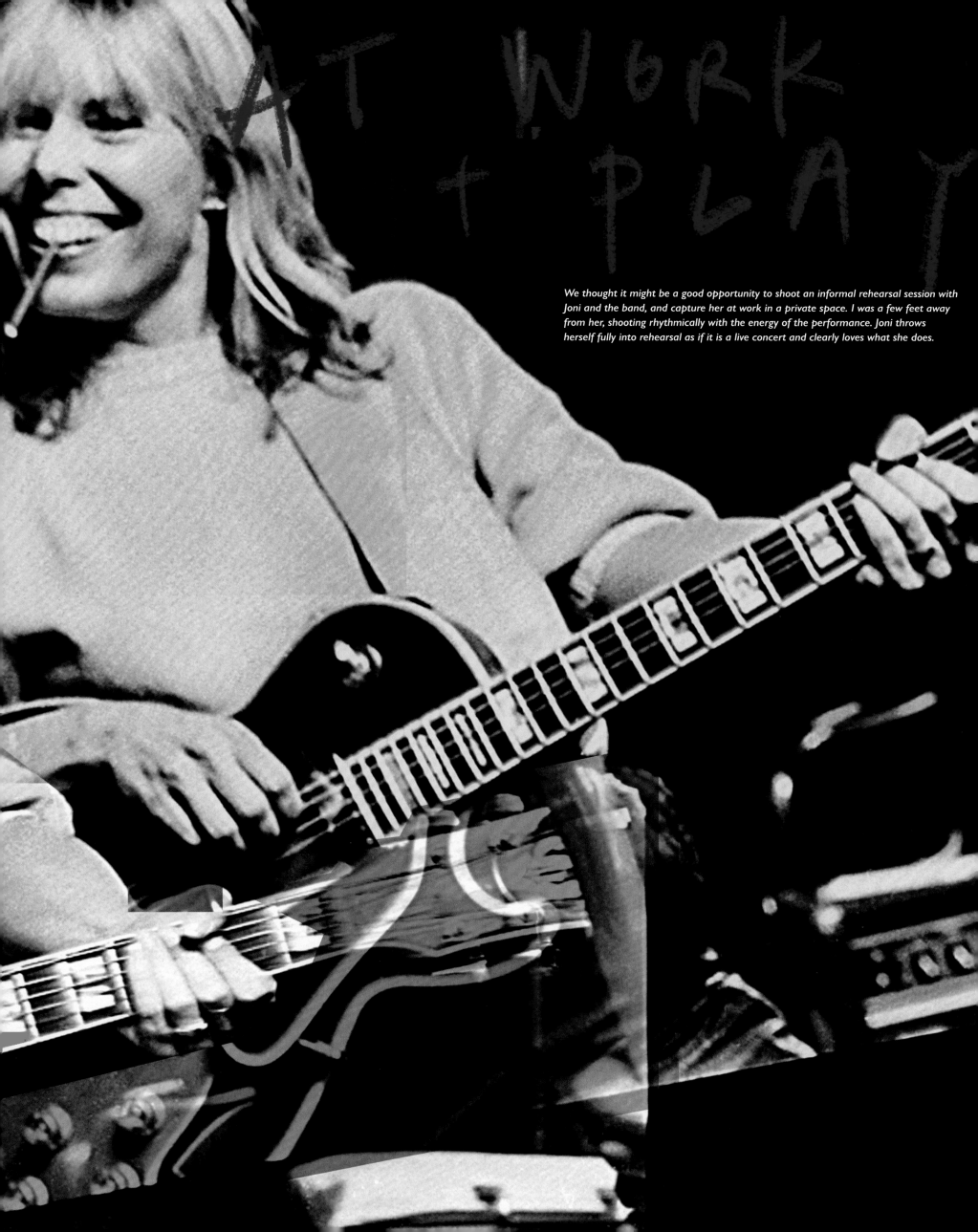

AT WORK + PLAY

We thought it might be a good opportunity to shoot an informal rehearsal session with Joni and the band, and capture her at work in a private space. I was a few feet away from her, shooting rhythmically with the energy of the performance. Joni throws herself fully into rehearsal as if it is a live concert and clearly loves what she does.

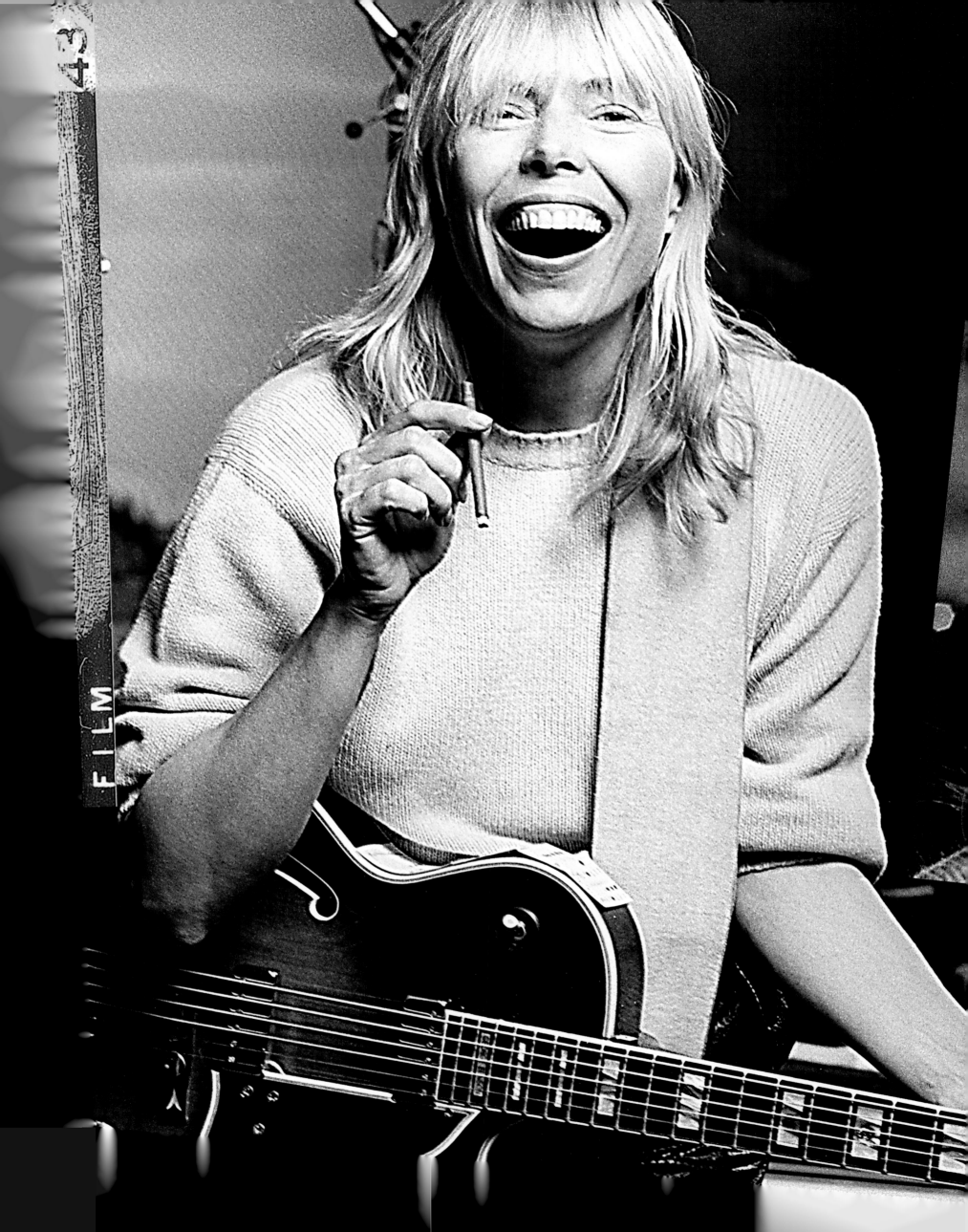

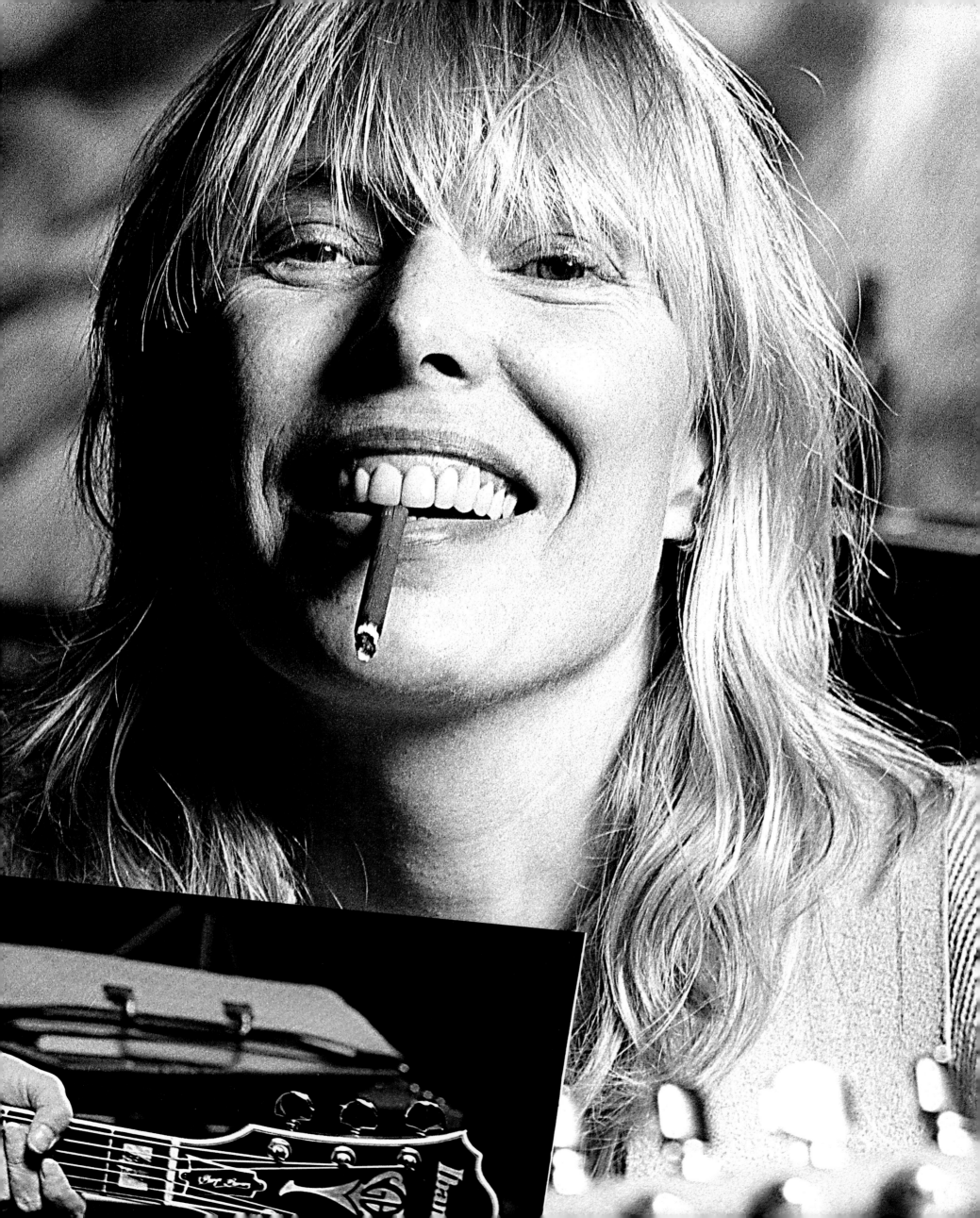

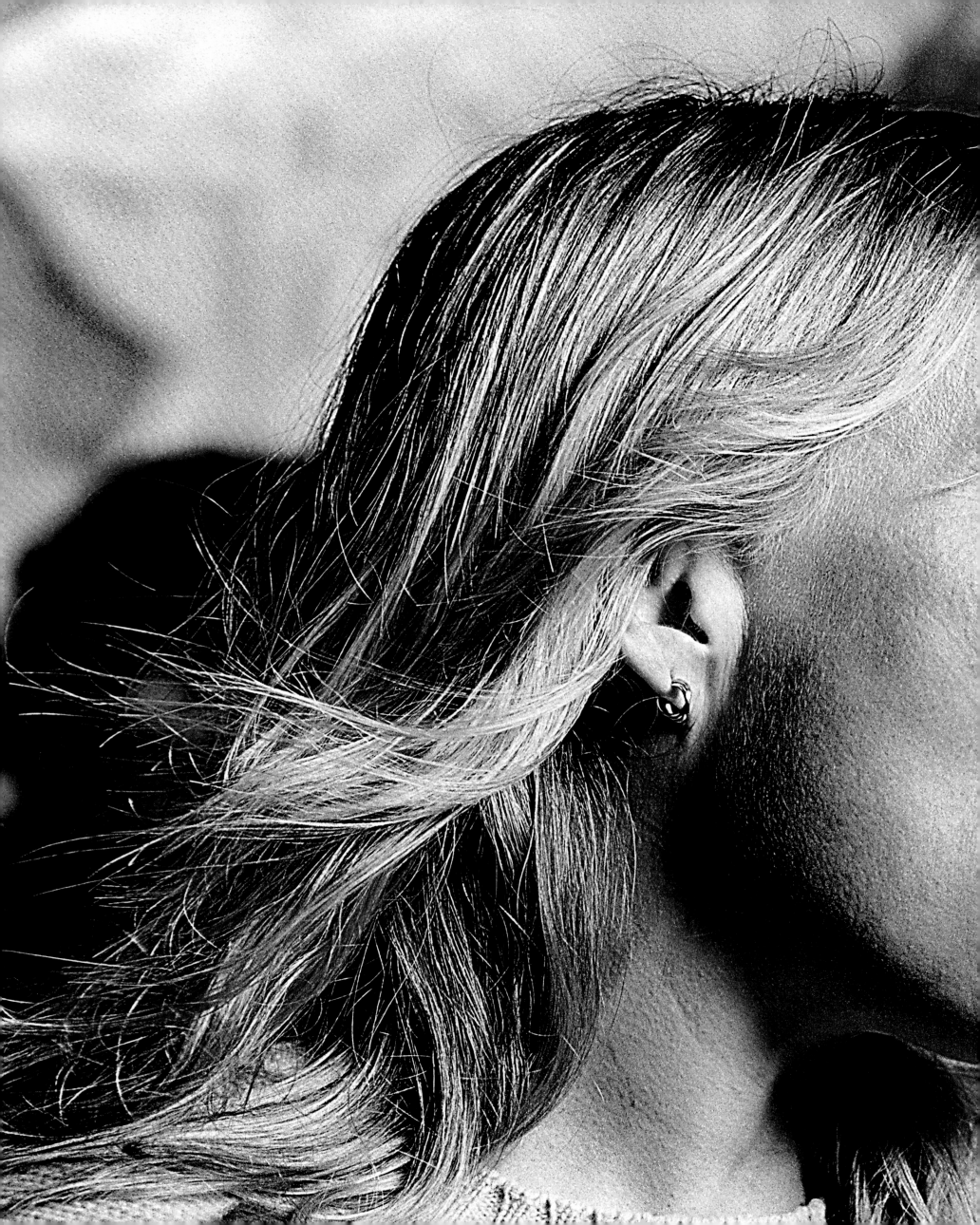

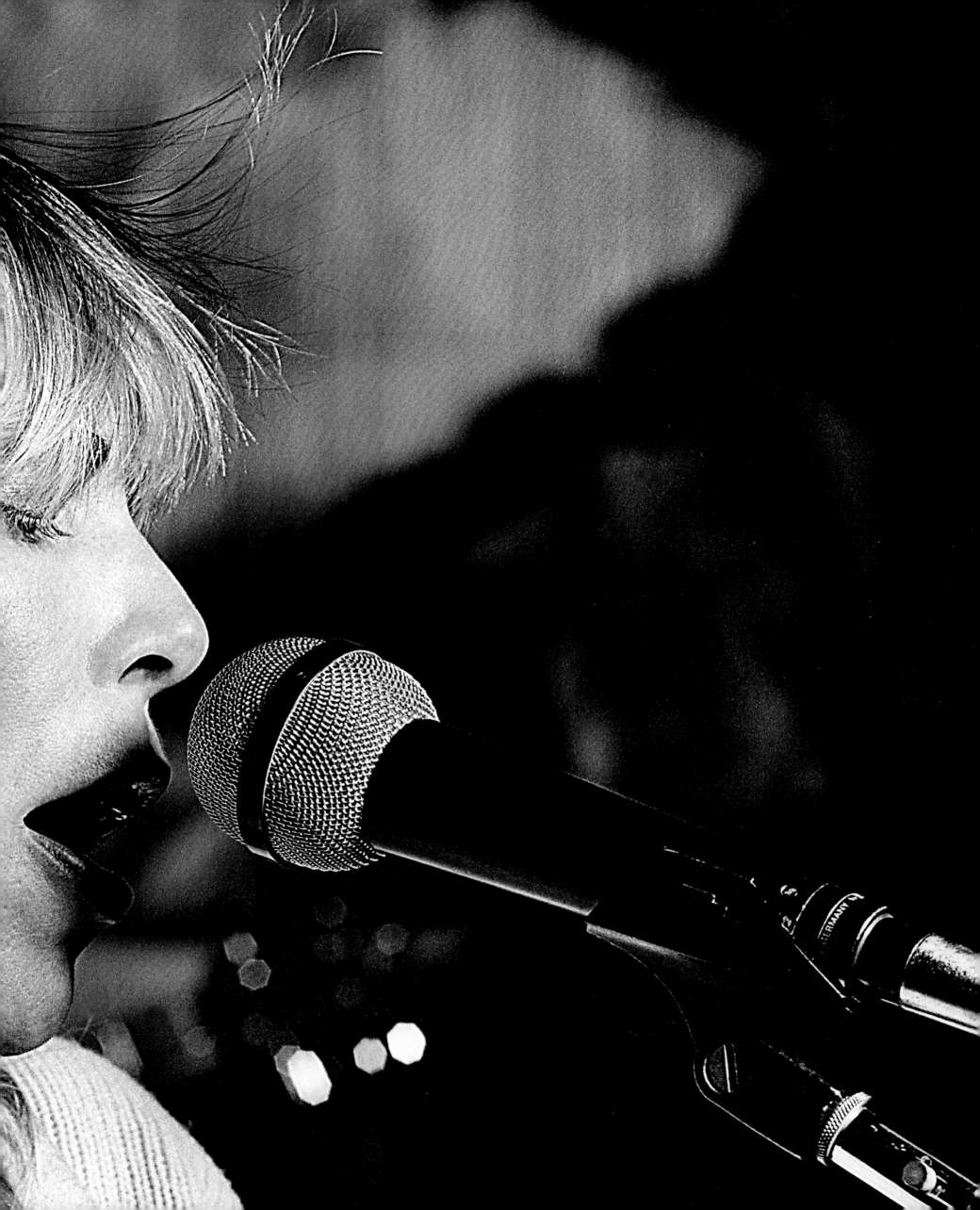

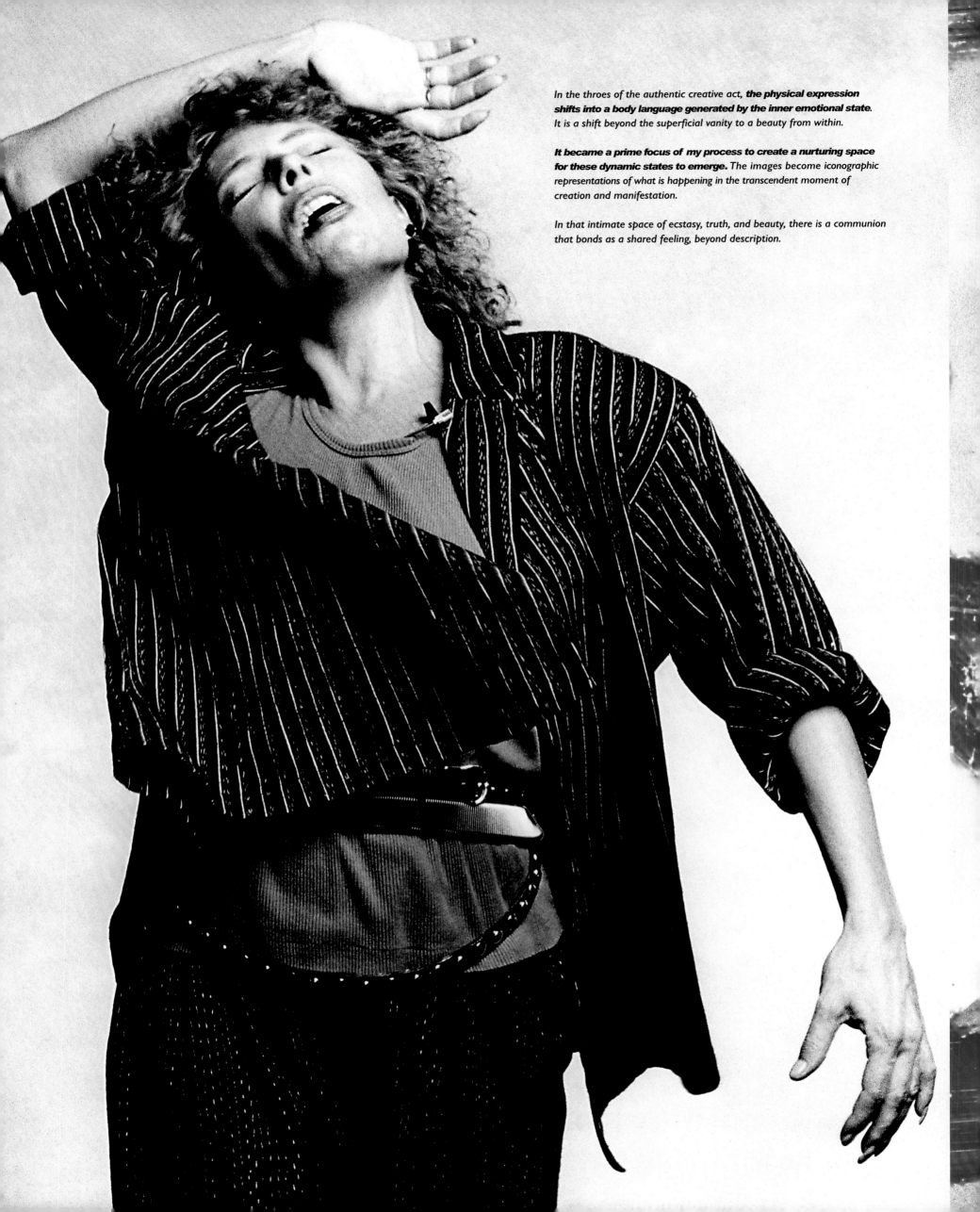

In the throes of the authentic creative act, **the physical expression shifts into a body language generated by the inner emotional state.** It is a shift beyond the superficial vanity to a beauty from within.

It became a prime focus of my process to create a nurturing space for these dynamic states to emerge. The images become iconographic representations of what is happening in the transcendent moment of creation and manifestation.

In that intimate space of ecstasy, truth, and beauty, there is a communion that bonds as a shared feeling, beyond description.

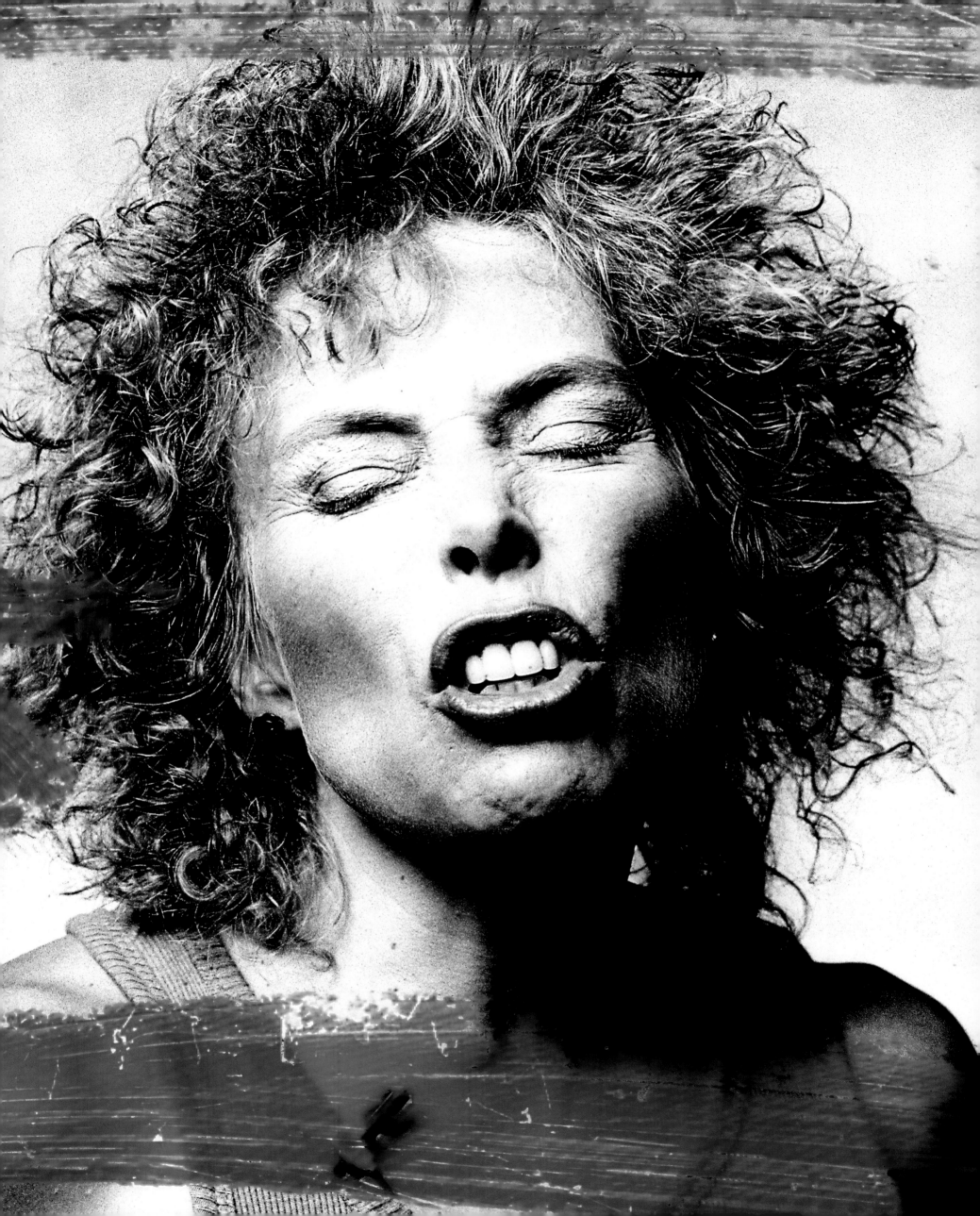

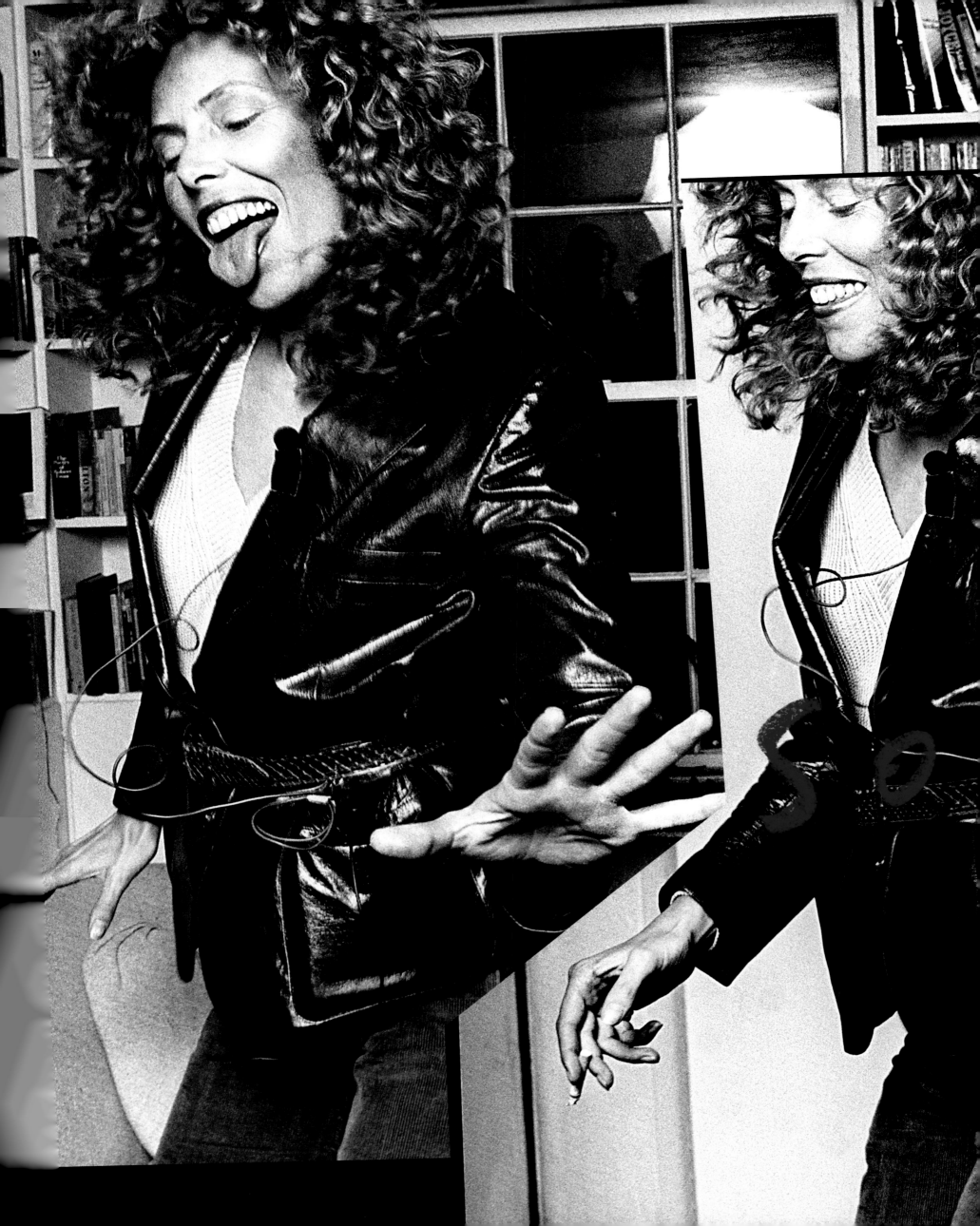

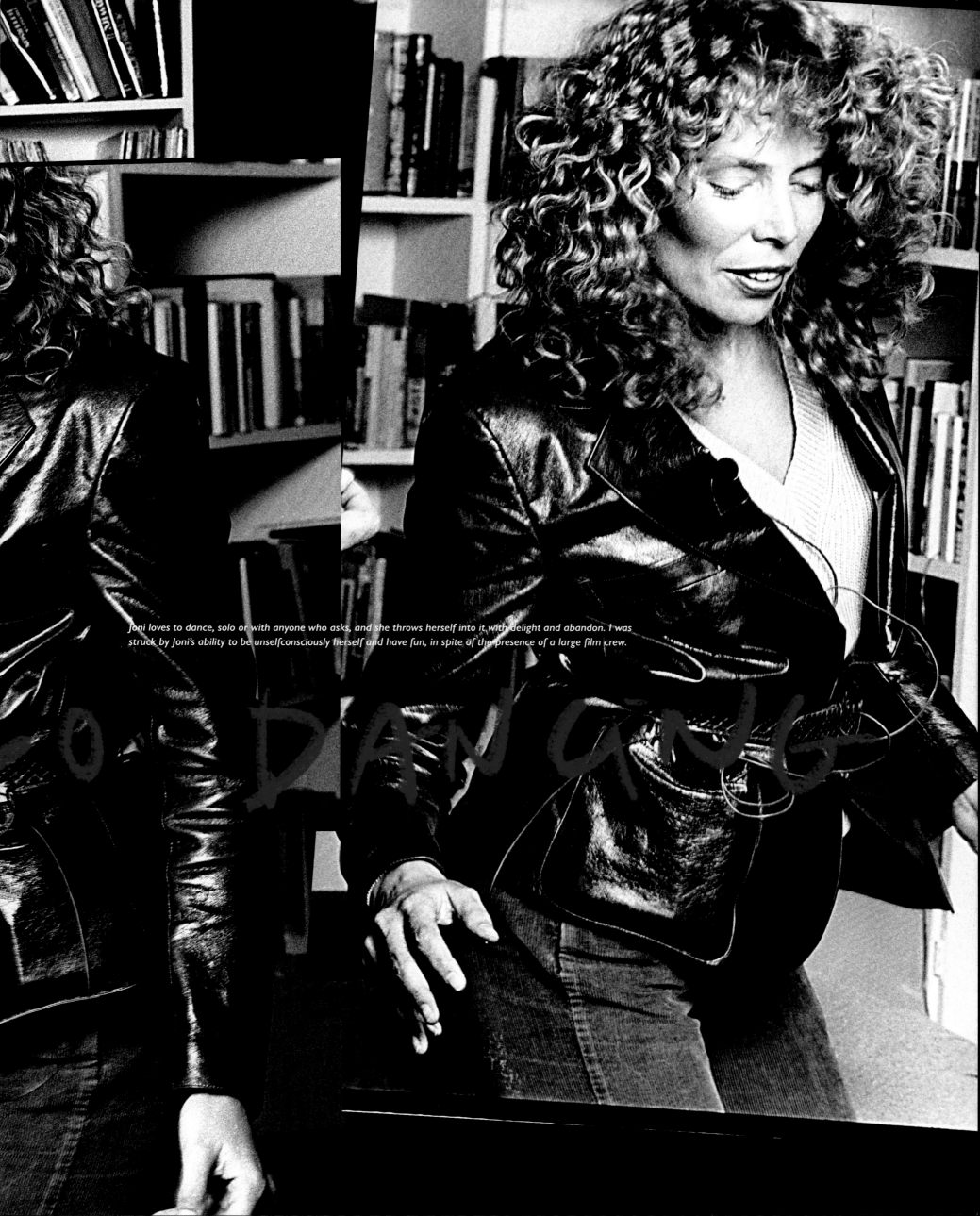

Joni loves to dance, solo or with anyone who asks, and she throws herself into it with delight and abandon. I was struck by Joni's ability to be unselfconsciously herself and have fun, in spite of the presence of a large film crew.

GO DANCING

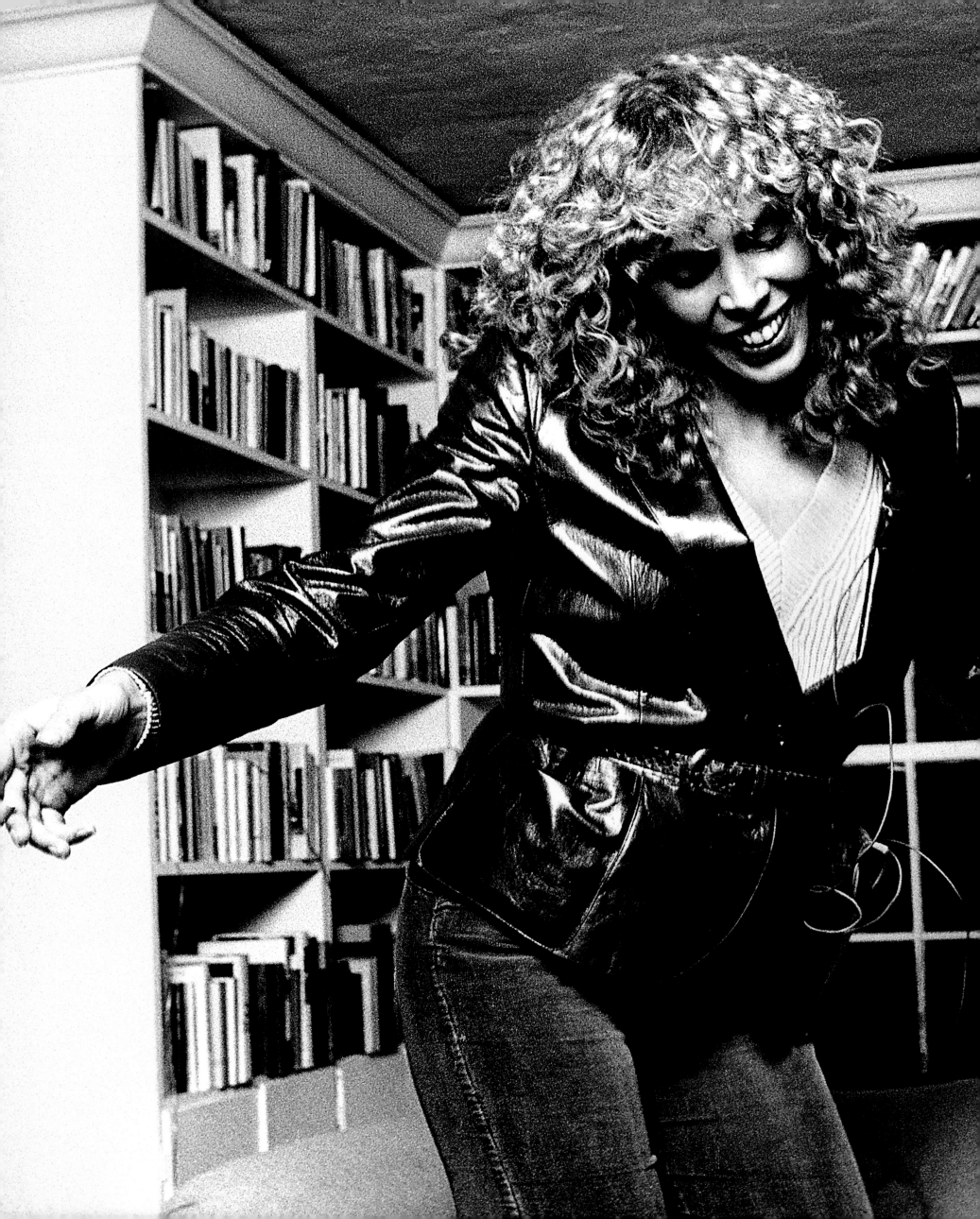

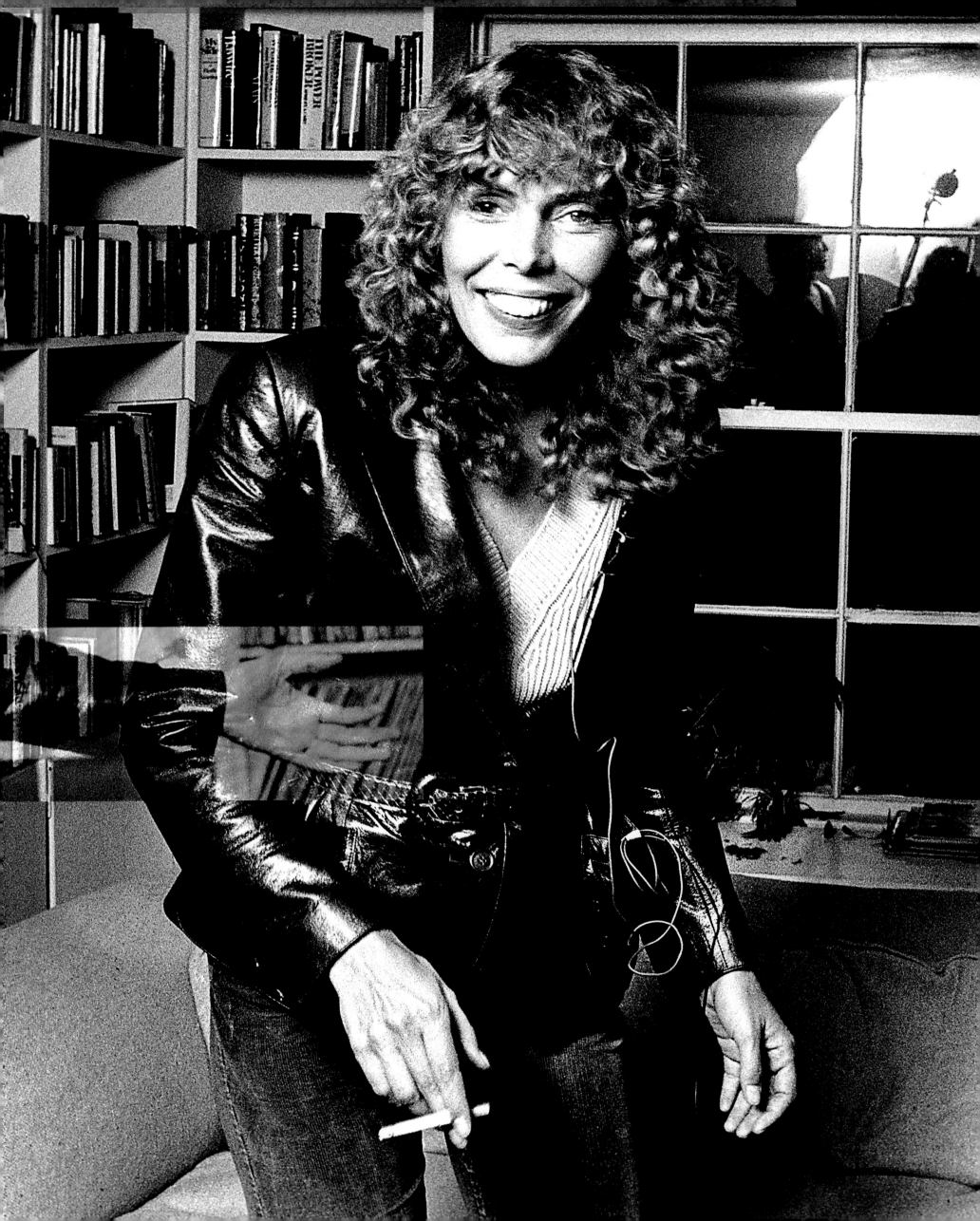

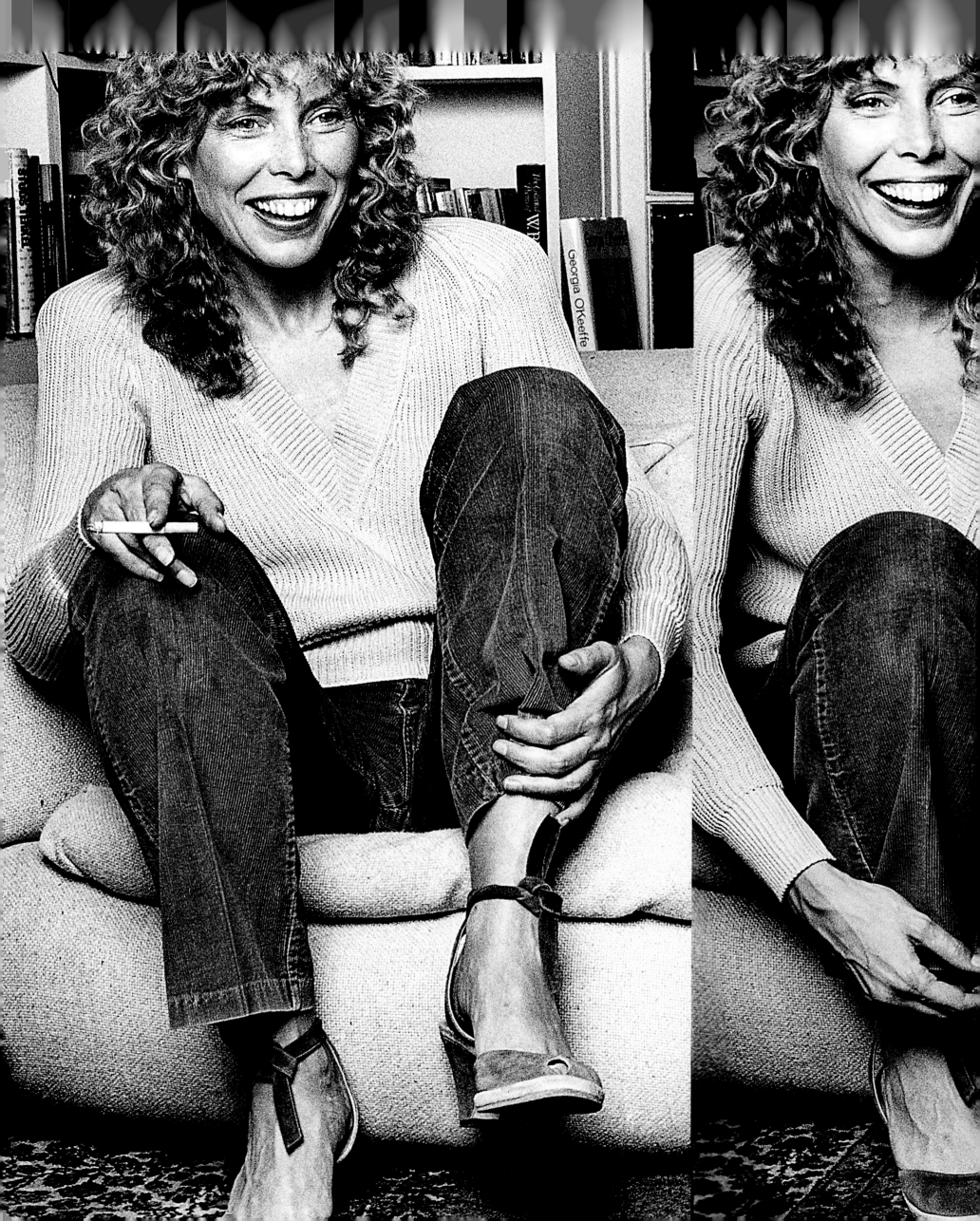

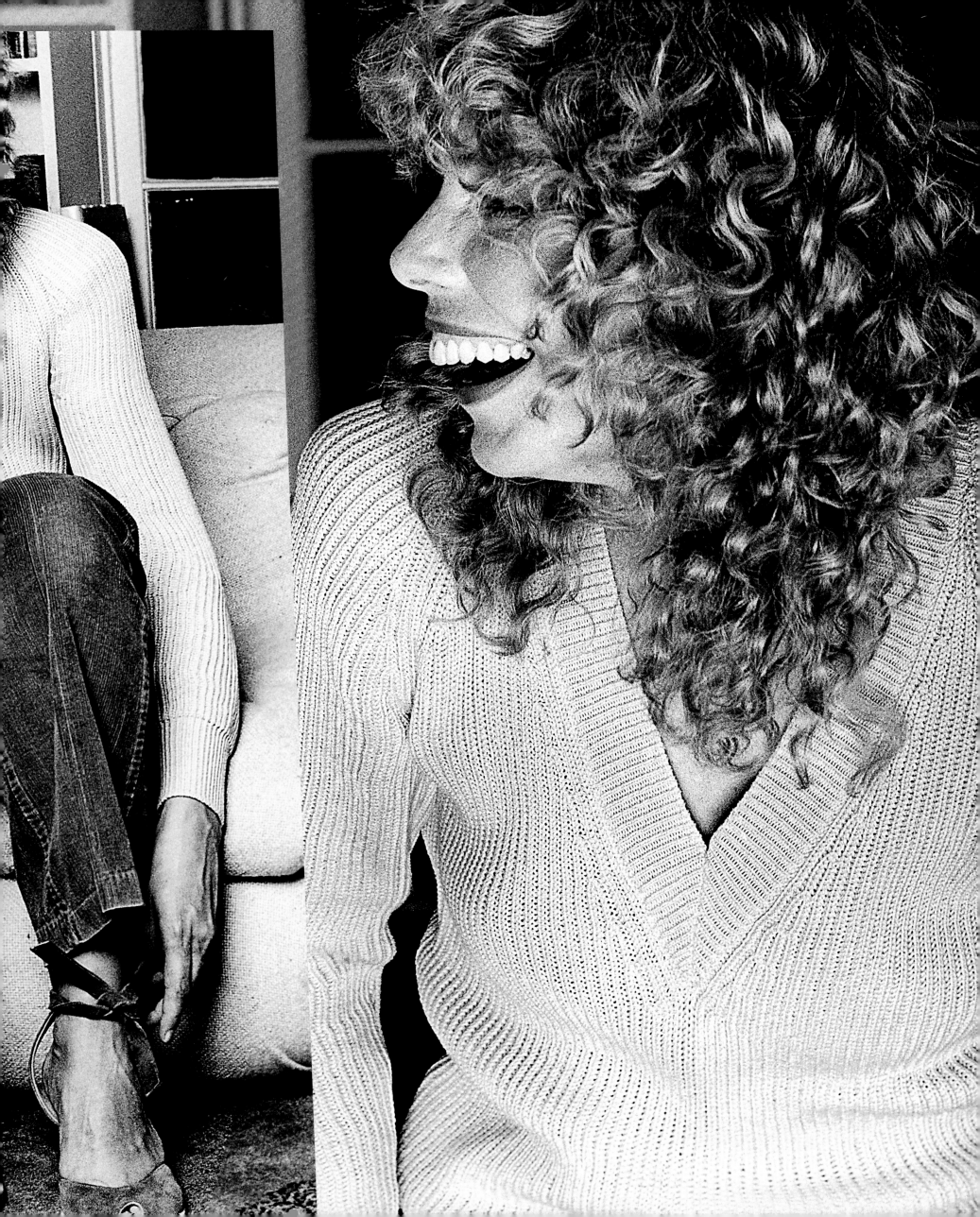

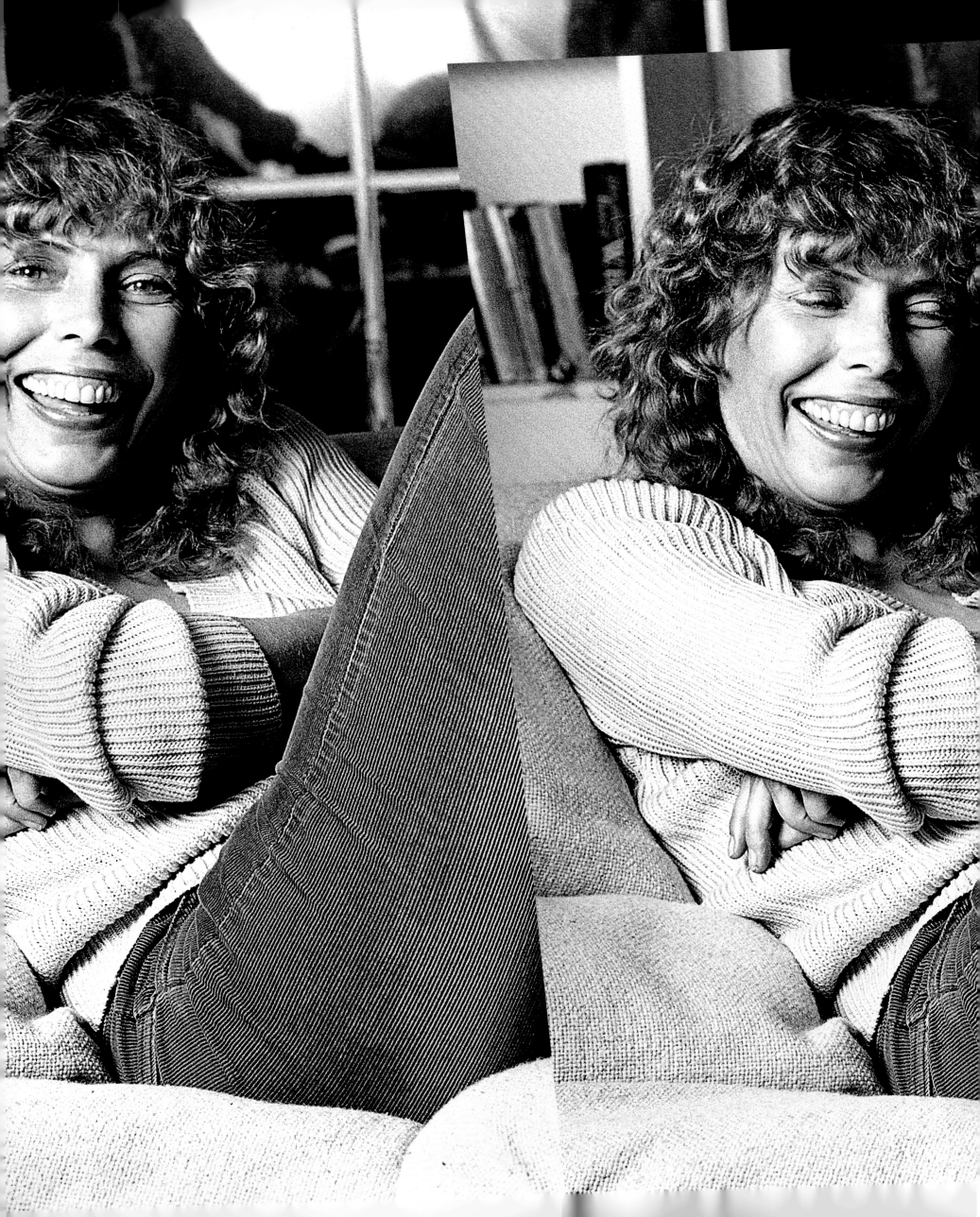

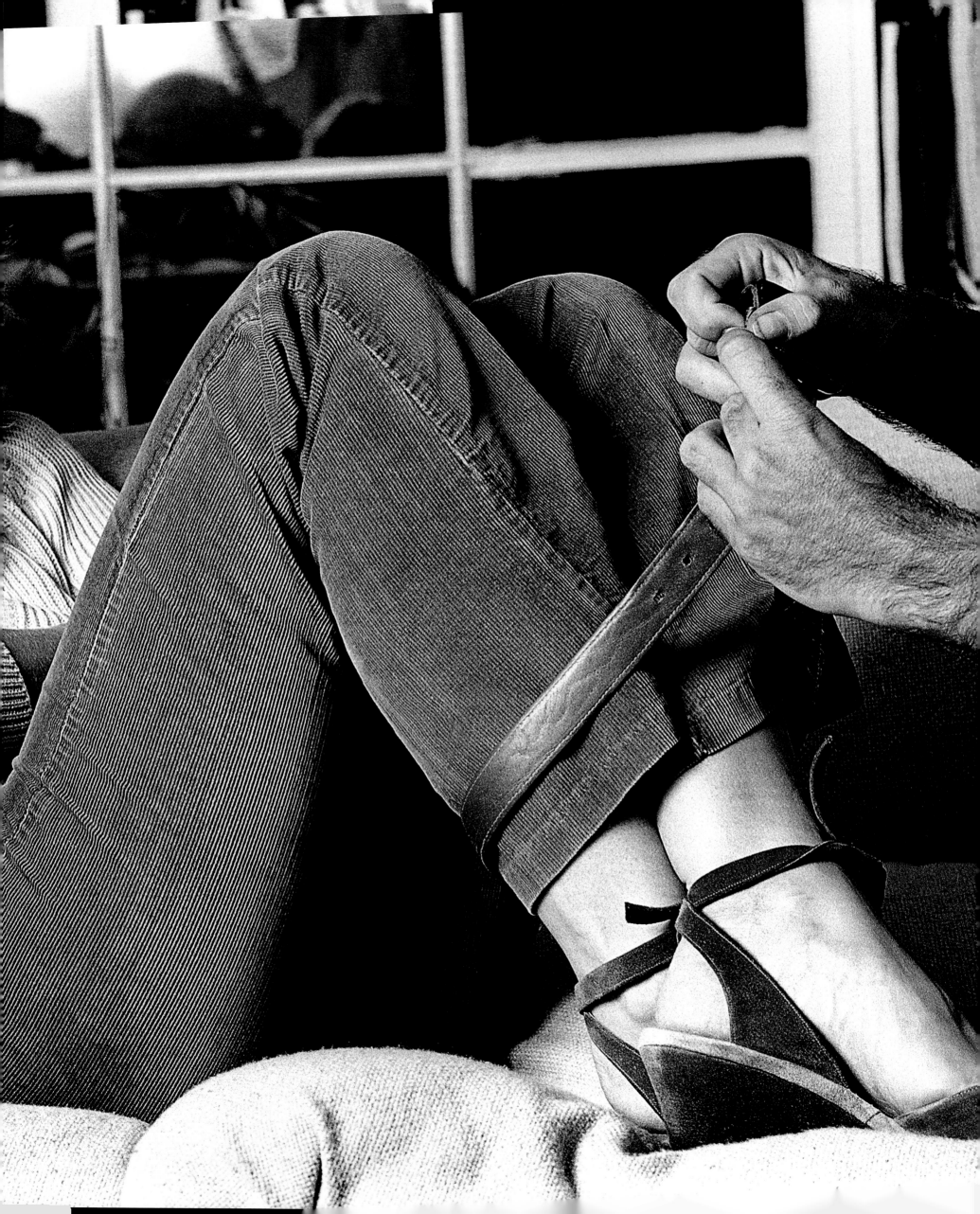

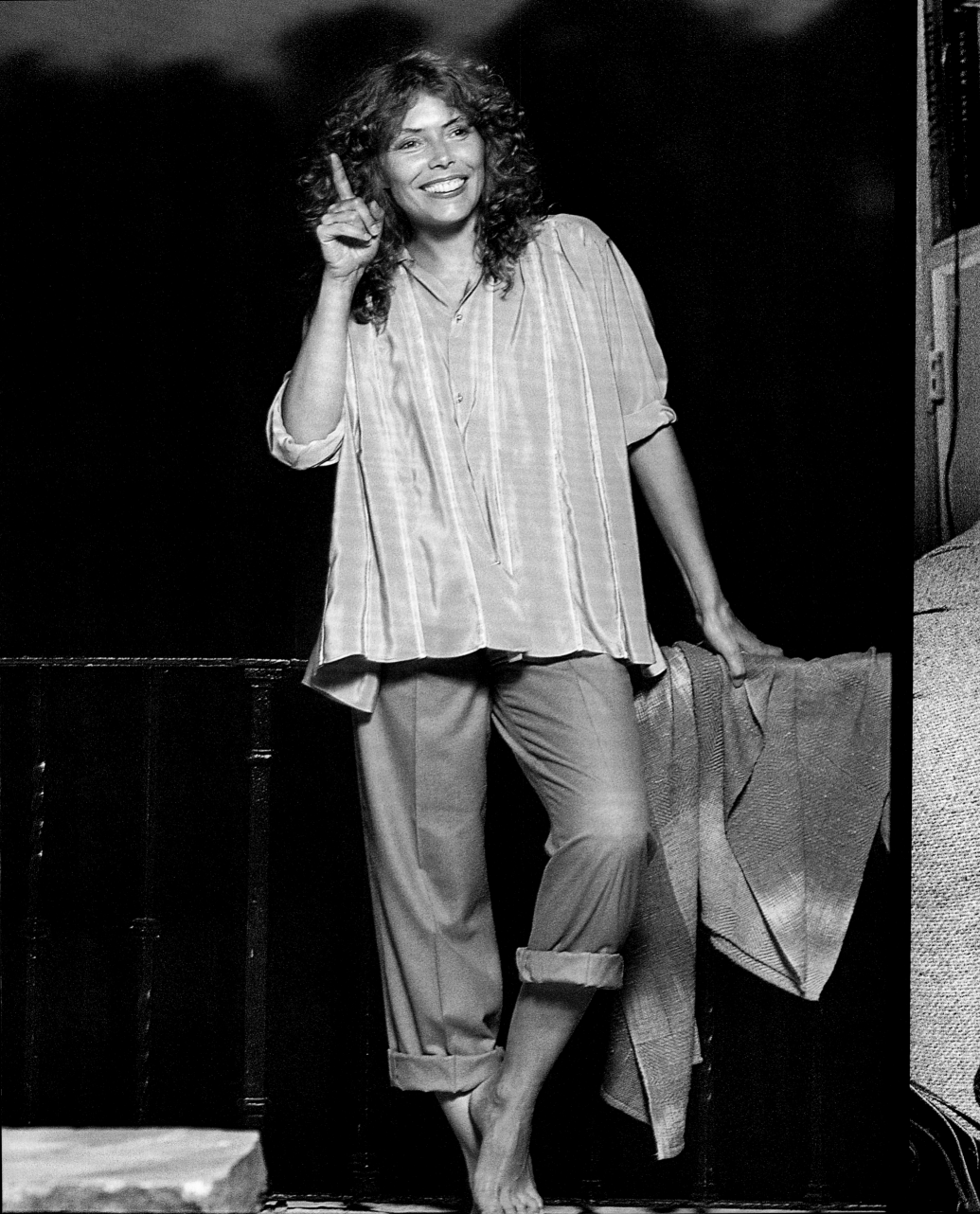

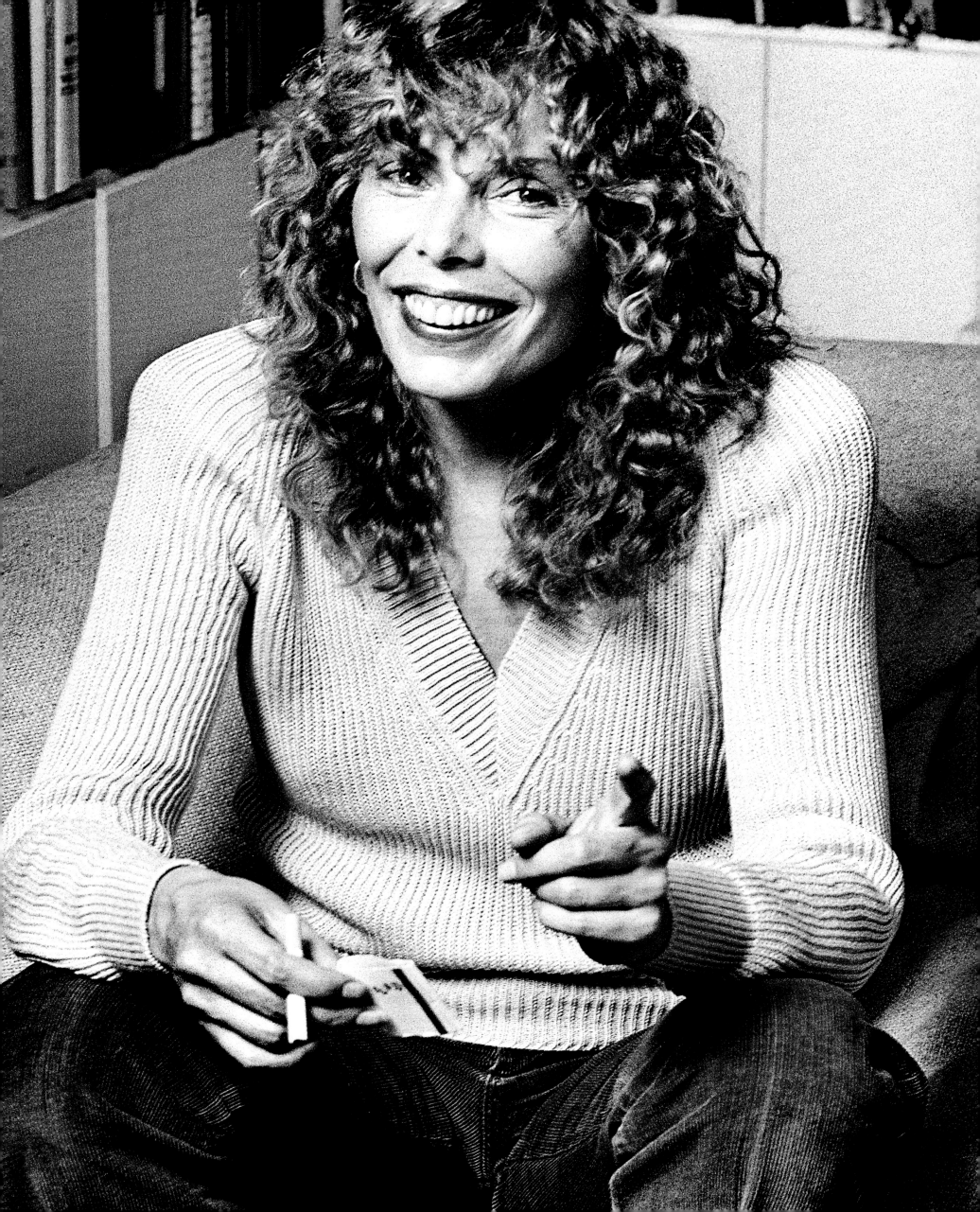

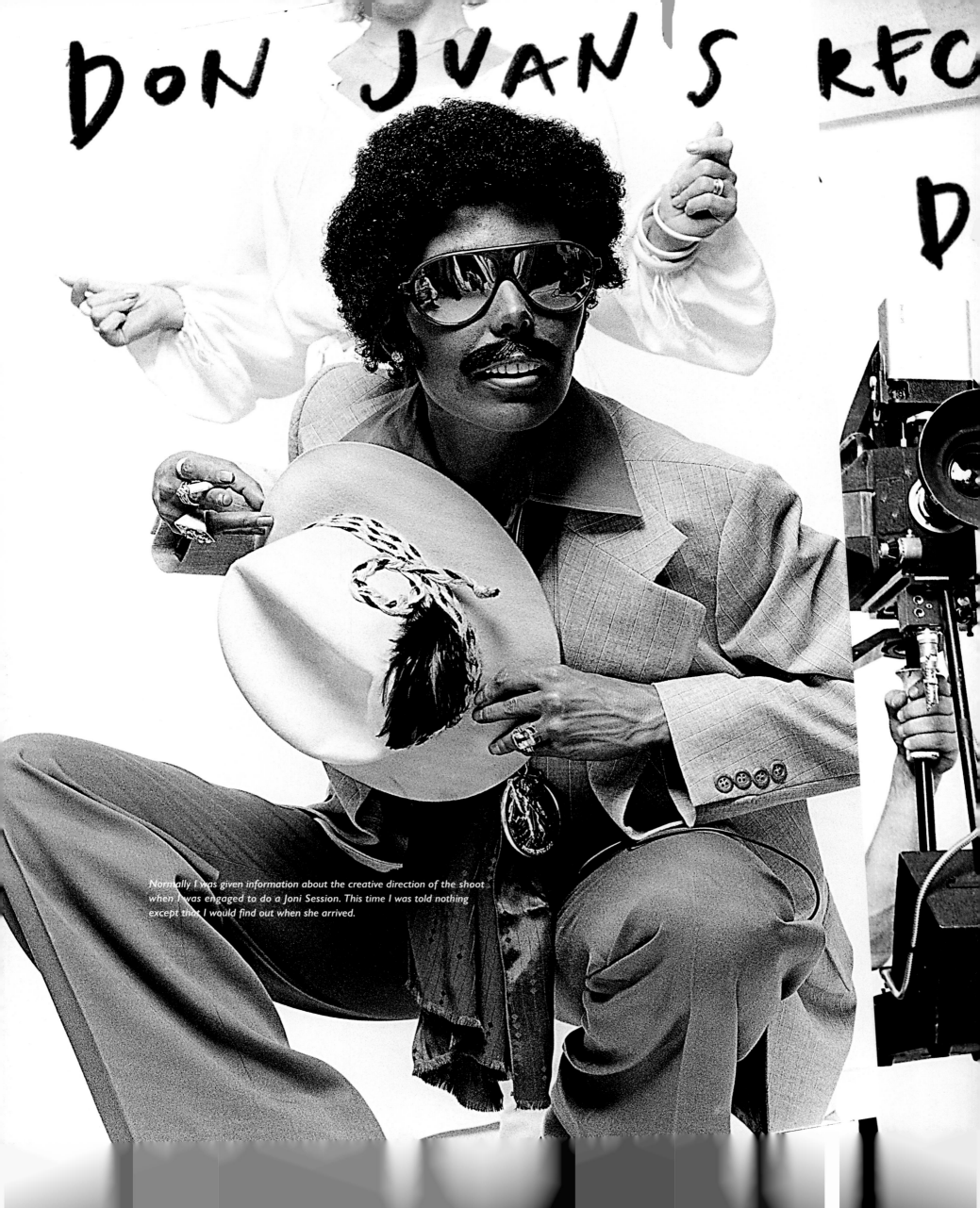

DON JUAN'S REC
D

Normally I was given information about the creative direction of the shoot when I was engaged to do a Joni Session. This time I was told nothing except that I would find out when she arrived.

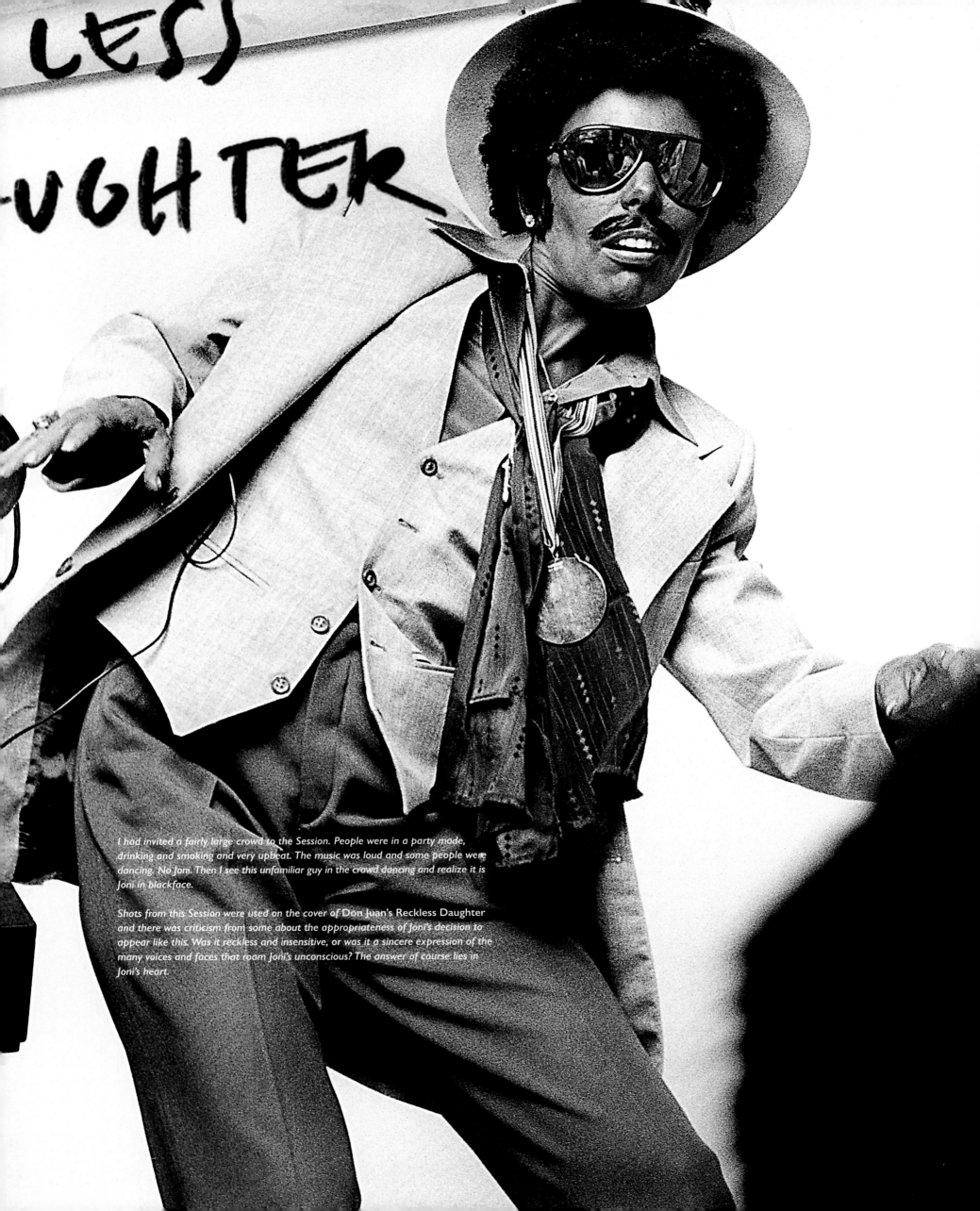

LESS -UGHTER

I had invited a fairly large crowd to the Session. People were in a party mode, drinking and smoking and very upbeat. The music was loud and some people were dancing. No Joni. Then I see this unfamiliar guy in the crowd dancing and realize it is Joni in blackface.

Shots from this Session were used on the cover of Don Juan's Reckless Daughter and there was criticism from some about the appropriateness of Joni's decision to appear like this. Was it reckless and insensitive, or was it a sincere expression of the many voices and faces that roam Joni's unconscious? The answer of course lies in Joni's heart.

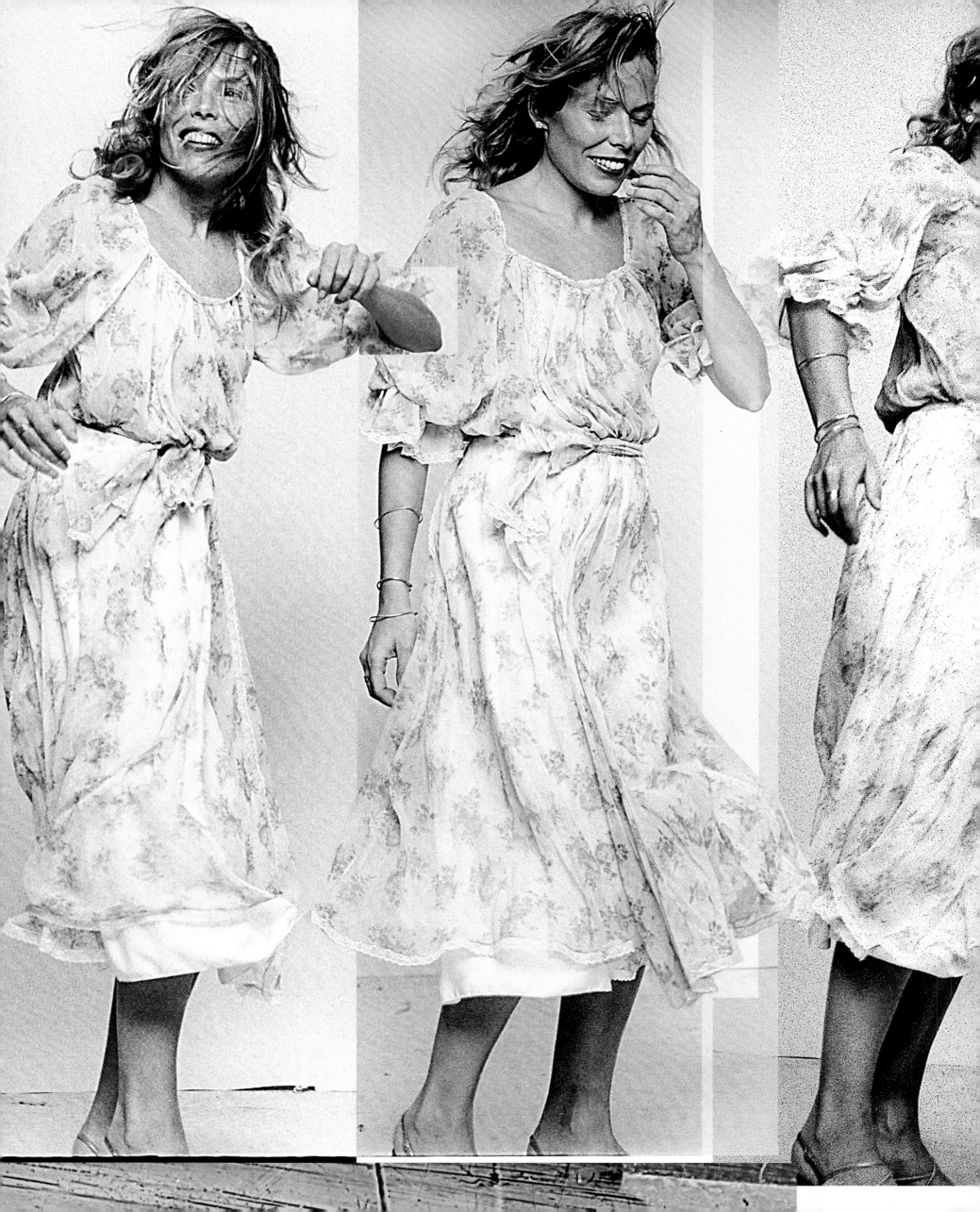

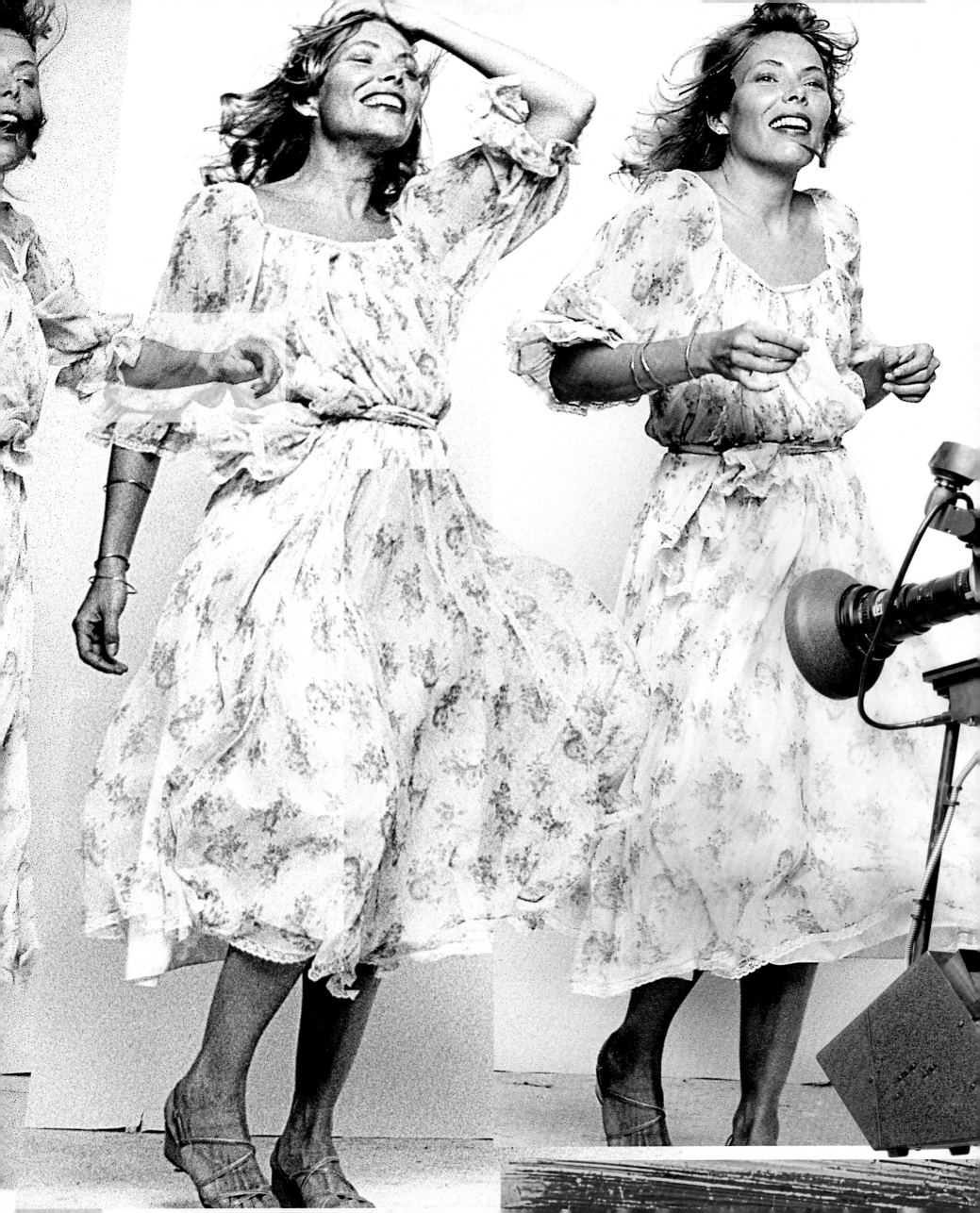

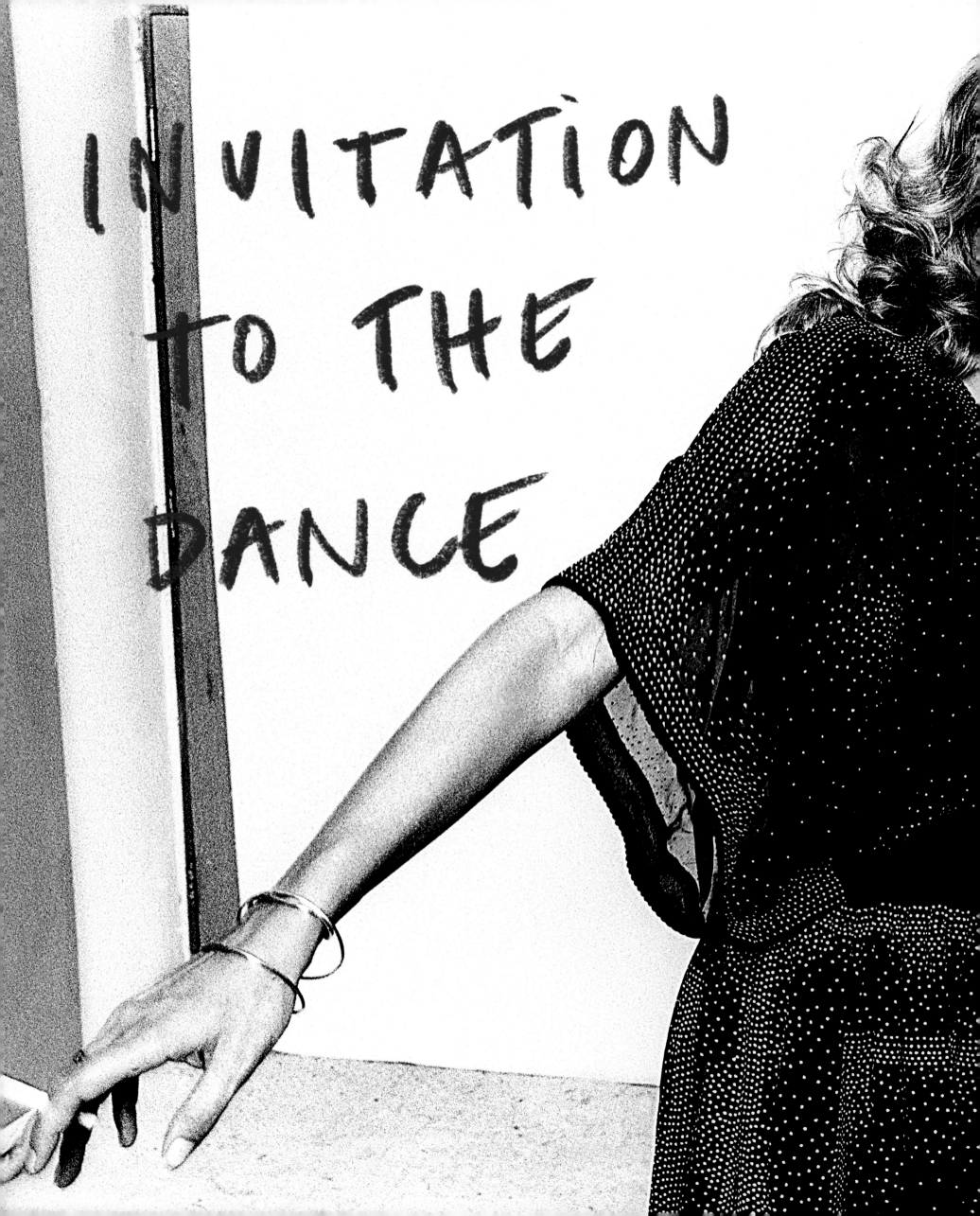

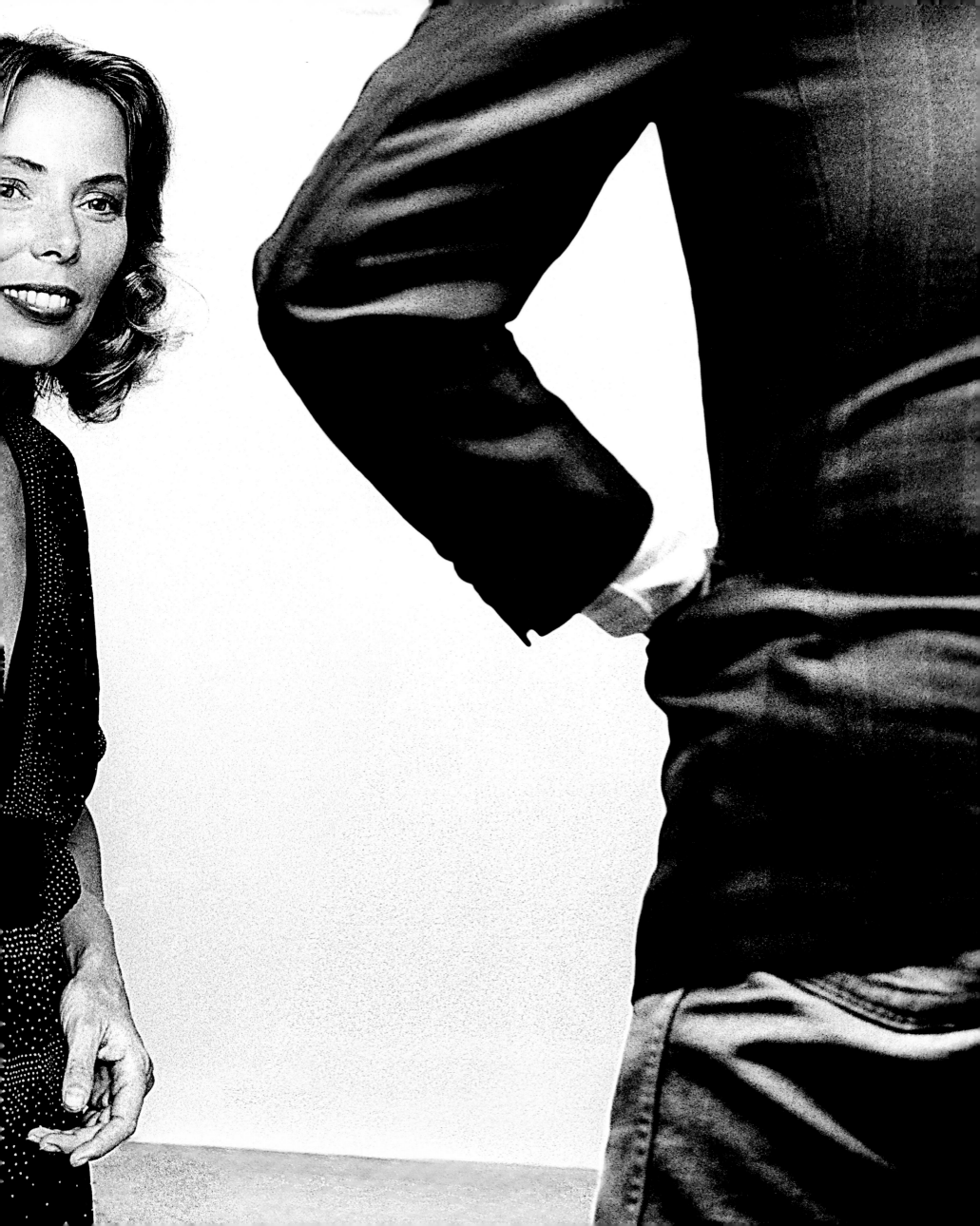

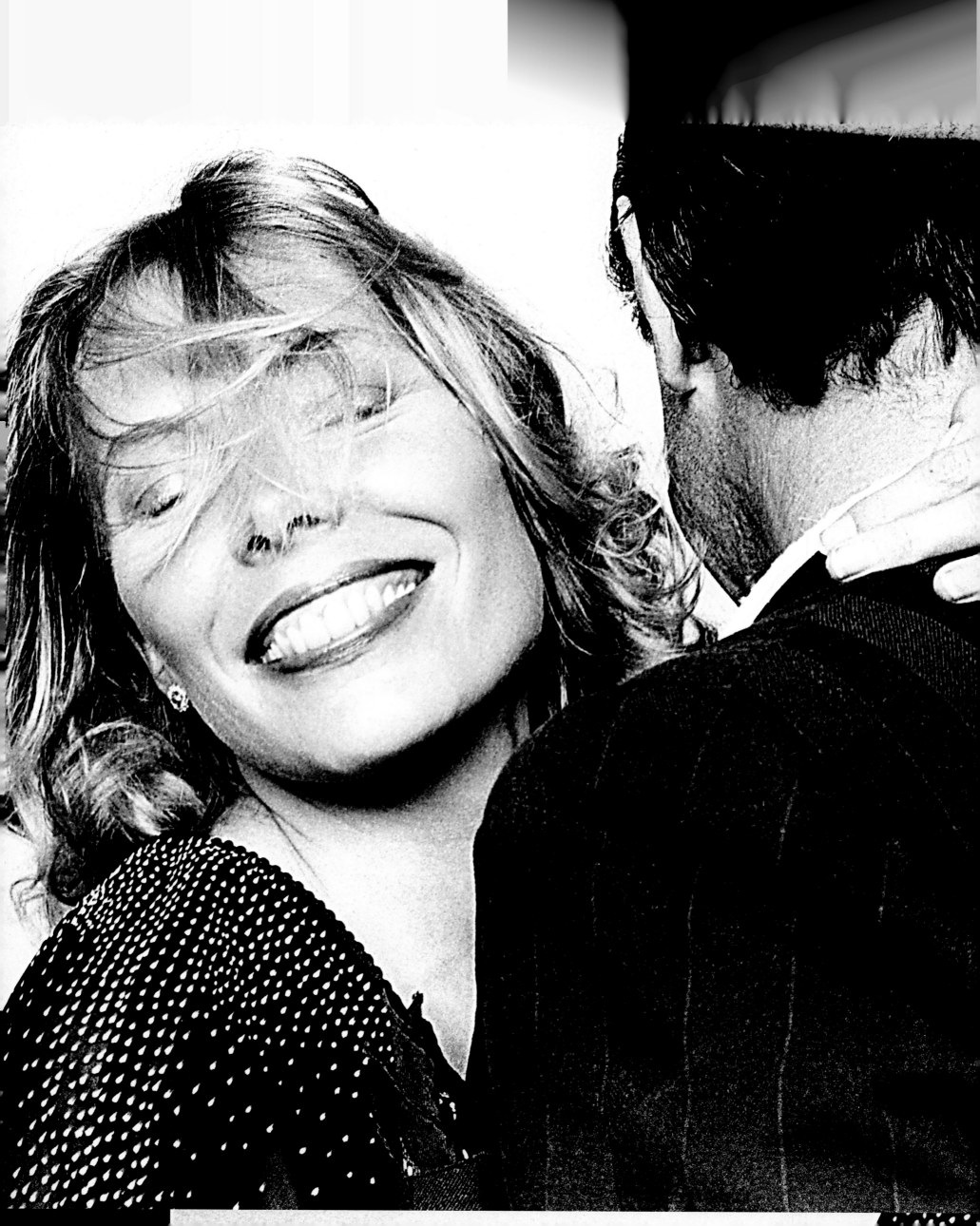

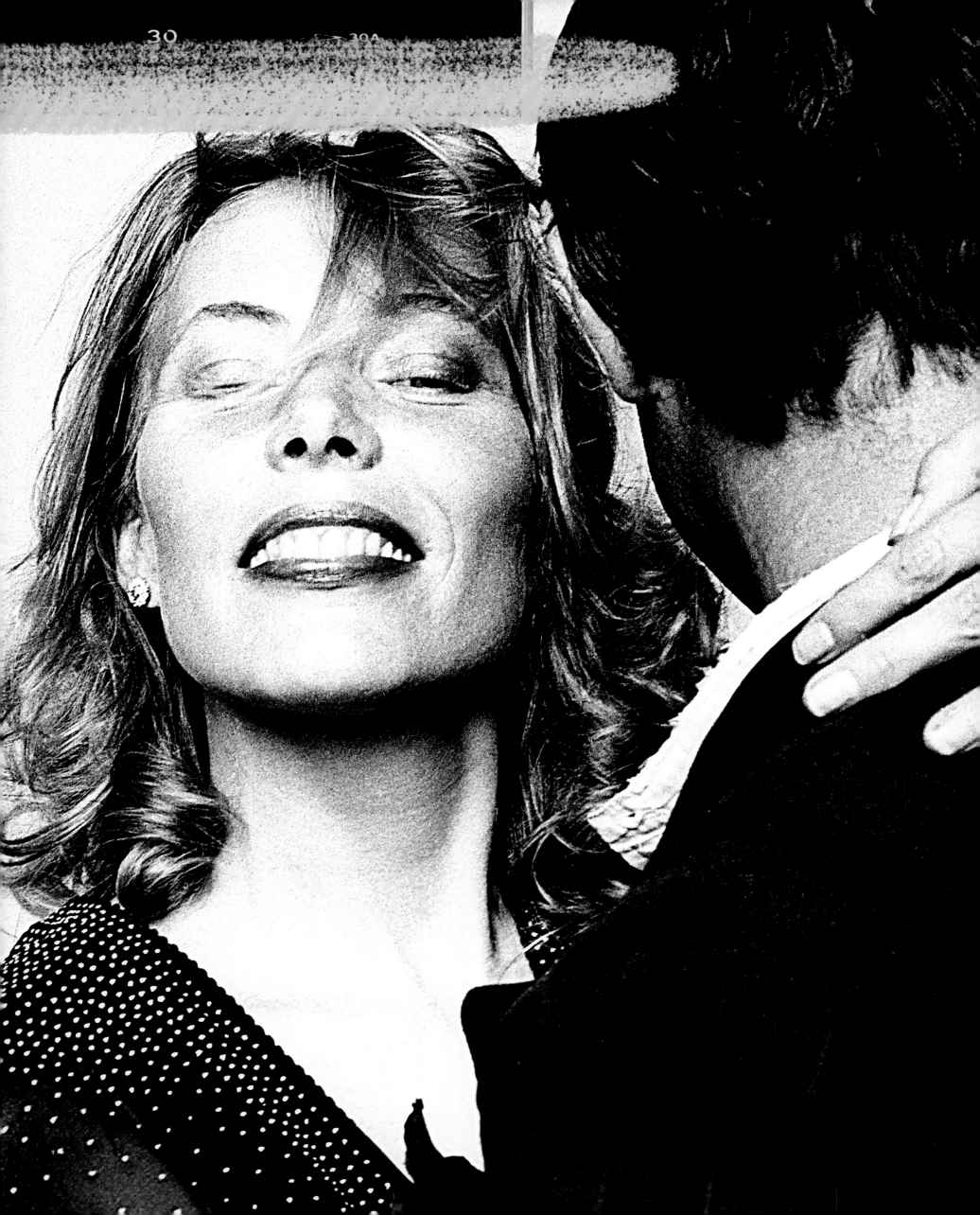

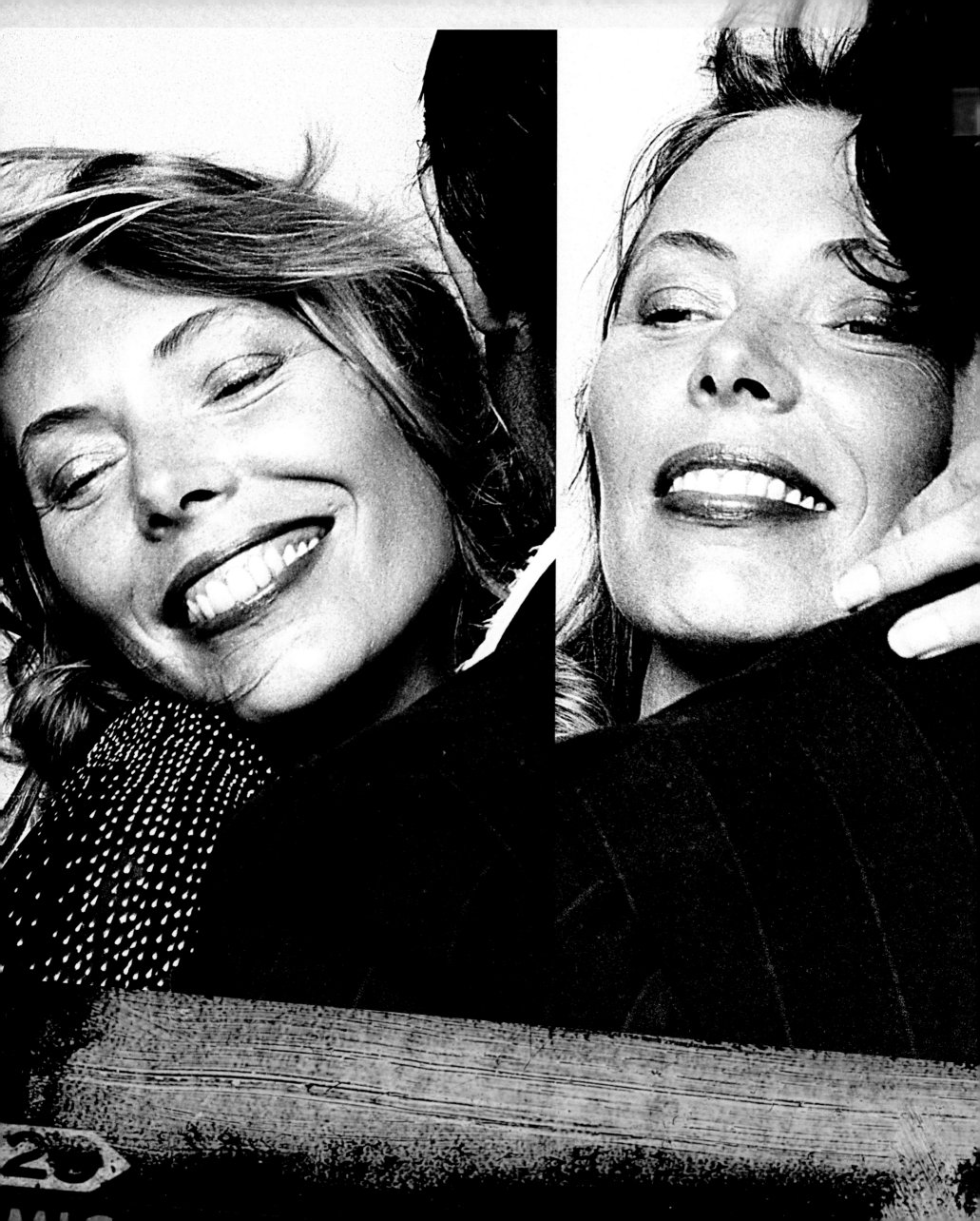

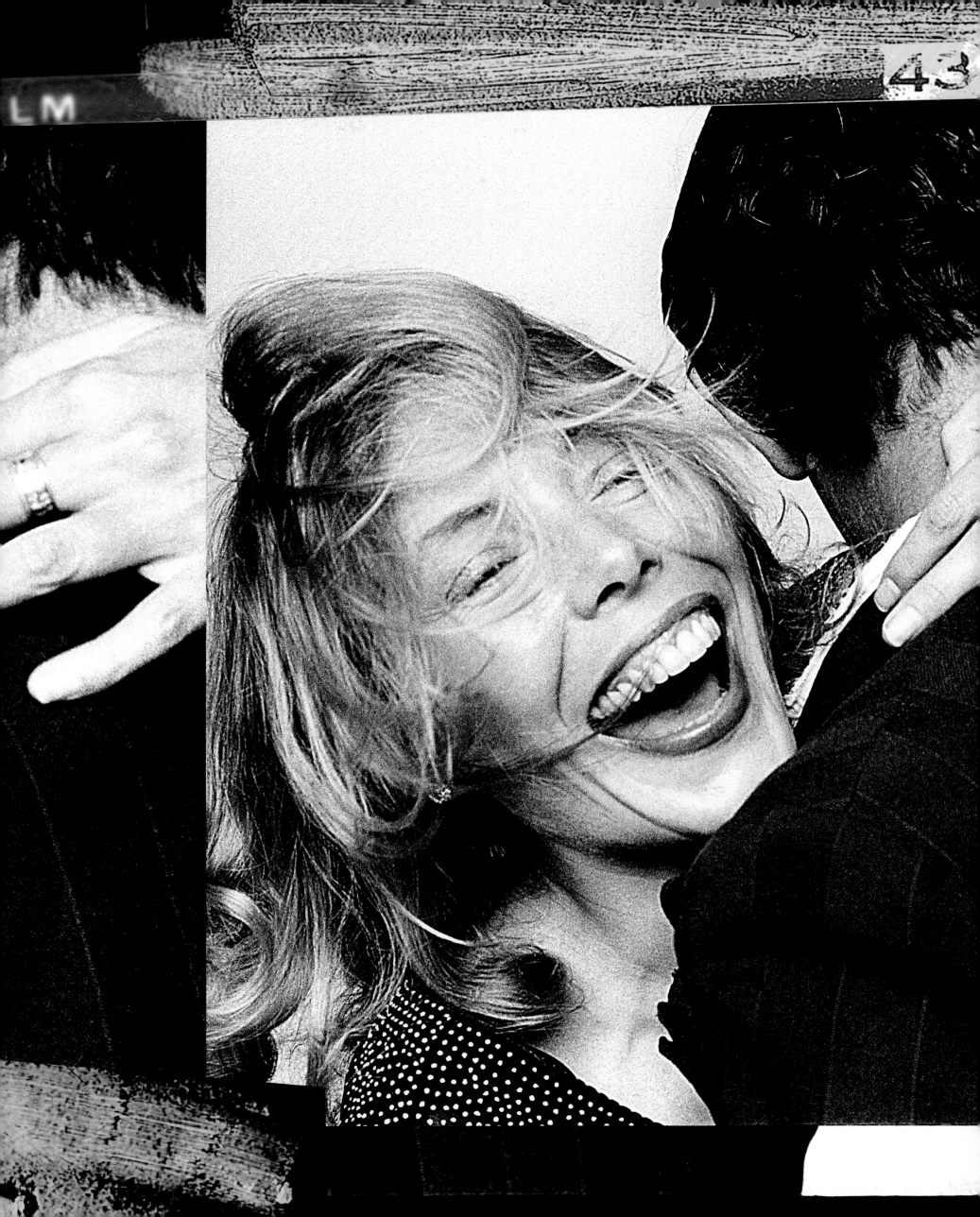

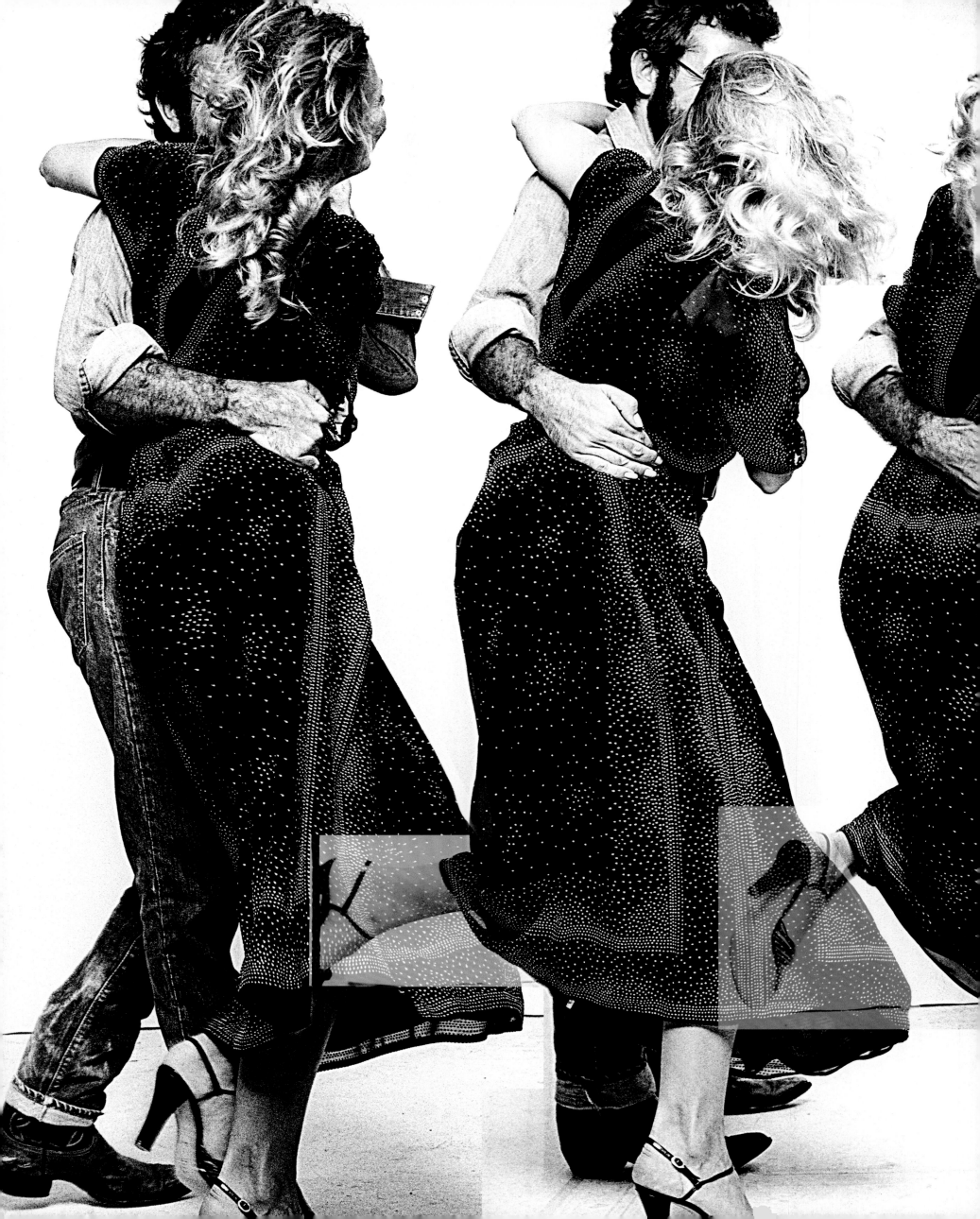

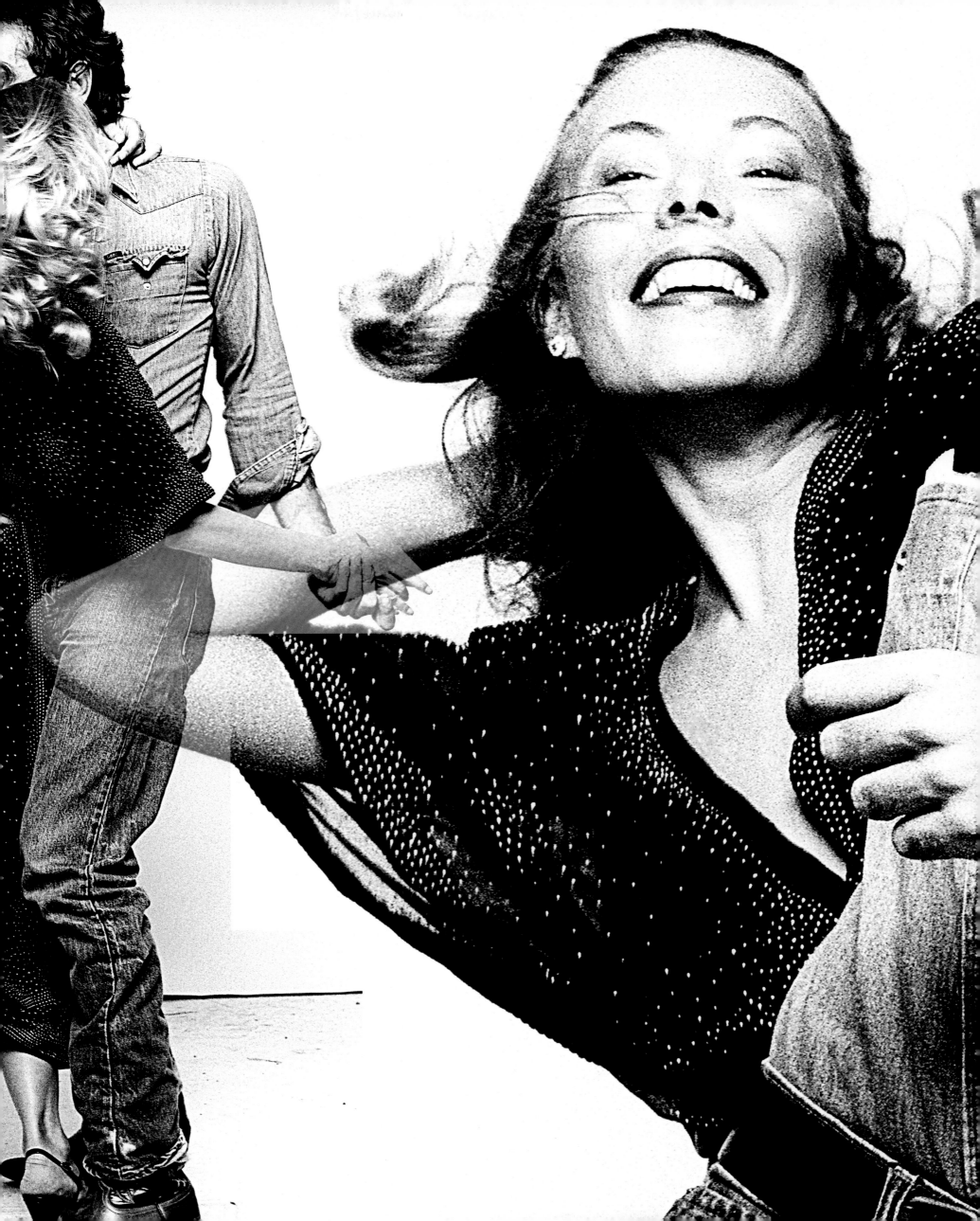

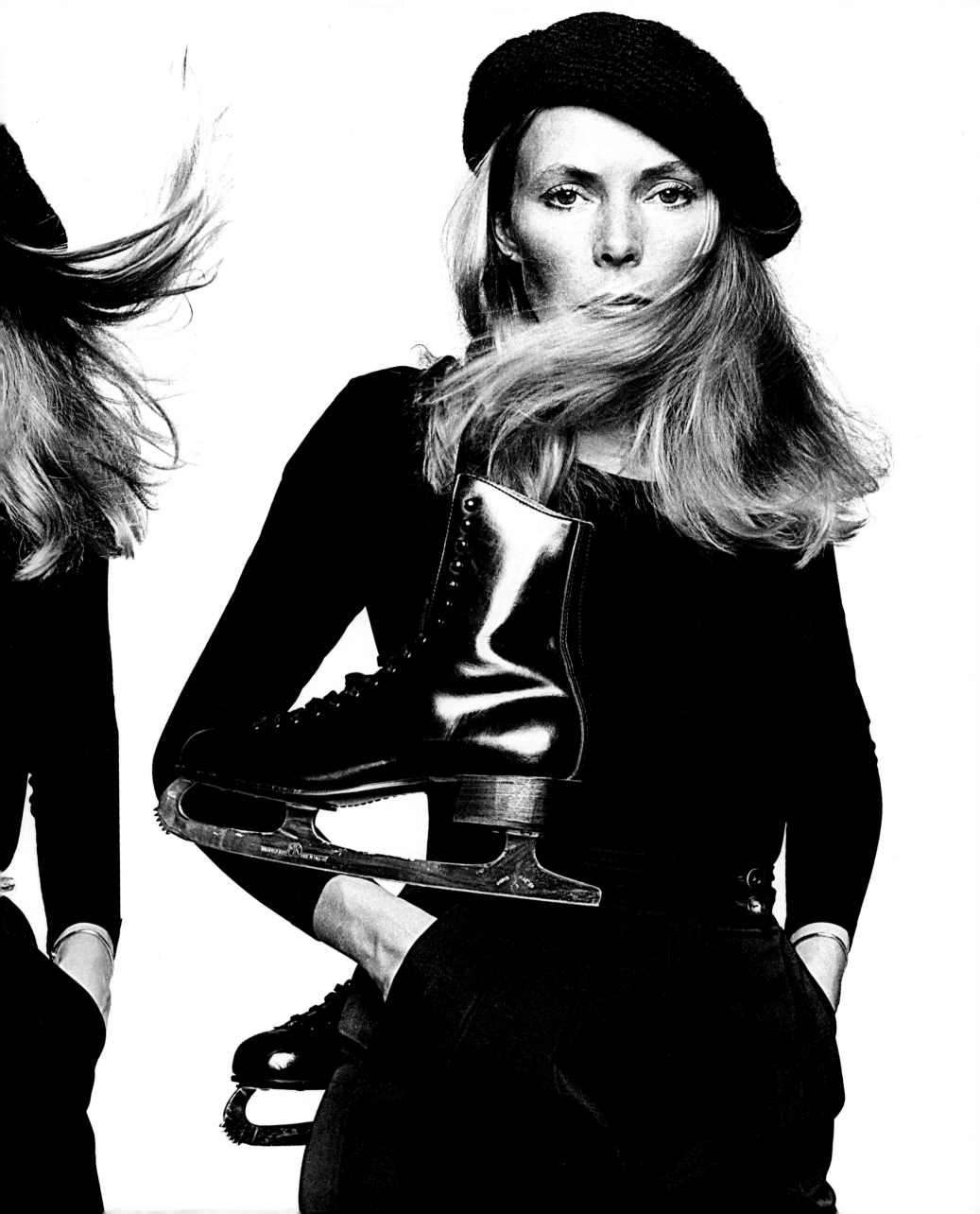

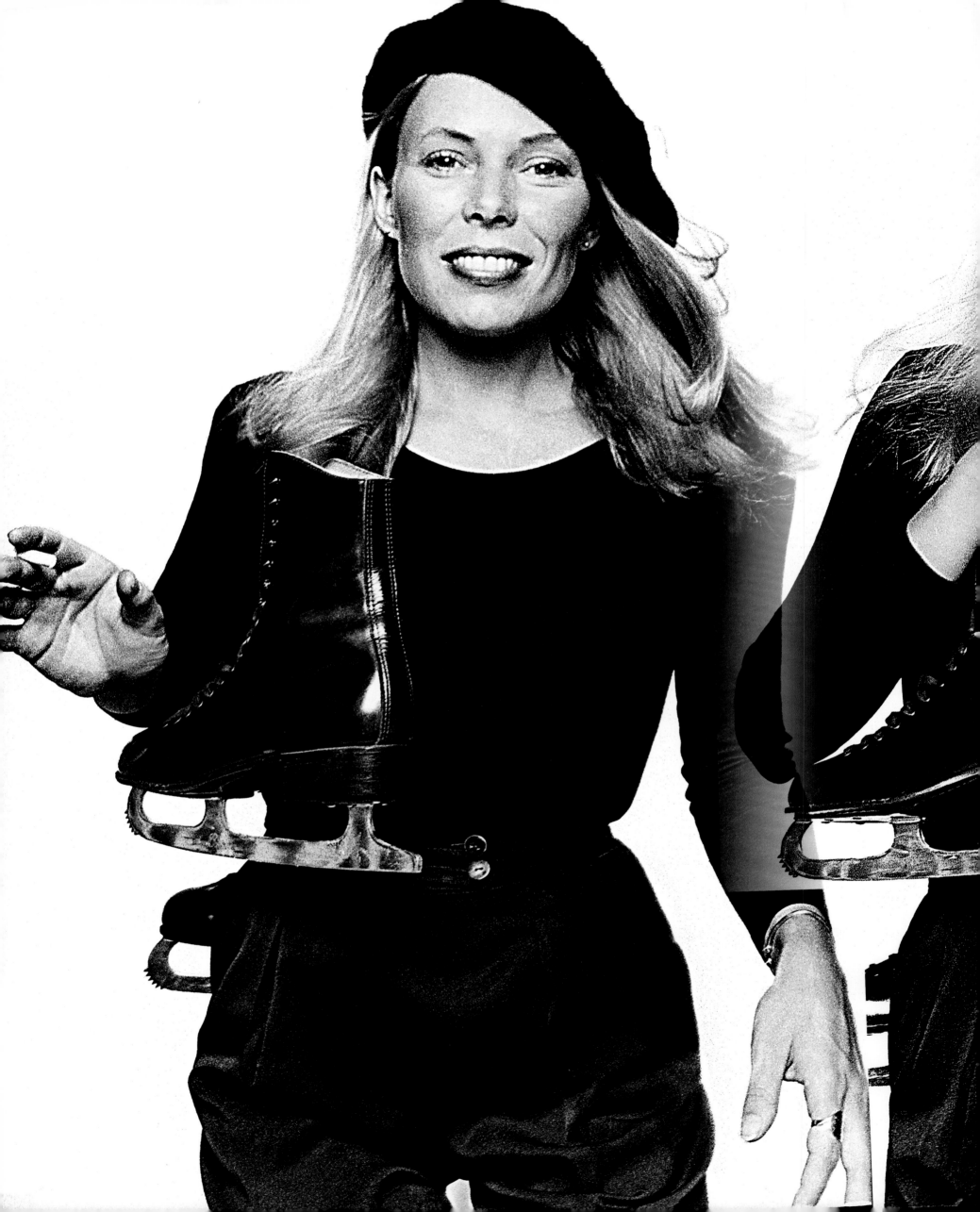

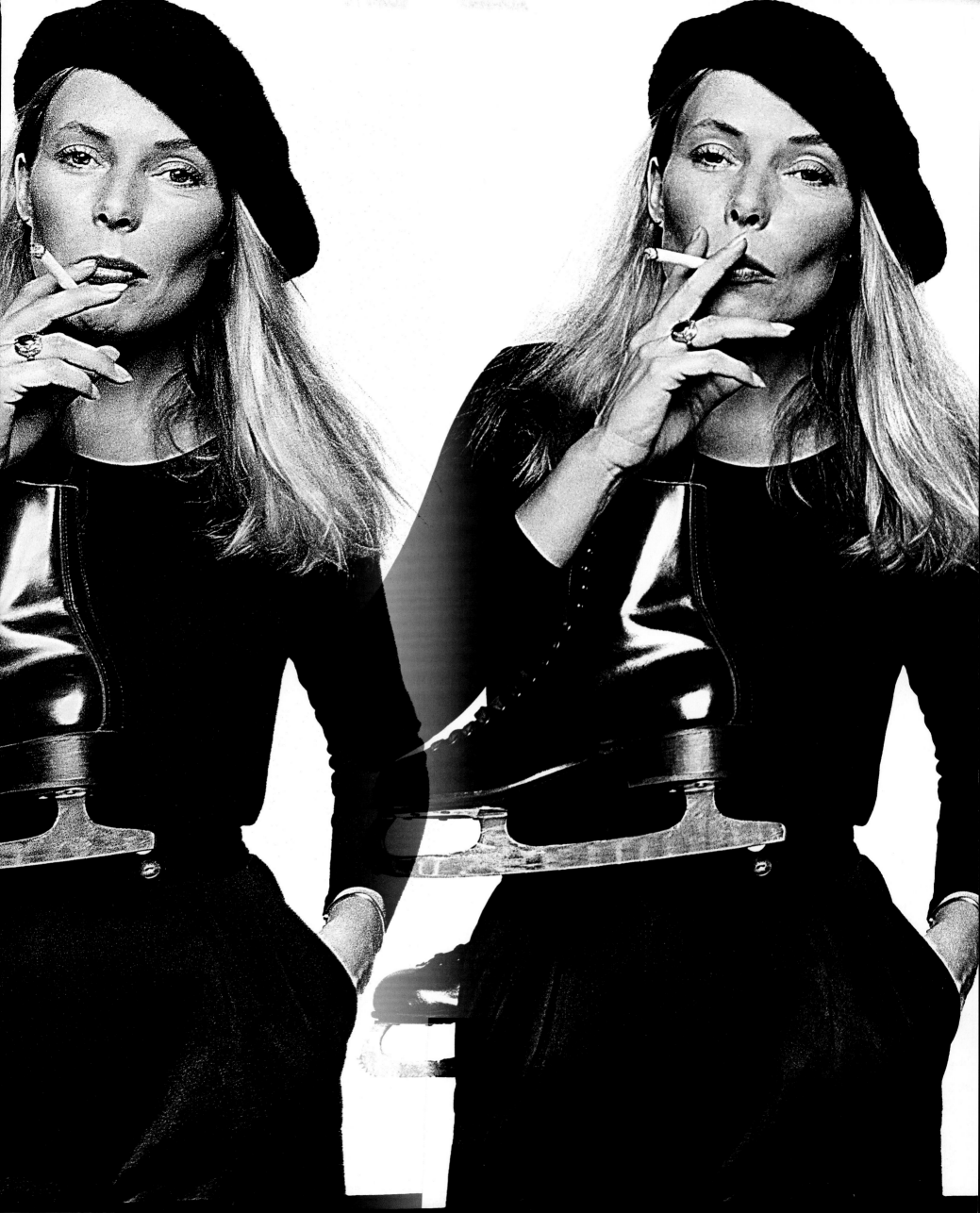

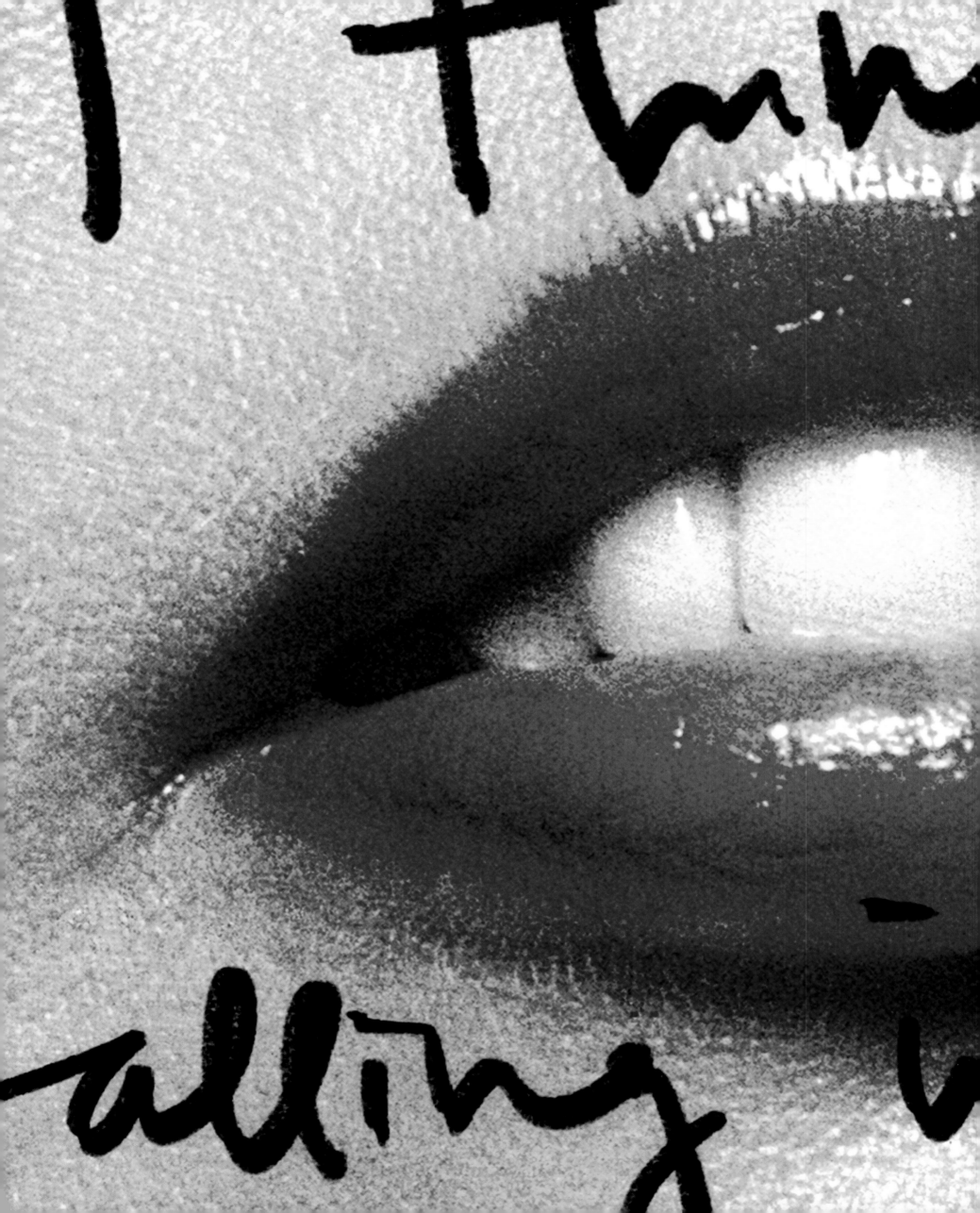

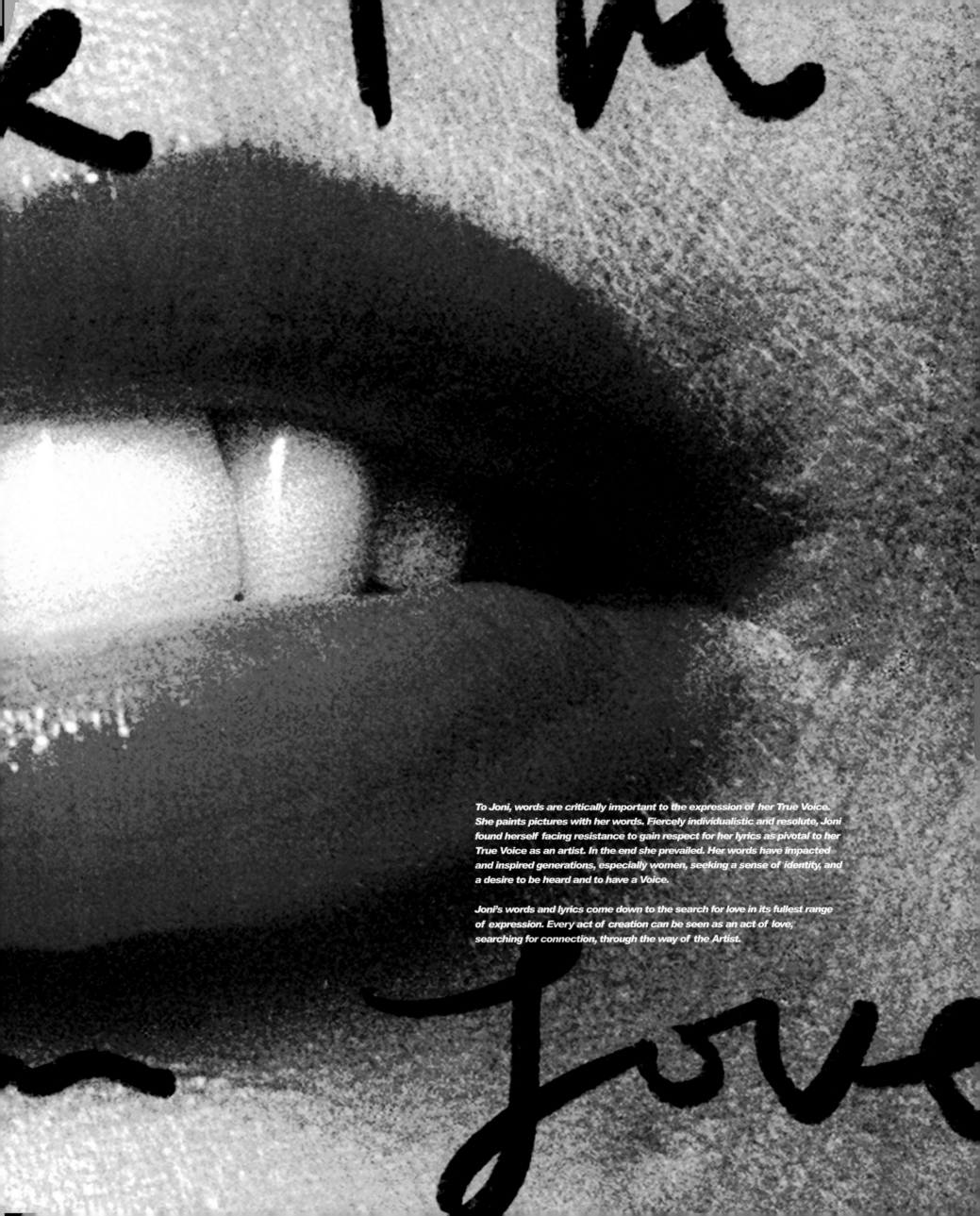

To Joni, words are critically important to the expression of her True Voice. She paints pictures with her words. Fiercely individualistic and resolute, Joni found herself facing resistance to gain respect for her lyrics as pivotal to her True Voice as an artist. In the end she prevailed. Her words have impacted and inspired generations, especially women, seeking a sense of identity, and a desire to be heard and to have a Voice.

Joni's words and lyrics come down to the search for love in its fullest range of expression. Every act of creation can be seen as an act of love, searching for connection, through the way of the Artist.

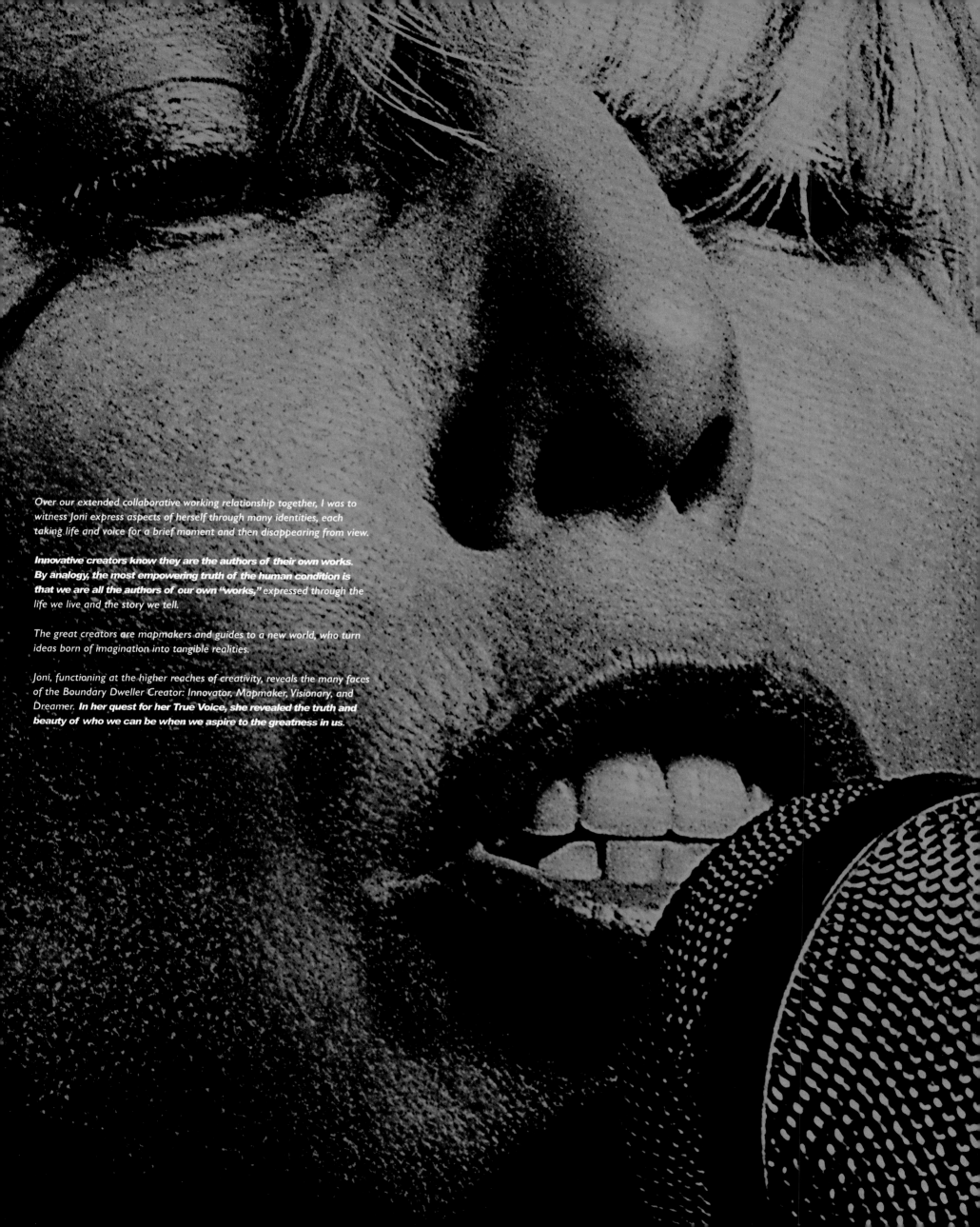

Over our extended collaborative working relationship together, I was to witness Joni express aspects of herself through many identities, each taking life and voice for a brief moment and then disappearing from view.

Innovative creators know they are the authors of their own works. By analogy, the most empowering truth of the human condition is that we are all the authors of our own "works," expressed through the life we live and the story we tell.

The great creators are mapmakers and guides to a new world, who turn ideas born of imagination into tangible realities.

Joni, functioning at the higher reaches of creativity, reveals the many faces of the Boundary Dweller Creator: Innovator, Mapmaker, Visionary, and Dreamer. **In her quest for her True Voice, she revealed the truth and beauty of who we can be when we aspire to the greatness in us.**

the many faces,
many voices of
Joni Mitchell

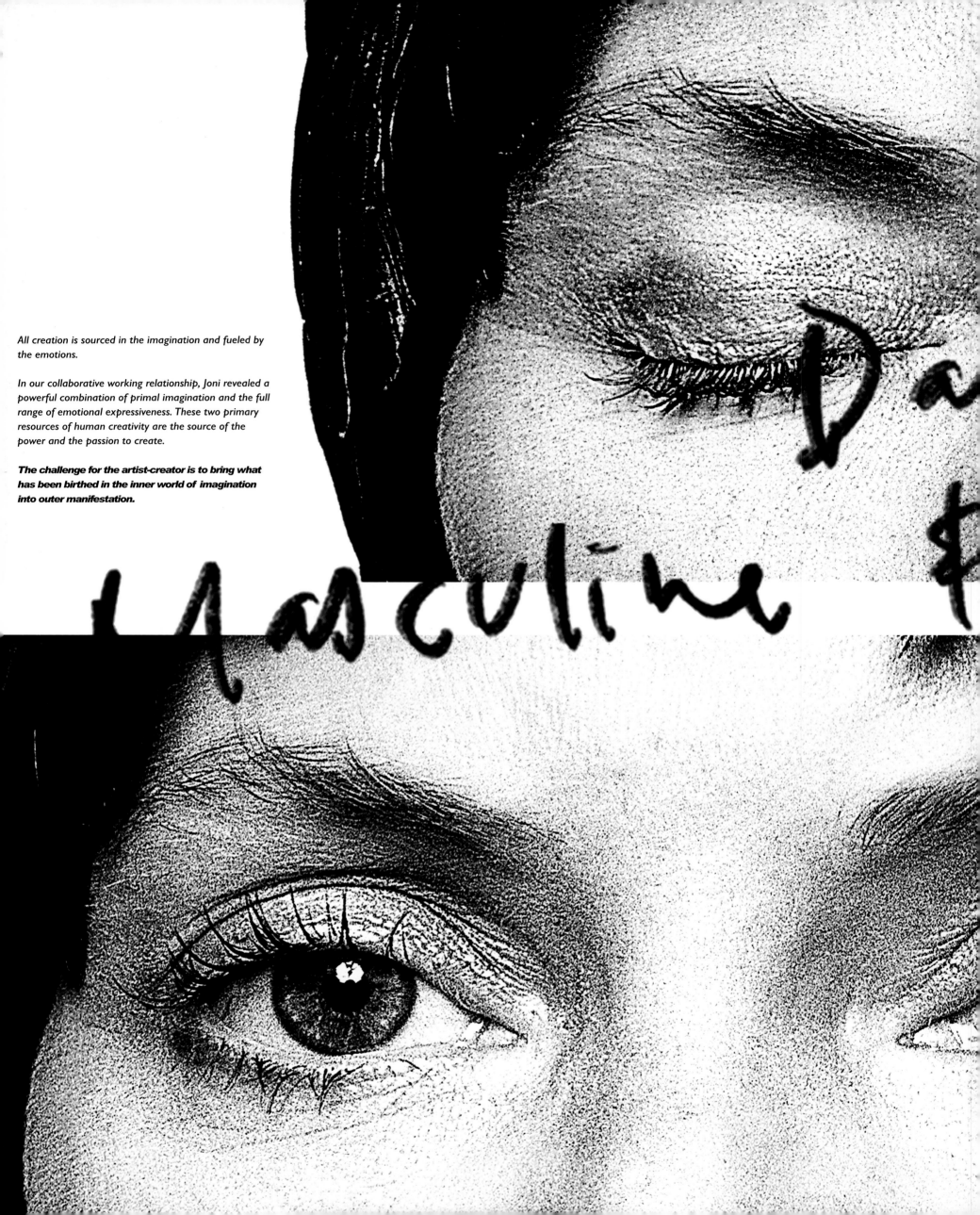

All creation is sourced in the imagination and fueled by the emotions.

In our collaborative working relationship, Joni revealed a powerful combination of primal imagination and the full range of emotional expressiveness. These two primary resources of human creativity are the source of the power and the passion to create.

The challenge for the artist-creator is to bring what has been birthed in the inner world of imagination into outer manifestation.

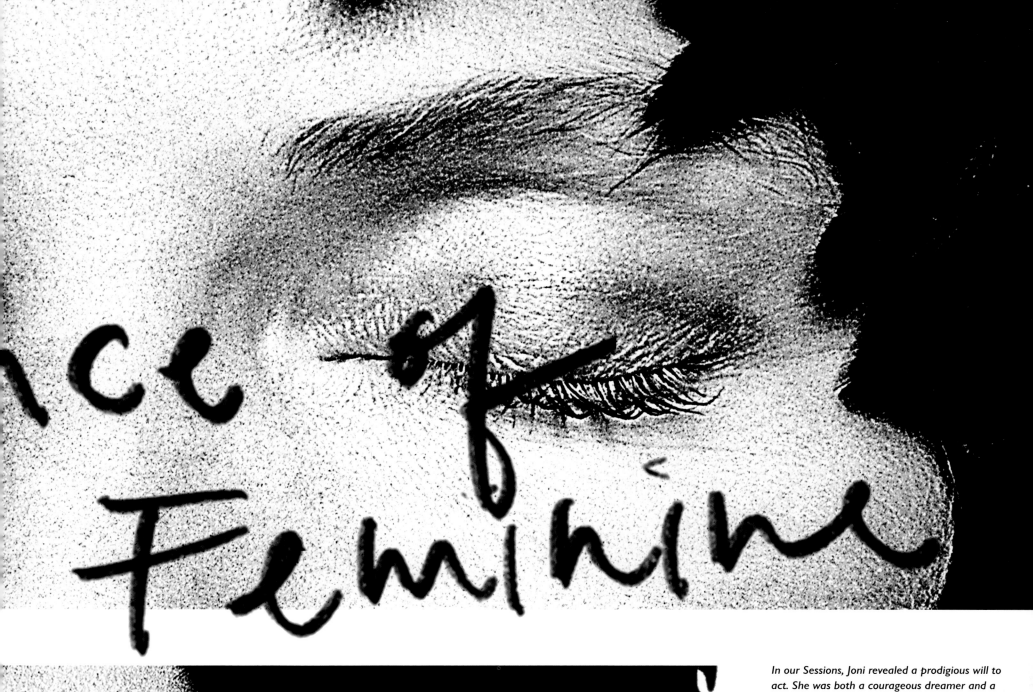

ce of

Feminine

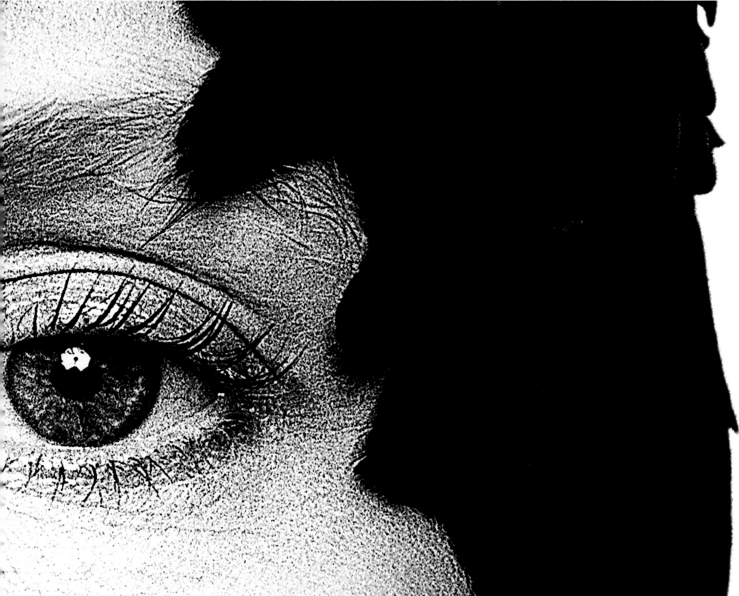

In our Sessions, Joni revealed a prodigious will to act. She was both a courageous dreamer and a daring manifester. The integration of these energies and forces, the feminine and masculine within, is the secret and key to empowered creation. Beyond her many voices as a songwriter, poet-lyricist, musician, and performer, Joni expressed herself in many symbolic identities.

As a Boundary Dweller Creator, Joni embodied the beauty and the magic of the dance of the power and strength of the feminine creator and masculine manifester, each **empowering the other, working in harmony as one.**

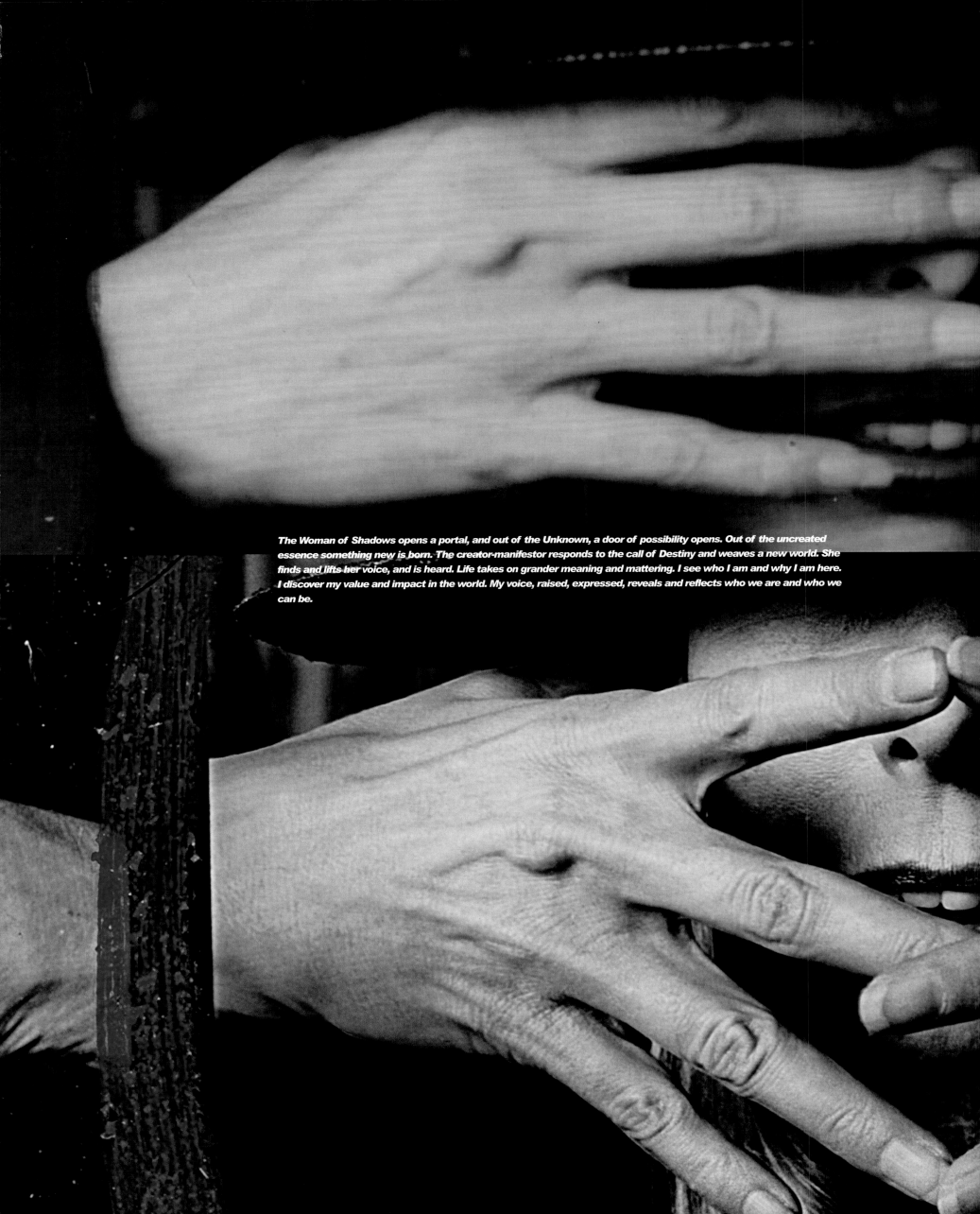

The Woman of Shadows opens a portal, and out of the Unknown, a door of possibility opens. Out of the uncreated essence something new is born. The creator-manifestor responds to the call of Destiny and weaves a new world. She finds and lifts her voice, and is heard. Life takes on grander meaning and mattering. I see who I am and why I am here. I discover my value and impact in the world. My voice, raised, expressed, reveals and reflects who we are and who we can be.

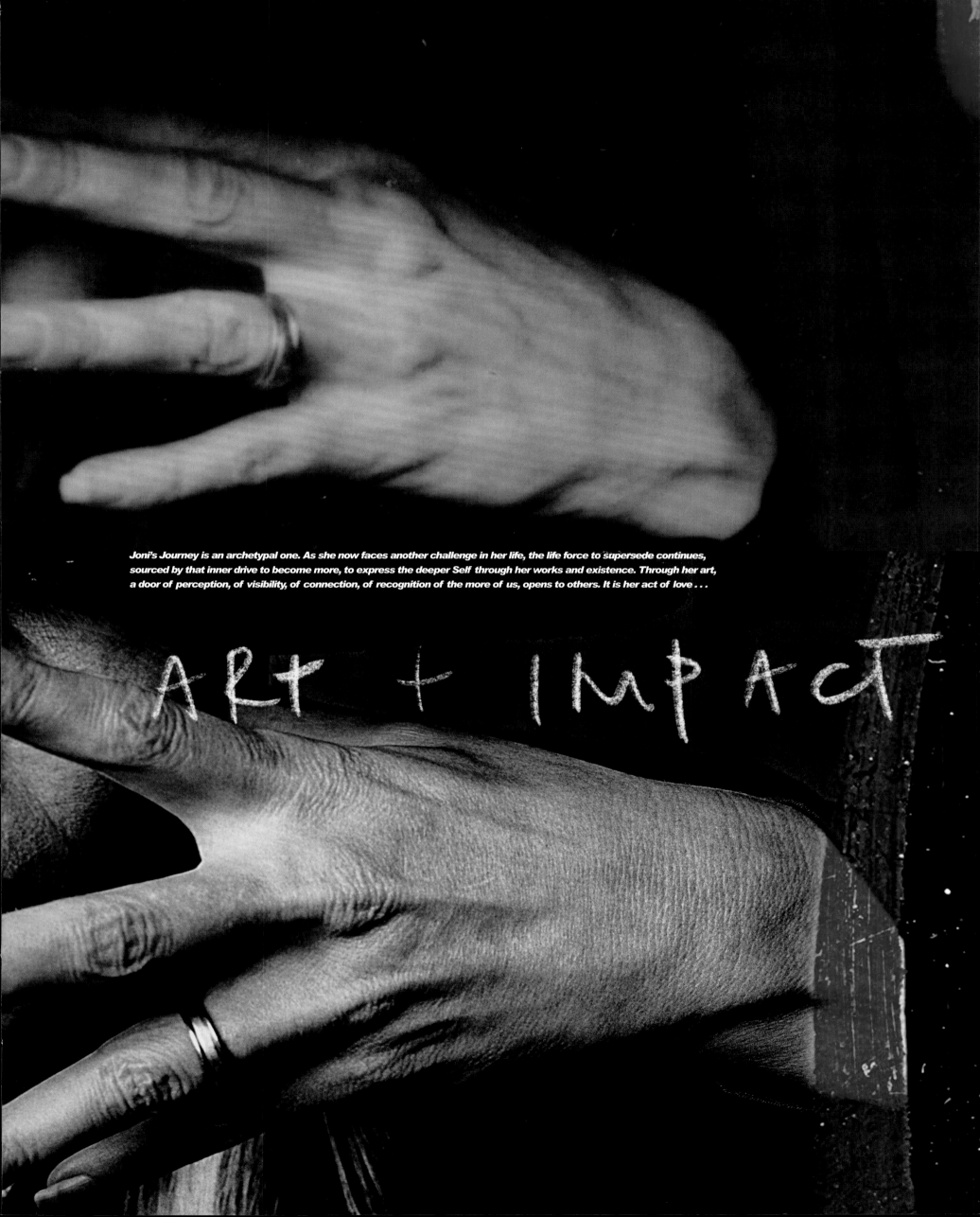

Joni's Journey is an archetypal one. As she now faces another challenge in her life, the life force to supersede continues, sourced by that inner drive to become more, to express the deeper Self through her works and existence. Through her art, a door of perception, of visibility, of connection, of recognition of the more of us, opens to others. It is her act of love . . .

ARt + ImPACt

Thank you to Joni, for the opportunity to participate

in one small facet of your grander journey.

Thank you to Guido, for being the inspiration for this book.

IN GRATITUDE

To a charismatic creative force, my soul mate and wife SUE KIEL,

CHARLES HANNAH for your commitment to walking side by side,

LEAH LEHRER you brighten the way with your passion and light,

DARIUS ANTHONY my soul brother who left too soon, I miss you,

RAOUL GOFF who had no hesitation in saying yes to a path less traveled,

BRET SIMISTER, a creator, innovator, inspired by shared visions,

ERWIN PEARLMAN in honor of our deep dive into the Essence of creativity,

TAMMY McCRARY, your heart and support is unwavering,

DERIK MURRAY for your generous help in supporting the vision,

Artist designer TONY HUDSON for my first Joni Session,

MARY ANN MATTIELLO for your heart-centered support from the start,

and BOB KLEWITZ, an early adopter of new possibilities.

S E E F F
PUBLICATIONS

COPUBLISHER
Norman Seeff

PHOTOGRAPHY, DESIGN, & TEXT
Norman Seeff

GRAPHICS LEAD
Leah Lehrer

HAND TYPOGRAPHY
Teek Mach

GRAPHICS ASSISTANTS
Nicolas Yang
Tai Power Seeff
Denice Hernandez
Shayne Seeff
Ron Ben

DOCUMENTARY PHOTOGRAPHY
Keith Williamson
Bob Klewitz
Jay Buchsbaum

PHOTOGRAPHY ASSISTANTS
Bob Klewitz, Johanna Van Zantwyk, Darius Anthony,
Keith Williamson, Jay Buchsbaum, Alan Levenson, Cameron Wong,
Gary Heery, Cathy Elliot, Natasha Ciura

CINEMATOGRAPHERS
Jonny Sharaf, Neil Reichline,
John Vincent, Georgina Karvallas, Gary Heery

Copyright © 2018 Norman Seeff

INSIGHT EDITIONS

PO Box 3088
San Rafael, CA 94912
www.insighteditions.com

PUBLISHER
Raoul Goff

DESIGNERS
Jon Glick and Katherine Yao

SENIOR PRODUCTION MANAGER
Greg Steffen

FIND US ON FACEBOOK:

www.facebook.com / NormanSeeff
www.facebook.com / InsightEditions

FOLLOW US ON TWITTER:

@NormanSeeff
@insighteditions

CONTACT US AT
STUDIO @ NORMANSEEFF.COM

 REPLANTED PAPER

Insight Editions, in association with Roots of Peace, will plant two trees for each tree used in the
manufacturing of this book. Roots of Peace is an internationally renowned humanitarian organization
dedicated to eradicating land mines worldwide and converting war-torn lands into productive farms and
wildlife habitats. Roots of Peace will plant two million fruit and nut trees in Afghanistan and provide
farmers there with the skills and support necessary for sustainable land use.

Manufactured in China by Insight Editions

10 9 8 7 6 5 4 3 2 1